The Art Business

Edited by Iain Roberts and Derrick Chong

Routledge
Taylor & Francis Group

LONDON AND NEW YORK

First published 2008
by Routledge
2 Park Square, Milton Park, Abingdon, Oxon OX14 4RN

Simultaneously published in the USA and Canada
by Routledge
270 Madison Ave, New York, NY 10016

Reprinted 2008, 2010

*Routledge is an imprint of the Taylor & Francis Group, an informa
business*

Typeset in Times New Roman by
RefineCatch Limited, Bungay, Suffolk
Printed and bound in Great Britain by
CPI Antony Rowe, Chippenham, Wiltshire

British Library Cataloguing in Publication Data
A catalogue record for this book is available from the British Library

Library of Congress Cataloging in Publication Data
The art business / edited by Iain Robertson and Derrick Chong.
 p. cm.
 ISBN 978–0–415–39157–3 (hardcover) – ISBN 978–0–415–39158–0
(pbk.) 1. Art–Economic aspects. 2. Art–Marketing. I. Robertson, Iain
(Iain Alexander) II. Chong, Derrick, 1963–
 N8600.A733 2008
 706.8–dc22
 2007036599

ISBN 10: 0–415–39158–X (pbk)
ISBN 10: 0–415–39157–1 (hbk)

ISBN 13: 978–0–415–39158–0 (pbk)
ISBN 13: 978–0–415–39157–3 (hbk)

Contents

Contributors

David Bellingham is programme director of the MA in Art Business at
Sotheby's Institute of Art London, where he leads units on the Ethics of
the Art Market and Art Market Research Methodologies and lectures
on the History of Classical Art. He is completing his doctorate at the
University of Manchester on the cultural and socio-economic aspects of
banquet scenes in ancient Roman wall-painting. Publications include *An
Introduction to Greek Mythology, An Introduction to Celtic Mythology* and
'The Jenkins Venus: Reception in the Art World and the Market' for a
forthcoming Sotheby's Institute of Art publication.

Joanna Cave is chief executive of the Design and Artists Copyright Society
(DACS). DACS led the campaign in support of the Artist's Resale Right
and is the main collecting society in the UK managing the Artist's Resale
Right. Joanna originally trained and practised as a sculptor and has
worked as chief executive in arts, education and legal organizations before
joining DACS in 2000. In 2004, Joanna was awarded a Postgraduate
Diploma in UK, European and USA Law of Copyright and Related Rights
from King's College London.

Derrick Chong is a senior lecturer in management at Royal Holloway,
University of London. He read business administration and art history in
Canada before completing a PhD at the University of London. The inter-
section of management and the arts is a core interest: this includes a
companion Routledge text, *Arts Management*, and serving as a consultant
lecturer in art business at Sotheby's Institute of Art London and Singapore.
He is Fellow of the Royal Society of Arts (FRSA).

Anthony Downey is the programme director of the MA in Contemporary Art,
Sotheby's Institute of Art London and a London correspondent for *Flash
Art International*. He holds a PhD from Goldsmiths' College, University
of London, and is contributor to *Third Text, BOMB Magazine (New
York), Wasafiri, New York Arts Magazine, Art Review, Journal of Visual
Culture, Pluk, Next Level, Untitled, Bridge Magazine (Chicago), Con-
temporary, Circa, Art and Architecture Journal, Contemporary Visual Arts,*

Skylines, *Wanderlust* and *Upstart*. He is currently researching a book on Aesthetics, Ethics and Politics.

Jeremy Eckstein is an economist and statistician by training. He has been analysing the art market since he joined Sotheby's in the 1970s to provide performance and other statistics and strategic advice to the British Rail Pension Fund during their art investment programme. He left Sotheby's in 1990, since when he has been working as a consultant undertaking economic, statistical and research projects in the art market as well as in the cultural and heritage sectors. He was one of the team selected to evaluate potential fine art funds on behalf of ABN Amro. He lectures on art business and investment subjects to MA students at Sotheby's Institute of Art, London.

Laura Harris, who is an artist by training, is programme coordinator for the MA in Art Business at Sotheby's Institute of Art London. Laura has previously worked for Christie's and has extensive work experience in various arts and media companies. Laura is currently working towards her next exhibition of paintings.

Charles Hill is a private investigator specializing in art crime investigations.

Henry Lydiate has specialized in art law since being called to the English Bar in 1974. He has written a regular column for *Art Monthly* since 1976, and his collected articles are published as the Artlaw Archive by Artquest for which he also provides online advice to artists (www.artquest.org.uk). He is founding partner of The Henry Lydiate Partnership, the creative arts business consultancy. His portfolio includes designing and delivering postgraduate business and legal modules for Sotheby's Institute of Art London and Singapore, Southwestern University Law School Los Angeles, and the University of the Arts London, where he is Visiting Professor.

Catherine Morel is senior lecturer in marketing at Sotheby's Institute of Art London. She is also associate research fellow with the Chair in Arts, Culture and Management at Bordeaux School of Management. Her PhD is from the University of Sheffield. Research interests include the relationships between art and business, corporate sponsorship of the arts, and corporate cultural diplomacy. She is co-author of a book on art sponsorship (*L'Anti-guide du mécénat culturel: pour un partenariat réussi entre l'art et l'entreprise*) to be published in France in 2008.

Clarissa McNair has been a private investigator since 1994, has an office in Philadelphia, but often accepts assignments in New York City and overseas. When not doing criminal defence work, she goes undercover (often for law enforcement) in the field of intellectual property on behalf of internationally recognized designers and manufacturers. Counterfeit products range from watches to pharmaceuticals. She graduated from Briarcliff College in New York with a BA in American history and is a published novelist.

McNair has her own firm, Green Star Investigations, Inc., and is licensed as a private detective in both Pennsylvania and Florida.

Iain Robertson is head of art business studies at Sotheby's Institute of Art, London. He is an Asia correspondent for the international edition of *The Art Newspaper* and a regular contributor to the *Australian Art Market Report*, advisor to the Asia Art Archive, Hong Kong and honorary director of education of MOMA Beijing. His book, *Understanding International Art Markets and Management*, a companion text for Routledge, appeared in 2005. He was awarded a PhD by London's City University in 2000 for a thesis on the emerging art markets of Greater China 1989–1999.

Sonal Singh, who was born in New Delhi, works for Christie's Indian Department in New York. She was a director at Bodhi Art, responsible for exhibitions and programmes at its four locations: Mumbai, New Delhi, New York and Singapore. She holds an MA in Art Business from Sotheby's Institute of Art London, where she specialized in the Indian art market.

Victoria L. Tseng works at Sotheby's New York. Previously, she practised law in California, specializing in intellectual property and corporate finance. She graduated with an MA in Art Business (Distinction) at Sotheby's Institute of Art London, and is also a graduate of Cornell Law School and the University of California at Berkeley.

Editors' preface

The Art Business grew out of a discussion between the co-editors about producing a series of essays – essentially a reader – for the MA in Art Business (MAAB) programme at Sotheby's Institute of Art. We were persuaded by Routledge that broadening the focus beyond the confines of a particular programme would make the book accessible to a wider readership interested in art business. It was also deemed impossible to replicate the full learning experience (i.e., trips and visits, speakers, group work, etc.) associated with studying at Sotheby's Institute of Art. For example, MAAB candidates in London have study trips to art fairs in Europe; they also benefit from access to Sotheby's auction house and outside speakers of leading dealers and other art market professionals. Core MAAB faculty, which includes consultant lecturers, were invited to contribute; moreover, we sought additional contributors working in the market for art in order to widen the overall perspective of the book. Interview data collected in collaboration with www.Xalt.tv, an alternative investment site focusing on global wealth management, is also included.

The original training course at Sotheby's Institute of Art (SIA), 'Works of Art', was established in 1969. The founding principles of an object-based focus and expert assessors working in the field remain. As such, SIA is among the world's leading institutions offering MA and PhD degrees, specialized courses, and study abroad programmes in art scholarship, connoisseurship, and art business. Students explore both the scholarly and practical sides of the art world to gain the skills and professional connections necessary for successful careers.

The MA in Art Business prepares students for the commercial art world. MAAB is not a business degree, but a degree in the business side of art. It is designed for students who already have an art history degree or like qualification and want to understand business theories and practices as well as the technical and structural elements of the art market. Work in the art market brings an altogether different set of challenges from the conventional business world. It is crucial to consider that the 'product' is a unique, aesthetic object bound by specific legal and ethical issues.

Since the original conception of this book, the MAAB programme has

expanded from its base in London to New York and Singapore. This healthy development for Sotheby's Institute of Art represents the growth of interest in creative industries and advances in the global marketplace for art.

Iain Robertson
Derrick Chong
London, July 2007

Foreword

The art market has grown spectacularly in both volume and value in the past few years. It is now a global industry worth in excess of $50 billion a year. In the context of such growth and of the increasing professional interest in all aspects of the market, *The Art Business* is both an essential guide and a welcome sequel to *Understanding International Art Markets and Management* (2005).

The book is a compilation of essays which deal with different topics of pressing concern to anyone who is already involved in the art market as a collector, dealer or museum curator. It is also of value to those who have a passing interest in the art trade, or who wish to study it from the standpoint of the financial markets. The contributors are experts in their field and write with a combination of pragmatism and academic rigour to illuminate an area of study that, I believe, requires proficiency in and knowledge of both.

The art market is still unregulated, quite unlike any other major market. Indeed there is no other class of traded asset where the purchaser, who may be spending upwards of US$50 million on a single work of art, receives no deed of title, apart from the seller's receipt and guarantee of authenticity. Thus the art buyer, whether a collector, investor or museum curator, is open to abuse and deception at the hands of an unscrupulous seller, or, indeed, of an innocent seller who is ignorant of a problem of authenticity, condition or provenance. There is, therefore, much to be gleaned about the processes of due diligence which the buyer should understand and put to use as his essential protection. It is still a market where the buyer must beware.

But the dangers of the art business should not be over-emphasized – its aesthetic and potential financial rewards are at the core of all these discussions. The benefits to be derived from investment in art are carefully covered, bringing to the fore the problems of tracking the market and the assessment of the value of a work of art. The extraordinary growth in the secondary and tertiary markets in contemporary art is another stimulating area which has brought with it a raft of opportunities for artists, intermediaries and collectors alike. Likewise the development of the art market in China and India is another topic of great interest, presaging a future of increasing globalization.

The Art Business provides an up-to-date guide to all these issues and more.

Julian Thompson

1 Introduction to studies in art business

Iain Robertson and Derrick Chong

The art market is the place where, by some secret alchemy, the cultural good becomes a commodity.

Raymonde Moulin, *The French Art Market* (1987 [1967]: 3)

It is the assumption of this book that a work of art is a gift, not a commodity. Or, to state the modern case with more precision, that works of art exist simultaneously in two 'economies', a market economy and a gift economy. Only one of these is essential, however: a work of art can survive without the market, but where there is no gift there is no art.

Lewis Hyde, *The Gift* (1979: xi)

Introduction

Raymonde Moulin's contemporary account of the Parisian art market of the 1960s holds true today. How is an aesthetic object, often without utilitarian purpose, assigned value? What mechanisms exist? In many respects, the art business world, as discussed in this text, represents Moulin's 'secret alchemy'. Moulin's research method of interviewing the key players (dealers, private collectors, museum curators, and critics) remains an object lesson. *The Business of Art* was based on conferences held in the United States under the auspices of the National Endowment for the Arts (Caplin 1982); and Art Basel 2006 was the launch pad for *Collecting Contemporary* by *ARTnews*-listed collector Adam Lindemann (2006), based on his own collecting decisions and access to interviews with key players. At the same time, the art market remains problematic for those who are uncomfortable with price tags attached to works of art. There are condescending references to a 'privately moneyed collecting system' or a 'commodification of art'. A more nuanced account is offered by Lewis Hyde (1979: xii) in *The Gift*: a work of art is a gift and that 'when we are touched by a work of art something comes to us which has nothing to do with the price.' This is a position explored by Robert Storr (2007), director of the 2007 Venice Biennale and dean of the Yale School of Art:

> [R]educing art's commercial value to zero means other values can emerge, other transactions can occur in the currencies of the imagination and intellect ... market values frequently have little or nothing to do with enduring aesthetic or anti-historical values. They are barometers of taste which is nearly always conservative compared to the lasting pleasures and challenges art has to offer.

Storr was drawing reference to the traditional role of the museum in taking works of art out of circulation once and for all.

> It is not possible to measure with any particular accuracy the X international art market or reach any conclusions regarding overall competition because dealer and auction firms frequently do not report annual totals for auction sales, revenues or profit, and the amount reported may not be verifiable.
>
> (Sotheby's 2007b)

The largely unregulated nature of the market for art was a prominent motif when the (UK) House of Commons' Culture, Media and Sport Committee (DCMS Committee 2005) convened to examine, by seeking written submissions and oral evidence from key stakeholders, the market for art. In the UK there is no legislative framework for the trade in art as for financial products under the Financial Services and Markets Act of 2000; nor is there an equivalent of the self-regulatory framework administered by the Advertising Standards Authority for the advertising industry. Rather it is more likely that dealers and auctioneers are subject to laws and regulations, which vary from jurisdiction to jurisdiction, that are not solely directed to the art market (e.g., import and export regulations, antitrust laws, cultural property ownership laws, data protection and privacy laws, anti-money laundering laws, and value-added sales taxes). Several trade associations – ABA (Antiquarian Booksellers Association), BADA (British Antique Dealers' Association), BAMF (British Art Market Federation), LAPADA (The Association of Art and Antique Dealers), SLAD (Society of London Art Dealers), and SoFAA (Society of Fine Art Auctioneers) – operate in the UK art market. Membership is optional, however, as some of the leading contemporary art dealers in London do not belong to SLAD, and Christie's, for example, is not a member of SoFAA.

Of course, the art market operates: 'The purchase and sale of works of art in the international art market is primarily effected through numerous dealers, the major auction houses, smaller auction houses and also directly between collectors' (Sotheby's 2007b: 1). Various 'arts councils' in different countries have, in recent years, shown interest in the workings of the art market: the Arts Council of England commissioned *Taste Buds* (Morris Hargreaves McIntyre 2004) and *Market Matters* (Buck 2004); Pro Helevetia commissioned *Art Market Switzerland* (Walliser-Schwarzbart 2003); and the Canada

Council for the Arts launched 'Assistance to Professional Canadian Contemporary Art Dealers', in 2006, to encourage the development of international links. A research-based monograph, *Talking Prices*, by Olav Velthuis (2005), grounded in economic sociology, highlights the social structures of the art market, with particular reference to how art dealers in New York and Amsterdam determine primary market prices for contemporary works of art.

Recent developments in art business have made it an intriguing subject for study: the rise in fine art and antiques as alternative investment vehicles (as represented by the emergence of art price databases, art indexes, and art funds); powerhouse contemporary art dealers 'poaching' artists; fine art and antiques dealers borrowing from luxury brand retailing to attract so-called mass affluent clients; the growth of art fairs around the world; globalization with significant pockets of wealth in emerging economies interested in collecting art; the emergence of new art market centres in the Far East (Hong Kong, Beijing, Shanghai, and Singapore) and the Middle East (Dubai and Abu Dhabi); ethical issues regarding looted and stolen art and cultural artefacts not least of all in public collections; the introduction of European Union regulation on *droit de suite* (artist's resale rights); and issues of corporate governance, such as public trust, gaining prominence with art museums. Furthermore, many developments which took root in the 1980s – corporate sponsorship of blockbuster art exhibitions, record-breaking auction prices, and the lifestyle celebration of superstar contemporary artists, dealers, and collectors – have become naturalized.

A review of *Art in America*'s (Summer 1988) issue on money and art at the end of the 1980s is very instructive. Several contributors asked about the cultural implications of the 'astronomical' auction prices for French Impressionist and Post-Impressionist paintings (van Gogh was a key artist here and buyers included Japanese corporations and Australia's Alan Bond), modern works by the likes of Jackson Pollock, Jasper Johns, Man Ray, and Edward Weston, and even contemporary artists such as Barbara Kruger. 'Neo-Geo' (associated with artists such as Ashley Bickerton, Peter Halley, and Jeff Koons) was cited as 'The New Thing' in contemporary art. They were a response to the insatiable hunger of a new breed of aggressive often neophyte collectors seeking out 'hot' artists. Corporate support for the arts, promoted by Business Committee for the Arts, a leading advocacy organization in the USA, raised concerns about the rise of blockbuster museum exhibitions financed by corporate sponsors and corporate art collecting.

Dealers were interviewed on the relationship between art (aesthetic value) and money (commercial or economic value) in the context of rising auction prices. Excerpts from statements by Leo Castelli, the then leading gallerist, and Larry Gagosian are illustrative:

> High prices achieved at auction affect everyone in the art world in many complicated ways. In particular, galleries that handle contemporary works in the secondary market are sometimes rather unhappy. They feel

the auction houses have been taking precious materials away from them. Such problems have never affected this gallery. On the contrary, it was favorable to my cause to see works of my artists attaining high prices in auction sales because it suggested to collectors that the prices we charge here are not in any way excessive. Therefore, I have friendly feelings toward the auction houses, though I can understand if, recently, some think the bidding has gone too high. These immense prices *are* a bit disturbing. They show the law of supply and demand operating in an extreme way.

(Leo Castelli in *Art in America* 1988: 78; emphasis in the original)

Art is a commodity but of a funny kind. It is held by relatively few people, and there is not as much liquidity as some of the recent financial reporting on the art market might suggest. People don't wake up in the morning and decide to buy or sell a van Gogh. Art is more beautiful than gold. It has a spiritual quality. People who buy art like art. I know of no collector who has absolutely no feeling for what he's buying. . . . Auction results are a factor in pricing, but more important is the word-of-mouth among collectors. Initial interest is sparked by a new artist, word spreads, there is a critical response, then gallery exhibitions, and possibly museum shows. Reviews in the *New York Times* can be very important. Some people treat the *Times* like a dope sheet. But serious collectors take a wider range of factors into account. A consensus develops around an artist. Some collectors are especially important in forming this consensus. They have buzz names, like certain dealers in the primary market. As a secondary market dealer, I also function as a collector. I acquire works for myself. This gives me a credibility I wouldn't have if I were just buying and selling and gave people the idea that I was just another buccaneer. Other dealers in the market work in the same way. In the eight years I've been in the art world, the dealer has emerged as an elite collector

(Larry Gagosian in *Art in America* 1988: 82)

Such sentiments – high prices at auction, conflict and cooperation between dealers and auctioneers, word-of-mouth and buzz marketing, and the dealer as an elite collector – would not be out of place today. The names change, though, reflecting the life cycle of dealers in the intervening two decades. Castelli died in 1999; his gallery, established in 1957, continues in a reduced state of operations. Gagosian has developed a leading position in the intervening two decades. Iwan Wirth of Hauser & Wirth, who opened his first gallery in Zurich, in 1992, is touted as a successor. Other dealers, who emerged in New York in the 1990s, like Andrea Rosen (est. 1990), David Zwirner (est. 1992), and Cheim & Read (est. 1997), have established international reputations. Likewise London has witnessed the rise of Jay Jopling's White Cube (est. 1993) and Sadie Coles HQ (est. 1997), to the first rank.

Property, often referenced as the process of gentrification, is never far from art market concerns: SoHo, as hub of the New York art world since the 1960s, started to give way to Chelsea in the 1990s, and current attention is given to non-Manhattan activity in Brooklyn (namely Williamsburg) and Queens, which has benefited from P.S. 1's relationship with MoMA (New York's Museum of Modern Art); and the Young British Artists (YBA) scene, associated with London of the 1990s, saw the emergence of the East End as a site for contemporary art.[2]

The observation of a leading critic, arguably a disinterested party, on the marketplace for art is even more apposite two decades later:

> Everywhere one sees signs of an increasing importance of art as an investment property. It has clearly reached unexpected heights of economic hyperbole. . . . In an eloquent tautology, art's monetary value has become its sublime value. Art and money have exchanged roles: money becomes 'divine' by being 'translated' into art. But that's enough to give art the only clear and absolute meaning – meaning as universal and substantial as money – it's going to get in this farcical world.
>
> (Donald Kuspit in *Art in America* 1988: 109)

Now analysts at Citigroup (2005) are using 'plutonomy' to describe the growing gap between the super-rich (few in number, but disproportionate in the gigantic slice of income and consumption they take) and the rest of us. Recent art market examples – entertainment impresario David Geffen selling Pollock's *No. 5* (1948) for $140 million in a private treaty sale, and casino owner Steve Wynn seeking compensation from his insurance company for $54 million, as the value knocked off a Picasso, from elbowing it – raise the spectacle of the $500 million painting. It is less a question of if, or even when, such a transaction will take place, but various *who* questions – of seller, buyer, intermediary, and artist – and *how* (confirmed private treaty or public auction).

Art business organizations

Several main types of organization are involved in art business: dealers and auctioneers of fine art and antiques are key intermediaries; public art museums are leading civic institutions in liberal democracies alongside libraries and universities; providers of ancillary services include art fairs, art advisors, insurance companies, art lawyers, and interior decorators and designers; and business corporations use art by building art collections and sponsoring museum exhibitions. The profit incentive is used as a primary point of separation: art museums are usually not structured to maximize profits for shareholders, thus an emphasis on not-for-profit or public sector organizations; dealers and auctioneers, on the other hand, and almost all ancillary service providers are for-profit (i.e., commercial) organizations.

Dealers and auctioneers

The owner of a work of art wishing to sell has four principal options: sale or consignment to, or private sale by, an art dealer; sale or consignment to, or private sale by, an auction house; private sale to a collection or museum without the use of an intermediary; and for certain categories of property (in particular collectibles) consignment to, or private sale through, an internet-based service (e.g., eBay) (Sotheby's 2007b). Selling fine art and antiques is the work of two key intermediaries: dealers and auctioneers. Dealers account for the majority of value of transactions in the international art market. As is the case with other intermediation businesses, personal contact and human relations remain important for success. Dealers need several competitive factors: relationships and personal interaction between the buyer or seller and the dealer; the level of specialized expertise of the dealer; and the ability of the dealer to finance purchases of art (Sotheby's 2007b: 5). The principal role as an auctioneer, as an agent accepting property on consignment from its selling client, is to identify, evaluate and appraise works of art through specialists, and to stimulate purchaser interest through marketing techniques, and to match sellers and buyers through the auction process (Sotheby's 2007b: 2). As an auctioneer earns commission revenue from the buyer (buyer's premium) and the consignor (seller's commission) 'a key challenge is to obtain high quality and valuable property for sale either as agent or principal' (Sotheby's 2007b: 3)

Two facets are worth noting about the structure of the art market. First, art in the marketplace has two circulation patterns: primary sales and secondary sales. Primary sales represent the first time a work of art is sold; this is conducted, in the main, by contemporary art dealers representing artists with the selling price shared on a 50:50 basis in most instances. Secondary market sales refer to all subsequent resales of a work.[3] Resales can take place through a dealer (as most primary market dealers also operate in the secondary market, especially in the case of artists they represent) or an auction house, which latter is considered a tertiary sales market. Second, public and private dealers exist. Public dealers (also called gallerists) operate retail gallery spaces that are open to the public. Indeed the Art Dealers Association of America (ADAA) cites public dealers in New York as offering the best free education in arts appreciation (given that art museums in New York charge entry fees). Exhibitions by London's Colnaghi (est. 1760) and Agnew's (est. 1817), both specialists in Old Master paintings and drawings, rival art museums. Being identified as a 'public dealer' is a prerequisite to exhibiting at many leading art fairs. Private dealers do not operate a retail gallery space open to the general public. Some of the leading dealers in London like Christopher Wood (Victorian art) and Crispian Riley (Old Master prints) operate as private dealers. Karsten Schubert and Anthony D'Offay closed successful contemporary art galleries in London to operate privately.

Even the largest auction houses are small, in terms of staff complement

and market capitalization, relative to firms of similar reputation in other industrial sectors. For example, Sotheby's, which is listed on the New York Stock Exchange (NYSE) under the symbol BID, has a global staff complement of approximately 1,500 (with two-thirds located in New York and London) and index membership in the S&P 400 MidCap (with market capitalization of $3.3 billion in May 2007). In a 2001 *Harvard Business Review* interview with Bernard Arnault, the major French auction house L'Etude Tajan represented an incidental part of the LVMH stable of luxury brands (Wetlaufer 2001). The Fine Art Auction Group, the fourth largest auction house in the UK (after Christie's, Sotheby's, and Bonhams), has annual hammer sales of about £20 million. Art dealers are primarily small- to medium-sized businesses managed from an owner-operator perspective. Richard Green, arguably the UK's most successful dealer with three locations in London's Mayfair, is essentially a family affair. A generational link is also evident with New York dealers like Aquavella and PaceWildenstein, and Canadian ones like Klinghoff (Montreal) and Loch (Winnipeg, Toronto, and Calgary). However, relative to start-ups in other sectors, there appears to be tighter growth potential for dealers.

Art dealers and auctioneers are embedded in the art business world of commercial culture. There are two key ways to sell fine art and antiques: sale or consignment to, or private sale by, an art dealer; consignment to, or private sale by, an auction house. Moreover, dealers and auction houses represent two legs of the same (fine art and antiques) body. This latter point is sometimes overlooked as dealers and auctioneers can bicker about who is making the easy money at the expense of the other's hard graft. Auctioneers can be likened to wholesalers and dealers to retailers. Indeed many dealers buy their stock at auction; and auctioneers recognize that a significant portion of their lots are bought by dealers (for stock or representing private collectors). Dealers can view the two-way charges collected by auctioneers – buyer's premium paid on the hammer price and commissions collected from consignors on the hammer price – as an easy gross margin of 20–35 per cent (based on the buyer's premium and the seller's commission).[4] Dealers do not appreciate auctioneers marketing to private collectors, who may compete on lots with greater emotion and less attention to the short-term resale value. Dealers feel that auctioneers engaging in private treaty sales are encroaching on the traditional marketplace of dealers. The historical role of the auction house has been to offer pure intermediation between consignor and buyer, hence the two-way commission; in doing so auction houses offer market price transparency.

The leading auction houses have expanded operations to include a dealer segment and finance segment alongside the conventional auction one. First, there are examples of auction houses taking a financial position in dealers. Christie's helped Amor Holdings, the fine art and antiques investment vehicle of Mark Law, to acquire a controlling stake in London-based Partridge Fine Arts, in 2005; in return, Amor arranged for Partridge to sell half of its inventory via a Christie's auction in order to settle the financing. In

2006, Maastricht-based Noortman Master Paintings became a wholly owned subsidiary of Sotheby's, with Robert Noortman joining the auction house's international advisory board, until his death in 2007. Sotheby's acquired 100 per cent ownership of Noortman's gallery and stock, as well as its $26 million in debts. Although no cash changed hands, Sotheby's paid Noortman the equivalent of $49.2 million in Sotheby's shares. Most recently, in early 2007, Christie's purchased contemporary art dealer Haunch of Venison, which provoked controversy (including exclusion of Haunch of Venison from Frieze Art Fair 2007). Second, the leading, international auction houses can offer certain collectors and dealers assistance with financing, generally secured by works of art. Few conventional financial lenders are willing to accept works of art as sole collateral as they do not possess the ability to appraise and to sell works of art within a vertically integrated organization (Sotheby's 2007b). The role of financing is to drive the auction business, but there is an ability to generate profit from the interest spread through two main initiatives: consignor advances and term loans (Sotheby's 2007a).

Public art museums

Considered 'a temple of the human spirit, the public art museum is also an important civic institution. This recognizes the art museum's 'relationship with modern democratic culture' (Carrier 2006: 15). At the same time, the art museum is an important art business organization: it serves as a final repository for works with validated reputations, some entering the primers of art history. Indeed the term 'museum quality' is used in the sales patter of auctioneers and dealers. General art museums include the British Museum, the Louvre, the Prado, and the Metropolitan Museum of Art. Museums of modern art include New York's MoMA, Tate Modern, and the Centre Pompidou.

The issue of art museums and public trust has been raised by the Association of Art Museum Directors (AAMD) – a membership organization which represents 175 directors of the major art museums in the USA, Canada, and Mexico such as the Art Institute of Chicago, the Philadelphia Museum of Art, MoMA, and the Art Gallery of Ontario – in several position papers since 2001. This is due to the rise of commercial exchanges, such as exhibition collaborations with for-profit organizations and over revenue generation schemes and relationships with private collectors and corporate sponsors (AAMD 2001a, 2001b, 2001c, 2006a, 2006b). The Solomon R. Guggenheim Foundation is often cited as being the most ambitious promoter of art museums from a branding perspective. Roberta Smith (2000), writing in the *New York Times*, sparked a national debate among art museum directors when she challenged them to ensure that objects on display are treated as works of art. Two exhibitions, both from 2000, were cited by Smith as being seriously flawed to the point of compromising the aesthetic mission of art museums: 'Giorgio Armani' at the Guggenheim Museum had the effect of turning the Frank Lloyd Wright building into a department store; and the

Los Angles County Museum of Art was turned into a historical society with 'Made in California: art, image and identity 1900–2000.' Leading members of AAMD replied with *Whose Muse?*, edited by James Cuno, now president of the Art Institute of Chicago, who made the case for the public trust and art museums:

> For in the end, this is what visitors most want from us: to have access to works of art in order to change them, to alter their experience of the world, to sharpen and heighten their sensitivities to it, to make it come alive or new for them, so they can walk away at a different angle to the world.
>
> (Cuno 2004: 73)

Stephen Greenblatt (1991: 42) uses 'resonance':

> the power of the displayed object to reach out beyond its formal boundaries to the larger world, to evoke in the viewer the complex, dynamic cultural forces from which it has emerged and for which it may be taken by a viewer to stand

and 'wonder' – 'the power of the displayed object to stop the viewer in his or her tracks, to convey an arresting sense of uniqueness, to evoke an exalted attention' – to describe two distinct models for exhibitions of works of art. He concludes that the impact of most exhibitions is likely to be enhanced if there is 'a strong initial appeal to wonder, a wonder that then leads to the desire for resonance, for it is generally easier in our culture to pass from wonder to resonance than from resonance to wonder' (Greenblatt 1991: 54).

In the UK, the most familiar art museums (e.g., the British Museum, the National Gallery, the Tate Gallery, the Victoria & Albert Museum (V&A) and the National Portrait Gallery) are designated National Museums and Galleries (NMGs). The DCMS/V&A Funding Agreement 2003–06 is instructive as a contract between a public funding agency (DCMS) and its client (V&A). The DCMS identifies four key strategic priorities:

- enhancing access to a fuller cultural and sporting life for children and young people, and giving them the opportunity to develop their talents to the full
- opening institutions to the wider community, to promote lifelong learning and social cohesion
- maximizing the contribution which the leisure and creative industries can make to the economy
- modernizing delivery, by ensuring that sponsored bodies are set and meet targets which put customers first (DCMS/V&A 2003: Annex A).

With direct funding from central government, NMGs are subject to scrutiny – including performance measurement targets – by the DCMS. New public

sector management imperatives – which are pronounced in the UK – put an emphasis on customer-focused delivery.

Ancillary art business service providers

A range of complementary providers exist to offer ancillary services. They suggest that buyers seek professional advice and guidance in starting and building a collection and maintaining its aesthetic worth and economic value. Organizations like the Art Fund (formerly the National Art Collections Fund) and the Contemporary Art Society, both in the UK, offer ways for more engaged spectators to participate. High net worth individuals (HNWIs) – used by wealth management firms like investment banks to describe individuals with investible assets of over $1 million (see Capgemini and Merrill Lynch 2006) – seeking to build a collection may seek art advisory services: some investment banks like to offer a specialist service; and there are consultants like Randall James Willette, former head of art banking at UBS's London office, who established Fine Art Wealth Management, a London-based art investment consultancy, which specializes in advising private banks on integrating art into their overall wealth management strategy for private clients. Insurance providers like AXA, Chubb, and Hiscox with specialist knowledge in fine art highlight that insurance – at a fraction of the cost of the art – is a necessity for any art owner. Gurr Johns (est. 1914 with offices in London, New York, Paris, and Munich) operates as a firm of valuers and fine art consultants, independent of any auction house or deal. Interior designers (and decorators) have gained a solid footing in the USA in gaining the trust of clients to include collecting art as part of their brief. Prominent public relations firms specializing in fine art include Sue Bond and Cassleton Elliott. Art funds (the most prominent being Philip Hoffman's The Fine Art Fund) focus on the financial returns of art investing. The Art Loss Register describes itself as 'the world's largest private international database of lost and stolen art, antiques and collectibles' which is about due diligence, recovery, and prevention of art theft and fraud. The International Foundation for Art Research (IFAR) 'offers impartial and authoritative information on authenticity, ownership, theft, and other artistic, legal, and ethical issues concerning art objects' as a not-for-profit organization dedicated to integrity in the visual arts. Institutional economic research firms specializing in fine art and antiques, such as the economic impact of art fairs, include Jeremy Eckstein (London), David Kusin (Dallas), and Claire McAndrew (Dublin).

Art fairs serve as a meeting place, an economic cluster, where art dealers set up stalls for a short period of time to display their wares to private collectors, institutional buyers, and the art press. The European Fine Art Fair (TEFAF) in Maastricht is the leading art fair for Old Masters, though classics from the twentieth century have been introduced as a way to attract younger collectors. It has been in the area of contemporary art that art fairs have grown most in prominence with the formation in the early 2000s of London's Frieze Art

Fair and Art Basel Miami Beach (as a December complement to June's Art Basel), and numerous spin-off fairs for newer galleries led by the NADA (New Art Dealers Alliance) as well as art fairs coinciding with Art Basel Miami Beach, Zoo alongside Frieze, Volta and Liste parallel to Art Basel, and Scope with its multiple sites. Jeffrey Deitch notes the heightened prominence of art fairs:

> Whether you think the increasing impact of fairs is good or bad, one thing is clear. This is the way things are moving, and you have to run with it as a gallery owner. I'm very focused on exhibitions and projects. I put a lot into them, and we love doing them and bringing in the crowd. I love that impresario-type role. Doing serious exhibitions and great publications – that's my favorite part of what we do. You can't do a great exhibition at a fair; you have to distill [the experience of the gallery and its program]. But even though I might prefer the semi-old fashioned way, you simply must do art fairs.
>
> (cited in Artinfo, 18 July 2006)

Deitch goes on to cite the role of art fairs in offering efficiency to museum curators on limited travel budgets and collectors with time as a scarce resource.

Business corporations using fine art and antiques

Corporate sponsorship of museum exhibitions and corporate art collections are prominent examples of how businesses use fine art and antiques to support commercial goals. The Business Committee for the Arts, created in 1967, was the first organization devoted to encouraging leading corporations to support the arts. The inaugural meeting was chaired by Nelson Rockefeller, the then chairman of Chase Manhattan Bank, at the Metropolitan Museum of Art. Corporate sponsorship is illustrated by the formation in the UK of the Association for Business Sponsorship of the Arts (ABSA) in 1976. The criticisms raised by Hans Haacke, often labelled an agit-prop artist – see an interview in *October* (Bois et al. 1984) – remains influential. For example, *Taking Stock (unfinished)* (1984) attempted to disclose the links between Charles Saatchi, Thatcherism, the Tate Gallery, and Julian Schnabel. Issues of corporate governance and public accountability were raised in relations between private collectors (such as Saatchi, who was a Tate Patron and owner of works by Schnabel, a highly collectible artist in the 1980s) and public institutions (in this case the Tate); moreover, there was political disquiet as Saatchi & Saatchi the advertising agency founded by Charles and his brother Maurice, helped Margaret Thatcher to win the 1979 General Election. An earlier work, *On Social Grease* (1976), critiqued what Haacke viewed as the role of arts organizations serving as publicity vehicles for corporations with image problems. The market moves on, such that Haacke's impact

may be out of date, though we witness his influence on contemporary artists like Andrea Fraser (2005) and cultural critics such as Chin-tao Wu (2002).

Corporate art collections by business services organizations such as investment banks and law firms can be cited. 'Under the motto "Art at Work" Deutsche Bank has assembled the world's biggest corporate collection, which today constitutes 50,000 works of art', which is displayed at over 1,000 branches, according to the bank. The London office of Clifford Chance, an international law firm, started collecting limited edition prints by artists working in the UK in 1990. The contrasting Scottish cases of Flemings and Drambuie illustrate that corporate art collections need to be managed. Difficulties can arise if the accumulation of art is not integrated into the organization's culture, precipitating a need to sell in times of financial difficulty, which recognizes the financial value of a non-working asset. The Fleming Collection, based in London, is considered the finest collection of Scottish art in private hands. Robert Fleming founded the merchant bank in 1845; when Flemings moved into new London offices in 1968, a decision was made to collect paintings by Scottish artists or of Scottish scenes by any artist. The sale of Flemings – now part of JPMorgan Chase – led to the sale of the collection in April 2000 to a new charitable foundation (The Fleming-Wyfold Art Foundation) and the conversion of an empty retail space into a gallery which opened to the public in 2002. On the other hand, the sale of the Drambuie art collection, conducted by Edinburgh-based auctioneers Lyon & Turnbull in 2006, was described as one of the biggest art sales in Scottish history (£3.2 million). Although the collection had been held by three generations of the Mackinnon family, owner of Drambuie, the whisky liqueur brand, falling sales of the liqueur has seen the company, now largely out of the family's control, engaged in a major sale of assets.

ABSA's change of identity to Arts & Business (A&B) was in recognition that the relationship between the arts and business extended beyond corporate sponsorship. A&B has sought to capture the rise of so-called 'creative development' initiatives in which business organizations seek to stimulate imaginative and innovative thinking among employees in order to achieve business solutions. Do employees, considered as an organization's resource, need to be treated differently from other types of resources because they are *human*? What are the management implications?

Consumption of fine art and antiques

Consuming fine art and antiques has been examined in several fields including the sociology of art, cultural economics, and marketing. The sociology of art includes the pioneering work of Pierre Bourdieu (1984 [1979]), with important contributions on the contemporary art market by Howard Becker (1982) and Raymonde Moulin (1987 [1967]). Cultural economics is a younger discipline with instructive contributions on the art market by William Baumol (1986), Bruno Frey (2000), and David Galenson (2001, 2005); moreover, the

subdiscipline has its own publications, *A Handbook of Cultural Economics* (Towse 2000) and the *Journal of Cultural Economics*. Marketing and consumer behaviour research on collecting includes the work of Russell Belk (1995).

Three levels of consumption of fine art and antiques can be identified, which make links to the key art business organizations (see Table 1.1).

Level 1 is represented by spectators (or appreciators) with the public art museum being a key example of an art business organization; Level 2 is represented by various types of collectors (public and private; individual and institutional); and Level 3 is represented by investors and speculators, including the emergence of art funds. In each level of consumption dealers (private and public) and auctioneers are active as intermediaries.

Level 1 consumption: appreciating art

The formation of the public art museum is of historical importance in making art available to the general public, and it remains fundamental to the general education of arts appreciation. Yet not everyone takes advantage of this opportunity, so there are 'attenders' and 'non-attenders' (of public art museums). Reasons to account for visiting art museums have been proffered by sociologists researching the arts and cultural economists.

Sociologists researching the arts such as Bourdieu emphasize the cultivation of taste. In particular Bourdieu argued against the Kantian view that the purity of aesthetic contemplation derives from disinterested pleasure. He challenged the view of innate taste: what are the social conditions for arts consumption? Bourdieu's research findings highlighted that arts participation, such as visiting public art museums, is closely linked to educational attainment (measured by length of time in full-time education or attainment) and social origins.[5]

Free entry to the public art museum is also optional (or a 'false generosity') in that it is reserved for those who have the privilege of making use of this freedom, according to Bourdieu (1984). A work of art has meaning and interest only for someone who possesses the requisite 'cultural capital' to

Table 1.1 Three levels of consumption

Consumption levels	Type of consumer	Art business entity
Level 1	Spectators (appreciators)	Public art museums
Level 2	Collectors	Public art museums
		Business corporations
		Private individuals
Level 3	Investors and speculators	Private individuals
		Art funds

unlock meaning from looking at works on display in an art museum. In distinguishing between a Brillo box and work consisting of a Brillo box – Andy Warhol's *Brillo Boxes* (1964) is used as an example – Arthur Danto cites a 'certain theory of art':

> It is the theory that takes it up into the world of art, and keeps it from collapsing into the real object which it is (in a sense of is other than that of artistic identification). Of course, without the theory, one is unlikely to see it as art, and in order to see it as part of the artworld, one must have mastered a good deal of artistic theory as well as considerable amount of history of recent New York painting.
>
> (Danto 1964: 581)

For example, Tom Hunter, the first contemporary photographer to exhibit at the National Gallery, makes references to the works of Manet and Velasquez through the perspective of local tabloid headlines. In doing so, Hunter is also drawing on the photo-conceptual tradition of the likes of Jeff Wall since the 1980s. Canadian Kent Monkman adds a 'queering colonialism' motif to his oils on canvas which invite a closer reading for references to Paul Kane and Cornelius Kreighoff, two historical Canadian artists favoured by private collectors.

Cultural economists use the notion of addiction and maximizing satisfaction. Appreciating art is a cultivated taste, and cultivation of taste means that preferences are changed by consumption experiences as an adult. The taste for art is acquired (or discovered) and the rate of art consumption increases over time with exposure – this suggests that art is addictive. Art consumption increases with an ability to appreciate art, which is a function of past art consumption. Satisfaction from art consumption rises over time. 'The activity of art is a maximizing activity. Without that assumption, economics has no place in the study of art or of anything else' (Grampp 1989: 8).

The increasing instrumentalism of arts policymakers in the UK, such as that adopted by the Department of Culture, Media and Sport, is challenged in a Policy Exchange document, *Culture Wars* (Mirza 2006). A similar position is adopted by Grayson Perry, the 'transvestite potter' (to borrow the descriptor used by the tabloid press), who was awarded the Turner Prize in 2003:

> New Labour has been pouring money into the arts not just because this is a good thing but because of the belief that the arts will heal communities, reduce crime and raise the aspirations of those not educated enough to know whether they like Bartók or Birtwistle. . . . While I appreciate that artistic activities may have a beneficial effect on some groups, I do not believe that thrusting mediocre culture targets will improve health, enliven run-down cities or bring [the lower half of the social class groups] C2DEs into the political 'we'. . . . The evidence that art has this power is

sketchy and based mainly on research commissioned by arts institutions with the aim of advocacy in mind.

<div align="right">(Perry 2006)</div>

The main priorities of the DCMS, as mirrored by the V&A, put an emphasis on two main groups (children and young people, and under-represented groups as measured by social class and ethnicity), the importance of measuring art's economic impact, and the marketing-orientation of public services with citizens reconceptualized as customers. It goes without saying that it is very difficult for NMGs to baulk at the priorities of their main funding agency even if they are deemed dubious. To do so runs the risk of being charged with elitism and catering to the interests of the affluent, well-educated spectators with public-subsidy.

Level 2 consumption: collecting art

'Collecting is the process of actively, selectively, and passionately acquiring and possessing things removed from ordinary use and perceived as part of a set of non-identical objects or experiences,' according to Belk (1995: 67), who examines individual collecting as a form of consumption, from a marketing perspective. He declares:

> In a materialistic society, the quality and quantity of our possessions are broadly assumed to be an index of our successfulness in life in general. In addition, by competing for rare objects of value, we are able to demonstrate our relative prowess and the effects of superior knowledge, tenacity, monetary resources, cleverness, or luck.

<div align="right">(Belk 1995: 87)</div>

Jean Baudrillard, in *The Cultures of Collecting*, adds:

> Collecting proper emerges at first with an orientation to the cultural: it aspires to discriminate between objects, privileging those which have some exchange value or which are also 'objects' of conservation, of commerce, of social ritual, of display – possibly which are even a source of profit.

<div align="right">(Baudrillard 1994 [1968]: 22)</div>

Collecting art is, from an historical perspective, an elite recreational activity. According to Moulin:

> Part of the pleasure of collecting lies in risk and competition. Collectors gamble on paintings and artists the way racing enthusiasts gamble on horses or market enthusiasts on stocks. . . . It is an elite recreation, a

game in which the losers are presumably those without culture or artistic taste.

(Moulin 1987 [1967]: 82)

Wealth remains a key factor in profiling private collectors. High net worth individuals have always been core to the art market. New collectors often come from the entrepreneurial super-rich class. Many are based in the USA, as indicated in the annual *ARTnews* list of top collectors, but international dimensions are more important than ever, with the rise of super-rich con-sumers in the emerging economies of Russia, India, and China. Russian buyers from the so-called oligarch class have been keen on repatriating Russian paintings from the late nineteenth and early twentieth centuries (i.e., the half century period before (communism took root). Non-resident Indians (NRIs), often working in the USA and UK, have run up prices for modern and contemporary Indian art. The rise of contemporary Chinese artists led by the likes of Cai Guo-Qiang, Yue Minjun, and Zhang Xiaogang during the last decade has reflected the buying behaviour of non-Chinese collectors.

Yet there is also the rise of the so-called 'mass affluent' segment (Nunes and Johnson 2004; Silverstein and Fiske 2004), first used in retail banking (e.g., £50,000 gross income for NatWest Premium Banking and £70,000 gross income for NatWest Black Card). How to persuade the mass affluent to spend some of their 'discretionary' income – that is income after paying out for taxes, mortgage, food, work transport, and savings – on fine art and antiques? Competing uses of discretionary income may include private school fees, exotic holidays, smart cars, designer clothes, and dining-out. The leading auctioneers have had varying degrees of success in promoting secondary showrooms in London for art and antiques at less than £5,000. (Sotheby's Olympia is closing in 2007; Christie's South Kensington, which launched a new sales programme in 2004, and Bonhams South Kensington remain in operation.) Smaller London-based auctioneers like Bloomsbury and Rosebery's have benefited from newer mass affluent collectors. Multiples, such as prints, drawings, and photographs in limited editions, can be a way to 'buy' a well-known artist at a fraction of an 'original' work.

Alongside institutional collectors like business corporations, there are private museums and art foundations. Very well-known examples of 'static' collections based on the taste of private individuals include the Wallace Collection (London), the Frick Collection (New York), the Isabella Stewart Gardner Museum (Boston), and the Barnes Foundation (Merion, PA). Two examples of private philanthropy from Canada can be cited: the Ydessa Hendeles Art Foundation (Toronto) for contemporary art and the Canadian Centre for Architecture (Montreal) established by Phyllis Lambert (née Bronfman). Most recently, prominent collectors like Saatchi (London), Pinault (Venice), and Louise Blouin (London) have established private museums.

Level 3 consumption: art investors and speculators

In the aftermath of the late 1990s Internet bubble, Dover Publications reprinted books from the 1930s on financial investing: *The Art of Speculation* by Philip Carret (2004 [1930]) and *Why You Win or Lose* by Fred Kelly (2003 [1930]). 'It is quite impossible to draw a sharp line and say of those on the one side, "These are investors!" and those on the other, "Those are speculators!",' according to Carret (2004 [1930]:8). He adds that speculators can be distinguished from gamblers: gamblers make decisions based on hope whereas 'speculators are those who use brains' to find 'hidden weak spots in the market'; as such 'the speculator is the advance agent of the investor' (Carret 2004 [1930]: 9). Vanity, greed, and the will to believe were identified by Kelly (2003 [1930]) as the three most malign influences to making money on the market. 'Speculation is amusing. Because good taste and good investment go hand in hand, the speculator qualifies as a connoisseur by the profit he earns' (Moulin 1987 [1967]: 99). This is an astute observation on buying art with intrinsic aesthetic qualities undervalued by the market.

'To flip' a work of art may be the nearest art market analogy to speculation. There is an expectation to profit by an upward movement in price realized over a short period of time by reselling a 'hot' work. Of course, there is a presumption that the risk is low (through insider access) thus making it very attractive – a sure winner. Contemporary art dealers will take steps to counter flips. Some will have 'lists' so that a buyer has to qualify on various levels before being able to buy in-demand works. The ideal buyer, according to many dealers, is the private collector who has expressed an intention to donate his or her collection to a prominent art museum. Art museums are attractive as part of the enhancement of an artist's reputation (or pedigree), which can influence subsequent prices (in the primary and secondary markets), but there is also a need to offer a discount relative to what the private collector is charged. Powerful dealers will attempt to 'blacklist' private collectors who are caught flipping the works of their represented artists; powerful dealers will also pressure collectors to offer them the first right of refusal when the time arises to sell. Much of this is the role of powerful dealers trying to control the placement of the works by their represented artists.

Risk and return are the key attributes helping to distinguish savings from investments. Risk-free savings with high liquidity such as high interest saving accounts tend to offer low returns. At the other end of the risk–return spectrum, gambling (roulette or blackjack tables) offers a high return at a high level of risk. More recently, spread betting (on almost everything that changes or moves) has been made available to individuals at a retail level. Into this mix are thrown alternative (or exotic) investments like fine art and antiques competing against foreign property, wine (especially red French Bordeaux), classic motors, and race horses. It is worthwhile to note that standard 'small print' risk factors exist when investing in art: past performance may not be repeated and should not be seen as a guide to future performance; one is not

certain to make a profit on one's investment and one may lose money; moreover, the consumer protection afforded to more conventional financial instruments is usually absent.

Caveats on art as an investment class have been identified by William Baumol (1986) writing in the *American Economic Review* at the time of the 1980s art boom. Baumol (1986: 10–11) posits several distinctions between the workings of the securities and art markets, highlighting that the equilibrium mechanism is more feeble in the art market. First, 'the inventory of a particular stock is made up of a large number of homogeneous securities, all perfect substitutes for one another'; on the other hand, works of art are 'unique' and 'even two works on the same theme by a given artist are imperfect substitutes.' According to Sotheby's (2007b: 2), 'objects auctioned are unique items, and their value, therefore, can only be estimated prior to sale.' Second, 'a given stock is held by many individuals who are potentially independent traders on the near perfectly competitive stock market'; in contrast, the owner of work 'holds what may be interpreted as a monopoly on that work of art.' Third, 'transactions in a given stock take place frequently, indeed almost continuously'; however, the resale of a given art object is more infrequent. Infrequency means lower levels of liquidity for art. Low trading volume may also lead to price fluctuations. According to Sotheby's (2007b: 9), 'the art market is not a highly liquid trading market, as a result of which the valuation of artworks is inherently subjective and the realizable value of artworks often varies over time.' Fourth, 'the price at which a stock is exchanged is, generally, public information'; on the other hand, 'the price at which an art work is acquired is frequently known only to the parties immediately involved.' There is no equivalent stock exchange for art; auctioneers and dealers serve as the key exchange intermediaries. Publicly available price data is limited to public auction sales. Works that are 'bought-in' (i.e., the final bid was below an undisclosed reservation, which is set lower than the low estimate) are also excluded. More importantly, there is incomplete sales data as sales through dealers operating in the primary and secondary markets are excluded. Precise arrangements between the auctioneer and the consignor – such as consignment charges or guarantees – are not disclosed. Fifth, 'in the case of a stock we know, at least in principle, what its "true" (equilibrium) price should be – it is the stock's pro rata share of the discounted present value of the company's expected stream of future earnings.' 'But, for a work of art, who would dare to claim to know the true equilibrium price?' Guides to collecting advise the buyer not to haggle – it is art, after all, not a used motor – though the dealer's listed price (if one exists) may be a starting point for any negotiations. Auctioneers publish low/high estimates for each lot as a guide to bidders, yet the reserve price (i.e., the minimum bid that must be reached for the sale to take place that is negotiated in advance with the consignor) is not disclosed. Failure to reach the reserve price results in the lot being 'bought-in'. On the other hand, in the heat of an auction lots can sell for several multiples of the high estimate. Baumol adds that a 'risk premium'

(which might be covered by carrying charges for security, insurance, and conservation) needs to be deducted from any apparent rate of return. Transaction costs of buying and selling art are higher than for other financial instruments. For example, buying and then selling at auction will consume 20–35 per cent of the hammer price.

Baumol (1986: 14) notes the importance of insider access to shape taste: 'Only those critics who have succeeded as instruments for the redirection of general tastes seem really to have been in a position to profit from their judgement.' He concludes on the non-financial returns of art:

> Ownership of art works may well represent a very rational choice for those who derive a high rate of return in the form of aesthetic pleasure. They should not, however, let themselves be lured into the purchase of art by the illusion that they can beat the game financially and select with any degree of reliability the combination of purchase dates and art works that will produce a rate of return exceeding the opportunity cost of their investment.
>
> (Baumol 1986: 14)

Baumol's caveats have not deterred the rise of players supporting the market for art as an alternative asset class. Indeed one can point to a growing industry built on art investment aspirations. Several examples can be cited. First, a body of economic analysis of art providing financial service through its potential for price appreciation has developed (see, for example, Throsby 1994; Campbell 2004, 2005; Mei and Moses 2002, 2005). How do rates of return on investment in art compare with returns elsewhere? What are the main determinants of the prices of art works? Such questions distinguish the treatment of art for its aesthetic qualities, through immediate consumption.

Second, numerous organizations such as Artprice, Artnet, Art Sales Index, and Art Market Research offer international art market data based on auction prices. Heffel offers an online service focusing on Canadian artists sold at auction in Canada; and Westbridge (2002) organizes Canadian art into sixteen indexes (including the Group of Seven, L'Automatistes, Painters Eleven, and the Beaver Hall Group). The reputation of contemporary artists, based on exhibitions and collections, is tracked by Kunstkompass (est. 1970) and Marek Classen's Artfacts. ArtTactic was created by Anders Petterson to offer financial analyst-like reports for contemporary art investors. Art price data based on auction sales, such as by Artprice, Artnet, and Art Sales Index, offers transparency and can be a general pointer on art market conditions. However, one needs to be wary of using indexes as a proxy for the actual price that a work will achieve at auction or with a dealer. Indexes show the average price paid for an artist's or movement's works over a given period. But, as Baumol has indicated, works of art are not interchangeable: artists enjoy and endure different periods of critical reception; both the provenance of the work and its physical condition can impact on its value; moreover, limited

transactions can cause distortions. Deborah Brewster (2006) notes in the *Financial Times* that average prices are being shown not price/earnings ratios. What is needed for a proper index is repeat sales data. This means tracking the actual changes in the sales price of a work of art. Such a task is not easy as the only sales data available in a transparent manner is through the major auction houses.[6] In an attempt at art market innovation, Jiangping Mei and Michael Moses, both finance academics, created the Mei Moses Fine Art Index based on repeat sale auction prices at Christie's and Sotheby's since 1950. (The high impact of their research led Mei and Moses to create Beautiful Asset Advisors to promote the 'Mei Moses Family of Art Indices'.) Art outperforms fixed income securities as an investment, though it significantly underperforms stocks in the USA, according to Mei and Moses (2002), who also note that art should be viewed as a risk-reducing strategy rather than a return-producing one. As a diversification tool, investors should not be looking at short holding periods. Mei and Moses (2005) have also examined the relationship between auction estimates and the long-term performance of works of art, concluding that price estimates for expensive paintings have a consistent upward bias over the long term of thirty years.

Third, the history of art investment funds, since they emerged in the early 2000s, has been patchy: 'as of late 2006 it is difficult to talk of an art fund industry that features a range of players, clear benchmarks for performance and transparency in competition', according to Caslon Analytics (2007). The success of the British Rail Pension Fund (1974–89) is often cited by supporters of art as an investment. The Fine Art Fund is the most successful story. Other prominent art fund examples have been less successful: Dutch bank ABN Amro departed from the art fund marketplace in 2005, one year after announcing its entry; and US-based Fernwood Art Investment, which received high media attention, floundered and closed in 2006. Other art funds are in various stages of development.

Art funds represent investors pooling resources, which help to diversify holdings. Popular examples of pooling resources in other sectors include mutual funds and real estate investment trusts (REITs). Art funds are structured like private equity funds. Two categories benefit from art funds: those who provide the capital that allows acquisition of art (limited partners); and those who manage the fund (general partners), who draw on a range of advisors and specialist service providers. Three life-cycle stages typically exist: fundraising, investment, and exit. Fundraising involves soliciting investment from several participants; the process of fundraising, which may mean informal contact between peers and formal road show presentations, may take a year or more, though most commitments appear to be made within six months. Investment involves acquisition of one or more assets (works of art) by the fund manager. Successful exit strategies matter: this means speedy, trouble-free, and lucrative sale of the work or works of art in the fund. Exceptional profits are dependent on fortune and the selection of what proves to be a winner in the medium term. Investors in art investment funds in the

UK will not benefit from rules and regulations made under the Financial Services Authority for the protection of investors. Shares in art funds are not dealt in or on a recognized or designated investment exchange nor is there a market maker in such shares. As such, it may be difficult to dispose of one's shares otherwise than by way of redemption – which often exacts a 'discount' or penalty from the investor. (Similar caveats for investors also hold for art funds in other major art markets like the USA and Switzerland.)

Fourth, short courses on investing in art for professionals and neophyte collectors have emerged. Euromoney has offered a three-day investing in art course in New York for $3,995, which suggests sufficient interest among finance professionals to offer art to private clients. Visual arts organizations are offering classes on collecting contemporary art (e.g., London's White-chapel Art Gallery first offered a five-week course, at £595, in the run-up to Frieze 2006).

Thematic organization

Following this introductory chapter, four main parts are used to organize the contents of the book.

I Technical and structural elements of the art market

Technical and structural elements of the art market are due to the nature of art as a product and the low level of regulation in trading in art. This poses interesting questions on how to value art. In Chapter 2 Iain Robertson argues that the current booming art market is characterized by price exceeding value. This is highlighted by examining four cases – three recent sales of paintings, by Klimt, Pollock, and Rubens, and a (Chinese) Ru vase – to posit that the demand side is taking precedence over objective appraisal value. Anthony Downey, in Chapter 3, considers aesthetic value and financial value with reference to contemporary art: is there a distinction between the two value sets, and can contemporary art generate that distinction? In Chapter 4 Jeremy Eckstein uses his direct experience with the British Rail Pension Fund and a proposed art fund by ABN Amro to discuss the role of art as an asset class, including art investment funds. The emerging markets of China and India – as sites for collectors *and* works of art – are addressed in Chapter 5 by Iain Robertson, Victoria L. Tseng, and Sonal Singh, which highlights that globalization presents 'Chindia' as an art market opportunity.

II Cultural policy and management in art business

The role of the state in cultural policy often focuses on public patronage in the arts. For example, France's socialist strategy of direct government control has helped to make Paris the museum capital of the world. Yet Catherine Morel's examination, in Chapter 6, shows that there are implications for

private patronage and contemporary art in France. In particular, Morel examines France's relative decline in the international art market. A key management function like marketing cannot be treated in a mechanistic and uniform manner by different types of art business organizations. In Chapter 7 Derrick Chong adopts exchange relationships, a key facet in marketing, to offer a comparative analysis of marketing commercial galleries and art museums, with reference to examples in the USA and the UK.

III Regulatory, legal, and ethical issues in the art world

Art and the law can be divided in two parts: protection of artists and the transaction of subsequent moral rights and artists' resale rights; and cultural property including illicit trade, stolen works of art, looted objects, and authenticity. Art theft, art forgery, and art fraud are topics of enormous interest. Henry Lydiate, a specialist in art law, focuses on authorship and authentication in Chapter 8; he examines the cases of Dali, Pollock, and Warhol to show that lineage is at the heart of the matter in many legal disputes concerning art. In Chapter 9 Joanna Cave, as the chief executive of the Design and Artists Copyright Society (DACS), the primary collecting society on artist's resale rights (or *droit de suite*) in the UK, discusses why the artist's resale right is good for artists within the context of the introduction of pan-EU legislation in 2006.[7] David Bellingham observes that no issue of *The Art Newspaper* is without a story of unethical art market practice; this invites him to address ethical issues in the art market in Chapter 10. Chapter 11 on art and crime is shared by Clarissa McNair and Charles Hill, two individuals whose writing is based on frontline experience: McNair, a private investigator working in the world of intellectual property, demythologizes the romantic notions of art theft by discussing the criminal underbelly of deception including Nazi era war art; Hill, who has an international reputation in art crime investigations, examines two well-known art museum robberies – at the Isabella Stewart Gardner and the Munch Museum – with an astute insider's perspective of the barbaric criminality involved.

IV Voices from the field

Iain Robertson conducted a series of interviews with various leading art business players – modern British and contemporary art dealers, auctioneers of Old Master pictures and drawings, classic motors, and Chinese art, a wine merchant, an art lawyer, an art fund manager, and the founder of an art market index – for Xalt.tv, an online provider of financial investment advice for wealthy families and their advisors, keen to offer an engaging overview of fine art as an alternative asset class. The interviews have been edited by Derrick Chong for inclusion in Chapter 12 to represent the guest presenters on the MA in Art Business programme. The arrangement of the interview data – things to consider in buying art; sectors of the market; art as investment; and

roles of the dealer and relationships with auction houses – reinforces many of the issues addressed in the individual chapters.

Acknowledgements

Derrick Chong would like to recognize the financial support of the Faculty Research Program grant 2006/07 from Foreign Affairs Canada (International Council for Canadian Studies file number 605-1-2006/07).

Notes

1 Similar findings appear in a study of the visual arts in the USA commissioned by the independent research organization RAND Corporation (McCarthy et al. 2005).
2 White Cube's decision to leave its original site on Duke Street, in the West End, for Hoxton Square in 2000 excited much attention; in 2006 White Cube returned to the West End (Mason's Yard, which is near Duke Street). White Cube now operates two galleries in London.
3 *Droit de suite*, which operates in some jurisdictions, is a method to pay royalties to living artists or their estates when a work by the artist is resold. It is one way for artists to gain some of the economic benefits of price appreciation.
4 For example, Heffel charges a buyer's premium of 15 per cent and seller's commission of 10 per cent if the hammer price is greater than C$7,500. In London, Christie's, Sotheby's, and Bonhams charge a buyer's premium of 20 per cent for the first £250,000; the seller's commission on a sliding scale based on combined annual sales of property.
5 Although based on the French experience, Bourdieu's general thesis has been shown to be valid in various Anglo-American countries like the USA, the UK, Canada, and Australia.
6 Works entering the permanent collection of art museums or other public institutions seldom become available for resale in the art market. Deaccessioning by art museums is more common in the USA than Europe, however, even in the most liberal American situations there is often a minimum non-selling period from the date of accession (with twenty-five years having featured).
7 It is important to acknowledge that DACS, albeit the primary collecting society in the UK, is not the sole one: for example, Artists' Collecting Society (ACS) was established in June 2006, with support from the British Art Market Federation (BAMF) and the Society of London Dealers (SLAD), as a community interest company. Less active is a third collecting society, Artists' Rights Administration (ARA).

References

Artinfo is available at www.artinfo.com; for the Association of Art Museums Directors, see 'Position papers and reports' at www.aamd.org; Sotheby's, as a publicly listed company, has a section for investors at www.sothebys.com; *Art in America (AiAm)* references are cited in the text.
Art in America (1988) 'Money and Art' issue (Summer).
AAMD (Association of Art Museum Directors) (2001a) 'Art museums, private collectors, and the public benefit', (October).
AAMD (2001b) 'Managing the relationship between art museums and corporate sponsors', (October).

AAMD (2001c) 'Revenue generation: an investment in the public service of museums', (October).

AAMD (2006a) 'Good governance and non-profit integrity', (June).

AAMD (2006b) 'Exhibition collaborations between American art museums and for-profit enterprises', (March).

Baudrillard, J. (1994) [1968] 'The system of collecting', in J. Elsner and R. Cardinal (eds) *The Cultures of Collecting*. Roger Cardinal, trans. London: Reaktion: 7–24.

Baumol, W. (1986) 'Unnatural value: or art investment as floating crap game', *American Economic Review* 76 (May): 10–14.

Becker, H. (1982) *Art Worlds*. Berkeley, CA: University of California Press.

Belk, R. (1995) *Collecting in a Consumer Society*. London: Routledge.

Bois, Y-A., Crimp, D. and Krauss, R. (1984) 'A conversation with Hans Haacke', *October* 30: 23–48.

Bourdieu, P. (1984) [1979] *Distinction: a social critique of the judgement of taste*. Richard Nice, trans. London: Routledge & Kegan Paul.

Brewster, D. (2006) 'Buying paintings by numbers', *Financial Times* (11 August).

Buck, L. (2004) *Market Matters: the dynamics of the contemporary art world*. London: Arts Council of England.

Campbell, R. (2004) 'The art of portfolio diversification', Maastricht University-LIFE Working Paper WP04-009.

Campbell, R. (2005) 'Art as an alternative asset class', Maastricht University-LIFE Working Paper WP05-001.

Capgemini and Merrill Lynch (2006) 'World Wealth Report: 10th anniversary 1997–2006', World Wealth Report.

Caplin, L. (1982) *The Business of Art*. Englewood Cliffs, NJ: Prentice Hall.

Carret, P. (2004) [1930] *The Art of Speculation*. Mineola, NY: Dover.

Carrier, D. (2006) *Museum Skepticism: a history of the display art in public galleries*. Durham, NC: Duke University Press.

Caslon Analytics (2007) 'Art fund note', (January), www.caslon.com/au/artfundsnote.

Citigroup (2005) 'Plutonomy: buying luxury, explaining global imbalances', Industry Note (16 October).

Cuno, J. (ed.) (2004) *Whose Muse? Art museums and the public trust*. Princeton, NJ: Princeton University Press.

DCMS Committee (Department of Culture, Media and Sport Committee), House of Commons (2005) *The Market for Art*. HC 414. London: The Stationery Office.

DCMS/V&A (Department of Culture, Media and Sport/Victoria & Albert Museum) (2003) 'Three year funding agreement (2003–2006) between the Department for Culture, Media and Sport and the Victoria and Albert Museum'. London: DCMS.

Danto, A. (1964) 'The artworld', *Journal of Philosophy* 61 (October): 571–84.

Fraser, A. (2005) *Museum Highlights: the writings of Andrea Fraser*. Cambridge, MA: MIT Press.

Frey, B. (2000) *Arts and Economics: analysis and cultural policy*. Berlin: Springer.

Galenson, D. (2001) 'Masterpieces and markets: why the most famous modern paintings are not by American artists', NBER Working Paper 8549. Cambridge, MA: National Bureau of Economic Research.

Galenson, D. (2005) 'Anticipating artistic success (or, how to beat the art market): lessons from history', NBER Working Paper 11152. Cambridge, MA: National Bureau of Economic Research.

Grampp, W. (1989) *Pricing the Priceless: art, artists and economics*. New York: Basic Books.

Greenblatt, S. (1991) 'Resonance or wonder', in Ivan Karp and Steven Lavine, eds., *Exhibiting Cultures: the poetics and politics of museum display*. Washington, DC: Smithsonian Institution Press: 42–56.

Hyde, L. (1979) *The Gift: imagination and the erotic life of property*. New York: Random House.

Kelly, F. (2003) [1930] *Why You Win or Lose: the psychology of speculation*. Mineola, NY: Dover.

Lindemann, A. (2006) *Collecting Contemporary*. Cologne: Taschen.

McCarthy, K., Ondaatje, E., Brooks, A. and Szántó, A. (2005) *A Portrait of the Visual Arts: meeting the challenges of a new era*. Santa Monica, CA: RAND Corporation.

Mei, J. and Moses, M. (2002) 'Art as an investment and the underperformance of masterpieces,' *American Economic Review* 92 (December): 1956–68.

Mei, J. and Moses, M. (2005) 'Vested interest and biased price estimates: evidence from an auction market', *Journal of Finance* 60 (October): 2409–36.

Mirza, M. (ed.) (2006) *Culture Vultures: is UK arts policy damaging the arts?* London: Policy Exchange.

Morris Hargreaves McIntyre (2004) *Taste Buds: how to cultivate the art market*. London: Arts Council of England.

Moulin, R. (1987) [1967] *The French Art Market: a sociological view*. Arthur Goldhammer, trans. London: Rutgers University Press.

Nunes, P. and Johnson, B. (2004) *Mass Affluence: 7 new rules of marketing to today's consumer*. Boston, MA: Harvard Business School Press.

Perry, G. (2006) 'Cheap art won't make poverty history, Tony', [London] *Times* (8 March).

Silverstein, M. and Fiske, N. (2004) *Trading Up: the new American luxury*. Boston, MA: Boston Consulting Group.

Smith, R. (2000) 'Memo to art museums: don't give up on art', *New York Times* (3 December).

Sotheby's (2007a) 'Investors briefing' (March). New York: Sotheby's.

Sotheby's (2007b) *Annual Report (for the period ending 31 December 2006)*. New York: Sotheby's.

Storr, R. (2007) 'Market value says little about art: museums should downplay price and let other values emerge', *The Art Newspaper* (8 February).

Throsby, D. (1994) 'The production and consumption of the arts: a view of cultural economics', *Journal of Economic Literature* 32 (March): 1–29.

Towse, R. (ed.) (2000) *A Handbook of Cultural Economics*. Cheltenham: Edward Elgar.

Velthuis, O. (2005) *Talking Prices: symbolic meanings of prices on the market for contemporary art*. Princeton, NJ: Princeton University Press.

Walliser-Schwarzbart, E. (2003) *Art Market Switzerland. Passages: the cultural magazine of Pro Helvetia*, no. 35. Zurich: Arts Council of Switzerland Pro Helvetia.

Westbridge, A. (2002) *Made in Canada: an investor's guide to the Canadian art market*. Vancouver: Westbridge Publications.

Wetlaufer, S. (2001) 'The perfect paradox of brands: an interview of Bernard Arnault of LVMH', *Harvard Business Review* (October): 116–23.

Wu, Chin-tao (2002) *Privatizing Culture: corporate art intervention since the 1980s*. London: Verso.

Part I

Technical and structural elements of the art market

2 Price before value

Iain Robertson

Introduction

Why is art so difficult to price? While art can be beautiful, much of its even-
tual price is tied into other more powerful values – such as expression and
depth of feeling – not an ability to record reality with representational accur-
acy necessarily, although this can be useful, but to advance our understanding
of ourselves and our world. This makes objective appraisals almost impos-
sible. Of course this is not true of all expensive art or of all art that is, in
different eras, widely considered to be great; but it does apply to much of it.
Goethe expresses it far better: 'Art was formative and expressive long before
it was beautiful, in the narrow sense of charming': Von Deutscher Baukunst,
1773. A contrary view of the artist and his representation (mimesis) is
expressed in Plato's *Republic*. The order of value being use, manufacture and
representation, the painter is regarded as the third stage recorder of reality
behind God the creator and the craftsman or maker:

> The art of representation is therefore a long way removed from truth and
> it is able to reproduce everything because it has little grasp of anything
> and that little is of phenomenal appearance.

In the *Republic* art is said to appeal to the inferior part of ourselves – that
in which reason is absent – and we are urged to be wary of its influence
on us. To which Nietzsche (1887, section 85) adds in *On the Genealogy of
Morals*:

> Artists continually glorify – they do nothing else – they glorify all those
> conditions and things which have the reputation of making man feel for
> once good or great or intoxicated or merry or wise.

The eventual price achieved by a work of art is also subject to strong
demand-side forces, which act often with little regard for the work of art's
artistic and historic properties. This is particularly the case in today's market

in which a so-called plutonomy effect (Citigroup 2005) – manifested in a great number of individuals with a substantial amount of money – is having an impact on the price of art. The current mantra is that today's wealth is so widespread and deep that the art market is no longer cyclical. This view would seem to ignore the fact that wealth and therefore price, are subject to the vagaries of world events, which have a tendency to readdress gross inequalities of income.

Three conditions describe, accurately, the buyers' position. First, under private value, the buyers may know why they value the object highly, but have no idea how their rivals view it. Second, interdependent value declares that each bidder relies absolutely on the expert appraisal. Third, common value maintains that each bidder knows the opinion of each of his rivals, and this chimes perfectly with his own view.

In the last resort, the vendor's interests and that of the work of art are protected by the undisclosed reserve.[1] It is important for the reserve to remain a secret, because it allows bidders to observe each others' gradually ascending bids and draw confidence that they are not alone in prizing them. Guarantees offered either by the auctioneer or a third party – such as a dealer – are a way of ensuring that the reserve is exceeded. In this case, the vendor is assured, at the very least, of the guaranteed sum for the work, but because the vendor has passed on this risk to a third party, the vendor is entitled only to 50 per cent of the amount that exceeds the guarantee.

The auctioneer working on behalf of the vendor has a vested interest – the commission – in achieving the maximum price for a work of art. The auctioneer can employ numerous devices to maximize price (see Robertson 2005: 239) and one which I have seen employed most effectively is delaying the hammer. The identity of the successful bidder need not be known, but the final price is made public. A bidding 'frenzy' is the ultimate aim of any auctioneer and a powerful vendor can incite participants by bidding up his or her own work of art and thereby bringing excitable parties into the fray. A feature of the current buoyant market is a deception known as mirror bidding. Evidence of this behaviour was noted on the bidding for Raphael's *Portrait of Lorenzo de Medici*, which sold to a telephone bidder for £18.6 million at Christie's London in July 2007. The under-bidder was an unidentified American who, together with another individual, alternated the bids between each other. The effect was to convey to the house that there was interest in the painting from more than one source and scare off rivals.

A characteristic of all bull markets (such as the current one) is for the demand side to take precedence over appraisal value, and this negates much of the objective appeal of interdependent value in which the appraiser plays the central role in determining value and price. It is not always the case, as Heilbrun and Gray (1993: 153) assert, especially in thin markets, that buyers at auction preserve their 'consumer surplus'.[2] This is particularly the case with private value in which a particularly virulent form of the 'winner's curse' operates.[3] Each bidder, having formed his or her own opinion on the price of

a work of art, discovers in the end that the combined blind efforts of all the bidders have taken price beyond value as represented by the notional estimate. The egalitarian nature of common value occurs infrequently in the art market because of the high levels of client secrecy and the irrationality of some buyer's behaviour at auction.

Auctions encourage irrational behaviour. Bidders in bull markets will wildly exceed their limits, often in the expectation of being able 'to flip' – that is to resell the work swiftly after purchase – soon after the auction. On the supply side, a consignor may sometimes insist of an auction house that a work be overestimated and that work may go on to sell. The problem in both supply and demand cases is that the chains of reasoning are broken when a work greatly exceeds the high estimate (or in a perfect market exceeds the middle estimate) which must, for the sake of clarity, be regarded as benchmarks of a reasonable price range.

Prices in the dealer market are arrived at through a different process from that of the auction house market. As Nietzsche states in *The Wanderer and his Shadow*:

> An exchange is honest and just only when each of those participating demands as much as his own object seems worth to him, including the effort it cost to acquire it, its rarity, the time expended, etc, together with its sentimental value. As soon as he sets the price with reference to the need of the other he is a subtler robber and extortioner.
>
> (Second supplement of *Human all too Human*, second edition 1886, extract 25)

Art dealers often fall below the high moral standards set by the philosopher. They measure very quickly how much a client is able and prepared to pay for a work of art and adjust prices accordingly, a predilection which comes to the fore in bull markets. Nevertheless, dealer prices as a rule are lower than those of the auction house, showing that the simultaneous interest of more than one potential buyer for a single object will excite higher prices. This dual pricing structure is made more complex by the fact that dealers are often the chief consigners to auctions, using the auction to enhance prices. The reserve has a different meaning to dealers than it has for auctioneers. Traditionally, prospective buyers may ask for a work of art to be retained for them until they are able to secure the necessary funds. Recently, there are reports of buyers who have reserved works with dealers being gazumped by a third party, a situation that undermines the long-established gentleman's agreement between client and intermediary.

The dealer's gallery still portrays itself as the harbinger of value and the legitimate arena for the development and protection of that value, avoiding ostentatious price decreases in the same way that an unsold work at auction goes unrecorded. A work of art cannot be sold below the accepted market price or zero.

Two significant tools in setting values are the repeat sales and the hedonic pricing models. The first method takes the price history of an object as the basis for current valuations and the latter divides the object into different characteristics and forensically analyses its properties in order to arrive at a final overall quality assessment. Only the value of cutting-edge contemporary art is set absolutely by another means and it is because the prices of this commodity are driven by exogenous rather than internal characteristics that we will not be dealing with this sector. Modern art, Old Master pictures, Chinese art and antiques all require the intervention of a professional to authenticate and appraise each work of art, and it is how value is created in these three markets that we shall look at in detail.

The shift in taste (which is a condition of history and world affairs) that led to price changes, irrespective of the object's artistic and historic value, is nothing new. A hundred or so years ago French Impressionist painting was almost worthless, deprived, as it was, of an effective channel of distribution. After the deposition of the last emperor in China in 1911, the best Chinese art could be 'acquired' very cheaply from a dispirited and impotent former elite. Stalin ensured that first rate Old Master paintings were eminently affordable when, over a period of years, he exchanged this Soviet owned commodity for hard currency to pay for manufactured American goods. Asian art, particularly sectors like Qing jade, (Ch'ing in earlier texts) imperial seventeenth and eighteenth century porcelain, archaic bronzes, Chinese brush paintings and particularly Yuan blue and white porcelain are, conversely, very highly priced today, with prices being driven by Chinese nationalism and unprecedented levels of liquidity. In the 1980s, Japanese buying did the same for Song (Northern Song, 960–1127, and Southern Song, 1128–1279) and Koryo dynasty (918–1392) ceramics as well as second-tier French Impressionist painting.

Some sectoral prices have suffered because of increased regulation, and it is now very difficult to bring a work of antiquity – particularly a funerary item – to the market unless it has a ratified provenance. The ownership history is of immense importance to the Old Master market, as we shall discover when we examine Rubens' *Massacre of the Innocents*. But authentification is the most important consideration, and gaps in information in the market occasionally allow astute buyers to acquire remarkable 'sleepers'.[4] This point is very well illustrated by the acquisition of Raphael's *Portrait of Lorenzo de Medici* (1518) in 1968 for a pittance by the dealer, Ira Spanierman, because the work was catalogued as 'Italian School' (a generic term used to cover any work produced in Italy sometime in the past). The painting was later confirmed by the Renaissance scholar, Konrad Oberhuber, in an article in *The Burlington Magazine* in 1971, to be by Raphael.

Other items, such as Modern and blue-chip contemporary works, have been made less attractive – or at least harder to sell – by the imposition of a new tax, *droit de suite*. A genuine reduction in supply for the highest quality items in all but the Contemporary market – which regulates supply by withholding works and by selection, which limits the number of works of art and

artists entering the market in the first place – combined with a broader based more liquid demand and improved methods of sale, has led to a striking imbalance in favour of the seller over the buyer. But, in a remarkable twist of fate, the historic markets (particularly Modern) are likely to benefit, and have already benefited, from the restitution of works of art from public museums and private collections to their owners (often dealers). These works were said to be appropriated from their owners by hostile forces in time of war. To date, the attention is focused on works of art acquired by the Nazis during their period in power. How long it will be before the descendants of other dispossessed individuals claim for loss in time of war or under a particularly repressive regime, is moot.[5]

I have chosen to examine exceptional works of art in the Modern, American, Old Master and Chinese antique markets, since these categories of art have performed so exceptionally well in the last few years (see Table 2.1):

- Modern: Gustav Klimt, *Portrait of Adele Bloch-Bauer I* (1907)
- American: Jackson Pollock, *No. 5* (1948)
- Old Master: Peter Paul Rubens, *The Massacre of the Innocents* (1611–12)
- Chinese: Ru vase (late Northern Song, 1100–1127).

I have, in each case, searched for reasons why a price wildly in excess of the estimated value was achieved or, in the case of the Ru vase, might, conversely, fail to be realized.[6]

Modern: Gustav Klimt, *Portrait of Adele Bloch-Bauer I* (1907)

One would suppose, bearing in mind the prevailing economic conditions, that the upward momentum of the price of any Modern work brought to sale would continue unabated – not so in the case of Monet or Renoir, but likely if the painting is by a highly regarded German Expressionist or Austrian Secessionist. The $135 million ($6,554 per sq. cm.) for the *Jugendstil* painter, Gustav Klimt's *Portrait of Adele Bloch-Bauer I* (1907), is the fourth highest recorded adjusted price to date. The Japanese fondness for the soft, pastel colours and innocuous scenes of Impressionism has moved, temporarily, on to a much harsher (often salacious) realism championed by European and American collectors and found in the *Neue Sachlichkeit*, German Expressionists and American Abstract Expressionists. Cubism fits the new mood of brutalism, as do the brash, punchy Pop Art images of Warhol and the ornate and gilded works of Klimt.

A work like *The Portrait of Adele Bloch-Bauer I* has out-performed the upwardly mobile, general Modern index because the market agrees that it is rare, of high quality, of good provenance and, crucially, the creation of a Bohemian artist.

What is meant by rarity needs no explanation; this painting is the only one of its kind – although the doll-like, inferior, *Bloch Bauer II* made $87.9

Table 2.1 High profile art market transactions by private treaty and at auction, 1987–2006

Jackson Pollock, *No 5* (1948) sold for $140m in 2006 by Private Treaty
Tobias Meyer of Sotheby's New York brokered the transaction between David Geffen (seller) and David Martinez (buyer).

Pablo Picasso, *Le Rêve* (1932) estimate for $139m in 2006 in unrealized Private Treaty
Bought for $7,000 in 1941 ($20,110 today) by the Ganzes. Sold in 1997 through Christie's for $48.4m ($63.4m today). Sold privately to Steve Wynn for $60m ($72.6m today) in 2000. Wynn reputedly received an offer of $139m for the painting, before he accidentally put his elbow through the picture. Current value of **$25m**.

Willem De Kooning, *Woman III* (1952–3) sold for $137.5m in 2006 by Private Treaty
David Geffen (seller) to Steve Cohen (buyer). In 1989 De Kooning's *Interchange* made $20.68m ($37.02m today), a record for a living artist at the time. Prices have moved up considerably since that time.

Gustav Klimt, *Portrait of Adele Bloch-Bauer I* (1907) sold for $135m in 2006 by Private Treaty
Klimt returned to descendants of Bloch-Bauers via restitution by Austrian government; Klimt sold by descendants to Ronald Lauder.

Vincent van Gogh, *Portrait of Dr Gachet* (1890) sold for $82.5m ($127.3m today) in 1990 at Sotheby's, New York
Purchased by the Barilla family of Padua, Italy. Unresolved ownership between the dealer Kramarsky and Franz Koenigs, the murdered owner. **Impossible to sell**.

Pierre-Auguste Renoir, *Bal au Moulin de la Galette* (1876) sold for $78.1m ($120.5m today) in 1990 at Sotheby's New York
Purchased by Ryoei Saito; 1997 value of **$45m ($58.5m today)**.

Pablo Picasso, *Garçon à la Pipe* (1905) sold for $104.1m ($111.2m today) in 2004 at Sotheby's New York.
Purchased by Philip H. Niarchos. Possibly the result of a pre-war duress sale and, therefore, unresolved ownership; 1950 value of $30,000 ($739,800 today). **Impossible to sell**.

Vincent van Gogh, *Irises* (1889) $53.5m ($95.7m today) in 1987 at Sotheby's New York
Sold unsuccessfully to Alan Bond, who failed to make the post-sale payments; 1995 value of **$40–45m ($55.2m today)**; purchased by the Getty Museum in California.

Peter Paul Rubens, *The Massacre of the Innocents* (1611–12) sold for $76.7m ($89.7m today) in 2002 at Sothbey's London
Purchased by Lord Kenneth Thomson; the Getty Museum was under-bidder.

million ($91.4 million today) at Christie's New York in 2006 – but what is meant by exceptional quality is less easy to pinpoint.

'Klimt's "golden phase",' writes Gilles Neret, 'which might well be regarded as his "golden age", begins with *Portrait of Fritza Riedler* of 1906 and culminates in *The Portrait of Adele Bloch Bauer I of 1907*' (Neret 2006: 65) – the same period which produced the architectonic landscape, *Schloss Kammer on the Attersee I* (1908), which made a record for the artist in 1997 of $21.4 million ($28 million today). The two portraits portray their attractive subjects

as birds in gilded cages, trapped in a mode of life that would disappear after the First World War – bound, literally, within their garments and, metaphorically, within the strict mores of a dying dynasty. There is a parallel between the fabric encased, female form of Adele and that of Velasquez's *Infanta Maria Teresa*, another prisoner of the system; and in both cases a strong sense of melancholy and pathos.

Essentially, Klimt was a decorator, undertaking decorations for the Kunsthistorisches Museum in Vienna in 1891. According to Ludwig Hevesi, a contemporary critic:

> Klimt's ornamentation is the figurative expression of primal matter, which is always without end, in a state of flux, turning and twisting in spirals, entangling itself, a whirlpool that takes on every shape, zebra stripes flashing like lightning, tongues of flame darting forwards, vine tendrils, smoothly linked chains, flowing veils, tender nets.
>
> (cited in Neret 2006: 60)

He was greatly influenced by the English artists Burne-Jones and Alma-Tadema as well as by Japanese art (the gilded, folding screens of the Sotatsu-Koetsu-Korin come to mind). Egyptian and Byzantine art were another part of his artistic vocabulary and he was highly thought of by the younger generation of Austrian painters like Egon Schiele and Oskar Kokoschka.

The Portrait of Adele Bloch-Bauer I is appealing today because it is poignant. It represents a fragment of the last creative surge before the apocalypse of the First World War some seven years later, and as such is historically and artistically very significant. Klimt was a contemporary of Freud, Otto Wagner, Schoenberg and Mahler in the belle époque.

Adele Bloch-Bauer I is decorative, but also enigmatic.

> It is sometimes nicknamed the Austrian 'Mona Lisa'. Painted in 1907, this depiction of a Viennese banker's wife, who was possibly also the artist's lover, is the epitome of Klimt's brand of Art Nouveau.
>
> (Lubbock 2006a)

But to Ronald Lauder, the man who bought her, Adele represents much more than art:

> This portrait is of a very erotic, beautiful woman looking at you with these heavy eyes and sensuous lips, a gaze that grabs you and doesn't let you go. I was alone in the room. I think I stood there for an hour. This was the first time I was travelling by myself. To me it symbolized my coming of age.
>
> (cited in Weideger 2006a)

This chimes with a trade consensus that sexually suggestive subject matter

and recognizable portraits fetch the highest prices. Add to this an interesting provenance – the work was appropriated from the Bloch-Bauers by the Nazis after the *Anschlus* in Austria – and the record price seems less surprising.

But the key to the nine-figure sum, I believe, lies elsewhere: Gustav Klimt was a self-styled Bohemian. He felt so strongly for the integrity of his work that he returned a 6,000 Crown advance from the Austrian government for failing to stifle criticisms of a prestigious public commission of the University of Vienna. Perhaps in response to the artist's anti-establishment attitude, the Emperor Franz Josef, declined three times his appointment as professor at the Academy. The artist's lifestyle was unconventional. He never married, was polygamous and produced a number of children. He dressed in Oriental style garments and was a founder member of the break-away Secession Movement.

The Bohemian artist or the artistic temperament is not a nineteenth century phenomenon – Rembrandt for one was a non-conformist – however, it is a nineteenth century term used to applaud the wild and roving behaviour, as well as unconventional approach to life, of the artist. It is a condition that we have come to admire, respect in, and, indeed, expect of, our artists ever since. The artist and dandy that the writer Rodolphe spies on his recuperative walk illustrate, perhaps, that unconformity in dress, not shabbiness, is at least part of the code for entry into Bohemia:

> On the gilded balcony of a newly built house he remarked a dandy, in a dressing gown, chewing the end of an aristocratic Havana. On the floor above sat an artist wafting abroad a fragrant mist of Levantine from a pipe with an amber mouthpiece.
>
> (Merger 1851, reprint 2004: 70)

The fact that Rodolphe himself wears a turban at home, but is engaged in a slavish commercial activity, provokes the line, 'The turban does not make the Turk' (Merger 1851, reprint 2004: 68). But profligacy is a prerequisite of Bohemianism, and something that he and Marcel manage with great alacrity, convincing each other that by buying the very best they are actually making a long-term saving. The group almost incidentally fall in and out of passionate love, and are turfed out of rented accommodation for failing to meet payments. They live, in short, chaotic, peripatetic lives, none able to make an adequate income from his vocation.

> For five or six years Marcel had worked at his famous picture, which he said represented *The Passage of the Red Sea*, and for five or six years this masterpiece of colouring had been persistently rejected by the judges. It had been taken so often to and fro between the artist's studio and the Musée that if it had been placed on wheels it would have rolled of itself to the Louvre.
>
> (Merger 1851, reprint 2004)

While Merger's novel is satire, it clearly had something to be satirical about. Written in instalments between 1845 and 1849, the notion of the free-spirited creator buffeted against the hard rock of economic reality and left unrewarded, unheralded and destitute at the end of his life clearly had resonance in nineteenth century Paris:

> Among the real Bohemians of real Bohemia I once knew a man named Jacques D---. He was a sculptor, and gave promise of splendid talent; but poverty and misery did not give him time to bring the promise to fruition. He died of decline, in March of 1844, at the Hospital of St. Louis, Ward Sainte Victoire, Bed 14.
>
> (Merger 1851, reprint 2004: 265)

Importantly for this chapter, I would like us to accept that whether myth or reality – for perhaps Bohemianism could have existed only in Paris at that particular time – a demonstration of Bohemianism among artists was the special ingredient in the success of the Modernists and the crucial factor in the high prices their work fetches, posthumously, at auction today. The enduring popularity of the image of a poverty stricken artist is illustrated by the great affection in which Carl Spitzweg's *The Poor Poet* (1839) is held by Germans today. Shacked up in a garret, his latest manuscript about to be used as fuel, wrapped in a blanket, an umbrella shielding him from the wet snow dripping down through the rough planked ceiling; he is the archetypal Bohemian (Hagen and Hagen 2005: 591). A more tragic depiction of another poet, Thomas Chatterton, painted by Henry Wallis, visually describes just where Bohemianism can lead; to a premature and lonely death. It is the tragedy, laced with beauty – Chatterton is surely that – that has clearly entered our subconscious and determined, in a rather sentimental way, the manner in which we expect our artists to behave. So, a Bohemian lifestyle becomes the leitmotif of avant-gardism, if not a guarantee of critical acceptance. In its most extreme form – and van Gogh is the exemplar – it is a terminus. In a letter to his mother in July 1890 Theo, Vincent's brother, writes, 'Life was such a burden to him; but now, as often happens, everybody is full of praise for his talents. . . . Oh mother he was so my own, own brother' (cited in Roskill 1990: 85). Six months later Theo also died. In 1990 *Portrait of Dr Gachet* sold at Christie's New York for $82.5 million ($127.3 million today).

Of course, critical acclaim at the tail end of an artist's destitute life does not automatically lead to immediate commercial success and subsequently high prices in the Modern market of the late twentieth and early twenty-first centuries, but, *ceteris paribus*, it is immensely helpful.

American: Jackson Pollock, *No. 5* (1948)

Records have fallen in 2006 for all the major post-war American artists. Joseph Lau, a Hong Kong property magnet, paid $17.3 million for Andy Warhol's

Orange Mao. Willem de Kooning's large abstract, *Untitled XXV*, recorded a massive $27.1 million and Clyfford Still's *1947-R-No 1*, free of a covenant restricting resale, made $21.3 million. It is within this context that we turn to Jackson Pollock's *No. 5*.

Pollock represents the painter as life force pregnant with energy and blessed with harmonic rhythm. The artist explained his work in 1951 by saying that he was in control of the process, but that he needed to express his feelings rather than illustrate them. The 'Action style' painting style that he adopted in 1947, a year before *No. 5*, has therefore, become art-historically important and opened the economic floodgates to the post-war American School.

But, what is it about *No. 5* that elicited such a high price? Like David Smith, certain works by Pollock will fetch extraordinary amounts of money and others will fail to meet the reserve. Early works by Smith depicting animals, still-lifes or landscapes are largely ignored in favour of *Cubi* (*Cubi XXVIII* made $23.8 million ($25.5 million today) at Sotheby's New York in November 2005). With Pollock, it is at the point at which he abandoned his brushes in 1947 and started pouring the paint directly onto the canvas (only to pick up his brushes again in 1953) that is seen by the market as the artist's most important and emblematic contribution to the history of Modern art.

This still does not explain how, at the height of the last boom in 1989, his *No. 8* from 1950 made a then record price of $10.5 million ($18.79 million today), and in under two decades a not dissimilar work could make, in nominal terms, almost fourteen times that value – some 82 per cent annual returns.

The price of *No. 5* must be set beside a growing interest among American buyers for home-grown artists, even those with a limited appeal outside the USA. The Mexican, Martinez (the *No. 5* buyer), is the exception that proves the rule. The Norman Rockwell work, *Breaking Home Ties* (1954), was estimated at between $4 million and $5 million at Sotheby's New York at the November 2006 sale and made $9.2 million. This was a record price for the artist at auction. Boosted by the touring 2006 exhibition 'Americans in Paris: 1860–1900', American artists such as Edward Hopper, John Singer Sargent and Mary Cassatt are appealing to American collectors because of their storytelling qualities that speak of American values. The sentimental nature of the subject matter in many of these works, combined with their high graphic qualities – much appreciated by new collectors and a factor behind Warhol's success – has coincided with the immense wealth of collectors like Wal-Mart heir Alice Walton and Crystal Bridges Museum of American Art, who recently joined forces with the National Gallery of Art in Washington, to buy Thomas Eakins' *The Gross Clinic* for $68 million (Mason 2006).

American art that has an international pedigree such as *No. 5* can be expected, therefore, to reach the heights attained by Pollock. American art that appeals only to Americans and is without universally acknowledged artistic qualities, an impressive provenance, any evidence that the artist led a Bohemian life, is destined to lose value over time. The American art sector, Pollock and his internationalist contemporaries excepted, in bucking the

Bohemian trend is conforming to the British nineteenth century model of representational and patriotic art for wealthy, untutored industrialists and entrepreneurs. The British market collapsed after the First World War and was already showing signs of slowing down some 35 years earlier as British economic might and the London art market lost its lustre (see The Settled Lands Act of 1882). Do we now, and does the market, regard the doyens of the nineteenth century, Alma Tadema, Leighton, Millais, Frith and others, as worthy of seven figures at auction? No, and so it will be with the American School, surely the most overvalued since the French Impressionists of the 1980s and the British Neo-Classicists of the late nineteenth century.

Old Master: Peter Paul Rubens, *The Massacre of the Innocents* (1611–12)

When a version of *The Massacre of the Innocents* by Rubens sold to Canadian billionaire, Kenneth Thomson, for £45 million ($76.7 million sale price, $89.7 million today) against an estimate of £4–6 million ($5.8–8.8 million), at Sotheby's London in 2002, it became the highest priced Old Master picture to sell at auction in history (although the Earl of Halifax is believed to have sold Titian's *Portrait of a Man* privately to an American for £70 million ($126 million): Reynolds 2006). The Getty was the under-bidder for the Rubens, setting its ceiling price at $71 million.

Astonishingly, the artist is not included in Kenneth Clarke's *Looking at Pictures*, but Gombrich explains that after Rubens' return to Antwerp from Italy in 1608: 'He had acquired such facility in handling brush and paint, in representing nudes and drapery, armour and jewels, animals and landscapes, that he had no rivals north of the Alps' (Gombrich 1972: 311). Gombrich points to the artist's skill in arranging a great number of figures into a harmonious composition and his ability to bring a work alive through a few deft 'finishing' brush strokes, even if the majority of the work had been carried out by studio assistants. This life that Rubens brought to his drawings, portraits and *tronies* (a painted face that is intended not as a portrait, but as a rendering of a particular type or character) based on characters and expressions 'had,' he continues, 'something to do with the bold and delicate touches of light with which he indicated the moisture of the lips and the modelling of the face and hair' (Gombrich 1972: 314). The vitality of his paintings, he explains, turns them from mere Baroque decorations into masterpieces.

Under the guidance of first Adam van Noort and, later, Otto van Veen, in Antwerp, Rubens, already well versed in the Classics, applied himself to copying the 'figures and motifs from prints by or after the great masters' (McGrath in Jaffé et al. 2006: 30), which he compiled in a notebook (destroyed by fire in 1720, but partially reconstructed from copies by Rubens' pupils). The drawings describe how he learnt 'to group together striking examples of gestures and expressions' (McGrath in Jaffé et al. 2006: 30) and how he had discovered from his apprenticeship with Van Veen, 'that an

attempt to seek a direct equivalence between text and image was an artistic cul-de-sac' (McGrath in Jaffé et al. 2006: 30). Rubens' admirer, Roger de Piles, who knew of the book, McGrath tells us, comments that this 'unusual and interesting exploration of the principal human passions and actions was derived from accounts of the poets, with exemplary drawings after the best artists, above all Raphael, so as to give painting its due by reference to poetry' (McGrath in Jaffé et al. 2006: 30).

By the time the artist arrived in Italy in 1600, he had already absorbed the lessons of the Classical and Italian masters. He continued his study by copying and studying the works of Antiquity and the giants of the High Renaissance from life. When he returned to Antwerp in 1608, he had an established reputation as a great talent, having created important works at the Spanish court – *The Duke of Lerma on Horseback* (1603) – and fulfilled a prestigious altarpiece for the Oratorian fathers of the church of Santa Maria in Vallicella in Rome (where he was mentored by Adam Elsheimer) from 1606 to 1608. 'Perhaps the greatest triumph of Rubens' eight years in Italy was the genius he acquired with a paint brush, It renders him, still today and above all, a painter's painter' (Jaffé et al. 2006: 20).

The Lichtenstein *Massacre of the Innocents* (1611–12) dates from this early part of his career, not only around the time of the birth of his first child, Clara Serena – whom he was to paint with Hals-like deftness and sureness in 1614 – to his first wife, Isabella Brant, whom he portrays with a self-portrait in 1610, but also at the time of the premature death of his brother Philip. It was an exceptional period for great commissions for Rubens, notably *The Elevation of the Cross* (1610–11), painted for the Church of St Walburga, now in Antwerp Cathedral, and *Descent from the Cross* for Antwerp Cathedral (1611–14). The *Descent* 'stylistically . . . marks a new stage in Rubens' career, which sees his youthful pictorial language fully evolved' (Jaffé et al. 2006: 20). Schama (1999: 165) goes further, and declares that 'Until Rembrandt arrived, nothing could top this for sacred drama.'

How does this early version of the 'Massacre' measure up beside these undeniable masterpieces? Alex Hope of Christie's (in Robertson 2006) suggests that few would number it among the greatest of Rubens' work or regard Rubens as the single finest of the all the Old Masters, yet Jaffé et al. (2006) regard it as the summation of the artist's learned travels in Italy.

The painting draws heavily on the *Laocoon and his Sons* (Marble group, Rhodes, 25 BC) and is a dramatically lit, energetic and forceful depiction, encapsulating the horrors of the event (Matthew 2:16–18) in a bloody torrent of violence and brutality. The soldier holding the child aloft, before it is smashed against the already bloodied pediment, is taken from a drawing by Michelangelo of Christ bursting from his tomb. But as Jaffé et al. (2006) point out:

> While these derivations are important, it is the bold, painterly technique that makes *The Massacre of the Innocents* such a compelling image. It

must be one of Rubens' first attempts to capture the fire of an oil-sketch in a larger format; to deliberately harness the vibrancy of the brushstrokes to convey the urgency of the narrative.

(Jaffé et al. 2006: 179)

Sotheby's catalogue explains the revolutionary and historically significant nature of the picture: 'Nonetheless, the ambitious and complex composition of this group of interlocked figures, is something entirely new in Flemish art, and announces the Baroque' (Sotheby's 2002: 27).

Provenance in Old Master paintings is crucial. We are informed in the Sotheby's catalogue that *The Massacre* was 'probably' in the collection of Giacomo (Jacomo) Antonio Carenna, in his Hotel on the Meir in Antwerp and listed in his will on 9 March 1669. By inheritance the work passed to his eldest son, Giovanni, and following his death it was 'presumably' sold at auction in Antwerp on 30 June 1691. It was then 'presumably' sold by the Forchondt brothers to Fürst Johann Adam Andreas I von Liechtenstein, in Vienna shortly after 2 August 1702. The Prince was the greatest of the Lichtenstein collectors, and the Lichtenstein collection itself represents one of the greatest holdings of the early works of Rubens. The painting is recorded in the Liechtenstein collection by 1733 (it bears their seals of that year) and passed to the Liechtenstein family in Vienna, exhibited in the Stadtpalais in Bankgasse until 1807, the Gartenpalais der Rossau until 1873, until it was sold by them to a Viennese dealer, Gluckselig, on 11 June 1920, by whom it passed to the father of the present owner in Dresden. The work was on display in the Gemaldegalerie Alte Meister in the Zwinger in the 1930s coming to rest at Stift Reichersberg in Upper Austria in 1973.

The precise date of the execution of the painting is uncertain (Jaffé et al. 2006: 179), but falls somewhere between 1609 and 1611. It is a 'recently rediscovered picture' (Sotheby's 2002: 21), so fresh to the market, but thought to be by Frans de Neve in a Liechtenstein inventory of 1763 and by Jan van den Hoecke in 1780. It was assumed to be by Van den Hoecke until its 'correct identification' (Sotheby's 2002: 21) in late 2001. *The Massacre* and another picture, *Samson and Delilah*, share similar histories. The *Samson and Delilah* was hung as a chimney piece and it is quite possible that *The Massacre* was too. Both were painted at around the same time and were originally thought to be the work of Jan van den Hoecke. Schama (1999: 141–2) explains how 'It depends for its effect on calculated juxtapositions of delicacy and brute force that are sometimes so startling they have led some commentators to conclude mistakenly that the painting could not be by Rubens at all'. And Sotheby's concludes: 'The initial mis-attribution of *The Massacre of the Innocents* by Fanti (the painter-compiler) is no more easily explicable than the attribution to Van den Hoecke' (Sotheby's 2002: 22).

The picture is in an almost untouched and staggeringly beautiful condition, something that has a great impact on the value of Old Master works and is particularly important in today's market. The colours shine vividly from

the canvas exhibiting the trade-mark glossiness of the finest Rubens paintings. Finally, it is a work entirely in the Master's own hand, without evidence of studio assistance.

Both works were sold by the Forchondt brothers to the Prince of Liechtenstein shortly after 1698 – although the Liechtensteins sold *Samson and Delilah* in 1880. This work, recognized as a Rubens in the 1920s, entered the National Gallery collection in London in 1980 at a cost of £2.53 million (£7.79 million today). The two paintings currently hang beside each other – *The Massacre* on long-term loan from its present owner, the late Kenneth Thomson – in the National Gallery in London.

Rubens was never without powerful advocates. Thomas Howard, 2nd Earl of Arundel and George Villiers, Duke of Buckingham, were two contemporary collectors of his work. The kings of Spain, Philip III and IV, Charles I of England and Maximilian of Bavaria were among his royal patrons. The artist's supporters were, geographically, sufficiently well spaced to avoid a collapse in his picture prices following the beheading of Charles I and flight of Buckingham in 1649 and the subsequent dispersal of both these collections onto the open market. The 193 works that the Buckingham family managed to sequester to the Spanish Netherlands were bought by a pupil of Rubens, and a financier, for 30,000 guilders (von Holst 1976). Sales from 1649 to 1653 disposed of 1,387 paintings and many an under-priced work of art was bought by an art-loving commoner, including Rubens' *Landscape with Gallows* (von Holst 1976: 128).

The artist found favour in France in the second half of the seventeenth century as the Duc de Richelieu's (the later *Massacre* was part of his collection) taste for the Baroque resulted in him selling works by Poussin (whose prices dropped dramatically during this period) in order to acquire fifteen works by Rubens (von Holst 1976). Even after the death of Louis XIV (in 1715) and the rise in popularity of the *fêtes galantes*, boudoir sized Rubens gained in popularity. The 1st Duke of Marlborough (1650–1722) was another admirer of his work and in the Enlightenment the artist was supported by Prince Kaunitz among others. At the end of the nineteenth century his many and varied supporters included Jakob Burckhardt, Sir Richard Wallace, Wilhelm Bode and Renoir. His reputation, and the importance of *The Massacre* in creating that reputation, would also have received a fillip from the exhibition in 2005–06 of his early works at the National Gallery in London.

In the art historical process, which sifts the also-rans from the minor, to the important, to the major, to the outstanding contributors to Western art, Rubens takes his place just below Raphael, Rembrandt, Michelangelo, Leonardo and Titian. He shares with Titian and Raphael (highest price at auction, £32 million (£36.5 million today) for *Madonna of the Pinks* in 2003) a consistently high estimation, something that Rembrandt, for one, did not enjoy.

The most recent benchmark prices for outstanding Old Masters date back to the forced deaccessions of the Stalinist era, the astute acquisitions of Mellon and the inflated prices achieved by Joseph Duveen. The $970,000

($13.52 million today) paid to Duveen by Mellon for Raphael's *Cowper Madonna* on 7 January 1929, and the $1.6–1.7 million ($24.1–25.6 million today) paid by the same collector for the artist's *Alba Madonna* in 1931, this time through Knoedler, are trifling by today's prices, and so tell us very little about today's values. In 2000, the highest priced work by the artist was a creditable, but still modest, $7.5 million ($9.08 million today) for *Portrait of a Man as the God Mars*. A more than tenfold increase in price for another work by the artist, two years later, needs some explanation.

The exceedingly high value of *The Massacre of the Innocents* is due to the great scarcity of 'Alpha' Old Masters, and great Rubens, on the open market. Tellingly, the high prices are unlikely to soften, even if the many cases of restitution reach a settlement in favour of the claimant in the next few years, and thereby bring more works to market. In this case the market will control the excess supply, and dealer inventories will expand to accommodate a surfeit. Old Master dealers are notoriously reluctant to bring Alpha works to market – a typical example being Raphael's *Lorenzo de Medici*, which was acquired for £115 (£1,435 today) in 1968 by New York dealer, Ira Spanierman, and held back until 2007, having increased in value over this period 6,000 times in real terms. So, prices will continue to rise in response to high quality images if and when they appear on the open market.

Chinese: Ru vase (late Northern Song [Sung in earlier texts], 1100–1127)

The phenomenal rise in the value of Chinese-taste ceramics is fuelled, according to Peter Wain, 'largely by its popularity in mainland China' (cited in *Millers*: Hearnden 2007: 233). The $27.7 million paid for a fourteenth century, blue-and-white baluster Guan (jar) Yuan dynasty (1279–1368), by the London dealer, Eskenazi, in New York in March 2006, demonstrates, 'that a well-researched item of exceptional quality and provenance will reach its full potential in the current market place' (Hearnden 2007: 233). It will, in addition, affect all good quality Chinese taste imperial works (an eighteenth century imperial 'swallows' bowl fetched $19.4 million at Christie's Hong Kong in November 2006). The 'Guan' sale also shows, by Eskenazi's intercession on behalf of American and European clients, that Western collectors have yet to be challenged at the very top of the market.

Gombrich devotes no more than a dozen pages to Chinese and Middle Eastern art in *The Story of Art* (1950) but manages, in those few pages, to compress the essential elements of Chinese art into the importance of the (curved) form; movement and meditation. 'Devout artists', Gombrich (1950: 108) asserts, 'began to paint water and mountains in a spirit of reverence, not in order to teach any particular lesson, nor merely as decorations, but to provide material for deep thought.' The Chinese, Gombrich maintains, appreciate the awe the artist felt at the moment of encounter with the object – usually nature. The ability of the artist to convey this experience is of the utmost importance.

If one were to choose a period in Chinese history when all Gombrich's elements associated with artistic greatness in China came together, it would be the Song dynasty (Northern Song 960–1127, Southern Song 1128–1279), and particularly the ceramics of that period. 'The Sung dynasty is', according to Harry M. Garner, 'rightly regarded as the classical age of Chinese ceramics and the Sung wares, often undecorated and relying entirely on form, colour and texture for their appeal, are supreme achievements of the potter's art' (cited in Neave-Hill 1975: 7). Decorative art in China does not imply inferiority, according to Mary Tregear (1997), and serious aesthetic commentary on the ceramic ware of this period (particularly during the Southern Song) reached new heights. The Ko Ku Yao Lun (Chinese critical writings, published in 1387) has this to say about Ru Yao (Ru type pottery; Ju Yao in earlier texts), the rarest and, arguably, most highly prized ceramic ware of the Song:

> That which was baked in the Sung dynasty was of a pale ch'ing colour. Pieces with 'crabs claw' markings are genuine, but those without such markings are especially good. Its paste is unctuous and very thin. Pieces are also difficult to obtain.
>
> (Neave-Hill 1975: 65)

Made at the end of the Northern Song dynasty for only twenty years or so, Ru Yao is even rarer today. This ware replaced Ding Yao (Ting in earlier texts) in Imperial affections at the end of the eleventh century because of the latter's imperfections. Ru Yao, a grey-bodied stoneware with iron-bearing glaze, is characterized, according to Mary Tregear (1997): 'By a fine-grained body, simple but elegant shapes – mostly bowls and vases – and an exceptional bluish glaze which could result in a soft hazy colour. The glaze is thick and semi-opaque with bubbles'. Neave-Hill (1975: 66), in *Chinese Ceramics*, adds: 'The glaze is smooth and dense, intractable and controlled and ranges in colour from a smooth opaque bluish-green through an opalescent lavender to a greyish-blue.

The Percival David Foundation (PDF) in London has fourteen pieces of the approximately one hundred extant surviving examples of the type. By far the largest collection is housed at the National Palace Museum in Taiwan. The stoneware Ru vase in the PDF (No. 61) covered with a greyish-lavender glaze (height 24.8 cm Northern Song twelfth century) is aesthetically and technically one of the finest works of art ever produced in China in which Tang (T'ang in earlier texts) virility has been replaced by Song elegance (Swann 1963).

The entry in the PDF illustrated catalogue describes No. 61 as:

> Vase, with globular body, long neck and flaring mouth, standing on a high, splayed foot. The mouth rim is bound with metal. The pale ash-grey stoneware body is covered with a thick greyish-lavender glaze with

greenish tones and a fine crackle stained grey in places. The base and foot are glazed and the rim of the foot has been wiped free of glaze.

This particular example is both rare and in perfect condition. The metal mouth rim has been removed and the rim is not chipped, although according to PDF, based on shard evidence, the mouth rim was originally much more flared, which suggests rim grinding.

A great deal of the value of this piece is placed on its balance and form. This example has a slight curvature of the neck and suffers a disproportion between neck and body. The monochrome glaze has one or two minute pit marks and a slightly matted or muted glaze colour. The crackles, likened to ice cracks, are darker than the norm. Crucially, the piece is without subsequent damage, breaks, cracks or chips. There is no evidence of glaze scratching, glaze polishing or grit and shrinkage. Each one of these factors would, in the order in which they have been presented, have a sliding scale impact on the value of the piece. For Imperial porcelain, for example, the price can be discounted, according to an interview with Julian Thompson, former chairman of Sotheby's Asia, by as much as 90 per cent if it is broken, 70 per cent if it is cracked, 50 per cent if it is chipped and 75 per cent if it is simply of poor quality. Conversely, there is a tendency today for buyers to demand and pay a premium for highly polished vessels, something that might actually add rather than detract value from a vessel in today's market. Restoration, on the other hand, never restores value in perfect condition. The vase may not be geometrically, chromatically and proportionately perfect in the manner of a piece of Qing porcelain or a Meissen figurine, but in conversation with Rebecca Feng of the PDF, the Ru Yao vase (No. 61) 'gives one a sense of what perfection should be.'

The vase has impeccable provenance. It may not have formed part of the PDF consignment which left China during 1930–31, offered for sale by the Yuin Yeh bank, which had received a considerable portion of the Imperial collection as part security against a loan to the Dowager Empress in 1901 to facilitate her move from the Forbidden City; but it is one the earliest pieces to be considered imperial. It entered the George Eumorfopolous Collection in the 1930s and was subsequently acquired by Sir Percival David. It has been included in exhibitions in Paris, London and in Japan from 1937 to 1999.

Past sales of Song ceramics are rare. Reitlinger records a purchase of nine pieces by the V&A in 1883 described as Song and Yuan, including white Ding Yao, Longquan celadon and brown-glazed ware, by a Dr Stephen Bushell in Peking (the author of the excellent *Chinese Art*) for which he paid between 4s and £2.12s (£10.30 to £135 today). Bing of Paris sold a tall white crackled vase, believed to be Song, for £320 (£19,334 today) in 1906, and Hayashi (Paris) sold the first medieval Chinese pottery to be sold as such at an European auction, which included a Jun Yao bowl and cover, for £156 (£9,945 today) in 1902. A Charles Russell sold two Song celadon bowls for £1,200 and £1,100 (£19,872 to £18,216 today) in 1960 and, crucially, a Ru Yao narcissus bowl

on four feet for the substantial sum of £2,200 (£35,222 today) the next year (Reitlinger 1961). The same narcissus bowl referred to in Reitlinger (1961) was resold at Sotheby's in 1970 for £46,000 (£511,980 today). This bowl would fetch, according to Julian Thompson, $10 million in today's market.[7]

Qing dynasty porcelain enjoys a much greater turnover in the European and, later, American markets of the eighteenth, nineteenth and twentieth centuries. William Beckford, Robert Fortune, Sir Anthony Rothschild and others are frequently cited by Reitlinger as buyers. The really extravagant prices, however, occur only with the appearance of the art dealer, Joseph Duveen. He is said to have offered £10,000 (£634,200 today) in 1895 and later £20,000 (£1.24 million today) in 1905 (according to his son Henry) for the two Exeter famille noire (famille verte on black background and very sought after) vases bought by the Marquess for £185 15s (£12,300 today) in 1888. Duveen's son, Henry, bought the Garland collection of mainly blue-and-white for £120,000 (£7.65 million today) in 1902 which he then sold to Pierpoint Morgan. He subsequently resold the collection to P.A.B. Widener, J.D. Rockefeller Jr., and Henry Clay Frick for £690,000 (£43.98 million today), with individual pieces fetching tens of thousands of pounds. Thereafter, until 1960 prices for the finest Qing dynasty porcelain exceed that of the other dynasties.

The lack of a significant price history, and a preference of the market for works from the later dynasties, make it very difficult to place an estimate on this seminal example of Chinese art. Conversations with leading experts in the field – Colin Sheaf of Bonhams, Gordon Lang and Julian Thompson of Sotheby's Institute of Art – have suggested anything from $10 million to $25 million.

For now, it is the Guan and the Qing 'Pheasant' vase (sold at Sotheby's Hong Kong for $14.8 million in 2005) that have set the records for Chinese art. The Guan is particularly important because it is an example of superb quality figure subjects painted in under-glaze blue-and-white from the Yuan period a mere 25 years or so after the introduction of cobalt blue into Chinese ceramic decoration (painting in blue cobalt under the glaze was discovered in China in the fourteenth century). While not in perfect condi-tion, the central panel painting is an extremely unusual subject matter. It is of splendid colour, resonance and assurance of design an early stage of artistry which was perfected (and never bettered) at great speed.

While there is no doubt that the Ru Yao vase would be highly estimated at auction, there is no guarantee that it would make more than the Yuan Guan or an exceptional five colour (*Falang cai*) piece from the Qing dynasty. It is perhaps too restrained for today's market and, despite its many attributes it might even fail to find a buyer. This is all the more extraordinary in the current climate of cultural repatriation in China, in which even foreigners like Steve Wynn are offering China back its lost treasures (in 2006 the Casino tycoon donated a fourteenth century (Hong-wu) Ming vase to a museum in Macau). One would have thought that a Song dynasty piece representing the

apogee of Chinese culture, as opposed to the offerings of the 'Barbarian' dynasties of the Yuan and Qing, would be the more treasured. That said, the extreme rarity of the vase could in the manner of the 'scarred' flat dish (see endnote 7), outweigh its imperfections and muted aesthetics to achieve close to the top estimate of $25 million.

Art market data

Art Market Research (AMR) was established in 1985 and produces 500 indexes accepted by leading art and financial institutions as measures of price movements in the art and related markets worldwide. AMR is based on taking art sales data from public auctions around the world. The data set has 1000 separate artist indexes and 300 sectors are represented.

Figure 2.1 shows the performance of the major markets from January 1985 to November 2007, based on data drawn from AMR.

The extraordinary performance of Chinese ceramics (from the Ming and Qing periods) has eclipsed even American and contemporary art, growing to over 12 times its January 1985 value by November 2007, but it is clear that there are high levels of correlation between all the major markets with the exception of the Han-Yuan period of Chinese art, which saw declining value from a December 1990 peak to a May 2002 trough, by which time it had lost more than five and half times its value. It has to be said that if the Han-Yuan basket had included an example of a Yuan blue and white Guan, it would have improved dramatically since 2002. Both China markets lost value in 1997 after the so-called 'Asia Economic Flu'. Among the ten items in the AMR basket of goods for the Han-Yuan sector, there are four Song items. American art has performed spectacularly, if erratically, over the period, losing 2.3

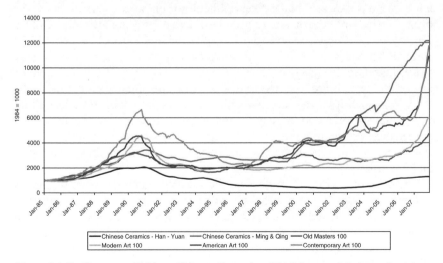

Figure 2.1 Performance Table – Chinese Ceramics, Old Masters, Modern, American and Contemporary Art.

times its value from August 1990 to November 1994, but was unaffected by the economic downturn in Asia in 1997 or the fallout of the 9/11 terrorist attacks in 2001. By November 2007 it had added 5.6 times more value to its November 1994 low and 2.3 times more value to its previous high in August 1990. Old Master prices remain stable throughout. Modern (European painting) was affected significantly by the events of 1990–91 and only returned to its October 1990 peak in May 2007. In the six months between that milestone and November 2007 it had added 1.3 times to its value. Contemporary art's performance has not been as exceptional or as volatile as might be expected.

Conclusion

Our recent art market history has told us that works of art acquired at the top of a bull market are hard to resell. There are many and various reasons why art thought to be great at the time of purchase is difficult to clear without a substantial loss. More often than not it is because the work was over-priced at the time. Ask Alan Bond about Van Gogh's *Irises*, which he bought at Sotheby's in 1987 for $53.5 million ($95.7 million today) and which sold to the Getty in 1995 for between $40 million and $45 million. Ask the heirs of Ryoei Saito: the owner of Daishowa Paper Manufacturing Company acquired Renoir's *Bal au Moulin de la Galette* at Sotheby's in 1990 for $78.1million ($120.5 million today). In 1997 it sold to an undisclosed buyer for $45 million ($58.5 million). Picasso's *Le Rêve*, which Steve Wynn was hoping to sell to Si Newhouse for a reported $139 million in 2006, is now widely regarded as unsaleable after Wynn accidentally put his elbow through the canvas – showing in the process how physically vulnerable art is as an asset. Restitution claims may bring more works onto the market from public museums, but they also make it very difficult for private owners to sell works over which hang the shadow of questionable provenance. Van Gogh's *Portrait of Dr Gachet*, which sold for $82.5 million ($127.3 million today) through Christie's in 1990, is subject to a claim for stolen goods dating back to 1939, and unlikely to reappear on the market. None of this bodes well for any of the items I have selected to discuss, with the possible exception of the Ru vase, which if it were ever to appear at auction would most likely find future buyers prepared to pay a higher price because of the impecable provenance and extreme rarity of the object. This opinion is supported by the measured but ever increasing rate of the increase of the Narcissus Bowl and flat dish.

The price of a work of art does not necessarily match its value. In today's bull market price very often exceeds value. It does so most often at the top end of the market where estimates appear as randomly selected numbers. In such cases it would be wiser, one would think, not to express value as a price before a bid or an offer has been registered. In reality, the appraisal-based bias (Campbell 2005) protects prices by preventing them from falling below an artificially fixed point. This suggests that the transaction of the work of

art is an undemocratic process, conducted secretly by private treaty or in elite forums and often displaying marked imbalances in information between sellers and buyers. When price, wildly and frequently, exceeds value at the top end of the art market, a correction is near at hand.

Notes

1 An undisclosed figure below the low estimate to which only the consignor and auctioneer are privy.
2 This can be viewed as profit margin, that is to say that the buyer pays less than he anticipated for the work of art.
3 A so-called 'winner's curse' normally operates immediately after a buyer has secured a Lot. The likelihood of anyone offering the owner more money for the work shortly after the sale is slim, although 'greater fool theory' maintains that there are always occasions, particularly in bull markets, when someone is prepared to do so.
4 A work that has been incorrectly catalogued or represented for sale, and sells for a relatively modest sum. It is subsequently discovered to be a significant work of art by a well-known or famous artist and its value multiplies accordingly.
5 The Duke of Rutland has asked the National Gallery to buy Nicolas Poussin's *Sacraments* – five paintings worth a total of £100 million. Lord Hampden has asked the Gallery to buy a Rubens oilsketch – *The Apotheosis of King James II* worth about £15 million. Lord Hampden has already consigned *A portrait of a young man* by Titian from the National Gallery to a London dealer with a price tag of around £50 million.
6 Retail Price Index adjustments to the equivalent value today are given throughout the chapter.
7 Sotheby's archive of auction catalogues offers a particularly sparse offering of sales of Ru ware since 1959. Two examples of repeat sale are noted. First, an Imperial Narcissus Bowl (Northern Song) auctioned by Sotheby's London on 17 March 1959 (Lot 26) for £2,200 (£36,806 today). The same was auctioned by Sotheby's London on 24 February 1970 (Lot 26) for £46,000 (£511,980 today). This is the narcissus bowl referred to in Reitlinger (1961). Second, an important Imperial Brushware (Northern Song) auctioned by Sotheby's Hong Kong on 28 November 1979 (Lot 23), with an estimate of HK$800,000, was bought in. The same was auctioned by Sotheby's London on 15 June 1982 (Lot 252) for £75,000 (£190,500 today). Third, a flat Ru dish (17.5 cm wide) with an underside rim chip, ground rim and grit spot on the front sold at Christie's, New York in 1992 for $1.54 million [$2.29 million today]. Julian Thompson thought the value of this piece had risen to $4.5 million by 2005.

References

Bushell, S. W. (1909) *Chinese Art Vol II.* London: Wyman & Sons.
Campbell, R. (2005) *Art as an Alternative Asset Class.* Maastricht: University of Maastricht/ LIFE.
Citigroup (2005) 'Plutonomy: buying luxury, explaining global imbalances', Industry Note (16 October).
Gombrich, E.H. (1972 [1950]) *The Story of Art*, 12th edn. London: Phaidon.
Hagen, R-M. and Hagen, R. (2005) *What Great Paintings Say*, Vol. II. Cologne: Taschen.
Hearnden, J. (2007) *Millers Price Guide 2007*, Vol. XXVIII. London: Octopus.

Heilbrun, J. and Gray, C.M. (1993) *The Economics of Art and Culture*. New York: Cambridge University Press.

Jaffé, D. and McGrath, E., Moore Ede, M.A. and Bradley, A. (2006) *Rubens: a master in the making*. London: National Gallery.

Lubbock, T. (2006a) 'The rich world of art's £73m man', *Financial Times* (23 June).

Lubbock, T. (2006b) 'Master of mediocrity', *The Independent* (10 July).

Mason, B. (2006) 'American beauties', *Financial Times* (25–26 November).

Merger, H. (1851; reprint 2004) *The Bohemians of the Latin Quarter*. Philadelphia, PA: University of Pennsylvania Press.

Neave-Hill, W.B.R. (1975) *Chinese Ceramics*. Edinburgh: John Bartholomew & Son.

Neret, G. (2006) *Klimt*. Cologne: Taschen.

Pierson, S. (1999 Revised edition) Illustrated catalogue of Ru, Guan, Jun, Guangdong and Yixing works in the Percival David Foundation of Chinese Art Section 1.

Reitlinger, G. (1961) *The Economics of Taste. 1760–1960*. London: Barrie Books.

Reynolds, N. (2006) 'Plea for emergency fund as Britain loses Canalettos', *Daily Telegraph* (22 February).

Robertson, I. (ed.) (2005) *Understanding International Art Markets and Management*. London: Routledge.

Roskill, M. (ed.) (1990) *The Letters of Vincent van Gogh*. London: Flamingo.

Schama, S. (1999) *Rembrandt's Eyes*. London: Penguin.

Sotheby's (2002) *Old Masters paintings, part one July 2002*.

Sotheby's (2006) *Preview* (June/July).

Sotheby's (2007) *Preview* (January/February).

Swann, P. (1963) *Art of China, Korea and Japan*. London: Thames & Hudson.

Tregear, M. (1997) *Chinese Art*. London: Thames & Hudson.

Von Holst, N. (1976) *Creators, Collectors and Connoisseurs: the anatomy of artistic taste from antiquity to the present day*. New York: Book Club Associates.

Weideger, P. (2006a) 'The eyes do not let you go', *Financial Times* (30 September).

Weideger, P. (2006b) 'Value in volumes', *Financial Times* (8–9 July).

Appendix

Conditions of business by auctioneers

Auction houses in the main operate as auctioneers, a key intermediary role in the art market. The worldwide art auction market has two principal selling seasons, spring and autumn. An auctioneer functions as an agent accepting property on consignment from its selling clients (consignors). An auctioneer sells property as agent of the consignor – it is not typically known that the consignor is the primary client of the auctioneer.

To buy at auction

Pre-auction work includes reviewing the catalogue (which may be available online), visiting the salesroom, contacting specialists (if required), and registering to bid. Auctions remain free and there is no obligation to bid. However, in the case of high profile auctions, seating may be reserved.

The catalogue is a vital document: each lot will include a description of the item, date or period, dimensions, and estimate (low/high). Moreover, the auction house needs to determine how many lots to include in a catalogue and the placement of the lots. In terms of the latter, the auction house is keen to place attractive and exciting works of art throughout the auction. A lot without a reserve is indicated. Key terms in reading an auction catalogue are listed below:

- Lot: Object or group of objects offered for sale as one unit.
- Estimate (Low/High): The estimate range is designed to help buyers gauge what sort of sum might be involved for the purchase of the lot. The estimate reflects opinions of specialists regarding the price expected at auction (excluding premiums and taxes). Estimates are based on factors such as quality, rarity, condition, provenance, and the prevailing market conditions. It is difficult to predict bidding wars which can result in the hammer price being much higher than the high estimate; likewise the hammer price might be below the low estimate (but above the reserve).
- Reserve: The minimum price a consignor will accept for the lot to be sold at auction. (The reserve requires the consent of the auctioneer.) This amount is never formally disclosed. The reserve cannot exceed the low estimate. A lot that does not reach its reserve is bought in.
- Provenance: The ownership or exhibition history of the lot might be included.

Bidding at auction from the floor (in person or via an agent) is the most conventional method, but telephone bidding has gained popularity in a globalized marketplace. Auctioneering is a spectacle so auctioneers need to create a buzz. This is about 'working the room' in order to generate competitive bidding. A skilled auctioneer will, in some cases, 'delay the hammer': this act of theatre increases suspense in the house, and may elicit further bids. (There can be delays between bids on high value lots, especially in the case of telephone bids in which the representative of the telephone bidder will engage in often lengthy discussion with his client before making a bid.) A skilled auctioneer wants to control the rhythm of a sale: a key goal is to encourage a 'feeding frenzy' – often associated with 'irrational' bidding among private collectors, who may not be constrained by the commercial imperatives of dealers – with a hammer price several multiples in excess of the high estimate.

- Bidding: Bidding starts below the reserve and tends to move in increments, or ticks, of 10 per cent. The next bid exceeds the previous bid (open-cry ascending bids).
- Hammer Price: The final bid price – at or above any reserve (see below) – when the auctioneer brings down the hammer. The hammer price does not include the buyer's premium.

- Buyer's Premium: The buyer of the property purchased pays a buyer's premium in addition to the hammer price. The rate of the premium – 10–25 per cent on a sliding scale is a typical range – is disclosed in the auction catalogue. Thus the purchase price is the hammer price plus the buyer's premium; the buyer is also subject to sales or value added taxes on the premium.
- Bought In: A lot fails to sell at auction because the reserve is not reached.

In assessing the success of an auction, certain statistics are touted: high total sales (which are calculated with the buyer's premium); and percentage of lots over the high estimate. Bought-ins represent relative failure, namely low bidder interest below the reserve.

Note that bidders at auction include dealers, who may be representing a client or buying to resell. In the case of the former, the dealer is acting like an advisor or consultant, and will be paid for such service (fixed fee or commission based on the hammer price). In the latter scenario, the dealer is acting like a retailer and buying inventory at auction. The holding period depends on the ability of the dealer to sell the property for a 'reasonable' profit.

To sell at auction

Auction houses need to acquire property to consign. Good property attracts buyers, who are more profitable to auctioneers than consignors. (For example, in September 2007, the buyer's premium at both Sotheby's and Christie's increased from 20 per cent to 25 per cent on the first £10,000.) As such, auctioneers are willing to offer auction estimates to prospective consignors.

- Consignor's Commission: The consignor's commission rate is on a sliding scale, which can range from 0–20 per cent; it is based on combined annual sales of property and the bargaining power of the consignor. In a seller's market, such as the current one, the consignor's commission is, typically, about 10 per cent. In addition to the commission, the consignor tends to be charged expenses for illustration and insurance costs.
- Guarantee: An auction guarantee to consignors is a minimum price in connection with the sale of an object at auction; in the event that the object sells for less than the minimum price (auction guarantee), the auctioneer must fund the difference between the sale price at auction and the amount of the auction guarantee. If the object does not sell, the amount of the guarantee must be paid, but the auctioneer has the right to recover such amount through the future sale of the object. The auctioneer is obligated under the terms of certain auction guarantees to advance a portion of the guaranteed amount prior to the auction. This

suggests that consignors benefit from a guarantee as the auctioneer assumes risk. However, most guarantees include a profit-sharing incentive for the auctioneer: for example, if the hammer price exceeds the auction guarantee, the auctioneer is generally entitled to a share of negotiated proceeds.

Private sales by auction houses

In addition to auctioneering, auctioneers are engaged in a number of related activities, including the brokering of private purchases and sales of fine art. Private sales can offer privacy not associated with a public auction and represents an auctioneer acting like a dealer. For consignors, a leading auctioneer can tap into a global network of collectors (both individuals and institutions). Likewise, some collectors seek a higher level of discretion than afforded by public auction. If a lot is bought in, the auctioneer (with the consignor's agreement) may consider a private treaty sale: this may be up to 10 per cent below the reserve. In the main, dealers detest auctioneers engaging in private treaty sales as the activity is part of the conventional role of dealers.

Financing by auction houses

Leading auctioneers also have finance segments. Two types of secured loans can be made:

- Consignor (Cash) Advance: Advances secured by consigned property to borrowers who are contractually committed, in the near term, to sell the property at auction. The consignor advance allows a consignor to receive funds shortly after consignment for an auction that will occur several weeks or months in the future, while preserving for the benefit of the consignor the potential of the auction process; and
- Term Loan: A general purpose term loan to collectors or dealers secured by a property not presently intended for sale. Term loans allow the auctioneer to establish or enhance mutually beneficial relationships with dealers and collectors and sometimes result in auction consignments. Secured loans are generally made with full recourse against the borrower. In certain instances, however, secured loans are made with recourse limited to the works of art pledged as security for the loan. To the extent that an auctioneer is looking wholly or partially to the collateral for repayment of its loans, repayment can be adversely impacted by a decline in the art market in general or in the value of the particular collateral.

Few traditional lending sources, even those with private wealth management capabilities, are willing to accept works of art as sole collateral as they do not possess the ability both to appraise and to sell works of art within a vertically integrated organization. Leading auctioneers believes that through a combination of art expertise and skills in international law and finance, they have the

ability to tailor attractive financing packages for clients who wish to obtain liquidity from their art assets.

Caveat emptor

The relatively low level of regulation in the art market has spawned some colourful language:

- To Flip: Same as used in other commercial sectors, namely a profit is made from reselling (flipping) a property shortly after it is purchased. Note that transaction costs of buying and consigning at auction are significant. Contemporary art dealers attempt to block flipping of represented artists by 'blacklisting' offending collectors.
- Phantom Bid (Chandelier Bid or Off the Wall Bid): The auctioneer will always take 'chandelier' bids if there is one bidder bidding below the level of the reserve. Above the reserve the auctioneer cannot do this as he runs the risk of buying in the lot above the reserve. The auctioneer then has to pay the seller without having a buyer. It is regarded as unethical behaviour.
- Burned: A tired property, namely one that has failed to sell once or more times at auction. Such 'old stock' excites very little attention; indeed it may even be refused by an auction house.

One wants to keep in mind the conventional rule of thumb to consumers: *caveat emptor*.

Sources: As a publicly-listed company on the New York Stock Exchange (NYSE), Sotheby's (sothebys.com) has compliance regulations to follow under the Securities and Exchange Commission, thus its 'Form 10-K Annual Report' (particularly Part 1) is extremely instructive; see also Sotheby's 'Investor Briefing' document. The catalogues and websites of leading auctioneers also include a section entitled 'Conditions of Business' (or like), which offers information for buyers, terms of consignment for sellers, and conditions of sale.

3 Selling used cars, carpets, and art

Aesthetic and financial value in contemporary art

Anthony Downey

> Art, it would seem, in its empathic modern sense at least, is irreducibly aesthetic. That is, one reason it is taken to be culturally important is because it offers something – a pleasure of the senses, in a cognitively expanded interpretation – which exceeds and ruptures the fixity of determinate judgement, in a singular but logically indeterminate manner.
>
> (Peter Osbourne)[1]

At the outset of a lecture I gave some years ago on the subject of contemporary art and value, I suggested that my audience, which was made up of postgraduate students with art history degrees, ask questions where and when they felt necessary. In most cases, this offer is thankfully not taken up until after the talk. On this occasion, however, my misplaced munificence was rewarded with a question before I had a chance to make my opening remarks. The questioner was seated in the front row and was therefore unavoidable; and her question – in all its pointedness and urgent delivery – was equally unavoidable. 'So what', she asked, 'is the difference between selling contemporary art and carpets – or, for that matter, used cars?' The enquiry, and its unexpected early intrusion into my lecture, flummoxed me for a moment, but I proffered – perhaps glibly in retrospect – the following response: although the art world exists and operates to all intents and purposes like any other economic system or business, art itself could not be, and indeed should not be, treated as a commodity. In this response, I was expressing an obviously idealistic belief: artistic practice and financial worth should not answer to the same rules of value; in fact, they *cannot* be answerable to the same ideals insofar as aesthetic and economic value are of necessity two different things. The words, even as I uttered them – and perhaps more so now in the current 'boom' environment of the contemporary art market – felt compromised from the outset. In the first instance, not only does the art world operate in a manner similar to a conventional consumerist system of commodification, but also that most contentious of aesthetic terms – value – would appear to be increasingly answerable to an economic system based upon a crude supply and demand model. How else, for example, do we account for the credulous

excitement surrounding the unveiling in London of what is apparently the most expensive, if not most speculative, art work ever made – namely, Damien Hirst's *For the Love of God* (2007), a platinum skull covered by 8,601 diamonds, costing £12 million to make and with a purported asking price of £50 million. It is arguable that such a work would not have been produced (*supplied*) without there being a buyer (*demand*) for it in the first place. In this instance demand – the financial wherewithal to buy such a work – would appear to have predicated the supply; that is, the aesthetic object. Demand, likewise, would appear to be fuelling the ever-increasing prices that contemporary art achieves at auction.[2]

This is not necessarily an anomaly in the contemporary art world: money, from wherever it originates, has been always associated with the so-called 'fine arts' and it is increasingly attracted to contemporary art in terms of both investment and as a so-called 'lifestyle option'.[3] Financial investment in contemporary art also confers a degree of what the French sociologist Pierre Bourdieu refers to as 'cultural capital'. Writing in 1986, Bourdieu outlined three distinct types of capital: 'economic capital' (which is obvious enough in itself in terms of definition); 'social capital' (predicated on networks of membership that confer influence and causal agency upon an individual); and, finally, 'cultural capital'.[4] In the third category, the forms and applications of knowledge that give individuals a perceivable benefit, and therefore status in contemporary society, also act interchangeably with social and economic capital. They have, in sum, a negotiable quality whereby 'cultural capital' can become a form of economic and social capital. There is nothing particularly ground-breaking in such insights when looked at from the vantage point of today: all knowledge carries a price and weight of exchange, so to speak. However, Bourdieu's model does provide us with a paradigm of sorts that sees a knowledge of aesthetic value – here equated not only with knowledge but also with the valency of ideas *per se* and their ability to interact with material networks of economic power – and financial value come together in a reciprocal relationship based on exchange. Aesthetic value and economic value disclose in this instant a degree of reciprocity founded upon the interchangeability of both. Furthermore, the commodified nature of much of the contemporary art world's output, always a factor of art production from at least the Renaissance onwards, is no longer seen (if indeed it ever was) in terms of being unusual in itself. On the contrary, contemporary art today is actively celebrated as a material commodity in its own right and therefore – in the wider scheme of how late capitalism produces objects of desire, be they cars or carpets – as a prioritized form of commodity fetish. And, again, this was most likely always the case, with one exception: the market for contemporary art (almost nonexistent in the 1970s) is now one of the strongest markets in art today. What is more, the art world and its practices seem to be acutely aware of this and artists such as Jeff Koons, to name but one of the more prominent practitioners who engage both the structure and the semiotics of commodity markets, have made a career out of actively playing the market. It is perhaps no

coincidence that Koons was a commodity broker on Wall Street for six years before becoming an artist. And he is, I would readily admit, but the latest in a long line of artists cum entrepreneurs that could be traced back to the Renaissance.

Once a relatively exclusive commentator on life, contemporary art has come to be (for better or worse) firmly imbricated within life itself; so why should it not, we may ask, bear some of the hallmarks of a commodity within our commodity-based culture? And where does that leave my original, albeit high-minded, reply to my erstwhile questioner – which to all intents and purposes was attempting to reassert a precarious and largely usurped ideal of a privileged autonomy for contemporary art in the early part of the twenty-first century? Rather than concede to the disconcerting vision of art seen solely as commodity (an object judged not by its aesthetic, contemplative value but its utilitarian value as an object of exchange), I offered a further definition to my questioner – who, it should be noted, had been less than impressed with the first offering. Art is first and foremost a creative act, I went on, and the exchange value that it accrues in our society is of secondary concern to its value as a contemplative object. In retrospect, I could have added to this and suggested that the aesthetic underwriting contemporary art has been developed, in part at least, as an investigation into the very notion of financial value – precisely the issue that I want to explore in the following discussion. This is to focus on one aspect of contemporary aesthetic practice, and I am therefore being highly selective; nevertheless, in doing so we address a categorical dilemma that has garnered an increasingly pertinent purchase in our neoliberal, globalized and consumerist driven Western societies: if we are to look at art solely in terms of financial value (a view my questioner was prompting if not supporting), then the sale of contemporary art had a lot in common with the selling of any other commodity one may care to mention. If, on the other hand, we consider aesthetic value – the singular properties of an art work and how we experience and understand the nature of those properties in an institutional and theoretical context – then it is more difficult to see art in the same category as a commodity. Contemporary art practice as a critique of commodification further crystallizes precisely this dilemma and appeals to an expanded sense of the aesthetic. I should, by way of a prudent caveat, make clear a number of points here: contemporary art production – in light of the financial demands of commodity display and the exigencies of market value and consumption – does not necessarily 'escape' systems of commodification, but it can offer insights into certain distinctions between aesthetic and financial value and how both are accrued. In what follows, which is admittedly a potted history of contemporary art, the question we are left with is relatively simple and yet not necessarily simplistic: is there a productive distinction to be had between aesthetic and financial value; and, concomitantly, can contemporary art generate that distinction from within its own practice?

The subject of contemporary art has become the focus of popular (if not populist) controversy and the locus for often heated national and international debate. It is not surprising, for example, to find contemporary art making front-page news, both for the record-breaking prices it regularly achieves and its occasionally controversial content. The widespread interest in contemporary art is nevertheless invariably stymied by the relatively obscure formal elements it employs and the often self-referential nature – and therefore abstruse to all but those with specialist knowledge – of the ideas it explores. How are we to interpret an unmade bed as art; or a light switch alternating between on and off; or a mound of sweets in a corner that we are encouraged to take away with us; or, for that matter, an artist whose practice consists of making food for his friends? What contexts, moreover, can we use to ground such practices when they are apparently without precedent in the history of art? A significant element in these debates and practices involves not so much up-to-the-minute art practices, or indeed art since the 1960s or so, as it does the work of Marcel Duchamp. In the most basic sense, Duchamp's work pointed not to the object of contemplation as such (the manifest aesthetic form of an art work), but to the abstract thought process behind it. The object, for Duchamp, was often the seemingly arbitrary opportunity for the reification of an idea.

Duchamp's *oeuvre* is complex and does not suffer abbreviated commentary easily; however, his theories on so-called 'non-retinal' art and his use of 'readymades' goes some way to disclosing many of the conundrums we encounter in determining both aesthetic and financial value in a contemporary context. His 'readymades', a term he first employed in 1915, were essentially 'found' objects that he nominated as art. The first, a bicycle wheel mounted on a stool, dates from 1913; however, it was his *Bottle Rack* of 1914 – a mass produced bottle-drying rack signed by the artist – that is considered to be the first readymade. The most famous of these readymades, or perhaps the most infamous, is his *Fountain* of 1917. Effectively a mass-produced urinal with the one-off pseudonym 'R. Mutt' painted on it, this work goes some way to describing what Duchamp meant when he used the term 'non-retinal': the objects were chosen to refute traditionally 'retinal' art work – art, that is to say, that existed on a purely visual level – and therefore address the realm of the intellect. Duchamp's *Fountain*, in the first instant, fundamentally questioned what art could be and, perhaps more importantly, it interrogated the nominal notion of aesthetic 'taste' – or 'value' – as a foundational criteria in the understanding of art. If anything could be designated art by the sheer volition of the artist then what differentiated the art object from any other object or commodity? And it is here that we get closer to a definition of contemporary art that is still the source of bemusement for some: it is the idea, the concept, that matters most in contemporary art practice, not the object *per se*. Which bring us to a number of essential distinctions between aesthetic and financial value: the object, sometimes of little intrinsic value, is often *just* an artefact upon which the privileged notion of the idea itself is

made manifest; or, to put it another way, 'value' in aesthetic terms is inextricably associated with the idea not the object. Second, anyone can make the object, but it is the artist who is the privileged originator of the idea to make that object in the first place. The ideal of craftsmanship and artistic skill, often a key component in attributing financial value, is elided here in favour of the concept itself.

I am no doubt simplifying the manifold issues that Duchamp addresses in his work. It is notable, for example, that his disavowal of 'retinal' art, including the visuality of painting itself, entailed a large measure of 'visual indifference' – a term which evokes a form of aesthetic indifference. In conversation with Pierre Cabanne, Duchamp noted not only his indifference to the object but also the absence of 'aesthetic emotion'. To the question, what made you chose readymades as a form of artistic expression, he replied that the decision

> depended on the object [and] at the end of fifteen days, you begin to like it or hate it. You have to approach something with indifference, as if you had no aesthetic emotion. The choice of readymades is always based on visual indifference and, at the same time, on the total absence of good or bad taste.[5]

Although Duchamp was to never fully articulate a definition of the 'readymade' that satisfied him, the works effectively predicate aspects of the direction that contemporary art was to take in the latter half of the twentieth century. It was the idea that came first, not its material manifestation or, for that matter, the value associated with the materials used; and this has been a feature of *inter alia* Minimalism, Land Art, Conceptualism, and Performance Art. Nevertheless, and herein lies the rub, Duchamp's *Fountain* has a definitive financial value attached to it that far exceeds its nominal utilitarian value as a urinal (a standard Bedfordshire model urinal, to be precise), and this despite the fact that the original was not only lost – what we have today are reproductions of the original – but not even made by the artist in the first place. A nominally priced, easy to attain object, becomes financially valuable because of the artist's intercession and after scholars and other commentators ascribe to it an iconic status and aesthetic 'value'. Thereafter, the market, in its insatiable desire for the iconic, attributes a financial value to it. However, the object itself seems to be questioning precisely the attribution of financial value to something that is 'valueless' – an everyday urinal no less.[6] To the extent that aesthetic value questions systems of commodification and the demands of an art market that is primarily the product of a capitalist system of financial investment and gain, it is still – as I noted above – subject to such systems. The art market will always, after a period of professional consideration from various commentators and interested parties, investment by gallery owners in artists, and against the unpredictable vagaries of trends and changing tastes, attribute an economic value to the art object. It is all the more ironic that when Duchamp showed his readymades to his contemporaries, in an attempt

to refute aesthetic 'beauty', they readily attached a degree of beauty to them. 'I threw the bottle-rack and the urinal into their faces as a challenge', Duchamp noted, 'and now they admire them for their aesthetic beauty'.[7]

The situation is, of course, more complex than I am letting on here and a more immediate example of aesthetic and financial 'value' coming into conflict can be found in the purchase of Carl Andre's *Equivalent VIII* (1966) by the Tate in 1972 and now housed in Tate Modern. I am aware that I am making something of a historical, if not ahistorical, leap at this juncture, and that needs quantifying. In noting Duchamp's contribution to contemporary art, the emphasis on idea rather than form, it should also be observed that much contemporary output still relies upon the material uniqueness of an art work. This is obviously the case when we look at contemporary painting. It is difficult to imagine anyone being able, in a manner other than the expression of an ironic take on originality, to perfectly reproduce, say, an Anselm Kiefer, or a Gerhard Richter abstract painting, or a Peter Doig for that matter.[8] So despite Duchamp's conceptual gambit, art to this day is still an object-based preoccupation; and therefore aesthetics, in a broad context, is still concerned with formal issues.[9] Which brings us back to Carl Andre's *Equivalent VIII*, a work that has garnered much by way of opprobrium and prompted the London-based *Daily Mirror* to publish an image of the work with the headline 'What a Load of Rubbish' when news of its purchase was made public. The source of subsequent public obloquy since its display at the Tate, *Equivalent VIII* consists of 120 firebricks arranged neatly, two high, six across, and ten in length. They are visually 'minimalist' insofar as there is very little to see here; very little, in fact, to find visual refuge in. And that can be a source of intimidation for someone not ready to engage with this work or merely unable – for whatever reason – to engage with it. For a work that is now over forty years old, it is still a source of disbelief (as it is no doubt to the Tate) that it attracts such bemusement, if not downright hostility, when first encountered. To fully explain why, we must return to the issue of aesthetics, specifically the aesthetic employed by Andre and other minimalists when it came to making their work, and how it challenged the idea (or should that be ideal) of the financial value inherent in a work of art.

First, Minimalism, like Duchamp's 'readymades', radically questions not only what art can be, but also what it can be constituted from. Andre's *Equivalent VIII* resembles not so much sculpture as it does the plinth upon which a sculpture would be traditionally placed.[10] In this respect, the work can be seen, to some extent at least, as a riposte to the 'retinal' and the perceived emotivism and artistic hubris of Abstract Expressionism.[11] Minimalism, nonetheless, discloses the individual's relationship to the art work to be nothing other than aesthetic in its import and impact. (And it should be observed that *Equivalent VIII* is an object capable of being perceived by the senses and is therefore aesthetic in the most traditional sense of the word *aistheton*: that which is capable of being apprehended by the senses.) Further characteristics include an extreme simplicity of form and a literal approach to

the art object; an ambition to explore essential elements of form and structure rather than gesture; and an acute awareness of the object's positioning in its spatio-temporal environment. All three of these aesthetic features are further complemented and yet partially contradicted by an apparent absence of intuitive decision-making in the production of the art object; a repudiation of illusion; and, perhaps most notably, a disavowal of the artist's presence as a 'signature' or craftsman. The industrial nature of the work is further exploited in the use of non-traditional materials such as Perspex, steel, glass, and welded iron.[12] These are not only inexpensive materials, but also void of apparent aesthetic merit in the traditional sense of the term. The artist, in a tradition that can be traced back to Constructivism, can be considered here in terms of being an artist cum engineer; and that does not fit neatly with the *art pour l'art* aesthetic of unique genius that attached itself to, among others, Jackson Pollock.

Minimalism challenged and toppled some of the most cherished conventions about what art was and what it could be made from, not least the ideal of the artist as craftsman. And yet, in its simplicity of form, the work discloses a concomitant retreat into a pure aesthetics of form, structure, and surface. Despite the apparent lack of an aesthetic in the traditional sense, *Equivalent VIII* has no meaning outside of its spatio-temporal context – its *place* in the world – wherein which we view it and therefore respond to it on an aesthetic level. This is to observe a shift away from a concern with spatiality *within* the confines of a work – a 'retinal' concern, to recall Duchamp's argument with art of his age – to a phenomenological concern with the work as it existed *within* space. The aesthetic experience of the work *is* its value; and its financial value cannot be attributed to the cost of its materials or their uniqueness as objects in their own right. (It is significant that a considerable amount of early minimalist work was literally disposed of after the run of a show.) *Equivalent VIII* does not, moreover, have an inherent unreproducibility like, say, a painting. The work has been remade by Andre himself using different materials but closely following the form of the original. Andre's fire bricks do not, likewise, cost that much by way of materials – and, in that age-old and tiresome cavil, anyone *could* have made the work. But no one did make such a work; until, that is, Carl Andre came along. And yet, *Equivalent VIII*, like *Fountain* before it, would be expensive on the open market – and the Tate, if it could deaccession works from its collection, would see a handsome return on this particularly iconic art work.[13] To observe as much is to problematize our earlier assertion about the dematerialization of the art object and the ascendancy of the concept: despite suggesting above that the object becomes less and less important, in light of the idea that lies behind it, we could conversely argue that the economics of the art market attributes financial value to that which, as an object, has little or no inherent value; thus further fetishizing, despite the aesthetic move away from, the object as the locus of 'value'.

This notion can be extrapolated onto the similar problem of reproducibility:

to perfectly reproduce a painting by, say Anselm Kiefer, would be a difficult task when put beside the reproducing of, say, Andre's *Equivalent VIII*. However, Andre's work, and those of his erstwhile peers such as Donald Judd and Robert Morris, would appear to invite reproducibility in the very objects they produce. It is this affirmation of modularity, uniformity, and an inherent reproducibility in the work of an artist such as Andre – or Judd and Morris, for that matter – that goes some way to disclosing how closely the work mimicked the very means of mass-production, and comparative devaluation, of consumer objects *per se*: the more an item is (re)produced, that is to note, the cheaper it becomes. Another of Andre's peers, Dan Flavin, consistently employed that most emblematic signifier of industrial reproducibility: namely, commercially available fluorescent light fixtures of the sort that lit many factory floors from the 1940s onwards. There are two broad and yet related ideas that need to be addressed here if we are to further define the distinction between aesthetic and financial value: the first involves the fact that reproducibility is an endemic part of our own culture and, to gloss Walter Benjamin's insights, the work of art no longer exists in a pre-industrial landscape like that of the mid-nineteenth century; on the contrary, it lives in an age of mechanical (and latterly digital) reproduction. Second, and around the time of Minimalism, art as a practice enters a period that is broadly defined in terms of its 'conceptualism', a movement that eschewed both the aesthetic and the object in favour of ideas – which returns us, as with all discussions of contemporary art, to Duchamp and his 'readymades'. The progenitor of video art, Nam June Paik, was to turn to video itself, that most transferable, mediated and reproducible of modern media, so as to go *beyond* the artistic strategem that Duchamp set into play in the 1920s. In an interview, the artist noted, 'Marcel Duchamp has already done everything there is to do – except video [. . .] only through video art can we get ahead of Marcel Duchamp'.[14] Add to this, the impermanence associated with performance art and one-off installations and we get closer to the original point: artistic practice and financial worth cannot be answerable to the same ideals of value inasmuch as aesthetic and economic value are of necessity two distinct entities. In fact, aesthetic 'value' would increasingly appear to be questioning the investment of financial 'value' in its practice; while financial value increasingly conforms to critical (aesthetic) consensus as to what qualifies as an exceptional, and therefore expensive, work of art.

To the extent that formal developments in contemporary art have often generated a degree of bafflement, if not outright hostility, on behalf of the majority of viewers (performance and installation art come to mind here), contemporary art works which draw upon collaboration have tended to compound the puzzlement with which contemporary art practices are often greeted. Sol LeWitt, for example, long engaged a practice whereby he would literally draft careful instructions for an art work on a sheet of A4 paper and

then forward it to the relevant individual or institution for them to carry out, to the letter, and therefore 'make' the work themselves. Long seen as a pioneer of Conceptualism, which finds its intellectual underpinnings in Duchamp, LeWitt was a believer that the idea preceded the art work and was the privileged bearer of 'value'. Many of his wall drawings existed only for the duration of the show he happened to be in and were subsequently painted over – a practice that effectively usurps the primacy, if not meaning, of 'object' itself. Again, this transience would appear to be at odds with financial value, but is nonetheless key to understanding the aesthetic value of the work. However, the financial demands of commodity display and value will always be at odds with this and LeWitt's work, like Duchamp's and Andre's, has a given financial value attached to it – an institution pays a fixed sum of money for the 'right' to reproduce LeWitt's work – regardless of the fact that it exists only as an idea until it is made manifest by the individual or institution who purchases it. We arrive here at something of an impasse between aesthetic and financial value: contemporary aesthetics, post-Duchamp, would appear to subjugate the object – the privileged bearer of financial value – to the idea; the latter an immaterial and therefore difficult-to-categorize 'value' in financial terms. And yet the art market will, of necessity, always find a way to commodify – even if it means commodifying that most abstract of phenomena: an idea.

More recent developments in contemporary aesthetics go someway to revealing the extent to which art questions the commodity-based environment in which a work must, of necessity, exist. Throughout the work of Cuban-born American artist Felix Gonzalez-Torres, we find both a concern with transcience and an aesthetic that owes much to minimalist and post-minimalist aesthetics in its reproducibility and its inexpensive materiality. Gonzalez-Torres' work is both complex and consistently relevant (he was only the second artist to be posthumously chosen to represent his country at the Venice Biennale in 2007 – the other being Gordon Matta-Clark in 1982) and in this respect it is difficult to offer an overview of it without doing it an injustice. However, and in light of my above discussion, I want to examine one work here, *Untitled (Portrait of Ross in L.A.)* (1991), that encapsulates many of his ideas if not formal concerns. The work is formally simple, consisting as it does of a mound of brightly coloured sweets squeezed into a corner. The gallery-goer is generously encouraged to take some of the sweets as part of the work itself; in fact, the very aesthetic of the work is activated only in that moment of participation and subtraction. The final form of this work, its completion so to speak, is its absence – its diminution *into* nothingness. Apart from exploring issues of formal dematerialization, Gonzalez-Torres's 'portrait' of his lover Ross Laycock is a lament insofar as the weight of the sweets in their original state is equal to that of his partner, who died in 1991 from an AIDS-related illness. The diminishing pile of sweets is therefore allegorical: it signifies – through absence and the deliquescence of matter itself – Laycock's body and the disease he suffered from. However, the

mound of sweets is ultimately replenishable insofar as in each reincarnation in a gallery or public space the work reassumes its 175 pound weight and the process resumes all over again.

Gonzalez-Torres' work explores several ideas, some public, others intimate; however, he also examined an aesthetics of transience that is at odds with the financial demands on the permanence of the object itself. Impermanence, to a certain degree, questions the financial demands placed upon the object as privileged bearer of economic value. Nonetheless, Gonzalez-Torres' work still carries a financial worth, despite its post-minimalist play on the cheapness of materials, uniformity, reproducibility, inexclusiveness, participation, and availability. What is more, his work is a precursor to what has been variously described as 'relational aesthetics', a contemporary art form that draws upon the interrelations between individuals rather than substantiative objects. The term was first used by Nicolas Bourriaud in the mid-1990s and was later popularized in his book *Relational Aesthetics* (2002), which has attracted much by way of both criticism and support. Stemming from essays published from 1995 onwards in *Documents sur l'art* – a journal jointly edited by Bourriaud and Eric Troncy – and in part from the 1996 show 'Traffic', curated by Bourriaud for CAPC Bordeaux, *Relational Aesthetics* was first published in France in 1998 before being published in English in 2002. For a relatively short series of essays the book has attracted a considerable amount of interest; a consequence, no doubt, of Bourriaud's rather grand claim that he has isolated not only a new aesthetic 'movement' in contemporary art (albeit one that is formally diverse and based upon loose rather than close associations), but also a critical language within which to discuss this development.

In a broad sense, relational art, for Bourriaud, engages in a form of practicable social interactiveness that co-opts collaboration, participation, intervention, research-led activities and community-based projects into both the form and content of the work. The emergence of these new formal strategies implies, in turn, that the 'criteria of aesthetic judgment' be yet again rearticulated. More specifically, relational art represents a branch of artistic practice that is largely concerned with producing and reflecting upon the interrelations *between* people and the extent to which such relations – or communicative acts – need to be considered as an aesthetic form. Focusing on the modes of sociability and socialization that issue forth from relational art practices, Bourriaud put forward *Relational Aesthetics* not so much as a 'theory of art [but as] a theory of form'; or, more precisely, a theory of formations.[15] The art work in this discourse is 'presented as a *social interstice* within which [. . .] new "life possibilities" appear to be possible'.[16] Putting to one side the question of whether or not Bourriaud has indeed isolated a new movement in contemporary art, and this is indeed debatable, the point being progressed here is that aesthetics, in terms of form, has been reconceptualized here into a series of dematerialized formations that engage architecture, performing arts, video, film, sound, participation, intervention, research-led activities, and community-based projects.[17]

In 1992, one of the progenitors of relational aesthetics, the Argentine-born, New York based artist Rirkrit Tiravanija, produced *Untitled 1992 (Free)*, an installation that involved him clearing the office space in the 303 gallery in New York and installing a makeshift kitchen where he cooked Thai curry for anyone who turned up. Subsequently, in 1999, Tiravanija reconstructed a replica of his apartment in the Gavin Brown Gallery. Being a fully working model of an apartment, it was open 24 hours a day and gallery-goers were encouraged to live and eat there. While this may seem to be a form of ersatz community service, the artist as social worker if you will, Tiravanija's work has been on the forefront of 'relational aesthetics' – the latter a key develop-ment in contemporary art today. What is clear, moreover, is that relational aesthetics and its practitioners, while not escaping systems of commodifica-tion, offer in their practice an increasingly attenuated version of what consti-tutes financial value in contemporary art. Can we, for example, judge an art practice in terms of financial value if all it does is generate opportunities for dialogue and social interaction? Furthermore, can an artist cooking for his friends be considered in any traditional sense as having a financial value? I ask these question in the spirit of enquiry and do not necessarily have definitive answers; however, and to reiterate my earlier point, it would appear that the most recent developments in aesthetics, as did the conceptual gambit proposed by Duchamp in the early part of the twentieth century, still ques-tion and to some degree interrogate the attribution of financial value to contemporary aesthetic practices.

The nature of disputes and controversies surrounding contemporary art can be located in the simple fact that the actual form certain ideas take has diversified and modified according to need and trends. The criteria and modes of criticism used to interpret art as a practice have also changed – so much so that to the casual observer they can represent yet another level of obfuscation. To note as much is to observe a truism: the idea of a universalist aesthetic point of reference, or even the notion of aesthetics as a nominal interpretive baseline, has been discursively displaced by political, social, his-torical, identitarian, and theoretical interventions. These developments, it should be noted, were both necessary and instructive insofar as aesthetic theory was largely an ideologically skewed series of value judgements that maintained a hierarchy of interpretive authority. And yet aesthetics as a topic, far from fading into a minor role, has become something of a notional cor-nerstone in recent deliberations on contemporary art.[18] However, none of this is even partially addressed without observing the shifts in the institutional contexts within which contemporary art is being produced, displayed and disseminated. In albeit succinct rather than explicative terms, this could encompass a discussion of, for example, the evolving professionalization of art schools and artists as practitioners; the exponential growth of the com-mercial gallery on both sides of the Atlantic (and the incipient privatization

of public galleries); the role of dealers and collectors in determining aesthetic and financial value (not to mention auction houses); the changing nature of the museum in contemporary culture; the role of art funds in buying art and the ensuing privatization of what was a relatively informal network of art-related occupations (evidenced in the emergence of so-called 'art-consultants'); the politicization of cultural production and the dissemination of art since the 1980s; and, finally, the emergence of new loci for the exhibiting (and buying) of art, not least the department store and internet. All of which sees contemporary art practices increasingly professionalized – which is not a bad thing in and of itself – to the point where they follow a business-like level of commodification and systems of production. The issue here involves the extent to which aesthetic value is being compromised by the increasingly commodified nature of our public institutions and the rampant commercialization of art as a component of the cultural industry. Which refers us back to our earlier point: aesthetics, post-Duchamp, has to some extent developed as a critique of the financial value attached to the object. While contemporary art cannot necessarily escape the ambit of the market and the demands of economic systems, it can at the very least offer a critique of those demands in the aesthetic form it adopts and adapts. And the stakes could not be much higher. In a milieu where both political and cultural arenas seem increasingly compromised in the face of global capital and the exigencies of the marketplace it would appear that aesthetics (specifically, the inter-disciplinarity of contemporary art practices) is being ever more called upon to provide us with insights into politics, mass culture, and the socio-politics of financial value. At this point, and by way of qualification after the event, it would be perhaps timely for me to rearticulate my one-time answer to my original questioner, albeit with a shift in emphasis: in an era of neo-liberal globalization, where the sinuous channels of commodification seem to know no bounds and the public/private sphere is being incrementally elided by corporations bent on commodifiying our innermost desires, aesthetics can offer – perhaps to a limited but nonetheless necessary extent – not only a critique but also a way of rethinking the very idea of financial value.

Notes

1 P. Osbourne (2000) 'From an aesthetic point of view', in P. Osbourne (ed.) *From an Aesthetic Point of View: Philosophy, Art and the Senses*. London: Serpent's Tail: 1–10 (p. 7).
2 In February 2007, the Sotheby's Evening Sale in London realized a then record for any sale of contemporary art in Europe (£45.8 million; $90 million), including a world record price of £5.7 million for Peter Doig's *White Canoe* (1990–91). In New York three months later, the contemporary art sale at Sotheby's saw Francis Bacon's *Study After Innocent X* (1953) soar over his previous $27 million record to $52.6 million; while Andy Warhol's *Green Car Crash* (1963) doubled its already ambitious estimate to sell for almost $72 million. At the same sale, Mark Rothko's *White Centre* (1950) sold for $72.8 million. All were record prices for these iconic artists and continue to reflect the exponential rise in the prices of contemporary

art and, as in the case of Rothko, late modern art of the post-war period. Sub-sequently, at Sotheby's Evening Sale on 21 June, Damien Hirst's *Lullaby Spring* achieved £9,652,000, a new auction record for a work by a living European artist.

3 For an interesting account of recent trends in both international economic struc-tures and the contemporary art market, see J.J. Charlesworth (2007) 'Bonfire of the Vanities', *Art Monthly* 305 (April): 5–8.

4 See P. Bourdieu (1986) 'The forms of capital', in J.G. Richardson (ed.) *Handbook for Theory and Research for the Sociology of Education*. Westport, CT: Greenwood Press: 241–58.

5 Marcel Duchamp, cited in P. Cabanne (1971) [1969] *Dialogues with Marcel Duchamp*. London: Thames & Hudson: 48.

6 The excremental is something of a theme in contemporary art and I am reminded here of Piero Manzoni's *Artist's Shit* (1961), a series of ninety tins containing the artist's faeces. Each tin was numbered and a label on each can referred to the contents as ' "Artist's Shit", contents 30gr net freshly preserved, produced and tinned in May 1961.' These tins were then sold for their equivalent weight in gold. Apart from the fact that these tins of the artist's faeces continue to fetch ever-increasing prices at auction, it has been alleged that the tins contain plaster and not the decreed contents – which suggests a double-take on Manzoni's ori-ginal in-joke and a further irony to cap off the controversy that has surrounded the work since its inception.

7 Duchamp, in H. Richter (1965) *Dada: art and anti-art*. New York: McGraw Hill: 207–08.

8 This has not stopped artists from 'reproducing' other artist's work. Mike Bildo, for one, makes perfect copies of iconic paintings by artists such as Jackson Pollock and signs them with his own name. Interestingly, and while Jackson Pollock's actual painting remained unsold in Sotheby's May auction in New York, a Mike Bildo reproduction of a Jackson Pollock did sell.

9 On this note, Barnett Newman, perhaps missing the point, was to argue that 'Marcel Duchamp tried to destroy art by pointing to the fountain, and we now have museums that show screwdrivers and automobiles and paintings. [The museums] have accepted this aesthetic position that there's no way of knowing what is what': B. Newman (1990) *Barnett Newman: selected writings and interviews* (ed.) by J.P. O'Neill. New York: Alfred Knopf: 247.

10 It should be observed that Andre, despite the apparently radical formal aspect of his work, consistently refers to himself as a sculptor and his work as sculpture.

11 The reaction to Abstract Expressionism was not solely a sculptural concern and is also notable in works such as Barnet Newman's monumental *Vir Heroicus Sublimis* (1950–51) and, later, in works such as Frank Stella's *Six Mile Bottom* (1960). In Stella's work periphery and lines correspond and the pattern is largely deduced from the actual shape of the canvas. The clarification of thought and process could be seen in terms of an automatic response to the actual process of painting.

12 In the context of industrialism and mass-production, it is of interest to note that one of the influences on Carl Andre, the Romanian artist Constantin Brancusi, once had one of his works impounded for its likeness to a propeller. *Bird in Space* (1923), a 4¼ foot-tall piece of bronze with a tapering bulge along its length, had been accompanied to New York by Marcel Duchamp for a show at the Brummer Gallery in 1926. The work failed to live up to the aesthetic standards of New York's customs officials, who failed to see a likeness to a bird in the piece and imposed *ad valorem* a $240 tariff for manufactured objects of metal, which was approximately 40 per cent of the sale price.

13 In an interview, and when pressed about the fact that his 'readymades' ultimately became as fetishized in a market context as any other work, retinal or not, Duchamp

replied that it was 'an absolute contradiction, but that is what is enjoyable, isn't it?' See Duchamp (2002) 'Marcel Duchamp Talking about Readymades', interview by Phillipe Collin (21 June 1967), in *Marcel Duchamp*. Ostfildern: Hatje Cantz: 39.

14 Nam June Paik in interview with Irmeline Lebeer (1974) *Chroniques de l'art vivant* 55 (February): 35.

15 N. Bourriaud (2002) [1998] *Relational Aesthetics*. Dijon: Les Presses du Réel: 19.

16 Bourriaud, ibid. p. 45. For Bourriaud, the litany of artists who utilize relational art practices, and thus enhance the relational spheres within which they operate, is extensive and includes *inter alia* Philippe Parreno, Liam Gillick, Dominique Gonzalez-Foerster and Pierre Huyghe.

17 While collaborative practices may be a source of puzzlement to many (a fact that might be summed up in the observation that there is not that much to actually look at when it comes to collaborative art works), it is in itself not that radical in its concept or practice. The influential group Fluxus – which counted among its numbers *the* key post-war European artist Joseph Beuys – could be seen as precursors to such activities; as could some of the social events engineered by Andy Warhol and other pop artists in the 1960s. We could add to this the manifold events staged by artists associated with Situationism and Dadaism. I have examined Bourriaud's thesis elsewhere. See A. Downey (2007) 'The politics of (relational) aesthetics', *Third Text* 21(3): 267–75.

18 The subject of aesthetics and art criticism has been explored in S. Perling Hudson (2003) 'Beauty and the status of contemporary criticism', *October* 104: 115–30. More recently, *Art Monthly* undertook a lengthy discussion of aesthetics throughout 2004 and early 2005. See J.J. Charlesworth 'Art and beauty', *Art Monthly* (2004) 279. For a critique of Charlesworth, see M. Wilsher (2004) 'Judgement call', *Art Monthly* 280. For a critique of both Charlesworth and Wilsher, see an insightful overview by S. James (2005) 'The ethics of aesthetics', *Art Monthly* 284. Elsewhere, as noted by James, the subject of aesthetics has produced a number of more far-reaching debates, including D. Beech and J. Roberts (2002) *The Philistine Controversy*. London: Verso, and I. Armstrong (2000) *Radical Aesthetic*. Oxford: Blackwell. In the context of philosophical inquiry, the 2004 translation of Jacques Rancière's *The Politics of Aesthetics: The Distribution of the Sensible*. London: Continuum, has further developed inquiry into the apparent opposition to be had between the terms 'politics' and 'aesthetics'; while Alain Badiou (2005) *Handbook of Inaesthetics*. Stanford, CA: Stanford University Press, has promisingly sought to subject philosophy, through the discourse of aesthetics, to the 'truth-event' of art itself. (Briefly, the 'inaesthetic' is defined by Badiou as 'a relation of philosophy to art which, maintaining that art is itself a producer of truths, makes no claim to turn art into an object for philosophy': Badiou 2005: 10.)

4 Investing in art

Art as an asset class

Jeremy Eckstein

Introduction

This chapter is based on my role as an art investment advisor to the British Rail Pension Fund and ABN Amro. For the most part, 'art' refers principally to paintings, although in fact the principles set out in this chapter apply equally to all categories of high-end works of art (i.e., to pieces with a relatively high unit value) including not only pictures but also drawings, prints, sculpture, porcelain, silver, vertu, jewellery and other categories of works of art and collectibles.

Disclaimer

The art market is not a regulated market. None of the statements contained in this chapter are intended or should be construed as constituting investment advice. As is the case for all asset classes, past performance should not be taken as an indicator of future performance, and therefore investors may not get back all they invest. Consequently art should be considered as an asset class only by investors who fully understand and can afford the risks involved.

Background

For most of the twentieth century art was considered principally in terms of its aesthetic merits. True, there were a few individuals – and one noted institution – who saw the investment opportunities, but they were very much in the minority. The phrase 'aesthetic dividend' was used to describe the pleasure derived from owning art, but all too often it sounded like an uncomfortable apology for the fact that art, unlike 'real' investments, produced no income. It certainly didn't pretend to be a serious observation on the investment merits of art.

Those people who spoke about 'investing in art' tended to be dealers or auction houses, in other words those who had a vested interest in attracting new money into the art market. Their attempts to attract new buyers by

claiming that art was a good investment lacked credibility in the financial markets, because they were unsupported by any robust quantitative analytic evidence. Fluctuations in art prices further undermined their attempts, and as the conventional financial markets became ever more closely regulated, the auction houses were unable to recommend art as an investment, as they did not have the status of recognized registered investment advisors.

The phrase 'alternative investment' was still occasionally heard when discussing motives for acquiring art, but few people were treating it seriously, and fewer still were properly equipped to talk the language of the sophisticated investor interested in diversifying his investment portfolio to include art. A very few banks were offering what they liked to call 'art banking services' to their high net worth private clients, but on close inspection these turned out to be largely advisory services, with little or no attempt to integrate their clients' art dealings into the context of overall wealth asset management.

From the early 1980s onwards, as art prices escalated ever higher, an investment motive was frequently imputed as a justification or rational validation for what was in reality largely an aesthetic decision. Given the outstandingly high prices currently being achieved in many sectors of the art market, it is clearly difficult to ignore the value of art holdings when making decisions about asset allocation or wealth management, but this is not necessarily the same as treating one's artworks as investments.

But in spite of this ambivalence as regards art as an investment *per se*, since the late 1990s there has been an increasing readiness on the part of serious investors to consider the merits of fine and decorative art as an asset class. There are two quite different reasons for this change of attitude. It is partly a recognition of the intrinsic attractiveness of art as an asset class, and partly also a result of the failure of conventional assets to deliver consistently attractive returns over a period of time. Some observers believe that the recent volatility of the world's major stock markets and their short-term over-reaction to news, are signs of an impending correction. This nervousness has only served to emphasize the attractiveness of relatively unvolatile hard asset classes such as art, especially since much of the news about the art market reaching the press at the present time reinforces the perception of its underlying strength.

With paper-backed assets such as stocks and bonds – and the increasingly sophisticated financial derivatives which are based on them – there is always a small but real risk of the asset becoming almost completely worthless; one has only to think of shares in companies such as Enron, WorldCom and others which were once regarded as 'blue-chip' stocks likely to be found in the most conservative pension fund portfolios.

By comparison, given the hard asset-backing of art, the corresponding investment risk is effectively nil. In the language of investment analysis, the downside risk of art is exceptionally low. Art has a high, effectively certain residual value – 'a good Canaletto will always be a good Canaletto'. The only

real risk to the value of the asset is that the collective cultural consensus on which art valuations are based will be withdrawn, and providing the art is carefully chosen, the risk of this happening is remote. That said, there is a considerable difference between the downside potential of Old Masters, say, with a cultural value consensus established over a period of centuries, and the risk involved in buying the works of contemporary artists whose value has yet to be put to the test of time.

The demand for hard information about the performance of art as an asset class has led to the emergence of formal market indices, most notably the Mei Moses Fine Art indices, developed by two professors at New York University's Stern business school. They (and others such as Art Market Research, Artnet and Artprice) provide reliable, independent measures of underlying performance based on the hard empirical evidence provided by large numbers of open market transactions. Although the methodologies underlying their construction may differ, investors may safely use these indices as benchmarks against which to monitor the performance of their art holdings (always providing of course that the indices are based on the same types of artworks as the investor has acquired). In contrast to the stock market, where index performance is very much accepted as the norm, knowledgeable dealers and other expert advisors in the art market are consistently able to add value to the underlying performance indicated by art market data, so that an actively managed art investment fund can expect to achieve returns significantly in excess of those predicated by published indices. This is one of the consequences of the lack of transparency and inefficiency which characterize the art market pricing mechanism, and which can be made to work to the advantage of the canny investor with a good advisor.

Performance characteristics of art

Although the various art market indices testify to the superior returns achieved by art over extended periods of time, in fact the appeal of art as an asset class is based on far more than simply the long-term returns achievable. Other specific fiscal characteristics of art which enhance its investment appeal include: its international marketability; its relative non-correlated or even counter-cyclic properties vis-à-vis conventional stock market assets; and an exceptionally attractive risk/reward profile (see Table 4.1 and Figure 4.1). Together these make for a highly desirable investment class, in which a superior long-term return is just one of the attractions.

Critics in the past were always quick to criticize art for its supposed volatility, claiming that this made it unsuitable for consideration as a serious investment. This claim was shown to be largely unfounded in research carried out in 2003 by the Glenmede Trust Company, a leading US financial institution, which applied the formal techniques of the financial analyst to the Mei Moses art market data. Using the Sharpe Ratio approach to calculate risk/ return ratios, the study demonstrated that adding fine art to a diversified

Table 4.1 Mei Moses Fine Art Indices 2006 results

Annual returns	Mei Moses all art	S&P 500 total return	US Treasury Bills	
			10 Year	Short Term
Last fifty years	10.0	10.62	6.69	5.45
Last five years	11.63	6.08	5.50	2.08
Last year	18.27	15.79	2.68	3.13

Note: Comparable data is given up to 2006 only.

© *Mei Moses Beautiful Asset Advisors: www.artasanasset.com*

portfolio produced a slightly greater return for each unit of risk, and a significantly better return with less volatility than most asset classes on their own. The report concluded:

> Fine art has shown a durable record of price retention and a low correlation to more conventional asset classes. These attributes could make art an interesting addition to a well-diversified portfolio, helping to reduce overall volatility while potentially generating long-term appreciation.

Since Glenmede's groundbreaking analysis, other investment banks have followed suit. The most striking endorsement of art as an asset class in the UK was when Barclay's included art for the first time in its annual review of the performance of a variety of asset classes (Barclays Capital, *Equity-Gilt*

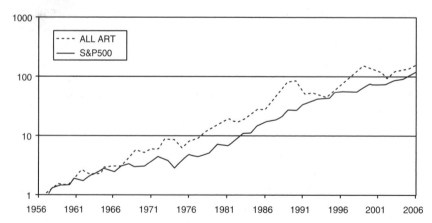

Figure 4.1 Mei Moses Annual All Art Index versus total return S&P500.

© *Mei Moses Beautiful Asset Advisors: www.artasanasset.com*

Study, February 2005). The review examined the performance of a range of asset classes over four classic different business cycle conditions (see Table 4.2). It acknowledged the potential of art as an integral element of a broader asset diversification policy, especially in the context of its volatility profile:

> In the long run, art reveals positive results during years of above trend inflation, which initially suggests that art is able to provide some hedge against inflation. The weakest performance for art is during periods of weak growth and low inflation – the exact point in the business cycle when equity returns are at their strongest. This suggests that combining art and equities within a portfolio may provide good diversification across the four economic scenarios. This diversification [argument] can also be seen when inflation is above trend and growth is below trend.

Using historical data for the UK, the review charted the twenty-year rolling correlation between inflation and the five-year annualized real total returns of each asset class to test how well they hedged inflation over time. Barclays Capital study observed:

> Even over a 5-year holding period equities failed to hedge against inflation for the bulk of the [twentieth-] century. It is only in recent years that equities have shown a positive correlation with inflation. Art, on the other hand, performed quite well between 1942 and 1962, and again from 1999 onwards.

The review also notes that 'art recorded a steady increase [from 1955], outperforming Gilts and cash'. On the basis of these features, the Barclays Capital study recommended an allocation of up to 10 per cent of a diversified portfolio in fine art (the original Glenmede report had recommended up to 12 per cent). The Barclays Capital study also made the following important point:

Table 4.2 Average post-war real total returns (%)

Annual returns	Above-trend inflation and growth	Above-trend growth and below-trend inflation	Below-trend inflation and growth	Above-trend inflation and below-trend growth
Equities	4.41	13.42	11.06	4.11
Bonds	−0.21	0.08	9.00	−0.79
Cash	−0.36	1.95	2.18	0.67
Art	9.23	7.54	−0.85	0.31

© *Barclays Capital 2005.*

Modern financial theory is placing a much greater emphasis on asset liability matching. As a result, defined benefit pension funds and some insurance companies have been eschewing equity investment in favour of bonds. The post-bubble regulatory environment has eliminated the ability of defined-benefit and insurance funds to ignore short-term equity volatility in favour of the long-run positive return. . . . We also think that European debt managers will increasingly look to issue more inflation-linked and long maturity debt in order to provide its savings industry with liability matching instruments.

The investment profile of the fine art asset class – and especially the historical tendency of art to provide a real return against inflation – makes it ideally suited to such investment objectives.

To summarize, the combination of (1) attractive yields projected for art compared to conventional asset classes, (2) an appreciation of the relatively low risk associated with such hard asset-backing, and (3) the development of sophisticated allocation strategies in a broader investment context, together ensure that art looks increasingly attractive as part of a diversified asset allocation strategy in a post-hedge fund era. The issue is no longer whether or not art is a viable, attractive asset class; that can now be taken as a given. The only substantive issue now is the most effective means of structuring efficient vehicles for investing in art.

British Rail Pension Fund

The first serious example of institutional investment in art was that undertaken by the British Rail Pension Fund, which began investing in works of art at the end of 1974. The original rationale for purchasing works of art must be viewed in the light of the financial and economic conditions prevailing at that time. The OPEC-led Oil Crisis in 1973 had had a catastrophic impact on the world's leading economies, leading many market observers – especially those in the UK – to seek a new paradigm in terms of investment strategy. First, stock markets had fallen dramatically – in the UK, the FT-Actuaries Index (the main indicator of stock market performance at the time) fell by over 70 per cent between the beginning of 1973 and the end of 1974 (when the Fund began to buy works of art) while in the USA the Dow Jones Index fell by more than 40 per cent over the same period. Second, rates of inflation were unprecedentedly high – the annual figure in the UK at the end of 1974 was only a little short of 30 per cent, while US inflation peaked at over 12 per cent per annum at around the same time. Third, sterling was depreciating strongly against other European currencies and the US dollar. Fourth, there was a sharp fall in the commercial property market, which had hitherto been a popular investment for pension funds.

Were such a situation to occur at the present time, an acceptable investment strategy might be to diversify into index-linked securities. However, no such

investments were available at that time. Against this background, the Fund's investment managers concluded that it would be advisable to seek to diversify a proportion of the Fund's investments into a class of assets where there were reasonable prospects of achieving long-term growth at least equal to inflation. Fine art was identified as an asset-backed investment whose financial characteristics were ideally suited to the Fund's requirements. The asset profile of fine art closely matched the Fund's liabilities, and it offered the further advantage of having an international marketability, thereby providing a hedge against the changing fortunes of the UK economy, as well as a protection against currency realignments. Additionally, artworks provided a convenient means of taking advantage of investment opportunities overseas without attracting the premium which was levied at the time on the purchase of foreign currency for investment purposes.

It was agreed that up to 6 per cent of the annual cash flow of the Fund should be allocated to works of art as part of a long-term diversification strategy, subject to the availability of suitable (i.e., investment-quality) items. During the acquisition period, which lasted from the end of 1974 to 1980, the Fund invested some £40 million in a variety of works of art; the intention was to concentrate principally on forming well-rounded collections, representative of each of the agreed collecting categories, as well as occasional outstanding individual pieces outside of these collections.

By the time the Fund ceased to buy art in 1980 it had acquired altogether some 2,400 works. Seven key collections together accounted for approximately 76 per cent by value of the whole portfolio: Old Master Paintings (18.8 per cent); Old Master Drawings (11.1 per cent); Impressionist Art (10.2 per cent); Chinese Works of Art (10.2 per cent); Books and Manuscripts (10.0 per cent); Antiquities (8.3 per cent); Medieval and Renaissance Works of Art (6.9 per cent). The remaining 24 per cent by value of the art portfolio was spread thinly across a wide range of other collecting categories, including Old Master Prints, Japanese works of art, nineteenth century decorative art, Continental pictures, English pictures, furniture, vertu, and silver.

The works of art acquired by the Fund were initially intended to be long-term investments. However, following a review of the portfolio in 1983 it was decided to sell a number of works which fell outside of the mainstream collecting areas and in 1987, prompted by unexpectedly strong trading conditions, it was decided in principle to dispose of the entire holdings of works of art. Plans were made for a carefully controlled programme of sales, to be implemented over a period of years.

The first sale, consisting of the Fund's collection of Old Master prints, took place in June 1987 and realized a total of approximately £2 million, compared to a book cost of £607,000. The time-weighted cash return (IRR) was equivalent to approximately 11 per cent p.a., which was some 2.5 per cent p.a. greater than the rate of inflation over the period. The satisfactory outcome of this first sale prompted a number of subsequent sales from the

Fund's other collections during the latter part of the 1980s and into 1990 (see Table 4.3 and Figures 4.2, 4.3, 4.4 and 4.5).

The selling programme was temporarily suspended towards the end of 1990 in the light of rapidly deteriorating market conditions. Selling resumed in 1994, with the return of strength in the art market, when it was decided to work actively to dispose of the remainder of the Fund's art holdings. The Fund's collection of Old Master pictures was dispersed in four separate sales: in December 1994 (cash IRR 12.8 per cent p.a.), July 1995 (cash IRR 6.9 per cent p.a.), July 1996 (cash IRR 5.4 per cent p.a.) and January 1997 (cash IRR 6.8 per cent p.a.). The other significant collections sold after 1994 were Persian and Indian Miniatures and Manuscripts in April 1996 (return 0.5 per cent p.a. in excess of inflation), European Works of Art in July 1996 (return 2.3 per cent p.a. in excess of inflation) and Ancient Glass in November 1997 (return 1.5 per cent p.a. in excess of inflation).

As at December 2000 it was estimated that the total income arising from the Fund's sales of its works of art amounted to £168 million. The overall cash IRR achieved on the sales was 11.3 per cent p.a., or approximately 4.0 per cent p.a. in real terms after allowing for inflation.

The Fund's collection of 2,400 items consisted of a relatively small number of high-value works and a much larger number of less valuable works. It was estimated in the early 1980s that no more than fifty of the works were individually worth £250,000 or more, but that together they accounted for well over one-third by value of the whole collection. A 'Top 100' group of works

Table 4.3 Subsequent sales from the Fund's collections

Category	Sold	Return
English Silver	Nov. 1987	Cash IRR 15.7 per cent p.a.
Japanese Prints	Jul. 1988	Return approx. three times total purchase cost
Oceanic Art	Jul. 1988	Return below the rate of inflation
Books and Manuscripts	Sep. 1988	Cash IRR 8.7 per cent p.a.
Continental Porcelain	Oct. 1988	Cash IRR 11.4 per cent p.a.
Continental Silver	Nov. 1988	Cash IRR 14.1 per cent p.a.
French Furniture	Nov. 1988	Cash IRR 11.6 per cent p.a.
Impressionist and Modern Art	Apr. 1999	Cash IRR 21.3 per cent p.a.
Chinese Porcelain	May 1989	Cash IRR 15.4 per cent p.a.
African Tribal Art	Jul. 1989	Cash IRR 4.1 per cent p.a.
Early Chinese Ceramics	Dec. 1989	Cash IRR 15.8 per cent p.a.
Gold Boxes and Vertu	May 1990	Cash IRR 12.9 per cent p.a.
Nineteenth century Continental Pictures	Jun. 1990	Cash IRR 14.6 per cent p.a.
Nineteenth century Victorian Pictures	Jun. 1990	Cash IRR 17.6 per cent p.a.

was subsequently identified, broadly corresponding to those works individually valued at £120,000 or more at the time. This group was estimated to account for approximately half of the value of the whole works of art portfolio.

Subsequent experience demonstrated that the returns achieved by these higher value core holdings tended to be generally superior to the returns achieved by the very much larger number of lower value works. In other words, the Fund's overall investment performance would have been markedly improved if the holding had been limited to a much smaller number of high-value, top-quality works of art. For example, just four of the Fund's twenty-five Impressionist and Modern Art collection sold in April 1989 accounted for over 60 per cent of the total realized sale proceeds and eleven accounted for over 90 per cent. The remaining fourteen works (56 per cent by number) accounted for less than 10 per cent of the sale proceeds. Again, just three of the Fund's seventy-five Chinese ceramics sold in December 1989 accounted for over 50 per cent of the total sale proceeds and twenty lots accounted for 90 per cent of the sale proceeds. The remaining fifty-five lots (73 per cent by number) accounted for only 10 per cent of the proceeds.

The fact that excessive diversification into low value works was ultimately detrimental to the Fund's overall performance, and that the same degree of protection against excessive volatility and changes in taste could effectively have been achieved with a substantially smaller portfolio of works of art, is a valuable pointer to the objectives which a fund launching today would want to follow.

Subsequent attitudes towards investing in art

The British Rail Pension Fund's art investment diversification programme had been mired in political controversy from the start, when it had been argued that the pension fund of a state nationalized body had an obligation to invest its funds in enterprises which created employment opportunities, especially during times of economic crisis. The subsequent performance of the art fund vindicated some of its critics, when it achieved its stated objective of producing a real return after inflation. However, no-one could have foreseen the strength of the recovery of the UK stock market during the period. The FTSE-Actuaries Index fell to a low of 61.92 during the fourth quarter of 1974 when the Fund started buying art, and exceeded 3,000 during 2000 when it made its final disposals and calculated the overall returns on the whole exercise. With this level of growth, it is hardly surprising that few if any of the works of art purchased by the Fund succeeded in out-performing the equivalent time-weighted stock market returns; in other words, with the benefit of hindsight, the Fund would have done better in performance terms if it had never made the decision to diversify into art, but had instead simply continued to invest in stock market securities.

Although beating the stock market had never been one of the Fund's objectives, nevertheless the superior performance of the stock market during the period of the programme inevitably cast a cloud over its achievements. Meanwhile, a range of sophisticated high-yielding investment vehicles made their appearance during the latter part of the twentieth century, that provided an ostensibly safer and more profitable home for institutional funds and for high net worth individual investors. As a result, there was little if any incentive to invest in art, and this remained the case until the late 1990s, when a combination of volatile stock markets and strengthening art prices led investors to reassess the comparative merits of the two, and revived interest in art as an asset class.

Recent art investment funds

The revival of interest in art as an effective investment in the late 1990s led to a number of serious attempts to float art investment funds open to sophisticated investors. The proposed structures of such funds varied from closed-end, limited partnerships to open-ended, continuously traded funds, with a variety of ingenious intermediate hybrid structures. Some were devised as essentially no more than straightforward 'buy and hold' operations, while others envisaged more dynamic trading platforms or made specific allocations to more actively traded portfolios. However, what they all had in common was the intention to raise funds from investors, and use the increased leverage opportunities offered by a large pool of money to achieve enhanced returns.

The target growth rates projected by the picture funds varied only slightly from fund to fund. Most based their forward-looking projections on the historical performance of the Mei Moses series, regardless of the fact that the specific investment objectives of a number of them made such a comparison totally invalid. After positing a degree of enhanced performance due to the skills of their chosen managers, most funds typically projected returns in the region of ± 15 per cent p.a.

The development of art investment funds took a further step forward in the summer of 2004, when the international investment bank ABN Amro announced that it intended investing in a range of art funds, thereby creating what amounted to a 'fund of funds'. In the event the bank subsequently decided not to pursue this particular initiative, but it is important to note that this decision was forced on the bank only because it transpired that there were too few already existing properly structured funds at the time to provide the degree of diversification the bank sought. The original endorsement of art as an attractive asset class was never in any doubt. So the way is still clear for the creation of new funds to reap the rewards of the intrinsically superior investment performance available from art.

Present opportunities for investing in art

It has already been noted that the investment characteristics of fine art make it particularly suited to the investment profile of pension funds, so it is no coincidence that one of the earliest documented cases of institutional investment in art was that undertaken by the British Rail Pension Fund (see above). At the end of 2004, in a move designed to open the field to individual investors, the Chancellor of the Exchequer announced that as from April 2006 the existing restrictions on pension fund investments were to be lifted and that individuals would thereafter be allowed to invest tax privileged money in art within the terms of their Self Invested Personal Pension Schemes (SIPPS). Although the concession was unexpectedly withdrawn in November 2005, shortly before it was due to come into effect, the reason for this change of mind was purely political; as in the case of the about-turn by ABN Amro earlier in the year, the decision had nothing whatever to do with the viability of art as an attractive hard asset-backed investment.

It is likely that pension investors will still be eligible for tax privileges if they invested in 'genuinely diverse commercial vehicles', possibly leaving the way open for formally structured Art Investment Trusts. And of course there is nothing to prevent high net worth individuals (HNWIs) investing in art as part of a planned asset diversification strategy outside of their pension provision. At the time of writing, there is at least one mainstream art investment fund, Philip Hoffman's The Fine Art Fund, open to serious investors in the UK and USA, and a number of smaller special situation funds based on the strength of the art markets in certain emerging market economies, such as India and China.

Timing is critical in the success of any investment decision, and this is also true in the case of art investments. Empirical research over a period of years indicates that the art market moves in broad cycles which tend to be uncorrelated with mainstream stock market activity. At the present time art market prices are strong, with every indication of further growth prospects. The big international art fairs and the periodic high-end sales by the major auction houses are a generally reliable barometer of underlying sentiment, and they are presently indicating a consensus that prices for investment quality fine art are strongly underpinned and continuing to move upwards, as long-term collectors are joined by an ever increasing number of new buyers.

So not only is art an attractive alternative asset class, but also the timing is propitious from an investment standpoint. The message is clear: art is a fundamentally attractive alternative asset class for sophisticated investors. Yet the fact remains that the vast majority of embryonic art investment funds that have tried to establish themselves in the past few years, have failed to raise sufficient investment funds for a successful launch, and have sunk without trace.

It is believed that no pension funds or other large institutional funds have followed the example of the British Rail Pension Fund and embarked on

a systematic investment diversification strategy involving art. Indeed, at the time of writing, there is just one well-established operational art fund pursuing an investment strategy based on a spread of conventional, mainstream sectors of the fine art market – and even that has so far reached a significantly lower total value of funds under management than was originally targeted. Apart from this one fund (which offers a number of specialized products) there are only a very few other noteworthy 'special situation' art funds believed to be operational at the present time. One, for example, operates effectively as a dealer-financing operation specializing in the acquisition, display, marketing and sale of works of contemporary art. There are also a small number of (mainly small) special situation funds based on emerging market opportunities – e.g. art funds specializing in Indian art, Chinese art, Latin American art etc.

Beyond these funds, which seek to attract investment money from sophisticated individual investors, there are a number of small informal funds, but these generally operate on a relatively modest scale as private pooled investment opportunities among select groups of investors, and are not open to subscription from the public.

Taken in aggregate, the activities of art investment funds, whatever their area of interest or precise nature, cannot be said to be impacting on the art market to any significant extent at the present time. So we have the interesting – and apparently anomalous – situation that while art is generally acknowledged to be an attractive (in some respects superior) asset class, few investors appear to have the appetite to take advantage of the opportunity.

This inevitably prompts the question: why are investors not prepared to put their money into art investment funds? The answer, sadly, is not hard to find. The art market remains an unregulated market as regards the provision of financial services, so investors are assuming a level of risk when putting their money into unregulated art funds. This risk, however small in practice, remains unquantifiable. Further, the lack of efficiency and transparency that is an acknowledged feature of the art market is a strong deterrent in the eyes of sophisticated investors, who are used to the full transparency of conventional investment classes. Also, transaction costs in the art market are higher by a significant multiple than corresponding expenses in any other asset class. Whether art works are acquired directly, or indirectly through investment in an art fund, it is hard to avoid these costs.

Another very important consideration is that the fund managers who largely represent putative art funds have, not surprisingly, tended to be individuals with an established expertise in art markets. However, they have no established credibility or track record of achieved performance as money managers in the high-end financial markets – again, a strong deterrent to potential investors for whom the experience of the fund manager is a major determining factor when deciding whether or not to invest in a fund.

Finally, the running of an art investment fund inevitably necessitates entering into an arrangement with art experts to advise on potential acquisitions

and sales. These experts are likely to be independent dealers, who might also be expected to have an interest in the works they are recommending to the fund. This situation leads to serious concerns over potential conflicts of interest. These conflicts potentially exist in other financial markets, but they have largely been overcome or eliminated in practice, in markets in which such activities are well regulated by the Financial Services Act or similar controls in other countries. The so-called Chinese Walls that protect investors in well-regulated financial service markets are absent as yet in the art market.

The system can be made to work – witness the one art investment fund currently operating in the UK. However, ironically, this offers little reassurance to potential investors because the fund's activities are kept strictly confidential. In particular, although occasional details are released concerning specific opportunistic sales, no general figures are made available regarding the fund's achieved performance overall. In any event, the fund has been operating for only a few years, and its optimum performance is posited over a longer, extended holding period. So there is little reassurance that can be given to potential investors on perhaps the most important feature of all (i.e., the returns which are being achieved in practice, as opposed to the theoretical returns which are being projected on the basis of historical performance benchmarks). Art investment funds are very much uncharted territory.

So potential investors remain wary of existing funds because of the perceived risks and lack of information, and they are unlikely to embrace the investment opportunities they offer until there is greater transparency and evidence of achieved track record. At present, there is little indication that art fund managers are going to open up their dealings for scrutiny. So perhaps art, the last great unregulated investment opportunity, will continue to remain largely unexploited for the foreseeable future.

The response to this state of affairs in the art world is mixed. There are those who would dearly love to see investors buying art, and who see investment interest as being one of the factors sustaining and underpinning strong prices. There are others who view art investment as potentially a destabilizing influence, and who would be happy to see art remaining very much a collectors' or connoisseurs' market.

Acknowledgements

Jianping Mei and Michael Moses, both of the Stern School of Business, New York University, and who created the Mei Moses fine art indices (see www.artasanasset.com) granted permission to reproduce the charts.

Figure 4.2 Canaletto: *Venetian View* (one of pair).

Bought June 1975, £220,000. Sold January 1997, $4.1 million. Cash return 11.9 per cent p.a. Real return 4.5 per cent p.a. after inflation.

Figure 4.3 Sancai glazed pottery figure of a Caparisoned Fereghan Horse, Tang dynasty.

Bought July 1978, £131,400. Sold December 1989, £3.4 million. Cash return 32.9 per cent p.a. Real return 23.3 per cent p.a. after inflation.

Figure 4.4 Imperial pink-ground bowl, Kangxi mark and period.

Bought May 1976, £29,700. Sold May 1989, HK$8 million (£615,400). Cash return 26.2 per cent p.a. Real return 16.2 per cent p.a. after inflation.

Figure 4.5 German gold and enamel snuff box, c. 1765.

Bought November 1975, FF187,000 (£20,800). Sold May 1990, SFr700,000 (£297,900). Cash return 20.1 per cent p.a. Real return 10.3 per cent p.a. after inflation.

5 'Chindia' as art market opportunity

Iain Robertson, Victoria L. Tseng, and Sonal Singh

Introduction

'Chindia' is a neologism which has gained currency in the business press in the 2000s, based on factors like growth rates, gross national product, sheer size of the working population and world's share of energy consumption, to represent the aggregate of China and India as an economic entity or market in relationship to individual Western economies.[1] As globalization in the twenty-first century is likely to become less western-centric, China and India will emerge as major global players.[2] Some predict, based on current trends, that by 2050 China and India will account for roughly half of global output. Rising material wealth, particularly among the middle classes in China and India, offer enticing consumer markets.

Along with being a dynamic economic entity, there is a case that Chindia is emerging as a vibrant cultural region for the production, distribution, and consumption of fine art. Since the mid-1990s art market centres have been established in China (Beijing and Shanghai) and India (Mumbai, formerly Bombay until the name change in 1995, and New Delhi). International off-shore centres in Hong Kong (which was returned by the UK to China in 1997 and operates under a formula of 'one country, two systems'), Singapore and Dubai are selling modern and contemporary Chinese and Indian art at record prices. Secondary locations like Taiwan and South Korea are also key secondary markets for the trade in modern and contemporary Chinese art.[3] Finally, auctioneers and dealers in New York and London have realized the market potential of both Chinese and Indian art.

The chapter's three authors write from the perspective of direct observation and engagement. Iain Robertson contributes to *The Art Newspaper* on the East Asian art market and has delivered public programmes on the art market for Sotheby's Institute of Art in the Far East, Victoria L. Tseng works for Sotheby's New York, and Sonal Singh was formerly a director at Bodhi Art, which specializes in contemporary Indian art, with galleries in Mumbai, New Delhi, New York and Singapore. She now works for Christie's New York. There is a focus on the art market trends and the activities of some key stakeholders such as contemporary artists,

private and institutional collectors and intermediaries (dealers and auction houses).

Note on currency: $ refers to US dollar, RMB to Chinese renminbi, and HK$ to Hong Kong dollar.

Note on transliteration: While Hanyu Pinyin is now the most universally accepted form of romanization, the transliteration of Taiwanese names (or Chinese names on Taiwan) have no methodical basis and appear as cited in authoritative documents.

CHINA

Iain Robertson

Background

Auctions were illegal in China from 1956 to 1986. By the 1990s the first serious auctions of modern and contemporary Chinese art took place in Beijing and were conducted, primarily, by Guardian. The watershed auction sale took place in 1997 when Guardian auctioned Chen Yifei's *Four Graces* for RMB2.3 million ($278,985), with unconfirmed rumours that the work was purchased by the consignor, Marlborough Fine Art. A small auction house called Songari attempted in October 1997 to sell exclusively cutting-edge contemporary Chinese art. Songari had familial connections to the late Mao Zedong, but this did not help the sale: out of 149 lots, only 63 per cent sold. In 1998 a precocious attempt by Christie's to bring the market for contemporary Chinese art to the West failed in London, with only 25 per cent of the lots finding buyers.

Christie's was not the only auctioneer to fail to sell contemporary Chinese art at the time. The market in those days favoured Chinese moderns and the so-called Romantic Realists led by Chen Yifei and Wang Yi-dong, who painted supine, quasi-traditional women, misty landscapes and the minority peoples of Greater China.[4] Other artists who fared well if and when they appeared at auction were the traditional brush painters and the modernist exponents of the brush like Chang Dai-ch'ien and Wu Guanzhong. First generation Western-style oil painters and modernists such as Chang Yu (San Yu) and Xu Beihong, who spent most of their life outside a politically unstable China in the early and middle years of the twentieth century, fetched very high prices when they appeared in mainland auctions, but more often than not they were sold through Sotheby's and Christie's in Taipei (where their works remain today). Second generation modernists such as Zao Wou-ki were also rarely for sale anywhere in China, with the main points of sale being Hong Kong, Macau or Taipei. His 1959 painting *14.12.59* sold at Christie's, Hong Kong, in May 2007, for HK$26 million ($3.32 million), well over the estimate of HK$5–8 million.

Most business in the market for contemporary and modern Chinese art was conducted offshore before 2000, with elite Hong Kong dealers, led by Hanart TZ, Shoeni and Alisan, dominating the primary market and influential Taipei dealers such as Lin and Keng controlling the bulk of the secondary market. There were, however, nascent markets in Beijing and Shanghai and more modest centres located in Hangzhou (brush painting) and Guangzhou. Much of the 'new' art could be found in artist's studios located in the premier Art Academies in Beijing, Chongqing, Hangzhou and Shanghai.

China's dealers in contemporary art could be counted on the fingers of two hands in the 1990s. The two market leaders, who remain powerful, are foreign-owned ventures: Red Gate in Beijing and ShanghArt in Shanghai. Today's success stories, to put Chinese contemporary art on the international cultural map, are all products of the carefully conceived campaign of these two commercial galleries, the aforementioned Hong Kong dealers and a handful of enterprises in New York, Paris and London.

China's first art fairs were chaotic affairs, attended by the very small collection of locally based dealers and populated largely by single artist stands. The China Art Exposition in Beijing in 1993, the Shanghai Art Fair and the Guangzhou International Art Fair in 1997 were unable to attract foreign interest. The next year, however, the Shanghai Fair dramatically changed the notion of what an art fair meant in China. With the support of Jiang Zemin the fair attracted around 100 Chinese organizations and, crucially, thirteen dealers from Europe, Asia and the USA.

The critical and curatorial framework surrounding the contemporary art sector in China struggled for a definition throughout the 1990s, unsure of the distinction between *yanju yuan* (researcher) and *cehua ren* (exhibition organizer). Key commentators from within China such as Hou Hanru and Li Xianting became the leading Chinese curator and writer respectively for the new art, but the most telling contributions undoubtedly came from abroad. David Elliott at the Museum of Modern Art in Oxford put Chinese contemporary art on the international stage with his exhibition, 'Silent Energy: The New Art from China', in 1993. Johnson Chang, owner of Hanart TZ, has done more than anyone else to make the reputations enjoyed by today's leading Chinese oil painters. Chang achieved this through various means: publications like *Made by Chinese* (2001) and *Paris-Pékin* (2002); oligopolistic partnerships with Jean Marc Decrop and Paris-based Galerie Enrico Navarra; and public exhibitions at the Fruitmarket (Edinburgh, 1996), the Cornerhouse (Manchester, 1997) and the Guggenheim (New York, 1997). Chang's main patron was entrepreneur and *bon vivant* David Tang (founder of retailer Shanghai Tang). Tang acquired seminal examples of early Political Pop art, many of which hang today in his China Club in Hong Kong.

The early patrons of contemporary Chinese art were few in number. Alongside Tang, two European collectors are notable. The Swiss ambassador to China, Uli Sigg, was a most prolific collector, buying often from the artist's

studio.[5] The late Peter Ludwig, an omnivorous and eclectic German art collector, was another early convert.

The whole Chinese art market edifice was predicated on metropolitan enclaves achieving ever higher living standards, muted censorship laws, a museum building boom and freer economic and cultural exchanges between China, the satellite territory of Hong Kong and Taiwan and the West. Most of these hopes have been realized and today's art market in China is, as a result, booming.

Post-2000

Around the critical core of dealers has developed a mass of foreign entrants – international dealers from the West – as well as locally owned businesses. They have established themselves primarily in Beijing and Shanghai. In Beijing they have come together in a former factory complex, designed by Bauhaus-trained East German architects during the Cold War, located in Dashanzi (or Art District 798) and Caochangdi and the village of Songzhuang on the outskirts of the city. Shanghai has its own gallery area in Moganshan Street and both cities boast brand new museums of modern art. Shanghai's version is run by Victoria Lu, a Taiwanese art critic. Beijing's is being privately funded and run out of Hong Kong by Jeffrey du Vallier d'Aragon Aronita of French Polynesian descent, with the start-up costs for the venture met by the sale of his art collection. These new, international institutions have added considerably to the cultural support mechanism in China, although their positions are tenuous. The establishment of MOCA Beijing, for example, is on hold for political reasons. Existing institutions, such as the He Xiangning Art Gallery, the National Art Gallery of China, the Liu Hai-su Museum and the Duolin museum and even very new ventures such as the Songzhuang museum are beginning to support the nation's cutting- edge artists.

China's auction houses have also proliferated since the mid-1990s.[5] There are at least ten significant auctioneers operating on a national level in China today. In Beijing the main outlets are Hanhai, Guardian, Zhong Mao Sheng Jia, Rongbao and Huachen. In Shanghai, the long-established Duoyunxuan and Chongyuan dominate the scene. In Tianjin, Wenwu has a significant turnover. It is at this, the tertiary level, that the influence of Taiwanese dealers and auction houses is felt on the China market. Taiwanese dealers and auctioneers began the lucrative process of selling to the Chinese the modern Chinese works they acquired on the international market a decade earlier. Christie's attempt to ratchet the market up another notch by holding an auction in Shanghai in partnership with auctioneer Forever was premature. The partnership was declared illegal by the Chinese government after the auction. A joint venture between one of the international houses and a Chinese partner is unlikely to be repeated in the near future.

Unlike India, there is a dearth of indigenous collectors for contemporary

Chinese art. Most of the major players are Westerners. Some, like Englishman Charles Saatchi, appeared late on the scene. Others, like Belgium-born, Baron Guy Ullens – sponsor of China's first ever Pavilion at the 2005 Venice Biennale, auctioned fourteen Turner watercolours, at Sotheby's London in July 2007, to realize his dream of the Ullens Center for the Arts (opened in the winter of 2007) located in Art District 798[7] – have been involved in the market from the start. Still others, like Americans Eloise and Cris Haudenschild pride themselves on collecting in niche areas such as photography and video art. Another recent convert to the Chinese art is the colourful department store entrepreneur, Kim Chang-Il from Cheonan (South Korea) whose Arario Gallery is a recent addition to the foreign contingent in Art District 798. The only major Chinese collector for the new art is the Qing Dao chemical magnate, Guan Yi, who houses his collection in a warehouse on the outskirts of Beijing. The lack of interest from the Chinese in contemporary Chinese art is confirmed by Sotheby's sales of this commodity in New York, in which only 13 per cent and 16 per cent of the buyers in 2006 and 2007, respectively, were registered as mainlanders.

Market performance

When I interviewed Brian Wallace, owner of the Redgate, in 1998, he was selling contemporary Chinese prints for $400–500, paintings for $5,000–10,000 and sculptures, of which he had yet to sell an example, for $1,500–4,000 each. Meanwhile, Uli Sigg had just paid Lorenz Helbling RMB7,500 ($975) and RMB10,000 ($1,300) for two landscapes by the cutting-edge artist Nanxi. That same year Christie's, London managed to get £5,750 ($9,602) for a Zhang Xiaogang *Bloodline Series Nos 54 & 55* and £12,650 ($21,125) for Yue Minjun's *Immortal Cranes*. Guardian had found a buyer for another work by the artist as early as 1992, selling *Genesis* for RMB25,300 ($3,048).[8] Songari sold a Fan Lijun for RMB420,000 ($50,724) in October 1997, but most significant works by today's big hitters: Yue Minjun, Zhang Xiaogang, Fang Lijun and Zeng Fanzhi, could be acquired for less than $30,000 a piece. When I returned in 2000 to Redgate, which had moved from the foyer of the China World Hotel to, appropriately, an old city gatehouse, the works of He Sen, oil paintings of eyeless young girls smoking cigarettes, were on show. They could be bought for as little as $1,000 a piece.

Almost overnight, in 2005, the market changed from emerging to mainstream, with specialist departments devoted to the new phenomenon, contemporary East Asian painting, being established by the international auction houses. Sales in Hong Kong, New York and even London have been astonishingly successful. In 2007 Zhang Xiaogang's *Bloodline: Three Comrades* sold for $2.1 million and Yue Minjun's *Goldfish* made $1.38 million at Sotheby's New York, both exceeding their high estimates. The sale of over 300 lots fetched over $25 million. The relative success of the New York auction – there were a significant number of works bought-in – was surpassed in Hong Kong

where Sotheby's auctioned Zhang's *Tiananmen No. 1* (a work that preceded the bloodline series), in a mixed modern and contemporary Chinese sale, for HK$15.4million ($1.97 million); Sotheby's reported HK$214.5million ($27.4 million) in total, with 91 per cent sold by lot (95.95 per cent by value). Less than a decade from the unsuccessful sale of contemporary Chinese art at Christie's London in 1998, a new auction price was recorded for Yue Minjun at Sotheby's London in June 2007: *The Pope* (1997) – an irreverent 'pope' image modelled after Francis Bacon's homage to Velasquez's Pope Innocent X – sold for £2.25 million ($4.26 million), well above the estimated £700,000–900,000. The work was one of seven Chinese works in an 'international' contemporary art sale that suggests quite clearly that the market is preparing the top contemporary Chinese artists for international stardom. The strategy seems to be working at present with a set of 14 abstract paintings by New York based Chinese artist Cai-Guo-Qiang, selling for HK $74.2 million to an Asian collector at Christie's on 25[th] November 2007 against an estimate of HK $28 million–36 million. The auction house took HK $107 million from this sale of contemporary art.

Immediate future

There is a consensus that the prices for the new Chinese oil painters will continue to rise, buoyed on foreign direct investment and, soon, indigenous buying from nouveaux riches mainlanders. There is no sense that the international art market might be about to come to the end of its natural bull cycle and that new markets are often the first casualties. There is little acknowledgement that the arts infrastructure in China is very new and rather makeshift and that the government is tolerant rather than supportive of artistic expression within the country. There is a lack of understanding of the relationship between speculation in China's nascent stock markets and buying and selling on its art markets. There is little thought given to Beijing's recent restrictions placed on the export of cultural property out of China and its eventual implications for the whole market. Few commentators appear to acknowledge the high costs of importing art into China and the complex tax regime which operates around the trade or appreciate the significance of currency controls and an artificially regulated currency and the negative effects that all of these have on the market. Finally, China is still a one party state, and art markets do not survive under authoritarian regimes.

TAIWAN

Victoria L. Tseng

Taiwan's art scene 1990–2006

Taiwan's art market performance is closely tied to both historical and socio-economic events and conditions. The market for classical works of art is still

very strong, but so is the secondary tier for Chinese and Taiwanese moderns. The market which has suffered most in the wake of China's artistic emergence is contemporary Taiwanese art.

The Taipei Fine Art Museum (TFAM) has provided the locus for the island's contemporary art movements since it opened in 1983. The most influential showcase for the cutting-edge has been the Studio of Contemporary Art (SOCA), which opened in 1986, and metamorphosed into I-Tone 'IT' Park. With the end of martial law in 1987, contemporary Taiwanese art came into its own and liberalized. In the 1990s exhibition spaces multiplied, providing fertile ground for young artists.

Shortly after the 1997 'Asia Economic Flu', the contemporary art market collapsed; however, blue-chip modern works continued to circulate. Galleries which had specialized in Taiwanese contemporary art (with the exception of IT Park) folded or began rotating art from China, Korea and Japan, to capture a broader audience. In Taipei, the Eslite Gallery, part of the Chern Ping bookstore chain, and Chi-Wen Gallery, the successor to Hanart TZ, are the main venues alongside IT Park. Elaine Chao, director of Eslite, travels to China monthly to keep abreast of developments in that country and brands the company in the art and book market. Eslite believes that 'loss leader' monthly exhibitions in China are more strategic than sellout shows in Taiwan. Joanne Chi-wen Huang is director of the only truly independent contemporary Taiwanese art gallery. The Chi-Wen Gallery focuses on photography and digital media. With international calibre artists like Yuan Goang-ming, Chen Chieh-jen and Hung Tung-lu anchoring her stock, Huang piggybacks emerging talent to the market. In the southern city of Tainan, SOKA gallery, which used to represent solely young Taiwanese artists, now also includes Chinese and Korean artists. However, the gap left in the Taiwan market with the demise of Hanart TZ (Taipei) has not been filled – and the market sorely needs another international dealer of equal stature.

In the tertiary market, Sotheby's and Christie's dominate total market share, even after their departure from the island at the beginning of the millennium, with local houses Ching Shiung Lou and Ravenel accounting for only a fraction of the trade. The Taiwan art market experienced steady annual growth starting in the early 1990s, to HK$200 million ($28.6 million) in 1997, before crashing in 1998. With the advent of the economic downturn and the return of Hong Kong to China in 1997, estimated prices were scaled up in anticipation of a sharp rise in the auction market as people shifted assets into art as a hedge against other potentially declining or immovable investments. But the transition was benign and the art market languished, prompting the international houses to shift their focus to Hong Kong.

The most recent Taiwanese success story is Hung Tung-lu, who is promoted through Hong Kong dealer Chang Tsong-zung. Lin and Keng in Taipei deal in top flight established artists, and in April 2006 hosted a not-for-sale collectors' exhibition, 'Chinese Modern Masterworks'. Holding back inventory rather than selling at the current high prices creates a supply shortage, and

director Tina Keng does a brisk business servicing collectors like Victor Ma, while watching her inventory value grow. Director Jeff Hsu carries classical, modern and contemporary works and has recently opened a second gallery space in China to sell contemporary Chinese art. In the late 1990s Hsu started the Ching Won Society to give lectures, handle works of art, assure a foothold in the industry and build connoisseurship in classical art among collectors who became his repeat clients. By 2006, he was the president of the Art Dealers' Association in Taipei, wrote the exhibition catalogue for modern master painter Pan Yuliang's retrospective at the National Museum of History in Taipei, launched a luxury tea brand with Pan's art work gracing the packaging and initiated a reproduction print project of Pan's most famous works which will sell for a 100 per cent profit margin. With a steady stream of profits, Hsu's central strategy in China is to help the sophisticated Taiwanese collector to sell lesser items from their collections at Chinese auctions. Hsu has also invested in a new auction house conducting sales offshore in Macau (a geographically accessible venue for buyers and sellers from Taiwan, China and Hong Kong).

The collectors

A handful of tastemakers play a crucial role in building a successful market for modern Asian works of art. Cheng Nai-ming, editor-in-chief of the leading Chinese language art periodical, CANS (Chinese Art News) magazine, often acquires works from artists featured in his magazine (which is a form of cross-validation). Victor Ma, another well-known industrialist and collector of modern abstract painter Zao Wou-ki's works, has amassed the best known collection of the artist's works. In some instances, savvy artists reap financial rewards by investing in themselves, such as international sculptor, Ju Ming, who has built a museum to display his work. Huang Yen collects both modern masters and contemporary art produced by Taiwanese artists. One of his favourite contemporary artists, Huang Min-jhe, described as the 'Klimt' of Taiwan, was accepted into the Ninth Fine Arts Exhibition of the Republic of China, sponsored by the National Taiwan Arts Center in 1980. Hsu Hong-yen used his earnings as a doctor to collect the best works of personal friends to capture the 'Taiwanese artistic identity'. His collection, now in Irvine, California, is frequently loaned to public institutions in Taiwan.

Market performance

The market made a phenomenal comeback in 2004, nearly doubling the 1997 high at over HK$400 million ($57 million) and rising each year thereafter. Since this time the premium over the high estimate has grown for average lots, but the top end has only increased at a diminishing rate.

Internationally, the market for modern Taiwanese art is very strong. For example, Cheng Chen-po's masterpiece, *Sunset at Tamsui*, sold through

Sotheby's Hong Kong in 2006 for HK$34 million ($4.53 million). But the market for the contemporary stars of the 1990s has softened considerably, with Chiu Yatsai and Cheng Tsai-tung rarely topping $30,000 at auction in New York and Hong Kong.

Immediate future

The future for Taiwanese art clearly needs to be separated from the future of the Taiwanese art market. Modern Taiwanese art will continue to gain in value at the top end, simply because of the great wealth of important collectors, however, cutting-edge contemporary Taiwanese art is in crisis, undermined by the contemporary Chinese art phenomenon and future competition from South Korea and South East Asia. The Taiwanese government is trying to help: it has established several museums in restored historic buildings, such as the Museum of Contemporary Art (MOCA), and reiterated a requirement for all new commercial construction to devote one per cent of the budget towards public art. It is uncertain whether such state support is sufficient to counter international trends, an unreformed art tax system and poor art education in schools.

CONTEMPORARY INDIAN ART

Sonal Singh

Background

From as early as the mid-1960s, work by a few select Indian artists had begun appearing intermittently at international auctions. The first sale of modern and contemporary Indian art was held in 1988 in New Delhi: works from the collection of India's largest media group, The Times of India, were auctioned by Sotheby's. Four years later, in 1992, Sotheby's organized a sale in New Delhi. Disappointed by the lack of turnout and high rate of lots being bought in, it was only in 1995 that annual auctions featuring contemporary Indian art were started by Christie's and Sotheby's, with sales held in London.

The sale of Chester and Davida Herwitz's collection held by Sotheby's New York on 5 December 2000 is often regarded as the first auction to put Indian art in the spotlight. This was the third sale of the Herwitz collection – the other two sales were held in 1995 and 1997 – and included 193 lots of Indian art bringing in a total of $1,383,000 with an average of $7,166 per lot (Sotheby's auction sale NY7563). The year 2000 was also important for the history of this market for another reason as it marked the launch of India's two main indigenous auction houses, Saffronart, an online operation, and Osian's, both based in Mumbai. Prior to this, most sales of contemporary

art in India were through private transactions with galleries or in some cases with the artists directly. This meant that galleries located in the centres for contemporary Indian art in India had a well-established structure.

The two cities leading the market are New Delhi and Mumbai. Galleries such as Vadehra, Dhoomimal and Kumar Art Gallery in New Delhi and Chemould and Sakshi in Mumbai have been in operation from the early 1930s, cultivating a small yet loyal following of buyers. However, artists did not have to deal through any one gallery in particular. Rather, an artist was free to sell to any gallery (or buyer) they chose. The idea of a gallery exclusively representing an artist did not exist.

Buyers for art at auction were mainly NRIs (non-resident Indians) living in the UK and USA; resident Indians were not seen buying at international sales in London and New York. Indian art was often also included at the 'Southeast Asian Pictures and 20th Century Indian Pictures' sales held by Christie's in a few other cities that have a strong NRI base, such as Singapore and Hong Kong.

Post-2000

Since 2000, there has been a noticeable shift within the Indian art market, not only in terms of sales but also in terms of visibility, as Indian artists have begun to be included in seminal international exhibitions at museums, art fairs and biennales. This has sparked interest from a broader global audience, with many of the high priced pieces going to foreign buyers. Yet, international buyers still account for approximately only 15 per cent of all sales. The main shift that has occurred within the market has been between the NRIs and resident Indians as a large proportion of buyers are now resident Indians and the number of collectors within India has continued to increase substantially every year.

As the market has grown, galleries have become more aware of their territorial rights where artists are concerned; most contemporary artists are now represented by a single gallery or dealer in a city. However, it is still rare for an artist to be exclusively represented by a gallery and the more popular the artist is, the more galleries he or she is likely to have. For example, Subodh Gupta, an artist described as the Damien Hirst of Delhi, is represented by several galleries: Peter Nagy of Nature Morte in New Delhi, Bodhi Art in Mumbai and Singapore, Jack Shainman in New York, in SITU in Paris and Pierre Huber's Art & Public in Geneva.

As artists are often represented by a number of galleries, competition between these galleries (dealers) to gain an exclusive relationship is very high. Thus, galleries have opened spaces in more then one city in an attempt to provide their artists with maximum visibility. Yet, most galleries are historically linked to a particular city such as Chemould, Sakshi and Pundole in Mumbai, Gallerie 88 and CIMA in Kolkata, Sumukha and Ske in Bangalore and Vadehra and Nature Morte in New Delhi. Bodhi Art, a recent gallery

entrant, has spaces in Mumbai, New Delhi, New York and Singapore, in order to establish a market position as one the most significant advocates of contemporary Indian art.

International auctions of modern and contemporary Indian art were, until recently, dominated by an older group of artists and included those who had played an active part in the Indian art scene before 1965.[9] In the past few years, however, auctions have begun to cover a larger range of artists and have started to include the work of a younger and more widely dispersed group. There are a number of reasons for this: the most obvious is the change in the demographic profile of buyers, with a younger, more adventurous group of collectors who are willing to diversify their art portfolios.

Public art and state patronage of art is not a common phenomenon in India; this may be due to the fact that the government tends to lean towards encouraging handicrafts. There is essentially one museum for modern and contemporary art, the National Gallery of Modern Art (NGMA) with branches in Mumbai and New Delhi (and plans for a third one in Bangalore), however, the NGMA is tightly controlled by the government and tends to favour retrospective exhibitions devoted to 'senior' artists.

While the art scene in India has a growing base of young artists, those that have managed to capture the interests of international art museums, art critics and private collectors are a handful. This group includes Atul Dodiya, Anju Dodiya, Subodh Gupta, Jitish Kallat, N.S. Harsha, Anita Dube, Nataraj Sharma, Bharti Kher, Hema Upadhyay and A. Balasubramniam.

Market performance

As in the case of all markets, it is difficult to estimate the net worth of the Indian art market because a large percentage of sales made are through galleries and private treaties. Numbers between $175 million and $440 million have appeared in the media; however, these figures are not supported by any evidence. In order to get a better understanding of the growth in the market for Indian contemporary art, one would have to turn to the auction results of this sector in the past few years.

In the first half of 2006, over ten auctions featuring modern and contemporary Indian art were held by Sotheby's, Christie's, Bonham's, Saffronart and Osian's; over $45 million was auctioned by Sotheby's, Christie's and Saffronart. Indian art has usually been included in two annual sales by both Sotheby's and Christie's; since 2005 Indian art has featured more often at the two auction houses.

The March 2006 sales held in New York by Sotheby's and Christie's brought in $12.17 million and $15.63 million, respectively, with over a dozen lots between the two going for over $500,000. Similarly, Saffronart's auction in May 2006 brought in $12.87 million, with 91 per cent of lots selling above their high estimate. This has not always been the case, though: Saffronart's May 2005 sale fetched $3.7 million, averaging just over $25,000 per lot as

compared to $86,000 per lot in 2006. This is also true for Sotheby's and Christie's: in 2004 their total value of sales for modern and contemporary Indian art were $1.92 million and $2.28 million, respectively.

Such significant price increases have not gone unnoticed and have received a tremendous amount of attention from the press, buyers and inevitably investors. A number of art funds have emerged to invest in contemporary art: these funds are associated with art galleries (Sakshi in Mumbai with venture capitalist Pravin Gandhi for Yatra), auction houses (both Saffronart and Osian's) and even national banks (including Kotak and ICICI).[10]

Immediate future

While there has been a swift expansion of the market over a relatively short period of time there has also been an increasing degree of speculation which makes one question the sustainability of the market. However, it is unlikely that prices for Indian art will fall as the buyers' base has continued to grow simultaneously. One of the main reasons for this is that the rapidly expanding middle class in India, which is looking to attain social and cultural status, will continue to demand art, especially that of younger artists whose work they can relate to. Another factor to keep in mind is that the international buyer's base has increased and in comparison to contemporary artists from the West and even China, the work by Indian artists is relatively undervalued. An example of this was the Christie's 'Asian Contemporary' sale held in May 2006. While the work of Indian artists averaged $51,000 per lot, the average lot price for Chinese art was $110,000.

Essentially regarded as immature, the Indian art market is also very opaque. Saffronart has become one of the leading auction houses for contemporary Indian art in part, due to the visibility of some of its transactions in the market. While the media hold the key to creating awareness among the public on the status of the art market, they have unfortunately played a negative role by focusing only on those lots that have achieved record prices. Further, the media has also glorified the possibilities of art investment, and in many ways has validated speculation within the market.

As the market grows and matures, one expects the bias it has had until now for paintings to lessen and it is likely that the discerning buyer will become more receptive of other media such as photography, prints and sculpture. Photography and sculpture have begun to create a presence: photographers like N. Pushpamala (born 1956) and Dayanita Singh (born 1961) and sculptors such as Sudarshan Shetty (born 1961), Valson Kolleri (born 1953) and N.N. Rimzon (born 1957) are exhibited frequently. Interestingly, international museums and galleries have always shown a greater interest in the genre of sculpture, installation and photographs and the majority of exhibitions for Indian art abroad have showcased work from these media.

The area where the market may be slow is with educating and developing

more buyers for the art. There is very little documentation of the work created by artists and scant government support in terms of museums, public art, biennales and so on. Commercial galleries have already begun to narrow this gap and will continue to play an important role in the creation of awareness and understanding of the sector, acting like quasi-institutions by publishing books, holding educational discussions and lectures and often supporting public art projects.

Concluding remarks

If China and India, as is often asserted, are to own the twenty-first century, we have seen a glimpse of the future. The consequences of globalization in the market for Chinese and Indian art include the pluralization of consumption and the convergence of taste. As New York and London are often teamed together in art market discussions, Beijing and Mumbai may be part of an extended list. Auction prices for a handful of Chinese and Indian artists are breaking the $1 million threshold; however, a marked divide remains between the prices paid for international contemporary artists like Damien Hirst, Jeff Koons and Lucien Freud and their equivalents from China and India. There is a case that the Chindia art market, namely the representation of artists, will have an impact on the history of art. More non-Western artists, namely contemporary Chinese and modern Indian, will feature. This will re-shape the notion of 'international'. The share of the market in trading art will grow to reflect the growth of primary and secondary dealers in China and India. India and China have seen the emergence of indigenous auction houses, while there remain barriers for international houses to take root in mainland China.

There have been differences in how the Chinese and India art markets have developed. In terms of art production, Socialist Realism in China ended in the late 1970s, with the growth of cutting-edge contemporary Chinese art establishing itself in the 1980s and 1990s, often parodying Western art and art history from a Chinese perspective; on the other hand, 'living' modern Indian artists, who were most productive in the 1950s and 1960s, have been key to the rise of the art market in the early 1990s. The radical nature of contemporary Chinese art, which attracts attention from the curators of international art shows like the Venice Biennale and Documenta, can be contrasted with the conservative nature of Indian art, though Subodha Gupta signals a radical aesthetic break from this tradition. The Indian art market suffers from weak state support; for example, the 2007 Venice Biennale was without an Indian pavilion, yet India has been a significant presence at recent meetings of the World Economic Forum (at Davos). In terms of collectors, contemporary Chinese art has attracted Westerners (led by Uli Sigg and Guy Ullens and continued by Charles Saatchi) and the Korean Kim Chang-Il, yet indigenous Chinese collectors remain thin on the ground; on the other hand, collectors of modern Indian art have been Indians by descent (either NRIs or those who

are resident in India). To generate greater buyer confidence and to help maintain prices, it is important to widen the collector bases for both Chinese and Indian art.

Notes

1 BRIC (Brazil, Russia, India and China) has also featured, which starts to render less relevant the categories of East and West, North and South.
2 See the unclassified report prepared by the US National Intelligence Council (2004) *Mapping the Future: Report of the National Intelligence Council's 2020 Project*. Pittsburgh, PA: GPO. One can already cite some corporate examples from China and India like the Bank of China, which neighbours Johnson & Johnson, JP Morgan Chase, GlaxoKlineSmith and Nestle on the *Financial Times* 'Global 500' (2007), Lenovo, which took over IBM's personal computer business, Mittal Steel and Tata Consulting Services.
3 The People's Republic of China (China) and the Republic of China on Taiwan have a complex geopolitical relationship. The Nationalist government on the island was recognized as the legitimate government of China – the Republic of China on Taiwan – until 1971, when the United Nations General Assembly voted to expel Taipei and seat Peking (now Beijing). Taiwan became a constitutional democracy in 1991 shortly after the election of the eighth president of the Republic of China, Lee Teng-hui. A two China situation has existed since that time and Taiwan is, officially, a de facto state recognized by no more than a handful of countries. The territory – technically it is not a nation or country – has, under the current Democratic Progressive Party and President Chien Shui-bian, asserted its Taiwanese-ness over its Chinese-ness. Taiwan's economic prowess is in great part compensation for its political fragility. It has produced an island culture far removed from that of its giant neighbour. The Chi Wen Gallery's description of Taiwanese sensibility is illustrative:

> Taiwan, a sub-tropical island, is paradoxically a shape-shifter: simultaneously high-tech and developing; sometimes resembling rapidly urbanizing areas of China, highly developed parts of Tokyo and corporate America. Taiwan's dense urban environment (Taiwan's population density is the second highest in the world after Bangladesh) combined with its affordable cost of living, a highly educated population and an openness to embrace outside ideas while maintaining its own national identity creates a vibrant and scintillating contemporary art scene.
>
> (www.chiwengallery.com)

4 (The Chinese Empire) See Temill R. (2003) *The New Chinese Empire and what it means for the United States*. Basic Books.
5 See B. Fibicher (ed.) (2005) *Mahjong: contemporary Chinese art from the Sigg Collection*. Hatje Cantz.
6 In 2000, the National Bureau of Statistics of China listed 75 art auction houses and 1,521 art shops or galleries; by 2004 the number of auctioneers had increased to 300.
7 Sotheby's London auctioned 'Important Turner Watercolours from the Guy and Myriam Ullens Collection' on 4 July 2007: fourteen watercolours were offered with total sales of £10.8 million, based on an estimate of £9.6 million to £14.4 million. Twelve works sold; two of the three works with the highest estimates (both £2 million to £3 million) were bought-in.

8 Zhang Xiaogang's 'Bloodline' series features disturbing portrayals of Chinese families from the Cultural Revolution.
9 Artists include M.F. Husain, Krishen Khana, Ram Kumar, J. Swaminathan and F.N. Souza.
10 In 2007 Copal Art, which is based in New Delhi, established two investment funds of 100 million rupees each and is hoping to start the country's biggest art fund by raising 1.5 billion rupees. The Osian's Art Fund raised 1 billion rupees, currently the largest art fund in India.

Part II

Cultural policy and management in art business

6 Private patrons in the development of a dynamic contemporary art market

Does France need more private patrons?

Catherine Morel

Introduction

France was the centre of the contemporary art market from the nineteenth century to the middle of the twentieth century; however, since the 1960s Paris has gradually been displaced (Gaillard 1999). The emergence of New York is cited; closer to France, one can also point to London and Switzerland as trading centres. Various internal reasons can also be cited to explain France's changed fortunes. First, overdue reform of the auction system took years to implement. Competition should have been introduced to the French art market by 1 January 1998; however, the law was not passed until 10 July 2000 and came into effect only in August 2001 (Quémin 2003: 53). Until then, *Commissaires Priseurs*, ministerial officers representing the Ministry of Justice, had enjoyed a quasi-monopoly over both voluntary and judiciary sales. With a system stretching back to the sixteenth century, complacency had taken root and led to the absence of innovation, despite figures showing the growing power of foreign auctioneers such as Sotheby's and Christie's and stagnating revenue by French auctioneers. In 1999, for instance, total art sales in France amounted to slightly more than one-third of Christie's and Sotheby's consolidated sales (Moulin cited in Quémin 2001). According to Artprice, in 2005 France contributed 6.6 per cent to global art sales, trailing the United States (43.1 per cent) and the United Kingdom (28.4 per cent).

The second explanation for France's decline on the elite art market stage is heavy regulation and taxation. For instance, *droit de suite* (artist's resale right), has been in place in France since 1920.[1] Value-added tax (VAT) on imports is also said to have discouraged business from entering the French market.

A third explanation concerns the absence of a strong body of French private collectors (individuals and business corporations), crowded out of the market by the overwhelming presence of public institutions. France provides an interesting example of a country where private initiative did support the art market in the nineteenth century and contributed to make Paris the centre of the art world before waning during the twentieth century (Too 2006). Quémin (2001) notes how France's private collectors are conspicuous by their

absence in the contemporary French art market. Similarly, Benhamou et al. (2002) report that business corporations account for only 5 per cent of the total purchases of contemporary art in France, and more than 60 per cent of French galleries never sell to business corporations; in comparison, business corporations represent 20–30 per cent of gallery sales in Germany (Benhamou et al. 2002: 273). To add insult to injury, the few important French collectors are not big buyers of contemporary French art (Quémin 2001). In order to remedy this situation, efforts have been made and steps taken by the French government to encourage private individuals and business corporations to become more involved in the financing of art.

The aim of this chapter is to explore the reported lack of collectors in France of contemporary French art, which includes examining the reform of the laws governing private philanthropy. Is it possible to create a dynamic group of collectors who could contribute in promoting French contemporary artists thus reasserting Paris' significance on the art map?

It seems relevant to start by assessing the role private art supporters used to play in France. Particular emphasis will be laid on the nineteenth century and the development of entrepreneurial patronage before examining the slower emergence of corporate support of the arts. Facts and figures are provided to demonstrate the weakness of private collecting in France today before considering tax-based solutions. Various factors which might explain the absence of private collectors of contemporary art in France are subsequently offered.

A short historical perspective on private support of the arts in France

When looking at the evolution of private support of the arts in France (Morel 2002), it is necessary to establish a distinction between entrepreneurial, the so-called *mécénat des grandes fortunes*, and corporate support of the arts or *mécénat d'entreprise*. The former refers to the support given to the arts by entrepreneurs or business magnates, who use their personal fortune to protect or encourage the arts. In contrast, the latter refers to the financial gain or material benefit offered to business corporations 'investing' in art and culture to promote a favourable reputation. Entrepreneurial patronage appeared in the nineteenth century as the development of capitalism and the wealth it brought enabled the bourgeoisie to engage in arts patronage and to challenge the cultural supremacy of the aristocracy. Corporate patronage of the arts started to develop in France after the Second World War.

Entrepreneurial patronage

As underlined by Boime (1976), changes in the relationship between patron and artist distinguish the nineteenth century from other epochs. First, the nineteenth century entrepreneurial patron was usually a parvenu, who shared

the same social background as the artist. Therefore the nature of their relationship was different from that observed in the classic form of patronage (i.e., the artist was considered as a social inferior). Second, there was a blurring of the categories of collector: those who bought works from the past through a broker and patron and those who protected living artists. If traditionally the two functions had been separate, in the nineteenth century, the entrepreneurial patron could carry out both activities, collecting and buying not only Old Masters, but also the works of living artists thanks to the emergence of art salons and dealers.

Entrepreneurs-as-collectors, who began accumulating in the 1830s and 1850s, bought seventeenth century Dutch and eighteenth century French paintings, emulating the aristocracy's practices and adopting its status symbols (Boime 1976). Art collections were maintained not only by industrialists like Eugène Schneider, manager of the ironworks at *Le Creusot*, but also by powerful bankers and financiers like the Rothschilds. According to Boime (1976), the drive to collect for most bankers was linked to their Protestant or Jewish origins and illustrated their need for acceptance and recognition by the landed (Roman Catholic) aristocracy. Similarly, department store owners were usually enthusiastic art patrons. One cannot help thinking that their passion was linked to their need to move away from their image as shopkeepers and to be recognized by the upper class (who usually descended from the aristocracy). The founders of *La Samaritaine*, Ernest Cognacq and Louise Jay, are probably the best examples of keen collectors, who despite their modest origins, managed to attach their names to an exceptional collection of eighteenth century art. Similarly, fashion designer Jacques Doucet (1853–1929), who resented being considered a mere supplier of fashion garments, started collecting eighteenth century masters to emulate his aristocratic customers (Chêne 2000).

As the century progressed, entrepreneurial patrons started to emancipate themselves from the aristocratic model, became bolder and with the help of art dealers, bought works from living artists, such as the Impressionists, who depicted a changing and modern world that appealed to the taste of the emerging merchant class (Boime 1976). The search for avant-garde styles and artists was also motivated by the desire of entrepreneurs to assert their ideals, status and individuality – and to outshine the aristocracy. The best example of such a change in collecting is probably Jacques Doucet: he sold his esteemed eighteenth century French art collection in 1912 and started buying contemporary artists such as Rousseau, Picasso, Matisse and Brancusi (Chêne 2000). Boime (1976) also notes that later collectors were usually keener than their predecessors to donate their collection to the French nation or a local town on the condition that the donor's name would be displayed.

The political, social and economic supremacy gained by the bourgeoisie over the aristocracy played a role in the buoyancy of private support of the arts, which took place particularly during the second half of the nineteenth century (Palmade 1972). Yet it is important to take account of other changes

as well. Entrepreneurs collecting art coincided with the emergence of a mar-
ketplace for works of art and the establishment of the critic-dealer system.
The *Salon des Refusés* (from 1863) offered artists, whose works had been
turned down by the jury of the official state controlled Salon, an alternative
venue to exhibit, publicize and eventually sell. This helped in marketing the
so-called avant-garde 'bohemia' (Mainardi 1993). Art dealers – *entrepreneurs*
as Moulin (1967: 109) calls them – embodied the new relationships between
the arts, money, artists and patrons that took shape in the nineteenth century.
The most influential art dealers in the nineteenth century and beginning of the
twentieth century were Paul Durand-Ruel (1831–1922), who supported the
Impressionists, Ambroise Vollard (1865–1939), whose faith in artists such as
Cézanne, Rouault and Gauguin eventually proved him right, and Daniel-
Henry Kahnweiler (1884–1979), who with Rosenberg (Rheims 2002: 244),
was the major promoter of Cubism. Art dealers severed the direct link
between artists and patrons (Boime 1976) but as intermediaries they shared
characteristics with each of their business partners. Dealers' moral and finan-
cial support was invaluable to impoverished and unknown artists. This genu-
ine desire for art dealers to help, defend and impose artists that they liked and
admired, on collectors, stemmed from a true love for the arts (as most of
them were amateur artists or collectors themselves). But there was also a
desire for prestige that they shared with patrons (Moulin 1967:132). However,
earning a profit was undoubtedly one of the art dealers' major motivations
and their interest in art and artists was always combined with a strong busi-
ness acumen and risk-taking spirit.

The cultural policy adopted by the Third Republic – that is by deliberately
concentrating on the arts, education and heritage – left the support of visual
artists in the care of the private sector. Certain authors, like Fumaroli (1992),
have praised this liberal 'hands-off' approach to the arts and wished it had
been applied during the Fifth Republic (1958 to current). Even though this
policy was detrimental to the performing arts, which struggled to find private
patrons to help them meet their high running costs, the visual arts and litera-
ture thrived. One outcome is that by the end of the nineteenth century, Paris
was the centre of the international art world (Farchy and Sagot-Duvauroux
1994) and, despite the wars of the twentieth century on European soil, it was
to remain a dominant place for contemporary art until the 1950s.

Corporate support of the arts

Corporate support of the arts did not really emerge in France before the
second half of the twentieth century. However, even as late as the 1960s,
very few companies were reported as using part of their revenues to support
the arts in France. Moulin (1967: 258) noted French corporate patronage
(*mécénat industriel*) was more modest than anywhere else in the developed
world. There is little doubt that the slow emergence of corporate support of
the arts in France is linked to the late development of the conceptions and

practice of marketing which did not take place until as late as the 1960s (Szarka 1992).

Brébisson (1993) reports a marked progression of corporate support of the arts in the late 1970s. This is a trend confirmed by Grangé-Cabane (1994: 20), who does not hesitate to use the term '*explosion*' to describe the evolution of corporate support of the arts in the 1980s. Among the various factors he puts forward in his report to explain this phenomenon, is the attempt by French companies to emulate their American counterparts. US-based firms, such as IBM and Kodak, were already active in financing arts projects in France in order to be accepted by their host country; high art patronage served to soften an image of cold and heartless multinationals.

Much more significant in the evolution of corporate support of the arts was the sudden social rehabilitation of businesses, which took place at the beginning of the 1980s, as Grangé-Cabane (1994: 22) reminds us: businesses moved from the status of scapegoats to one of sacred cows! Quite ironically, the Socialist government of Mitterrand (elected in 1981) contributed to the rehabilitation of businesses. Indeed, by embracing a more liberal approach to economic policy from 1983 onwards, it acknowledged that businesses (by creating wealth and jobs) had a vital role to play in the recovery of the French economy, plagued at the time by unemployment and inflation.

Consequently, the corporate world's attitude changed drastically. French companies, which traditionally had been reserved and much more focused on production than on marketing, adopted a proactive attitude to market themselves (and not only their goods or services) and to improve their image. Corporate support of the arts appeared as a new – although it was not – and promising communications tool, which could play a part in changing public opinion. The creation of Admical (*Association pour le Développement du Mécénat Industriel et Commercial*), in 1979, by three young businessmen (Axel Leblois, Patrick Humières and Pierre-Antoine Huré), also proved decisive in the development of corporate support of art. Jacques Rigaud, a former elite civil servant at the Ministry of Culture and the then manager of Radio Télé Luxembourg, was asked to chair the new association. Since then, Admical has lobbied in favour of *mécénat* and has played an active role in the design of various laws, the first of which was passed in 1987.

The '*explosion*' of sponsorship in the 1980s, as reported by Grangé-Cabane (1994), was based on the enthusiasm shown by companies for this new communication technique and to a certain extent, by the more positive attitude of the Ministry of Culture towards companies which led to the 1987 law. However, it should be made clear that the phenomenon remained limited to large business corporations, in particular Paris-based ones with strong links to the state. This represented 'a form of externalized State patronage' according to Rozier (2003: 59). A prime example is the *Caisse des Dépôts et Consignations* whose managing director, much to his staff's dismay, invested FF3 million per annum to put together a collection of contemporary art (Golliaud 1994: 84). Similarly, analysis of the support of French foundations by business

corporations by Archambault (2003) revealed that state-owned or recently privatized companies were particularly well represented.

The economic recession of the early 1990s meant that most French companies cut communications budgets, with corporate support of the arts harder to justify. If the 1980s represented boom years of expensive and ostentatious communications campaigns – including corporate support of the arts – then the 1990s were marked by a new approach. For companies that decided to carry on with their efforts in arts support, it was time for lessons to be learned and for strategies to be reassessed. The largest businesses started to design and follow much more defined and coherent strategies in terms of corporate image and identity. The rationalization of corporate sponsorship was on its way.

Weakness of private support of the arts in France

Despite efforts to hype corporate support of the arts in France, an objective observer would admit that the figures are not very encouraging. Estimates provided by Admical show that around 2,000 companies were involved in arts sponsorship and patronage in 2002 – in other words, less than 0.2 per cent of the total number of companies in France (Vescia 1996: 113). Of the 2,000 companies, 1,200 were supporting various art forms (which is to say that business corporation support of contemporary art remains minute: see Table 6.1).

Interestingly enough, Admical (2006) recently changed their research methodology and found out that 18 per cent of companies with more than 200 workers were engaged in corporate support, which in effect corresponds to 800 businesses in total.

France, with slightly more than 1,000 foundations, ranks low relative to other advanced nations (Archambault 2003). Using the figures published by the Bertelsmann Foundation (2001) and Anheier and Romo (1999), Archambault (2003) points to the examples of the USA (16,221 foundations), the UK (3,147) and Germany (2,799). A survey by Ernst & Young, in January 2006, reported 115 business-corporation foundations in France. However, very few of these corporate foundations are dedicated to the arts let alone to contemporary visual art; it seems that French corporations remain conservative in their taste (Sagot-Duvauroux 2006). Notable exceptions of French corporate foundations involved in contemporary art include the Fondation Cartier pour l'art contemporain, the Fondation d'entreprise Ricard (Frèches 2005: 68) and the Fondation EDF.

Table 6.1 Number of companies engaged in various arts support activities (estimates)

Year	1992	1993	1994	1995	1996	1998	2000	2002
Companies	900	750	850	1,100	1,000	1,100	1,200	1,100

Source: Adapted from Admical.

Private individuals in France collecting contemporary French art are even thinner on the ground. The lack of inspiring collectors, who could pave the way to more private involvement in the contemporary French art market, is noted by Sagot-Duvauroux (2006). Using 2004 data collected by *ARTnews* on top international collectors, Sagot-Duvauroux (2006) shows that France has nine top collectors (compared to 109 in the USA); moreover, only four of these French collectors indicated a strong interest in contemporary art. The *ARTnews* list for 2006 has François Pinault as the singular Frenchman in the Top 10, and only four collectors in contemporary art are French (Hélène and Bernard Arnault, Antoine de Galbert, Marc Landeau and François Pinault in alphabetical order).

Pinault, Arnault and, to a certain extent Galbert, are of particular interest to our discussion as they represent 'mega' collectors – ones France should try to cultivate. Indeed Moulin (2003) reminds us that top collectors perform various functions in the art market. Playing both an economic and cultural role, they can alternatively be dealer (they buy and sell), curator, sponsor, supporter of public art institutions, etc. They are among the most influential taste makers and a key player in the art triangle, with art museums and commercial galleries.

Both Pinault and Arnault are entrepreneurs who built their own business empires – this is to say that they did not inherit wealth (which remains quite unusual in French capitalism). As owners of luxury good companies (LVMH for Arnault; Gucci, Yves St Laurent and the Printemps department store for Pinault), both Frenchmen started collecting contemporary art as novices. Moreover, both have acquired stakes in auction houses (Pinault owns Christie's and part of Piasa, and LVMH used to have a stake in Tajan). Pinault's status as a mega collector owes much to his desire to house his collection: in the first instance, there was the vast project of rehabilitating the Ile Seguin, which until 1992 was the home factory of automaker Renault. This was to serve as the site for his foundation for contemporary art. Alas! In May 2005, Pinault announced in *Le Monde* that he was giving up on his project in France (Pinault 2005); furthermore, he was taking his collection of 2,000 contemporary and modern works to Venice. According to Pinault, local authorities and politicians had failed to support him in his project, which faced various postponements. He did not want to wait until 2010. France lost the chance to host one of the biggest art foundations in Europe and, in the process, sent a negative message to other private individuals keen to establish their own museum-foundation.

Antoine de Galbert, who inherited his fortune from the hypermarket chain Carrefour, has been luckier in his enterprise and La Maison Rouge has become a landmark on the Paris art scene since its opening in June 2004. It has produced innovative exhibitions such as the one showing domestic collections in private residences of collectors (who all remained anonymous). Designer Agnès B is also one of the few French collectors to have appeared in the 2006 edition of *Art Review*'s 'Power 100' along with Pinault and Galbert.

Outside Paris, one should also mention the Fondation Maeght in Saint Paul de Vence which was one of the very first foundations for contemporary art in France; there is also the Fondation pour l'art contemporain set up as a *Fondation Reconnue d'Utilité Publique* (*FRUP*) near Annecy by Claudine and Jean-Marc Salomon in 2001.

France's apparently limited success in generating private philanthropy and the low level of corporate support for the arts motivated President Chirac to issue new measures, in an attempt to launch a process that previous laws had not managed to trigger. The next section will examine the key elements of the 2003 law.

The use of tax measures to boost private art support

In order to encourage greater private support of the arts, France has chosen to emulate the USA, where taxation measures are a major factor in explaining the high level of donations (of art and money) to the arts (O'Hagan 2003). Under a tax-based system, donors are allowed to deduct contributions to arts institutions from their income taxes. In effect, the state accepts to forgo some of its taxation revenues, which are channelled to arts institutions selected by the individual. In other words, the state still subsidizes arts institutions but indirectly. The choice of art institutions to support is left to the individual taxpayer.

When deciding to support the arts, a company (or an individual) in France is faced with various possibilities, most of them set by the laws of 23 July 1987 and 4 July 1990. However, both laws were so convoluted that they led to a 'legal hell' and achieved very little. As a consequence, they were significantly amended by the law of 1 August 2003 (Loi Aillagon after the then Minister of Culture).

Making donations

The most striking element of the law of 1 August 2003 is certainly the improved tax deduction offered to corporate patrons. Since 1 January 2003, 60 per cent of the donated sum can be deducted directly from the amount of payable taxes and not from the taxable earnings as before. As a result, the law is almost doubling the tax relief offered to corporate patrons. It is important to bear in mind that in order to qualify for tax reductions, corporate donors must demonstrate that the returns they will get from their donation are markedly disproportionate in value in comparison with the donated sums. Officially, the value of the expected returns should not exceed 25 per cent of the initial sum donated.

As an example, a company makes a donation of €400 to an art project. Below is a comparison of taxes paid before and after 1 August 2003 (note that French corporation tax rate of 33.3 per cent was unchanged).

Before 1 August 2003:

Taxable earnings	10,000
Donation	400
Tax liability	9,600
Taxes to pay	**3,197** (33.3 per cent of 9,600)
Tax 'bonus'	**133** (3,330–3,197)

From 1 August 2003:

Taxable earnings	10,000
Tax liability	10,000
Taxes to pay	3,330
Donation (60 per cent of 400)	240
Taxes to pay	**3,090** (3,330–240)
Tax 'bonus'	**240** (3,330–3,090)

The law on museums (4 January 2002) provides an incentive for businesses to donate money to help the state or a public institution to acquire a work of art considered as part of national heritage: the business can deduct 90 per cent of the donation from taxes payable. In the case of private individuals, the rate is 66 per cent of the donation to an art organization from their payable taxes (within the limit of 20 per cent of taxable income).

Establishing a foundation

When deciding to create a foundation, a French company seems to be spoilt for choice – one wonders why there are still so few of them! First, together with private individuals, businesses can apply for the prestigious accreditation of *Fondation reconnue d'utilité publique (FRUP)*. It is a *permanent* foundation whose special status can be granted only by the Ministère de l'Intérieur (Home Office) after a recommendation by the Conseil d'Etat (State Council). A representative of the state will usually sit on the board of the FRUP. There are only three FRUPs set up by companies (Crédit Agricole, Caisse d'Epargne, Maif) out of the 472 French FRUPs listed by Archambault (2003).

A *Fondation d'entreprise* is set up for a minimum period of five years, which can be extended by a further three years. The endowment should amount to €152,500. Until 2003 a business foundation was not allowed to receive donations. This is no longer the case so employees can donate to their company's foundation.

The third solution for businesses is to entrust institutions like the Fondation de France or the Institut de France with a certain amount of capital and discretion to manage the funds. In return, they receive, in the case of Fondation de France, the prestigious title of *Fondation sous l'égide de la Fondation de France* or, in the case of the Institut de France, they see grants carrying their name being attributed to the cause they support. One of the

few foundations *sous égide de la Fondation de France* set up by a business is the EDF foundation in existence since 1987.

Art collections

In purchasing works of art by living artists, businesses can deduct 20 per cent of the sum paid from taxable earnings each year for five years, as long as it does not exceed 0.5 per cent of annual turnover. In exchange, businesses were originally asked to make the works accessible to the general public. However, in a speech given during one of France's leading art fairs, the Foire Internationale d'Art Contemporain (FIAC), in 2005, Donnedieu de Vabre, Minister of Culture, declared that offering access to staff, clients and business partners would be enough to qualify for the tax rebate.

If a business on its own initiative buys a work of art which is considered as part of the national heritage, it can deduct 40 per cent of the amount spent from its tax bill.

Among the few French corporate art collections, one can mention the Société Générale, AXA (Nordstern), Renault and CCF (now part of HSBC).

In the case of private collectors, it has been put by Cabanne (1981: 208) that the state leaves the collectors to collect and then collects the collectors. One way to achieve this is through the *dation en paiement* (rather similar to the British acceptance in lieu), which was introduced by the law of 31 December 1968 (law no. 681251) to promote the conservation of the national artistic patrimony. Under this tax provision, estate taxes can be paid by private individuals with works of art, books or collections of high artistic or historic value. The acceptance of the *dation* is subject to the recommendation of a government-appointed commission, which determines the quality of the offered objects. Thanks to *dation en paiement*, France has received some extraordinary collections: the Picasso Museum in Paris is a notable example. Indeed Gaillard (1999), in his report on the competitiveness of France on the international art market, also recommended more measures to encourage bequeathing private collections to the State.

Why private art support of art is weak in France

Historical and political reasons

Each country has its own model of philanthropy which is built around its culture, its social and political organization (Zimmer and Toepler 1999) and based on different historical patterns of patronage. France is no exception. The political notion of the state, as the guarantor of the general interest, remains a major and enduring influence on private giving in France.

The state's involvement in the arts started very early in France. Royal patronage gradually eclipsed that of other societal actors like princes, organized religion or corporations (Farchy and Sagot-Duvauroux 1994: 52).

Indeed any daring patronage from private individuals was soon perceived as a power challenge. Jacques Coeur (1395–1456), court banker to Charles VII, and Nicolas Fouquet (1615–80), superintendent of finance under Louis XIV, are perfect examples of men whose magnificent arts patronage was severely punished (both of them were jailed) because it had overshadowed the king and therefore the state: 'Colbert (Louis XIV's minister) was directed to harness all the arts of France to glorify his royal master, not upstart thieves' (Sinclair 1990: 49). Indeed, under Louis XIV (1643–1715), royal patronage of the arts gained another dimension as it demonstrated the grandeur and superiority of the French king and nation (Farchy and Sagot-Duvauroux 1994: 53). It is only when the cultural centralism developed by Colbert started to collapse during the eighteenth century that private patronage started to flourish again (Farchy and Sagot-Duvauroux 1994: 54). The Revolution put an end to it. Leaders of the French Revolution, in a manner not dissimilar to that of the Royals before them, used culture and the arts for political purposes (Rosanvallon 1990: 110). Art and culture became the entire responsibility of the state in its mission to create a national identity and to educate citizens. This arrangement has never been significantly challenged by other societal actors, who have been systematically kept at bay or under tight scrutiny whenever they showed signs of engaging in actions of general interest. This is the case of the Catholic Church, for instance, whose traditional role in the running of foundations has undoubtedly a lot to do with the state's long lasting opposition to them (Pavillon 1995: 28). The creation of a Ministry of Culture in the twentieth century (see below) shows how art and culture are still at the heart of the French state today.

Emergence of the aesthetical state

The French Ministry of Cultural Affairs (as it was called at the time) was created in 1959, with the intellectual figure André Malraux at its head. The major aspect of Malraux's '*Etat esthétique*' or 'aesthetical welfare state' (Urfalino 1996: 21) was its focus on contemporary artistic creation and the support to professional artists. In effect, the Ministry of Culture has spent five decades subsidizing cultural institutions and professional artists. In the 1980s, the ministry experienced an increase of its budget and opted to offer additional support to artists, which led critics to suggest that the Ministry of Culture should be renamed the Ministry of Artists!

The creation of the Fond National d'Art Contemporain (FNAC) in 1975 and of twenty-three Fonds Régionaux d'Art Contemporain (FRAC) in 1982 contributed to what has sometimes been regarded as the 'nationalization' of the contemporary art market. FNAC, with its collection of 60,000 works of art, acquired 11,000 works of 3,500 artists between 1991 and 1999 and the FRACs acquired 14,000 works from 2,500 artists between 1982 and 2000. Museums (such as Musée National d'Art Moderne or MNAM) also saw their budgets increase substantially in the 1980s (Moulin 2003: 56). Numerous

contemporary works of art were also commissioned by the state at national and local levels.

It is worth noting that public institutions do not seem to buy from commercial galleries; 60 per cent of the money spent by FNAC to buy works between 1987 and 1998 went to commercial galleries. In the case of the MNAM, it buys almost exclusively from private collectors or artists (DEP 2000: 7). Unsurprisingly private galleries sometimes feel squeezed out of the market by public institutions. This was confirmed by the survey of commercial galleries in France carried out by Benhamou et al. (2002) which showed that certain commercial galleries considered publicly funded institutes of contemporary art as competitors; these publicly funded institutions nurture and promote contemporary artists without cooperating with commercial galleries (DEP 2000: 7). It is as if publicly funded institutions had monopolized the representation of the avant-garde.

Contemporary art market observers in France note that a museum-orientation, with its own aesthetic qualities, has emerged in art production (Heinich 1998: 275). Hence, the domination of installations, for instance, which invite institutional rather than private collectors. Quémin (2001: 129) notes that the strong presence of the state in the contemporary French art scene might hinder market growth in foreign markets. Some of Quémin's interviewees regretted the high visibility desired by French funding bodies when exhibiting abroad. Prospective foreign buyers may perceive the promoted artists as state-sanctioned and thus too official and of doubtful long-term value.

Cultural reasons

Top collectors of art in France are extremely reserved about publicising their collections. According to Quémin (2001: 124), fears of the potential introduction of a wealth tax on art works (Impôt de Solidarité sur la Fortune or ISF),[2] inheritance and gift tax, security risks and traditional bourgeoisie discretion can explain this behaviour. Unease in being a collector in France is noted. One notices this in the ongoing debate over the term *mécène*. It derives from the name of a wealthy Etruscan noble called Caius Cilnius Maecenas (63–8 BC), who helped and supported poets like Virgil, Horace and Propertius and who directed their work towards the glorification of Rome and the Emperor Augustus. *Mécène* usually designates the activities of private individuals, who freely devote their time and fortune to protect and encourage artistic life in their country. Often associated with aesthetes, it has reactionary and elitist connotations. Although *mécènes* are usually acclaimed and revered figures for taste, freedom, and risk-taking support of unknown artists, their generosity is also associated with wealth – and consequently with power – which can be interpreted as ostentatious displays. In the USA, exhibiting one's collection in public is regarded as a cultural obligation of the wealthy, yet in France the same visible gesture can be perceived as tasteless and vulgar;

moreover, it challenges the state as the sole representative to promote art and culture to the general public.

Quémin (2001: 125) offers recent examples of such discreet behaviour by French collectors. At the Pierre et Gilles exhibition at the New Museum in New York (September 2000 to January 2001) it was easy to identify Swiss, German and American collectors who had lent works; however, it was almost impossible to trace those lent by French collectors. Some of them went as far as to hide the fact that the works were actually in a French private collection. Similarly, when Suzanne Pagé was looking for collectors to organize a special exhibition, 'Passions Privées', on private collecting at the Musée d'Art Moderne de la ville de Paris (December 1995 to March 1996), two-thirds of the ninety-two – almost exclusively French – collectors who lent works for the exhibition refused to allow their identity to be released.

Conclusions: reasons for optimism

There is a widely held belief that tax incentives are by definition 'good for the arts' (Schuster 1986: 353). The promoters of the 2003 law in France argue that it takes time for the benefits of tax incentives to art and culture – as in the USA – to take root. But such a proposition underestimates the role played by economic, cultural, historical and political factors to explain the enduring weakness of private support of the arts in France. Tax incentives alone cannot induce generous behaviour, let alone a sudden will to collect or support (contemporary) art. As noted by Schuster (1999: 64), 'grafting a tax incentive onto tax law in a context in which public initiative has been the norm and private initiative has not been deployed in pursuit of collective purposes' will probably not be very effective. The key to the problem of private support of the arts does not lie as much in the implementation of tax incentives as in the changing view on the relative roles of private and public sectors. Such an ideological change is obviously a far more complex and long-term problem to address. Infoscopie (2000) conducted a qualitative survey, commissioned by the Fondation de France, to investigate the involvement of business corporations in supporting the arts. Some respondents complained about a certain French exception, namely the general lack of recognition and legitimacy granted by publicly funded institutions and the media to corporate patronage.

If the state wants to encourage French consumers and collectors of contemporary art, opportunities may be found across the Channel: for example, the Arts Council of England's 'Own Art' scheme offers zero per cent credit (maximum £2,000) to novice collectors to buy contemporary artworks from participating commercial galleries. Such a scheme in France might help to widen the base of new and young collectors; at the same time, it could stimulate additional sales for commercial galleries dealing in contemporary art. The situation for commercial galleries, as surveyed by Benhamou et al. (2002: 272), is one of managing key accounts: one-third of the commercial galleries

rely on their five largest collectors for over half of their annual turnover; for the average commercial gallery, the five biggest collectors account for one-third of annual turnover.

A 2005 report produced by the Fondation de France (2005) indicates that one of the main reasons why there are so few foundations set up by private individuals in France is the law which is set to protect direct inheritors (often sons and daughters). Challenges can be made by the inheritors if they feel that a decision made by their parents, for example, to establish a foundation diminishes what is left in an estate. Reform of inheritance legislation could help to mitigate an externality hostile to encouraging private philanthropy.

Some encouraging signs must be reported amidst all the negatives. If, as mooted by Cabanne (1981: 210), private support of the arts (*mécénat*) exists in France, it is despite the state ('Si le mécénat existe en France, c'est malgré l'Etat'). In other words, ambitious and aggressive collectors have not waited for the state to promote and validate artists. For example, l'ADIAF (Association pour la Diffusion Internationale de l'Art Français), established in 1994, is a not-for-profit organization of 150 contemporary art collectors and connoisseurs. Its mission is to promote French contemporary art abroad and to develop a collector's mentality in France. One of its initiatives is the Marcel Duchamp Prize – inspired it would seem by the Turner Prize in the UK – organized in association with the Centre Pompidou and featured at FIAC.

Emulating their UK, German or Swiss competitors, some French banks and insurance companies have also realized how they can capitalize on a corporate collection. Société Générale, for instance, has started lending some of their works to museums in France; their UK subsidiary has been involved in the promotion of contemporary French art in London with 'Paris Calling', a project initiated by the French Embassy and the AFAA (Association Française pour l'Action Artistique).[3] The aim for 'Paris Calling' was not only to reinforce the links between the British and French contemporary art scenes but also to give exposure to the works of French contemporary artists. Such initiatives are welcomed, and illustrate how private and public organizations can work together in the promotion of French art and artists abroad (Morel 2006).

Is France interested in developing a strong pool of indigenous private art collectors? If so, there needs to be an emphasis on advocacy, financial assistance and education but also greater reliance on the private market actors (dealers and auction houses) to engage and nurture these collectors. Failing that, France, already eclipsed by the USA, might not be in a strong position to face new competitors from Chindia and the Middle East.

Notes

1 At the time of writing the European Union harmonizing directive on *droit de suite* was not as yet complete in France. The law was passed on 30 June 2006, but the application details were still being discussed. Until otherwise stated, *droit de suite* applies only to works sold at public auctions. The flat rate, levied on sales over €15, is 3 per cent with no maximum sum payable. However, in early 2007, details of the

new proposal – rate of 4 per cent for works up to €50,000 with a maximum sum payable of €1,000 – caused a stir among visual artists.

2 Fine art and antiques, so far, have been exempted from wealth tax.

3 'Paris Calling' was a celebration of contemporary art from France held in more than twenty galleries, museums and art centres in and around London from June to December 2006. Exhibitions included eleven new commissions, solo shows from France's big name artists like Pierre Huygues and emerging talents; moreover, international group shows were co-curated by French and British arts venues.

References

Admical (2006) 'Résultat de l'enquête nationale ADMICAL-CSA: les chiffres clés du mécénat d'entreprise 2005.' Paris: Admical.

Anheier, H. and Romo, F. (1999) 'Foundations in Germany and the United States: a comparative analysis', in H. Anheier and S. Toepler (eds) *Private Funds, Public Purpose*. New York: Kluwer and Plenum: 79–121.

Archambault, E. (2003) 'Pourquoi la France a-t-elle si peu de fondations?', *Revue Internationale de l'économie sociale* 287: 68–84.

ARTnews (2006) 'ARTnews 200 top collectors' issue of *ARTnews* 105(7): 135–47.

Art Newspaper (2006) 'Tax and art' special report in *The Art Newspaper* (September).

Art Review (2006) 'Power 100' issue of *Art Review* (November).

Benhamou, F., Moureau, N. and Sagot-Duvauroux, D. (2002) 'Opening the *Black Box* of the *White Cube*: a survey of French contemporary art galleries at the turn of the millennium', *Poetics* 30: 263–80.

Benhamou-Huet, J. (2001) *The Worth of Art: pricing the priceless*. New York: Assouline.

Bentelsmann Foundation. (2001) *Foundations in Europe*. London: The Directory of Social Change.

Boime, A. (1976) 'Entrepreneurial patronage in nineteenth century France', in E.C. Carter II, R. Forster and J.N. Moody (eds.) *Enterprise and Entrepreneurs in Nineteenth- and Twentieth Century France*. London: Johns Hopkins University Press: 137–91.

Brébisson, G. de. (1993) *Enquête sur le mécénat*. Paris: Ministère de la Culture, Département de la Prospective et des Etudes.

Cabanne, P. (1981) *Le Pouvoir culturel sous la vème république*. Paris: Olivier Orban.

Chêne, V. (2000) 'Jacques Doucet: le médicis de nos temps rétrécis', *Mécènes* 1.

Des Etudes et de la Prospective (DEP) (2000) 'Les galeries d'art contemporain 1999', in *Développement culturel*. Paris: DEP.

Farchy, J. and Sagot-Duvauroux, D. (1994) *Economie des politiques culturelles*. Paris: PUF.

Fondation de France (2005) 'Enquête nationale auprès des foundations: observatoire de la générosité et du mécénat.' Paris: Fondation de France.

Frèches, J. (2005) *Art & Ci: l'art est indispensable à l'entreprise*. Paris: Dunod.

Fumaroli, M. (1992) *L'Etat culturel: essai sur une religion moderne*. Paris: Fallois.

Gaillard, Y. (1999) *Marché de l'art: les chances de la France*. Paris: Rapport au Sénat.

Golliaud, C. (1994) 'L'art et les mauvaises manières,' *Les cahiers du samedi du Nouvel Economiste* 929: 83–5.

Grangé-Cabane, A. (1994) *Donner au mécénat un nouvel essor*. Paris: Ministère de la Culture.

Heinich, N. (1998) *Le Triple Jeu de l'art contemporain*. Paris: Minuit.

Infoscopie (2000) *Les Perspectives de l'engagement des entreprises dans les actions d'intérêt général*. Paris: Fondation de France.

Mainardi, P. (1993) *The End of the Salon: art and the state in the early Third Republic*. Cambridge: Cambridge University Press.

Morel, C. (2002) 'The evolution of corporate support of the arts in France', PhD thesis, University of Sheffield.

Morel, C. (2006) 'Corporate cultural diplomacy', paper presented at the ICCPR conference, Vienna (13–16 July).

Moulin, R. (1967) *Le Marché de la peinture en France*. Paris: Minuit.

Moulin, R. (2003) *Le Marché de l'art: mondialization et nouvelles technologies*. Paris: Flammarion, Collection Champs.

Musée d'art Moderne de la ville de Paris. (1995) *Passions privées* (catalogue). Paris. Musée d'art Moderne de la ville de Paris

O'Hagan, J. (2003) 'Tax concessions', in R. Towse (ed.) *A Handbook of Cultural Economics*. Cheltenham: Edward Elgar.

Palmade, G. (1972) *French Capitalism in the Nineteenth Century*. Newton Abbott: David and Charles.

Pavillon, E. (1995) *La Fondation de France*. Paris: Economica.

Pinault, F. (2005) 'Ile Seguin: je renonce', *Le Monde* (10 May).

Quémin, A. (2001) *Le Rôle des pays prescripteurs sur le marché et dans le monde de l'art contemporain*. Paris: Rapport au Ministère des Affaires Etrangères.

Quémin, A. (2003) 'L'évolution du marché de l'art: une internationalization croissante', in *Culture Etat et Marché*. Paris: La Documentation Française: 50–55.

Rheims, M. (2002) *Les Collectionneurs: de la curiosité, de la beauté, du goût, de la mode et de la spéculation*. Paris: Ramsay.

Rigaud, J. (1996) *Pour une refondation de la politique culturelle*. Paris: La documentation française.

Rigby, B. (1993) 'Heteronomy and autonomy in Bourdieu, *Les règles de l'art*', *French Cultural Studies* IV: 271–81.

Rosanvallon, P. (1990) *L'Etat en France: de 1789 à nos jours*. Paris: Senil.

Rozier, D. (2003) 'Le mécénat culturel des entreprises', in *Culture Etat et Marché*, Les Cahiers Français 312: 56–61. Paris: La Documentation Française.

Sagot-Duvauroux, D. (2006) *Le Marché de l'art contemporain*. Paris: La Découverte.

Schuster, M.D. (1986) 'Tax incentives as arts policy in Western Europe', in P. DiMaggio (ed.) *Nonprofit Enterprise in the Arts*. Oxford: Oxford University Press: 320–60.

Schuster, M.D. (1999) 'The other side of the subsidized muse: indirect aid revisited', *Journal of Cultural Economics* 23(1/2).

Sinclair, A. (1990) *The Need to Give: the patrons and the arts*. London: Sinclair Stevenson.

Szarka, J. (1992) *Business in France: an introduction to the economic and social context*. London: Pitman.

Too, J.X. (2006) 'Paris on the rebound', *Art Review* 1: 112–21.

Urfalino, P. (1996) *L'Invention de la politique culturelle*. Paris: La Documentation Française.

Vescia, R. (1996) *Aujourd'hui le mécénat; treize entretiens sur le mécénat humaniste et humanitaire*. Paris: Cercle de l'art.

Zimmer, A. and Toepler, S. (1999) 'The subsidized muse: government and the arts in Western Europe and the United States', *Journal of Cultural Economics* 23: 33–49.

7 Marketing in art business

Exchange relationships by commercial galleries and art museums

Derrick Chong

A keen eye and a network: this formula neatly summarizes what is required of any serious, professional art gallery in its dealings with artists on one hand and collectors on the other. Although the financial side of things is obviously crucial, success also depends on a complexity of subjective and relational factors.

<div style="text-align: right">

Florence Marguerat on dealers and their artists in *Art Market Switzerland* (Marguerat 2003: 51)

</div>

The whole idea here is about a free exchange of commentary and ideas. It's a discourse on an international scale. In a contemporary society, for contemporary art, with everything becoming more interconnected, I think it's an essential aspect of how museums have to confront the world.

<div style="text-align: right">

Thomas Krens, director of the Solomon R. Guggenheim Foundation (Guggenheim 2006b)

</div>

Introduction

'Marketing is an organizational function and a set of processes for creating, communicating and delivering value to customers and for managing customer relations in ways that benefit the organization and its stakeholders,' according to the American Marketing Association.[1] Core to defining marketing are activities which foster exchanges of value between parties. This is to suggest that marketing is an inherently social phenomenon based on managing relationships. Exchange relationships, which underpin the concept of marketing, are examined with reference to two major art business organizations: commercial galleries and public art museums. The two opening quotations, on contemporary galleries operating in the international art market and the globalization strategy of the Guggenheim Foundation, are instructive in noting 'relational factors' and 'free exchange' respectively. First, the owner-operators of commercial galleries (gallerists or public dealers), Larry Gagosian, Marian Goodman, Barbara Gladstone, David Zwirner, Victoria Miro, Maureen Paley, Jay Jopling, and Sadie Coles, for example, are part of the same elite contemporary art market sector – the leading lights at Art

Basel, Art Basel Miami Beach, and the Frieze Art Fair in London. They compete to manage two sets of relationships: artists supply the goods for sale, thus securing the representation of key artists is crucial for success; and collectors (both private individuals and institutions like public art museums and business corporations) form the nucleus of sales and appreciation. Large contemporary art dealers have two divisions: staff to manage relationships with artists (artist representation); and staff to manage relationships with collectors (key account sales management). Second, public art museums, such as the Victoria & Albert Museum, the Philadelphia Museum of Art, and the Montreal Museum of Fine Arts, though not driven by the commercial imperative of profit maximization, need to manage two overlapping sets of relationships: elite patrons (or donors) as a source for works of art and capital funding; and spectators (or recipients) include elite patrons; however, wider support is deemed important as attendance is a prominent headline measure of success. The Guggenheim Foundation, with current museum operations in four countries, is the most expanionist art museum with a mission statement that includes: 'and strives to engage and educate an increasingly diverse international audience through its unique network of museum and cultural partnerships' (Guggenheim 2005b).

Andrea Rosen identifies three responsibilities for her gallery in New York: first, to work for the long-term development of each artist's career, acting as a liaison to international galleries and museums as well as placing works in collections; second, to create a historical archive for each artist; and third, to act as an accessible public space in which the exhibitions become an exemplary gesture of the power of subjectivity to the audience at large.[2] Commercial galleries and public art museums are, as Marcel Duchamp recognized, part of an art market system that operates by a form of endorsement or cross-validation of artists and art works by key tastemakers (such as critics, curators, and historians):

> In the final analysis, the artist may shout from all the rooftops that he is a genius; he will have to wait for the verdict of the spectator in order that his declarations take a social value and that, finally, posterity includes him in the primers of art history.
>
> (Duchamp 1973 [1957]: 47)

Gaining entry into a public art museum – notwithstanding limited deaccessioning initiatives used by some art museums – represents a final repository for a work of art. 'A place in history as a bottom line for my artists' is a sentiment that ambitious gallerists may harbour. Indeed the term 'museum quality' has a particular purpose in art business: it is used as a sales technique by commercial galleries, operating as retail intermediaries in a largely unregulated art market, to signal inventory (works of art) of the highest aesthetic quality; museum quality relies on an art market system that acknowledges the public art museum as the final repository. Social relations and experiences

are mediated by the institutional circumstances of commercial galleries and public art museums. Many elite commercial galleries prefer the notion of 'placing works' in particular collections. An ideal situation for a commercial gallery is selling to a private collector, who has intentions of donating his or her collection to a prominent and public art museum. (From a dealer's perspective, a full selling price can be charged to a private collector, whereas public art museums often require a discount. A work donated to a museum 'exits' the art market; at the same time, it enhances the pedigree and future sales of the artist and primary dealer.) This is consistent with the research of Morris Hargreaves McIntyre (2004), a consultancy that articulated thirteen stages of progression in the art market, from 'artist attracts recognition of peers' (stage 1) to 'collector's bequest of collection to museums' (stage 13 as the end point) with an intermediate stage such as 'dealers build artists' reputation through sales including international art fairs' (stage 7).

This chapter adopts a conventional marketing approach to highlight the role of exchange relationships in art business with reference to commercial galleries and public art museums. Three distinct dimensions of marketing within organizations are used: marketing as culture, marketing as strategy, and marketing as tactics (Webster 1992). First, marketing as culture focuses on the philosophy associated with the marketing concept. The current fascination with relationships – as expressed in relationship marketing, customer relationship management, and loyalty management, for example – reflect a move away from transaction-based exchanges. Second, marketing as strategy emphasizes segmentation, targeting, and position (STP). This is about competitive positioning, namely the importance of market segmentation and branding, in current marketing practice. Who is the customer for the product offered? What is the unique selling proposition (USP)? Third, marketing as tactics addresses the elements of the marketing mix, or the so-called 4Ps. This has been interpreted as the marketer being a mixer of the marketing elements (product, price, promotions, and place) to strengthen exchange relationships. Finally, the pros and cons of marketing in art business are considered.

Marketing philosophy as exchange process

Core to marketing is the process of exchanging products of value. Exchange represents a voluntary transfer between two parties. In *The Practice of Management*, which remains a key work in management literature, Peter Drucker (1954) made a forceful case for the role of marketing as we have come to understand it: 'There is only one valid definition of business purpose: to create a satisfied customer', and 'Any organization in which marketing is either absent or incidental is not a business and should never be run as if it were one' (Drucker 1954: 50–51). 'Marketing myopia' is the title of a seminal 1960 *Harvard Business Review* article by Theodore Levitt, who articulated what is now assumed to be conventional marketing wisdom: 'The entire corporation must be viewed as a customer creating and customer satisfying

organism. Management must think of itself as not just producing products but as providing customer-creating value satisfactions', and 'Selling focuses on the needs of the seller. Marketing on the needs of the buyer' (Levitt 1960: 56). A satisfied customer, according to Drucker (1954) and Levitt (1960), is viewed as the root source for organizational success. This seems commonsensical enough.

In terms of stakeholder groups, the role of the customer as central to the exchange process was established at the outset.[3] More than most management specialisms, the philosophical basis of marketing management was established within a relatively short period of time, during the 1950s and 1960s, based on the experience of American firms. Leading business schools continue to promote the importance of marketing as a pan-organizational philosophy based on delivering customer service. Individual firms satisfying customers would contribute to national wealth creation, as measured by rising gross domestic product per capita. All this is to suggest the role of marketing in helping to manage a liberal, capitalist system.

However, as noted at the outset, identifying the customer or customers is not always straightforward for commercial galleries and public art museums. Various exchange relationships need to be managed. Seller–buyer (e.g., gallerist–collector) is the most explicit commercial exchange. Other examples from art business include gallerist–artist, museum–donor, and museum–spectator. Moreover, the tenor of the exchange can vary from transaction-based (i.e., one-time exchanges of value between two parties that have no prior or subsequent interaction) to relationship-based (i.e., there is an expectation of continuing exchanges and future interactions between the two parties).

Gallerists/dealers

Consider the complexity of the exchange situations presented to the gallerist (dealer) who has to manage two sets of relationships, with artists and collectors, in order to be successful. Transaction-based exchanges may emphasize the practical sales maxim, 'Always Be Closing', so that revenue generation is of foremost importance to the gallerist. In an unregulated marketplace with high operating costs there can be pressure to shift stock. But such an approach is short-sighted:

> The best dealers are not salesmen in the classical sense of the word. Their passion and their connoisseurship and their knowledge have to combine to convince someone to acquire something that has no ostensible function in life, and that's not always as easy thing to do. It is distinct from the normal business world because of that.
>
> (Renato Danese, New York Chelsea-based dealer, cited in Artinfo July 2006)

Relationship-based exchanges mean that the dealer 'supports his protégés by

exhibiting and purchasing their work – because the dealer believes in them and is confident that others will trust his intuition' (Marguerat 2003: 51). Artists, as the source of product for the dealer, are important. Who is represented by the gallery is an important signal to collectors. Successful dealers tend to think of artists as partners and exhibitions as collaborations. 'It has always been the goal of the gallery to retain a specific territory for each artist that we represent,' according to Andrea Rosen. The term 'stable' – with unfortunate analogies to horses and fashion models – is often avoided. There are usually no contractual ties to prevent an artist from changing gallery representation. This means that dealers need to manage relationships with artists on a personal level – and many artists want to be loved. At the same time, to establish an artist's reputation beyond a restricted circle requires a dealer who can 'make and cultivate contacts with the art world, and with a clientele for whom the acquisition and ownership of works of art is part of their belonging to a certain environment' (Marguerat 2003: 51). This is about cultivating relationships with collectors (e.g. private individuals and curators at public art museums). Who buys the work is important for primary art market dealers. Money alone is not sufficient to close a deal, which avers a transaction-based approach to art-dealing. Dealers representing in-demand artists do not want works to be flipped for a quick profit by speculative buyers. Much more so than sellers of other products, dealers have a great stake in the subsequent ownership history (provenance) of works, which has an impact on an artist's market value.

Public art museums

The marketing situation is even more complex for public art museums. As noted, public art museums, like other not-for-profit or voluntary organizations, tend to have two client groups: donors and recipients. Donors include elite patrons, business corporations, and public funding agencies. Recipients include elite patrons (see Ostrower 2002), general visitors, and non-visitors (who may be taxpayers). Elite patrons, who may be trustees, overlap as donors and recipients in the sense that they benefit directly from their patronage to the art museum.[4] According to the Association of Art Museum Directors (AAMD 2001c), private collectors are the single most important source for accessioning works of art as part of the permanent collection. Various revenue streams are identified (e.g., endowment income, membership dues, museum store sales, private philanthropy, corporate sponsorship, and public agency funding), 'as well as new forms of public-spirited entrepreneurship and innovative non-profit business development' (AAMD 2001a: 2). Public funding agencies can influence the behaviour of art museums if they provide a significant proportion of funds that cannot be substituted. In the UK, where direct funding from central government is crucial to the survival of public art museums designated National Museums and Galleries (NMGs), attention has been devoted to customer-focused delivery as part of new

public sector imperatives (Power 1990). NMGs are subject to scrutiny by the Department of Culture, Media and Sport (DCMS). This includes performance measurement targets like widening participation or access. For example, the key goal for the Victoria & Albert Museum in its Funding Agreement with the DCMS 'is to open up the Museum to the widest possible audience' (DCMS/V&A 2003: para 2.5.1). Genuine audience development means widening the base of spectators – as opposed to the easier marketing task of generating 'more of the same' spectators. Performance targets are identified. There are six specific quantitative targets linked to the DCMS's priorities on children and under-represented social class groups: total number of visitors; number of visits by children; number of venues in England to which objects from the collection are loaned; number of C2-D-E visitors (representing the lower half of the six conventional social class groupings used in the UK) required to achieve an 8 per cent increase by 2005–06 on the 2002–03 baseline; number of website hits (unique users); and number of children in organized educational programmes both on-site and outreach. Qualitative measures (by activity, outcomes, and measures of success) are developed to support the DCMS's priorities on children and young people, the wider community (to promote lifelong learning and social cohesion), and economic impact.

Competitive positioning

Branding has been described as a form of corporate storytelling with a tendency towards anthropomorphism: that is, brands like people have personalities. Commodity is the opposite of brand value: the former assumes low switching costs and little loyalty on the part of consumers between competing suppliers; the latter is based on a high degree of perceived differentiation by consumers, emotional attachment (brands make an appeal to the heart), and high switching costs.

As most commercial galleries are entrepreneurial business ventures, the role of the dealer as owner-operator – the name on the shingle above the door – is crucial to the competitive positioning of the gallery. The personality or charisma of the dealer can be crucial. Individual commercial galleries as retail outlets have a limited life cycle: glance through the advertisements in *Art in America* or *Flash Art* from the late 1980s and one is struck by how many galleries either no longer operate or had yet to be established. This also suggests challenges for succession. Leo Castelli (who died in 1999) was as famous as the artists he represented. For example, his twenty-fifth anniversary lunch photograph (1 February 1982) by Hans Namuth shows Castelli surrounded by leading artists (Andy Warhol, Robert Rauschenberg, Ed Ruscha, and James Rosenquist were seated, while those standing included Ellsworth Kelly, Dan Flavin, Joseph Kosuth, Richard Serra, Jasper Johns, and Claus Oldenberg). A companion photograph would have included Castelli with his collectors!

As an important civic institution, art museums deal with competitive

positioning in a different manner: 'Each museum has a unique identity, and its collections and programs serve the distinctive interest of its community,' according to the AAMD. 'The Museum of Fine Arts, Boston' is not 'the Boston Museum of Fine Arts'. The historical point of reference for the MFA, Boston is the Metropolitan Museum of Art as the two leading art museums to be formed via nineteenth century cultural capitalism. MFA, Boston speaks of an identity as an international art museum that just happens to be situated in Boston – not a regional art museum as the 'Boston MFA' may imply. Moreover, the MFA, Boston considers itself as a private institution (i.e., not in receipt of public subsidy) offering a public service. On the other hand, the Philadelphia Museum of Art is very much a civic institution embedded in Philadelphia (from its legacy dating to the Centennial Exposition of 1876, prominent geographic location at the end of the Benjamin Franklin Parkway, and ongoing relationship with the City of Philadelphia). In conceiving a museum of modern art for London – what opened in 2000 as Tate Modern – Nicholas Serota (1996) had 'urban' (New York's MoMA and Paris's Centre Pompidou) and 'rural' and 'humanistic' (Copenhagen's Louisiana) models in mind: so-called points of parity from a marketing perspective. At the same time, as a good marketer, Serota recognized the need for points of difference – that is the Tate experience had to be particular to London.[5]

Competitive positioning in marketing assumes the context of inter-firm rivalry. How does the firm compete in its chosen business? What is the firm's unique selling proposition (USP)? In particular, Ries and Trout (1981) have been influential in promoting positioning as about battling for the mind of prospects. Market segmentation is about 'managing heterogeneity' (Smith 1956). What are the ways to segment the heterogeneous marketplace into a number of smaller homogeneous segments? How to target the most 'profitable' segments?

Through the marketing perspective of globalization, three art business cases are discussed: the rise of the market for contemporary art, the Guggenheim Foundation's institutional partnerships, and market segmentation in art museums. For example, Theodore Levitt's 'globalization of markets' thesis appeared in *Harvard Business Review* in 1983 and was revisited in 2003 at Harvard Business School (Levitt 1983; HBSWK 2003). Globalism and consumer marketing was the focus of the high-impact paper. There was an emphasis on demand-side preferences (a convergence of taste and plurality of consumption) and supply-side economies of simplicity. The malleability of consumer preference – 'preferences are constantly shaped and re-shaped' (Levitt 1983: 102) – is a worthwhile point. 'With Levitt's help, companies today realize that the market is what they make of it, not what they find' (HBSWK 2003). The globalization of markets, the blurring of boundaries, and fragmentation are trends within the context of competition which have an impact on art business. The core markets of New York and London are supplemented by Switzerland (namely Zurich, Basel, and Geneva), and

the European Union cities of Paris, Cologne, Berlin, Milan, and Madrid. Non-Western entrepôts in Chindia and the Middle East are becoming more significant for the international auctioneers.

The market for contemporary art

Of all art market sectors contemporary art is the most accessible – the barriers to entry for artists, dealers, and collectors are relatively very low. 'Contemporary' is a moving marker (essentially works created during the previous twenty-five years) so there is a continuous supply of artists. Dealers can emerge and develop a reputation within a relatively short period of time. Likewise collectors may be taking a punt on works that have the potential to become classics. There is a sense of opportunity, excitement, and continuous innovation.

Various methods exist for an artist to have dealer representation in several major art centres: the artist's lead (or parent) gallery might manage the relationship with galleries in other countries to ensure consistency in pricing and the quality of collectors; or there may be an understanding that the artist can seek independent gallery representation in other countries. 'Glocal' is the marketing term to suggest a winning combination of global reach and local touch (e.g., HSBC's strapline as 'The world's local bank'). Leading dealers – garnering the adjective mega or super – have been aggressive in opening multiple sites (in the same city and in different key cities) to cater to collectors and to offer wider exposure to artists. For example, in 1999, to celebrate her gallery's tenth anniversary, Andrea Rosen opened Gallery 2 as 'an inspiring and liberating arena to show a large range of selected one-time exhibitions.'[6] More recently, one can cite Gagosian (five galleries and growing), Yvon Lambert (Paris and New York), White Cube (West End and East End galleries in London), and Hauser & Wirth (Zurich, three galleries in London, and in partnership in New York as Zwirner & Wirth) as the leading exponents. This can be viewed as developing in scale and scope (more sites and larger spaces). Artists may be attracted to a gallery that has a distribution network encompassing several major art market centres or spaces large enough to curate museum-like exhibitions. Size and significance may be a factor that attracts publicity in the art press and allows for the most prominent stalls at art fairs. This can enhance the reputation of the gallery in the eyes of collectors. One caveat to multiple sites in different time zones for relationship-based services is over-stretch and the loss of the owner-operator's role in managing crucial exchanges.[7]

The growing interest in collecting contemporary art has encouraged the creation of art fairs catering to different art market segments. Frieze in London and Art Basel Miami Beach represent elite artists, dealers, and collectors with the accoutrements associated with private wealth management and wooing UHNWIs (ultra high net worth individuals). The appearance of so-called 'A-list' celebrities and the type of collector who is listed in *ARTnews* creates a

media-savvy social scene. Of course, the institutional collectors representing the museums of modern art, art foundations, and corporate collections are also important. Alternative art fairs also emerge: Art Basel Miami Beach has spawned a dozen; Zoo, which parallels Frieze, was initiated to promote emerging galleries based in London. One might add that the middle rank of art fairs – often with a regional accent – such as FIAC in Paris, Art Cologne, ARCO in Madrid, and Turin's ARTissima have had to compete harder in the face of elite art fairs to retain leading gallery participation which is a draw for collectors. In 2007 Dubai's Gulf Art Fair was launched with ambitions to compete at the top tier of international contemporary art fairs within five years. At the other end of the art market, the Affordable Art Fair (AAF), which operates in the USA (New York), the UK (London and Bristol), and Australia (Sydney and Melbourne), seeks to encourage neophyte buyers from the aspiring middle classes – some may be upgrading from framed reproductions or seeking an alternative to mass-produced 'luxury brands' – thus keen on the accessible price points ($100–5,000 for New York and £100–3,000 for London) and a welcoming invitation that 'AAF is the fab, funky fair where you can look, love and leave with contemporary art' (used for London). Attention is not on collectors or connoisseurs; rather the buyers may have eclectic tastes and limited specialist knowledge.

Commercial galleries have the advantage of making decisions – Who gets invited to the opening reception at Art Basel and Frieze? Who gets on the waiting list for a hot artist? Which private collectors, who are also museum trustees, should receive preferential treatment? – with a focus on the interests of the artists they represent. For the most part, commercial galleries can bypass the widening participation or access agenda that public art museums must address. For example, a street-level gallery is not considered a necessity (see, for example, Richard Gray in Chicago and New York) – it is a matter of the key collectors being able to reach you.

The Guggenheim Foundation's institutional partnerships

The Guggenheim Foundation's multinational network of museums and cultural partnerships has been the vision of Thomas Krens, since his appointment as director in 1988. At present the Guggenheim owns three museums (the flagship New York site built by Frank Lloyd Wright, the Peggy Guggenheim Collection in Venice, and the Guggenheim Hermitage Museum in Las Vegas) and provides curatorial direction and management services to two museums (Guggenheim Museum Bilbao and Deutsche Guggenheim in Berlin). Two further international partnerships have been pursued by the Guggenheim. In 2005 the Guggenheim announced a bid, in partnership with the Centre Pompidou and property developer Dynamic Sun International, in response to the West Kowloon Cultural District (WKCD) in Hong Kong, which was part of a 40-hectarce waterfront site being developed by the Government of Hong Kong to create 'an integrated arts, cultural, and entertainment district'

that offers 'an exciting possibility for cultural exchange, sharing, and dialogue' (Guggenheim 2005a). The cancellation of the WKCD project by the Government of Hong Kong in 2006 was received by the Guggenheim by the announcement of a joint project in Abu Dhabi, capital of the United Arab Emirates, to establish a museum, the Guggenheim Abu Dhabi, to be designed by Frank Gehry (Guggenheim 2006a).[8] In pushing the boundaries of what it means to be an art museum, Krens has tested what can serve as an exhibition (Smith 2000). For example, 'Giorgio Armani', an exhibition in 2000 devoted to the fashion designer, was criticized as a form of product placement; other controversies include 'Art of the Motorcycle' (sponsored by BMW with BMW motorcycles in the reception) and an exhibition devoted to the motion picture *Star Wars*. 'Rubens and his Age: masterpieces from the Hermitage Museum' featured at the Guggenheim Hermitage Museum at The Venetian (a resort-hotel-casino complex) in 2006. (Of course, other Las Vegas casinos, such as Steve Wynn's Mirage Resorts, have used Van Gogh, Renoir, Picasso and Monet as star attractions, though not in partnership with other museums.)

The current director of New York's MoMA is unimpressed with the Guggenheim's conduct and behaviour:

> What distinguishes the Guggenheim is that rather than keeping a fine balance between the museum as school and theatre, a place of learning and a place of enjoyment, it has focused its energies on becoming an entertainment center and appears to be no longer interested in or committed to the ideas and the art that gave birth to the museum at its founding.
>
> (Glenn Lowry cited in Cuno 2004: 138)

The AAMD, without making reference to the Guggenheim, has raised concern that

> several joint exhibition ventures with for-profit companies have received an increasing level of attention. These newly-emerging collaborations with for-profit partners to organize, travel, and promote museum exhibitions are high-profile exceptions to traditional museum approaches of organizing and funding exhibitions.
>
> (AAMD 2006b: 1)

A more rigorous approach, with consideration of the long-term consequences for art museums from revenue-generating, private–public partnerships, is advised by the AAMD:

> Proponents of exhibition collaborations with for-profit enterprises often make their case by citing changes in our global culture. Their argument is that 'education' and 'entertainment' as well as 'art' and 'experience', are becoming more and more fused. Moreover, the growing sense of

cooperation between for-profit and not-for-profit ventures in many other aspects of daily life has further broken down traditional barriers between these kinds of organizations.

(AAMD 2006b: 1–2)

In a 2006 interview Krens accepted the criticisms from MoMA's Glenn Lowry as part of the competitive rivalry that exists in New York 'among the various institutions for audience and identity' (Guggenheim 2006b). MoMA is the leading museum of modern art in the world, according to Krens, so the Guggenheim needs to develop methods to compete against other top modern art museums such as Tate Modern, the Centre Pompidou, and Amsterdam's Stedelijk. With five venues, the Guggenheim announces that total attendance, which is used by many as an indicator of success, surpasses 2.5 million. Moreover, Krens objects to critics who perceive the Guggenheim exporting a commodity that is somehow the same wherever the Guggenheim is situated. The notion of franchising, with its fast food connotations, is not a word used by Krens. Rather Krens talks of free exchange – as noted in the opening quotation – and 'pioneering' is how Krens describes the various transactions (or partnerships) with other institutions:

> The fact that these institutions would choose to work with us and enter into a long-term agreement to share collections, to share staff, to share programming, in effect, to regard ourselves as a kind of how would you say – free-trade zone or strategic alliance of some kind, I think is significant.

(Guggenheim 2006b)[9]

Krens cites Tate as an example of a public art museum doing nationally – with two museum sites in London and ones in both Liverpool and St Ives – what the Guggenheim is doing internationally: 'it has an opportunity to use its collections and to reach a wider audience, and that's essentially what is driving us' (Guggenheim 2006b). The Guggenheim's business model is admired by Twitchell (2004), who views the international partnerships as a way for the museum as a brand to be leveraged (see Krauss 1990 for an opposing view). In examining what the public art museum might become, a prominent art historian believes that Krens should 'be praised for understanding that only when high art is as popular as mass culture can it compete' (Carrier 2006: 217).

Market segmentation by art museums

'Marketing segmentation is essentially *merchandising* strategy, merchandising being used here in its technical sense as representing the adjustments of market offerings to consumer or user requirements', according to Smith (1956: 6; emphasis in the original). Audience development for art museums can mean the conscious allocation of core resources across different audience segments.

It is from this retailing perspective that Blattberg and Broderick focused on what they perceived to be the key dilemma faced by art museums: having separate and distinct audiences. Several ways to serve such audiences were proffered:

- separating the museum into two distinct parts so that each sub-organization can serve the needs of its constituency effectively
- creating marketing managers who are responsible for understanding the needs of these two distinct segments
- redesigning the product so that the general public is given a product that meets their needs (more involving and more entertaining) while at the same time serving the other audience which like and appreciates more sophisticated art exhibits
- requiring the curatorial staff to think more the way retail buyers do, who not only worry about the quality of the merchandise but also about the appeal of the product to each segment
- creating profit centres to analyse and manage the two distinct museums just as companies manage different products (Blattberg and Broderick 1991: 345).

Anne d'Harnoncourt, director of the Philadelphia Museum of Art, objected to market segmentation as applied:

> I was quite disturbed by the background paper for this conference [organized by the National Bureau of Economic Research to investigate the economics of art museums] that posited the possibility or the necessity of museums' addressing two very different kinds of audiences. The paper argued that there is the collector-donor, sophisticated audience, and there is the general public audience, and museums ought to divide what they do and divide their resources to serve those two audiences quite separately. It seems to me that that may possibly undermine the whole mission of a museum, which is to bring as many people as you can to a kind of experience that they can only get in an art museum: direct contact with a work of art. . . . So I think that the idea of dividing our resources to cultivate donors on one hand, and to please a general public on the other, is dangerous.
>
> (d'Harnoncourt 1991: 36–7)

D'Harnoncourt continued:

> The issue of marketing is a fascinating one, and one that raises every museum hackle that I know. It is an issue that we keep coming back to because no curator and no museum director wants to hang a gallery full of objects or install an exhibition and have nobody there. However, marketing has to do with products, and if you say, let us change

the product to fit what the audience wants, that makes everybody nervous.

<div align="right">(d'Harnoncourt 1991: 37)</div>

In the intervening years since 1991, art museums have become more adept at creating opportunities for spectators to buy stuff and spend cash. Art museums create corporate identities in order to function as a credible liaison between art and commerce (see, for example, Gerber 2003). Commercial-oriented zones like shops and café-restaurants are prominent, situated by the front and highly visible. Moreover, access is available without paying an admission fee. Souvenir shopping is crucial as art museums are marketed as international destination sites. Merchandising is part of the event or experience; it is about offering a tangible association or reminder of an event or experience. Tiered food and drink outlets with different price points, from self-service to decent wine lists, have been adopted by larger art museums. According to MoMA's director:

> The art and food are utterly complementary. The better the food, the more intense the museum experience. . . . I would love it if the Modern [MoMA's new restaurant with the 2004 reopening] emerges as one of the great restaurants in New York.
>
> <div align="right">(Lowry cited in Collins 2004)[10]</div>

Market segmentation is about providing greater maximization of consumer or user satisfactions. Two examples from Tate are illustrative. First, art museums speak of membership as a service that is offered to the general public: it is a commercial exchange not necessarily an act of philanthropy; and access is not limited to those who are 'invited' to join. Friends of Tate has adopted price segmentation, namely determining which of its services add differentiating value for customers and then charging for those services separately. Thus a basic Friend is available for £54 per annum. Add one guest and the price is £75. Additional supplements are available: London private views (£20); Tate Liverpool support (£5); Tate St Ives support (£5). Second, demographic variables, focus groups, and lifestyle metrics are being used by art museums. Attracting younger spectators – aged 16–24 years is a key segment – to the permanent collection through a hook, has been adopted by Tate Modern:

> Tate Tracks is an experiment between art and music.
>
> We invited musicians to walk around Tate Modern and find a piece of art to inspire them to write a track. It's about art inspiring art. Each month, a new track will be showcased on a pair of headphones in front of the work that inspired it.
>
> For one month, Tate Modern will be the only place in the world where you can listen to it.
>
> <div align="right">(www.tate.org.uk/modern/tatetracks)</div>

Partnerships (musician / artist) include Roll Deep / Anish Kapoor; Graham Coxon / Franz Kline; Klaxons / Donald Judd; The Chemical Brothers / Jacob Epstein; and The Long Blondes / Jannis Kounellis. Tate's 'From My Space to Your Space' project – the first event in May 2007 was a giant sleepover for 150 schoolchildren in Tate Modern's Turbine Hall – seeks to involve young people as part of Tate Modern's new extension by Herzog & de Meuron (budgeted at £215 million and anticipated to open before the 2012 Olympic Games in London).

The marketer as mixer

The elements of the marketing mix, now distilled into the 4Ps (of product, promotions, price, and place), owe much to the pioneering work throughout the 1950s and 1960s by HBS's Neil Borden.[11] The marketer is viewed as making operational decisions about the right mix of the 4Ps to best attract customers and fend off competitors. It is important to remember the notion of an art market system as the collective social basis of curators, collectors, critics, dealers, and artists. Innovation is crucial for the art market. The diffusion of innovation, as advanced by Everett Rogers (1962), addresses the process by which an innovation is communicated through channels over time among members of a social system. Marketers refer to adopter categories: innovators, early adopters, early majority, late majority, and laggards. For example, innovators are venturesome and on the cutting-edge; early adopters, where opinion leaders are situated, earn respect for well-informed decision-making; and the early majority, where the so-called 'tipping point' takes place, are described as conformity-loving and cautious, who adopt in order not to lose status. The tipping point thesis as the process in which beyond a certain point, the rate at which the process proceeds increases dramatically has been popularized by Malcolm Gladwell (2000).[12]

By way of illustration, the 1997 Royal Academy exhibition, 'Sensation: works by young British artists from the collection of Charles Saatchi' curated by Norman Rosenthal, is instructive. Several points were promoted to 'early majority' audiences. So-called YBAs served as a loose term used to group artists, with Damien Hirst cited as the most prominent, who graduated from art schools in the late 1980s and early 1990s and grew in prominence in the mid- to late 1990s; this occurred alongside music's Britpop (e.g., Oasis, Blur, Pulp, and Suede) and the Cool Britannia umbrella (which included fashion designers like Stella McCartney and Alexander McQueen). Saatchi as the collector is cited as an innovator. A gallerist like Jay Jopling of White Cube – representing Hirst and Jopling's partner Sam Taylor-Wood – was influential. Likewise Serota, not least of all through the Turner Prize, has also been viewed as shaping public opinion. Critics like the Stuckists, who might be labelled as laggards in resisting the process of adoption, counter that a negative consequence associated with the promotion of the YBAs is homogeneity with a small circle of artists and art production gaining the most attention.[13]

Product

The product represents a bundle of tangible and intangible benefits – including brand values – purchased by the consumer. The dealer offers a work of art, which is very tangible, along with a service including the dealer–collector relationship. A visit to an art museum is a move towards intangibility; indeed, some art museums have embraced services marketing and the concept of marketing an 'experience'.

'It is the artist who makes the name of the dealer' is an apposite saying. The keen eye of the dealer is about talent-spotting and managing the career development of artists. The economic life span of a contemporary art gallery may be limited to the desire of the owner-operator to remain active in looking at new art. Certainly there is the need to represent new and emerging artists alongside established artists. Selection is a crucial decision as the level of commitment is high. For many collectors, the product is the art work itself plus the artist and the dealer's reputation. Editing is a part of the dealer's task to offer a coherent story of what is being offered. What is the aesthetic vision of the dealer? How do the artists sit together? What unites the different bodies of work of an artist? It is about helping the collector to feel confident in making a purchase – that the work is of 'value' and that this value will increase. For example, Sadie Coles trained with Anthony d'Offay before opening Sadie Coles HQ in 1997. Coles represents Sarah Lucas, one of the original YBAs, and the gallery has had an international orientation since the outset (e.g., the first exhibition was by John Currin with early artists from the USA including Elizabeth Peyton and Richard Prince). Moreover, Coles is aware of the need to develop talented artists, and in 2005 two artists were shortlisted for major contemporary art awards in the UK: Jim Lambie for the Turner Prize and Daniel Sinsel for Beck's Futures at the ICA. Likewise, the emergence of contemporary Chinese artists is partly about the need for innovation from time to time in the contemporary art market, so Marian Goodman includes Yang Fudong (born 1971) as a gallery artist.

Contemporary artists and their dealers have recognized the importance of offering products beyond 'original' paintings and sculptures. 'Multiples' or 'limited editions' are an opportunity to leverage the brand value of an artist. Even leading dealers offer such works by gallery artists online. It presents an opportunity for entry level collectors to buy an 'authentic' work by a famous artist at an affordable price point. (It is comparable to luxury brands like Prada or Gucci offering more affordable accessories. And it is not new in art. Rodin signed contracts with multiple foundries to create casts of *The Kiss*. Lithographs by Warhol and Riopelle are readily available.) Media diversity by artists beyond traditional paintings and sculpture have provided challenges and opportunities. For example, even the relative immateriality or gaseous state of works of art (such as performances or land art) can be made tangible and sold in the form of photographic and videographic reproductions.

Visitors to a public art museum can look at works in the permanent

collection. Yet some view this as too static, hence a focus on events-driven programming such as temporary displays (or travelling exhibitions). Temporary exhibitions are marketed like theatrical productions: time-sensitive bookings are made in advance for a particular date and time. Fixed duration and the 'rarity' of having certain works combined together are also features of temporary exhibitions. A buzz needs to be created: book, now, in advance, to avoid missing out on this unique exhibition! How to promote the permanent collection has posed challenges for art museums. Some art museums have shifted from the art object as a source to a spectator orientation (i.e., the art museum serves as a resource for self-reflection by spectators). James Cuno, president and director of the Art Institute of Chicago, refers back to historical roots:

> The purpose of an art museum is to preserve and provide informed access to works of art. In the case of encyclopedic art museums such as the Art Institute of Chicago, this mandate applies to works of art both as discrete, self-referential objects of human artistic production and as representative examples of the world's artistic legacy. . . . Our founders believed that art museums – as civic institutions – would, along with symphony orchestras, theaters, libraries, and schools, civilize the expanding population of the modern, immigrant city. In turn, these recent arrivals to our city brought new and diverse cultural forms from their native lands
> (Cuno in 'Report of the President and Director', in AIC 2006: 5)

There is a transition of sorts from the convention of emphasizing art objects available at art museums to considering the role of spectators and how the art museum caters to non-attenders ('there is nothing I want to see' or 'museums are boring') or the uninitiated who are not able to decode art works on display.

Price

Price is often viewed as a marketing complexity. Achieving profitable pricing practices is fundamental to the concept of exchange.[14] Setting the right price is a marketing challenge as it requires taking into account two factors: value of the product to the buyer and cost to the producer or seller. The correlation between value and cost is not always easy to determine. Different pricing challenges are faced by dealers and art museums.

'Prices are not just about works of art, but also about the people who produce and consume them. Prices serve as a ranking device when it comes to artists' (Velthuis 2005: 8). The dealer needs to document and communicate value to the collector. Dealers want to avoid what is described as 'the most serious impact of price negotiation: [namely that] customers learn that price is a key element in the negotiation' (Cressman 2006: 34). How to focus on value to avoid the destructive cycle of price negotiation? For example, the

ADAA (2000: 4–5) attempts to influence collectors by identifying the key things to consider when weighing a potential purchase: *authenticity* ('no one wants to buy a fake'); *quality* ('it is always advisable to buy the best one can afford'); *rarity* ('rarity tends to enhance value'); *condition* ('a reputable dealer will inform a prospective purchaser of any significant repairs and defects'); *provenance and exhibition history* ('a good provenance can help establish authenticity, art-historical importance and title'); and *value* ('taste and market conditions change and values change accordingly').

Art museums, on the other hand, tend to emphasize other values (aesthetic) over price of acquisition (which very rarely features as part of the message found on didactic boards). As such, attention focuses on entry tariff to the permanent collection as a pricing decision facing almost all public art museums. In the USA, most art museums adopt some form of subsidized pricing such that the visitor does not pay for the full cost: 'Charging admission fees comparable to their expense would create an economic barrier to the public and undermine the museum's role as a public institution' (AAMD 2001a: 1). Even so, MoMA reopened in 2004 with an admission price of $20, arguably the highest in the USA; the Metropolitan followed suit with a 'suggested donation' of $20. In the UK, the NMGs sponsored by the DCMS were able to drop admission charges in 2001, thus offering free entry to the permanent collection.[15] This is part of the current agenda of widening participation and social inclusion (Mirza 2006). Charging entry to the permanent collection is more contested in the UK, where historical links between libraries and museums, which date to the mid-nineteenth century as part of mass education, remain strong by advocates of free entry to museums. (However, all the NMGs in London do charge entry to major temporary exhibitions, comparable in price to West End cinema screenings. Likewise, merchandising and food and drink charges are not covered by the DCMS access mandate.) Sociologists of art, led by Pierre Bourdieu's pioneering work on the role of educational attainment and social origins as key factors influencing arts participation, have as much to contribute to pricing decisions as marketers and public policy makers. To what extent is price the most significant barrier to entry? Do non-price barriers pose a more challenging hurdle for art museums to address? If art museum attendance is a 'lifestyle' choice, what factors help to shape such choices?

Promotions

Promotion is king in the art world. The better known is the dealer or artist the greater the likelihood they are 'the top dogs'. Likewise, so-called superstar museums (Frey 1998) derive such status, in part, from prominence among tourists and world fame among the general public. Promotions or communications is a catch-all term in marketing that includes word-of-mouth, advertising, public relations, sponsorship, and personal selling. Targeted communications is about reaching the key decision makers for organizational

success. Word-of-mouth – whether natural, genuine, and honest or 'manu-factured' – can be crucial. It is about giving people a reason to talk about your brand and making it easier for that conversation to take place.

The art world is performative, thus dealers rely on word-of-mouth to create a buzz. This can be particularly important at art fairs, which are short in duration. Personal selling – essentially managing human relations with artists and collectors – is crucial for a dealer. Remaining in constant contact with artists to follow the progress of work is important; even more so if the gallery seeks the gallery space as a platform for artistic exchange rather than a 'white cube' retailer. Furthermore, there is the effort to promote artists. Given the role of relationships in managing a gallery, personal selling to collectors is vital. Adaptive behavioural techniques are needed as the process is one of helping the prospective collector solve a problem. Advertising is expensive, but it does have signalling benefits to the artists represented by the gallery and other artists the gallery may want to represent. Artists may view the expense incurred by the gallerist as an indication of ongoing commitment to the relationship. For example, the Gagosian Gallery had a one-page advertisement in *Tate etc* (Spring 2007) to congratulate Carsten Höller on being selected for the Unilever Series Commission at Tate Modern.

Art museums nurture corporate sponsors and elite patrons. The outside back cover of the Spring 2007 edition of *Tate etc* was used by UBS to pro-mote 'Saturday Live, a cutting edge programme of live works that aims to make us all think a little differently – which is our goal in business, as well as art.' Both MoMA's reopening and Tate Modern's rehang benefited from UBS sponsorship. It is increasingly difficult to see temporary exhibitions being mounted in the absence of corporate sponsorship, which is used by risk-averse art museums as a form of security in case ticket sales are below target. Developing personal relations with elite patrons is crucial for success-ful fundraising. This includes securing donations of art (which is key to building the permanent collection), enlarging the endowment (based on the strategy of elite universities in the USA where more than fifty have endow-ments in excess of $1 billion), and advancing capital development projects (such as a new museum building or extension). Shorter time cycles are increa-singly common with annual fundraising campaigns.

Place

There has been a tendency to think of place as the physical site where one goes to make a purchase; this has been connoted with real estate, hence being static and difficult to change. Channels of distribution has emerged as a term, which emphasizes flow from producer to consumer through intermediaries. In the secondary art market, there has been a conventional distribution equa-tion: auctioneers as wholesalers, dealers as retailers, and art museums as final repository. In the most flamboyant marketing rhetoric 'place' is reconceived as 'customer-value delivery systems'.

Channel conflict and disintermediation have emerged as distribution topics in marketing. First, in order to achieve overall channel goals auctioneers and dealers should cooperate. However, dealers do face channel conflict from auctioneers when auctioneers engage in private treaty sales, which dealers feel is an abrogation of the conventional role of conducting public auctions. The rise of art restitution means that museums may be 'returning' works of art to the art market. Second, disintermediation has been mooted as a way to reduce costs and enhance service: technological change, namely the internet, has meant that conventional intermediaries have new competitors. Yet dealers may be less susceptible to disintermediation relative to travel agents (competing against the likes of Expedia) and book sellers (competing against Amazon and Abebooks). In a similar vein, there is little direct selling by artists to collectors, that is to say bypassing dealers. In many ways, this highlights the value – and power – of dealers to the art market system. As such, dealers can be hostile to the emergence in the current art market boom of a new intermediary, self-appointed art advisors/consultants (in an unregulated industry), who seek to represent collectors to dealers. Paid by new collectors (clients) – who are used to the professional services of financial and legal advisors in making business decisions – art advisors also attempt to negotiate a commission (approximately 10 per cent) from dealers for each completed sale. More importantly, the dealer–collector relationship takes on a different tenor with an art advisor added to the equation.

The physical presence of the art museum remains important. As such, art museums have two types of 'spaces': external and internal. Both can be considered part of the museum's 'place'. The museum building is an important part of a public art museum's identity and can be considered its external space. During the last several decades superstar architects have been called for new museum buildings and extension projects. A good part of the Guggenheim Bilbao's identity is Frank Gehry's building. More attention is placed on Toronto's Royal Ontario Museum 'crystal' extension by Daniel Libeskind given the collapse of his 'spiral' museum project with the V&A. The internal space is also part of the museum's 'place'. This includes how works in the permanent collection are displayed and what this means for spectators: for example, until its reopening New York's MoMA had a narrative of modernism that accentuated the rise of Abstract Expressionism (Pollock, an American painter, was a successor of the European tradition of Cezanne by way of Picasso); on the other hand, Tate Modern was deliberate in having a series of non-chronological and thematic 'suites' (exhibition spaces), essentially designed for greater fluidity by spectators. The role of 'private' spaces for patrons (called friends or members) as a portion of overall space can be controversial if the art museum is in receipt of significant public funding. Likewise the proportion and location of internal spaces devoted to commercial activities (retail merchandising and food and drink) can be contentious as encroaching on the aesthetic experience. Additionally, in terms of space/place, the role of the internet is of increasing importance. Rather than

being a substitute to a 'physical' visit, an engaging and interactive website can be an invitation to younger and newer audiences.

Multiple locations have become important for commercial galleries and art museums. More commercial galleries are operating multiple locations within the same city and in different cities; likewise, the Guggenheim and Tate are at the fore of operating multiple museum sites. Commercial galleries cite closer ties to collectors and additional spaces to curate exhibitions for artists. Art museums may be looking for new audiences (and patrons) when venturing to the United Arab Emirates and China.

Pros and cons of marketing in art business

Competitive markets are viewed as the customer's best friend. Art business organizations may well agree. An international art fair, whether in Maastricht, Basel, New York, or London, creates an economic cluster by bringing together the main sellers and buyers for a limited period of time. For example, Art Basel has been described as 'a label, marketplace and service. A brand-name that constitutes what would seem an almost unique success story' (Müller 2003: 36). Of course, Maastricht's The European Fine Art Fair could also be cited as an example in Europe. The influence of art fairs for contemporary art (namely Art Basel Miami Beach and Frieze): exposure to the public, and art needs to take on the competition. Rigorous entry criteria, in order to monitor and restrict the participation of commercial galleries, enhance the intensity of inter-gallery rivalry, which benefits private collectors and art museum curators. The piggyback effect with the emergence of alternative art fairs to coincide with the major ones is an indicator of success. Visitors to Tate Modern benefit from the existence of other museums of modern art in New York and Paris and elsewhere as points of reference.

On the other hand, critics see the emergence of marketers as 'new intellectuals' as corrosive to a civil society. They contend that the ideology of marketing places a premium in 'listening to the consumer', that is a neo-liberal discourse of the market with consumption being paramount. A fundamental task of marketing is to teach citizens how to consume. Mass media, advertising, and public relations firms are cited as representing corporate control over ideas and public expression (Ewen 1988; Schiller 1989). Sophisticated marketing imagery has instilled consumerist values in institutions of civil society (Brighton 2002). The AAMD recognizes that corporate sponsorship arrangements generate high publicity for business corporations and art museums:

> American businesses have increasingly viewed art museums as venues for sponsorship both to serve the public interest and to address corporate relations and marketing goals. This circumstance provides obvious opportunities to art museums that seek to expand and diversify their base of financial support and to reach new audiences. At the same time, it

presents challenges to ensure that the museum's educational mission is not compromised by external commercial interests.

(AAMD 2001a: 1–2)

Of course, there are critics who feel that the balance has already tipped in favour of Fortune 500 firms. Visual artist Hans Haacke (see Bourdieu and Haacke 1995) has intervened to shed light on the influence of business corporations on contemporary culture. A similar ideological stance is evident in the critique of Wu (2002) into the growing influence of business corporations in art (e.g., corporate-sponsored art awards and corporate art collections) and the type of exhibitions that can be mounted by public art museums (owing to the reliance of corporate sponsors as underwriters). Twitchell (2004) counters that if 'High Culture' is beginning to look more like the result of our culture, is this blurring of distinctions to be regretted?

Acknowledgements

A much shorter version, which excludes commercial galleries, appears as 'The rise and rise of art marketing discourse', in R. Rentschler and A-M. Hede (eds) (2007) *Museum Marketing: completing in a global marketplace*. Amsterdam: Elsevier Butterworth-Heinemann: 203–14.

Notes

1 AMA definition of marketing was adopted in 2004; see www.marketingpower.com
2 See www.andrearosengallery.com
3 Marketing focuses on customers, whereas finance focuses on the owners (shareholders or stockholders for public companies) and human resource management emphasizes employees.
4 In the USA, most public art museums operate with self-perpetuating boards. Trustees can be groomed with secondary boards and 'junior' (aged 25–40 years) members. More explicit guidelines – modern etiquette rules for new-wealth patrons – have been established by some elite arts organizations of the annual giving expectation of trustees. The so-called 'Great and the Good' (of minor aristocrats, knighted captains of industry, and First Division civil servants, and senior academics) are often tapped in the UK, though the so-called 3Gs culture embedded in the USA, to 'give money, get money, or get off', has yet to take root.
5 It is worthwhile to recognize Serota's political astuteness since he assumed directorship of the Tate Gallery in 1988. He made an argument that the original Millbank site (now Tate Britain) was too small to display the contents of the permanent collection. His first major project was to rehang the permanent collection on an annual basis under the banner New Displays. More significantly, Serota led the debate about why London, as an international city, did not have a museum of modern art; in doing so, he drew attention to the original arrangement at Millbank, of historic British and modern International art under one roof, as an anomaly by international standards.
6 See www.andrearosengallery.com
7 The case of Saatchi & Saatchi, as the advertising agency established by Maurice

and Charles Saatchi, is apposite. Levitt's 'globalization of markets' thesis has been cited as an impetus for the advertising agency to expand in the UK and then aboard as a means to better represent clients operating on a global basis. However, the brothers were ousted from the agency and created M & C Saatchi.

8 At 30,000 square metres, the Abu Dhabi museum will be the only Guggenheim museum in the region and will be larger than any existing Guggenheim worldwide. It is expected that the museum will be constructed within five years.

9 France is also exporting museum culture. For example, the Louvre is also entering Abu Dhabi.

10 The reopening of MoMA in 2004 included comments on the availability of food and drink. With a separate street-level entrance – and not requiring museum entry and offering access beyond MoMA's opening hours – is the Modern, a fine-dining restaurant featuring French-American cuisine; adjacent to it is the Bar Room; moreover, two private dining rooms are available. The Modern is in partnership with Danny Meyer's Union Square Hospitality Group.

11 Borden's teaching method, that is the classic case study method associated with HBS, meant that he used an *aide memoire* of twelve marketing mix elements in discussing business-to-business marketing situations: product planning, price, branding, channels of distribution, personal selling, advertising, promotions, packaging, display, servicing, physical handling, and fact finding and analysis. Most of Borden's elements are incorporated into the 4Ps, yet fact finding and analysis can be considered as a fifth 'P' of probe or marketing research. Moreover, branding has gained heightened prominence since the 1980s; and through the contemporary perspective of relationship marketing and customer relationship management, servicing can be interpreted to encompass activities ranging from personal attention by retail staff to developing long-term buyer–supplier partnerships.

12 Gladwell identifies three personality types: connectors (know lots of people), mavens (accumulate knowledge and have information) and salesmen (skills to persuade).

13 See www.stuckism.com

14 See the work of Thomas Nagle's Strategic Pricing Group, a member of the Monitor Group.

15 Some NMGs with art collections like the British Museum, the National Gallery, the National Portrait Gallery, Tate Modern, Tate Britain, Tate Liverpool and the Wallace Collection already had free entry. The V&A Museum offered free entry in November 2001. Tate St Ives still charges.

References

For the Association of Art Museums Directors, see 'Position papers and reports' at www.aamd.org; Guggenheim material is available from the 'Press office' at www.guggenheim.org; see www.artinfo.com for ArtInfo; www.artdealers.org for the Art Dealers Association of America; www.marketingpower.com for the American Marketing Association; and Andrea Rosen Gallery at www.andrearosengallery.com.

AAMD (Association of Art Museum Directors) (2001a) 'Art museums, private collectors, and the public benefit' (October).

AAMD (2001b) 'Managing the relationship between art museums and corporate sponsors' (October).

AAMD (2001c) 'Revenue generation: an investment in the public service of museums' (October).

AAMD (2006a) 'Good governance and non-profit integrity' (June).

AAMD (2006b) 'Exhibition collaborations between American art museums and for-profit enterprises' (March).

ADAA (Art Dealers Association of America) (2000) *ADAA Collectors' Guide to Working with Dealers*. New York: ADAA.

AIC (Art Institute of Chicago) (2006) *Annual Report 2005/06*. Chicago, IL: AIC.

Blattberg, R. and Broderick, C. (1991) 'Marketing and art museums', in M. Feldstein (ed.) *The Economics of Art Museums*. Chicago, IL: University of Chicago Press.

Bourdieu, P. and Haacke, H. (1995) *Free Exchange*. Randal Johnson, trans. Oxford: Polity Press.

Brighton, A. (ed.) (2002) 'The rise and rise of management discourse', special issues of *Critical Quarterly* 44 (3–4).

Carrier, D. (2006) *Museum Skepticism: a history of the display of art in public galleries*. Durham, NC: Duke University Press.

Collins, G. (2004) 'A destination for food (and some art, too)', *New York Times* (27 October).

Cressman, G. (2006) 'Fixing prices', *Marketing Management* (September/October): 32–37.

Cuno, J. (ed.) (2004) *Whose Muse? Art museums and the public trust*. Princeton, NJ: Princeton University Press.

Danto, A. (1964) 'The artworld', *Journal of Philosophy* 61 (October): 571–84.

DCMS/V&A (Department of Culture, Media and Sport/Victoria & Albert Museum) (2003) 'Three year funding agreement (2003–2006) between the Department for Culture, Media and Sport and the Victoria and Albert Museum'. London: DCMS.

D'Harnoncourt, A. (1991) 'The museum and the public', in M. Feldstein (ed.) *The Economics of Art Museums*. Chicago, IL: University of Chicago Press.

Drucker, P. (1954) *The Practice of Management*. New York: Harper & Row.

Duchamp, M. (1973) [1957] 'The creative act' (1957), reprinted in G. Battcock (ed.) *The New Art*. New York: E.P. Dutton: 46–48.

Ewen, S. (1988) *All Consuming Images: the politics of style in contemporary culture*. New York: Basic Books.

Frey, B. (1998) 'Superstar museums: an economic analysis', *Journal of Cultural Economics*, 22: 113–25.

Gerber, E. (in conversation with B. Wismer and H. Moser) (2003) 'Controversial commercialization: the culture of museum shops', in E. Walliser-Schwarzbart (ed.) *Art Market Switzerland. Passages: the cultural magazine of Pro Helvetia* no. 35. Zurich: Arts Council of Switzerland Pro Helvetia.

Gladwell, M. (2000) *The Tipping Point: how little things can make a big difference*. New York: Little, Brown.

Guggenheim (2005a) 'Centre Pompidou and the Solomon R. Guggenheim Foundation announce partnership for Hong Kong proposal', Press Release (28 October).

Guggenheim (2005b) 'The Solomon R. Guggenheim Foundation: mission, overview, director', Press Release (September).

Guggenheim (2006a) 'Abu Dhabi to build Gehry-designed Guggenheim Museum', Press Release (8 July).

Guggenheim (2006b) 'Thomas Krens, director of the Solomon R. Guggenheim Foundation, talks about the role of museums and the mission of the Guggenheim', *Charlie Rose Show* (3 January).

HBSWK (Harvard Business School Working Knowledge) (2003) 'Historical perspective: Levitt shaped the debate', *HBSWK* (16 June), www.hbswk.hbs.edu/item/3542.

Hyde, L. (1979) *The Gift: imagination and the erotic life of property*. New York: Random House.

Krauss, R. (1990) 'The cultural logic of late capitalism', *October* 54 (Fall): 3–17.

Levitt, T. (1960) 'Marketing myopia', *Harvard Business Review* (July–August): 45–56.

Levitt, T. (1983) 'The globalization of markets', *Harvard Business Review* (May–June): 92–102.

Marguerat, F. (2003) 'Four variations on a theme: dealers and their artists', in E. Walliser-Schwarzbart (ed.) *Art Market Switzerland. Passages: the cultural magazine of Pro Helvetia* no. 35. Zurich: Arts Council of Switzerland Pro Helvetia.

Morris Hargreaves McIntyre (2004) *Taste Buds: how to cultivate the art market*. London: Arts Council of England.

Mirza, M. (ed.) (2006) *Culture Vultures: is UK arts policy damaging the arts?* London: Policy Exchange.

Müller, H-J. (2003) Who's afraid of the avant-garde? Art Basel – popularizing contemporary art', in Walliser-Schwarzbart (2003): 34–36.

Nagle, T. and Cressman, G. (2002) 'Don't just set prices, manage them', *Marketing Management* (November–December): 29–33.

Omlin, S. (2003) 'Setting a value on art: indices, ratings and closed systems,' in Walliser-Schwarzbart (2003): 15–20.

Ostrower, F. (2002) *Trustees of Culture: power, wealth, and status on elite art boards*. Chicago, IL: University of Chicago Press.

Pavitt, J. (ed.) (2000) *Brandnew*. London: V&A Publications.

Power, M. (1994) *The Audit Explosion*. London: Demos.

Ries, A. and Trout, J. (1981) *Positioning: the battle for your mind*. New York: McGraw-Hill.

Rogers, E. (1962) *Diffusion of Innovations*. New York: Simon & Schuster.

Schiller, H. (1989) *Culture, Inc.: the corporate takeover of public expression*. New York: Oxford University Press.

Serota, N. (1996) *Experience or Interpretation: the dilemma of museums of modern art*. London: Thames & Hudson.

Smith, R. (2000) 'Memo to art museums: don't give up on art', *New York Times* (3 December).

Smith, W. (1956) 'Product differentiation and market segmentation as alternative marketing strategies', *Journal of Marketing* (July): 3–8.

Twitchell, J. (2004) *Branded Nation: the marketing of Megachurch, College Inc., and Museumworld*. New York: Simon & Schuster.

Velthuis, O. (2005) *Talking Prices: symbolic meanings of prices on the market for contemporary art*. Princeton, NJ: Princeton University Press.

Webster, F. (1992) 'The changing role of marketing in the corporation', *Journal of Marketing* (October): 1–17.

Wu, Chin-tao. (2002) *Privatizing Culture: corporate art intervention since the 1980s*. London: Verso.

Part III

Regulatory, legal, and ethical issues in the art world

8 Authorship and authentication

Henry Lydiate

Introduction

Authentication of authorship of an art work is an important artistic and art business issue. Both issues are interrelated: whether or not a work is an authentic Giotto, Rembrandt, Van Gogh, Dali, Pollock or Warhol is just as important to the art historian, curator and critic as it is the seller, buyer, dealer, investor, insurer or auctioneer. Academic art experts inform, influence and advise art market professionals in their commercial dealings.

Consideration of authentication of artworks cannot fail to raise the issue of contemporary works by German artist Hans Haacke, who memorably created works that dealt centrally with issues of authenticity and provenance. In 1974 Haacke was asked to contribute a new work to an international group show, *PROJEKT 74*, at the Wallraf-Richartz-Museum in Cologne, celebrating its 150th anniversary. He conceived an installation work, *Manet-PROJEKT 74*, about the provenance of a painting in the museum's permanent collection by Manet, *Bunch of Asparagus* (1880) that would be exhibited on an easel, together with ten wall panels containing information about the lineage of the original work, from Manet's studio through many changes of ownership, to the present. Social and economic details of the many owners of the work would be displayed on the panels, particularly a well-known German financier who had assisted in the Museum's buying of the original painting, and whose financial operations dated back through the Nazi era. It was out of respect for this man that the Museum announced its decision to reject Haacke's proposed conceptual art work, which was therefore not shown. But Haacke's concept has been well documented and is referenced to this day; one critic viewed the *Manet-PROJEKT 74* work as a 'powerful allegory' of Walter Benjamin's maxim (from his thesis on the Philosophy of History) that 'there is no document of civilization which is not at the same time a document of barbarism'. Undaunted, however, in 1975 Haacke recycled his concept to produce and successfully exhibit a work, *Seurat's Les Poseuses (Small Version) 1888–1975*. Both these conceptual works relied upon the existence of credible evidence of the making of the work and its lineage of ownership over ninety years.

All legitimate lines of enquiry should, ideally, lead back to the original artist's studio, as should enquiries to resolve related legal issues, such as who has the legal right to own and deal with the object; to reproduce, publish or otherwise merchandise a copy of the object; or to alter or change the object after its completion by the original author.

The older the art work, the more difficult it is to achieve a satisfactory or convincing audit trail back to the original artist (who may have died centuries before), in which case the art market, particularly buyers and collectors, ultimately decides the current market value (usually, but not always, advised by academic art experts). The newer the art work, the easier authentication should be, especially where the original artist is still alive or died in recent times.

This chapter explores key ethical, legal and practical issues involved and arising. Lineage is the heart of the matter, and so our explorations will be chronological.

Antiquities and Old Masters

Up to and including the Dark Ages, hard evidence about artists, their works and working practices is inevitably scarce, and authentication of art work made during those centuries is undertaken more through a mixture of scientific analyses of the objects and scholarly guesses and assumptions, than by documentary audit trails back to the original artist.

Just as the Italian Renaissance shed light on the nature and content of Western art, posterity has also benefited from the survival of a wealth of documentation detailing the commercial transactions of (mostly commissioned) artists during that seminal art historical period, and to a certain extent beyond it. Surviving letters of the artists, their assistants, benefactors, patrons, commissioners, and related legal documents, paint a vivid picture of the successful artist operating also as a sophisticated business manager. Written commission contracts appear to have been the norm, specifying in elaborate detail what should be created (say, a three-panelled altarpiece), detailed design specifications (often requiring figurative representations of the patron and his family), the nature and extent of the hands-on involvement of the maestro (who must paint the faces and hands, though his assistants may paint background or clothing), specification of materials to be used (so much *lapis lazuli* or gold leaf), completion and delivery dates, installation arrangements, a guarantee of how long the work would last, and the master's overall fee to be paid in stages. The survival of such enormously valuable documentation into modern times, as well as the works in question, can put beyond doubt authorship and authentication issues.

The creation of moveable artworks emerged out of the Italian High Renaissance, and through the Mannerist period, when the foundations of what we now know as the secondary art market were developed. In other words, artworks also began to be bought and sold as commodities or gifted,

often as a demonstration of wealth, social standing and the possession of high cultural values.

The commodification of moveable artworks accelerated in the Netherlands during the seventeenth century. As the most powerful and successful trading nation in the then developed world, the Dutch economy boomed, and the considerable disposable incomes of newly rich trading classes fuelled what became a booming trade in commissioning, buying, selling, and investing in paintings, particularly though not exclusively from Dutch painters like Vermeer and Rembrandt. This period coincided with the North European Protestant Reformation of Western Christianity, which stimulated the increasing secularization of artist's subjects – Vermeer's *Girl with a Pearl Earring* (1660–05); Rembrandt's *Anatomy Lesson of Doctor Tulp* (1632) – and attracted secular art dealers and collectors, and (with increasing circularity) encouraged artists to create uncommissioned, speculative, autonomous works to stock the thriving market. And the market gradually began to spread, first through Western Europe, eventually throughout the developed world.

Old Master paintings from this period onwards have become the subject of authorship and authentication disputes, largely due to the absence of credible and detailed documentation contemporary to the original authorship. Over the intervening centuries to date, this has led to many disputes – academic, curatorial, legal and business: acceptance or repudiation of an art work in an artist's canon; whether and if so how to tackle problems of conservation, restoration and replacement; the deliberate fabrication of fakes and forgeries; and intentionally, recklessly or carelessly trading in artworks of questionable authorship. In the absence of persuasive contemporary evidence, heavy reliance is placed on academic experts to achieve resolutions. In recent times, for example, academic experts have judged that studio assistants, followers or imitators, in fact painted some works that for centuries had been accepted as original Rembrandt's. Such repudiations or declassifications can have enormously deleterious consequences for an owner of such a work when it comes to reselling such inauthentic work in the art market.

Further legal and business complications can and often do arise, through the absence of persuasive contemporary evidence and, more especially, from the absence of a credible documentary audit trail from the original author, to its first transfer or sale out of the artist's possession, through the many changes of legal possession and ownership, to the latest owner who wishes to bring it to the art market for sale. And this is where good evidence of a legitimate audit trail of ownership, and of original authorship, so often coincide.

Modern and Contemporary art

The second half of the nineteenth century saw the birth not only of Modern Art, but also of the image of the artist as an outsider, estranged from mainstream society both in thought and expression, and in lifestyle. From around

the time of Manet's painting of *Le Déjeuner sur l'herbe* and the establishment by him and his so-called Impressionist fellow painters of the *Salon des Refusés*, in 1863, *la bohème* was rapidly becoming society's normal perception of the artist. These new bohemians chose internal, personal, emigration from contemporary culture, often physically removing themselves from western civilization to distant exotic lands – like Gauguin's self-imposed exile in Tahiti.

Although the works of Modern artists are relatively closer to us in time, which ought to make it easier to establish the provenance of their works (both in terms of true authorship and of legal ownership), the nature of their bohemian lifestyles and attitudes to their contemporary society more often than not resulted in less clear evidence than is available from earlier times. It almost became the norm for artists to sell or give away their works without bothering with contractual or documentary formalities, for the new owners to do likewise, and so on down the market chain – until there came a legal or business challenge to the latest seller about true authorship or legal ownership.

Such bohemian attitudes and sloppy conduct of the commercial dimension of artistic practice were adopted by generation after generation of Modern artists, and on into the contemporary era, where it is still commonplace for artists' studio sales to be executed without formal documentation – and for collectors to acquiesce accordingly. But in the case of living artists and those who died less than seventy years ago, international intellectual property laws can and do have vital roles to play in resolving authorship and authentication disputes.

Most countries now have copyright laws, automatically giving to the author of an original art work exclusive legal rights of reproduction and merchandising, thereby enabling them to prevent or authorise others doing so; such rights normally last for up to seventy years after the artist's death. International copyright laws are helpful in addressing questions of authorship, because for over two centuries legislators throughout the world have had to define in statute who is an author, or joint author. In the UK, for example, the current definitions are: 'author' in relation to an artistic work means the person who creates it; and 'work of joint authorship' means a work produced by the collaboration of two or more 'authors' in which the contribution of each 'author' is not distinct from that of the other 'author' or 'authors'. Other countries have similar definitions, and they raise important professional practice issues for contemporary artists who engage studio assistants to create or help to create their works, or who work in creative partnership – especially in the making of mixed media artworks. Such professional practice issues can be readily resolved through the use of written contracts of employment for studio assistants (as was evidently done during the Italian Renaissance), and of written partnership agreements between creative collaborators.

But international copyright laws are also important because they are

inextricably linked with related intellectual property laws that go to the heart of the matter: statutory moral rights. These were developed in France during the *fin de siècle* and on into the early twentieth century, and are based upon the unique French philosophical and jurisprudential concept of *droit d'auteurs*. There are several statutory moral rights laws, automatically giving to the author of a copyright art work certain exclusive legal rights, including the right to claim true authorship, and the right to prevent what the English call 'false attribution of authorship' – and the French call *droit de paternité*. In most countries, such rights last for the same length as copyright (for up to seventy years after the artist's death), except in the USA where they last up to but not beyond the artist's death, and in France where they last indefinitely. These rights mean that artists or their estates have the exclusive legal right to assert that a work is a true original of theirs, or to prevent others from asserting that a work is theirs when it is not.

An exploration of three contemporary attribution disputes – Dali, Pollock and Warhol – will serve to illustrate and clarify.

Dali

The surrealist artist Salvador Dali died in 1989, but his legacy caused substantial legal problems of an equally surrealist nature for a dozen or so years after his death. The litigants were the Gala-Salvador Dali Foundation, established by the artist to curate his works and manage his Museum at Figueres in Catalonia, and Demart, the company he established to administer his intellectual property rights. Accordingly, when Dali died, his works went in one direction, to his Foundation, and his intellectual property rights (including his statutory moral rights to claim or deny true authorship) in another, to Demart. The conflict between these two commercial vehicles, established during Dali's life with his approval, centred on the concerns of the Foundation about the way Demart dealt with Dali's intellectual property rights. Indeed, the Foundation sought the legal right to administer Dali's intellectual property rights on the grounds that Demart had failed to do so properly.

Dali established the Foundation in 1982 in order to manage his museum at Figueres, and also to protect and promote his work. The Demart company was created in 1985, and Dali then signed over to it all of his intellectual property rights until 2004. The beneficiaries of Demart's business profits would be Dali (until his death) and the Foundation. Dali's concept was simple: Demart would generate income to support the Foundation. However, after Dali's death in 1989, difficulties arose when Demart's operating costs prevented sufficient profit from copyright royalties being paid to the Foundation. In 1994 the Foundation tried to become the administrator of Demart's intellectual property rights, against the latter's wishes. In 1995 the Spanish government was persuaded by the Foundation to enact legislation transferring the administration of Demart's rights to the Foundation, and in 1997 the Spanish High Court (and in 1999 the Spanish Supreme Court) confirmed the

lawfulness of this action. The Spanish king, Juan Carlos, is honorary president of the Foundation and was publicly vocal in his support of this move. Later in 1999 Demart issued court proceedings in Spain, claiming that the Spanish government's transfer of the rights was unlawful.

In other words, at the heart of the litigation lay the directly conflicting claims from the two parties that each had the exclusive right to administer Dali's intellectual property rights throughout the world. This made it extremely difficult, if not impossible, for legitimate would-be users of Dali's images to negotiate copyright licensing deals to merchandise them, and for issues of authorship and authenticity to be authoritatively settled.

What made this bizarre situation surreal was that Dali's works had been the subject of arguably the most acts of forgery and counterfeiting encountered in modern times. It is generally acknowledged that Dali during his lifetime readily signed blank sheets of paper, for a fee, which would-be publishers might use later; estimates range from 100,000 to 500,000 such sheets. This resulted in large numbers of works being of very questionable authenticity, which it should have been the earnest task of both Demart and the Foundation to be pursuing rather than fighting each other, especially when Robert Descharnes, Dali's old friend and Director of Demart was widely acknowledged as one of the world's leading Dali authentication experts (a matter which was also wrapped into the Demart – Foundation dispute because the latter body questioned his credibility as such an authority).

A further complicating factor was whether Dali had the legal right to assign his statutory moral rights to Demart in 1986, three years before his death. Under UK law, which follows the approach taken by most countries in the world, statutory moral rights cannot be 'assigned' (transferred to someone else) by the artist. This is because, unlike copyright, moral rights are personal and not economic rights. Moral rights legislation usually makes special provisions for transfer of moral rights at the artist's death: in the UK such rights automatically pass to anybody named in the artist's will but, if there is no such provision in a will, the moral rights pass to the artist's estate – in Dali's case, this would be the Foundation.

In July 2004, the Foundation published the following statement:

> Demart has accepted the claim brought by the Foundation whereby it sought the dissolution of the Salvador Dalí Pro Arte Trust. As a result, the Foundation will become the full owner of the entire stock capital of Demart, which it had already been managing as the sole director. The Foundation withdraws the legal action brought against Demart worldwide since the situation is now such that it is unnecessary to continue with the action. Demart withdraws all of the legal action it had brought against the Spanish State and the Dalí Foundation or third parties regarding matters affecting the dispute concerning the industrial or intellectual property rights, which the foundation currently directly or indirectly controls.

This is great news that the Foundation is pleased to announce to the art market, since it finally brings a peaceful end to legal disputes that have now been entirely overcome. This is the best possible way to honour Salvador Dalí on the occasion of the centenary of his birth.

Thus ended a legal saga that had damaged the market for Dali's works for more than a decade after his death, with all the intellectual property rights, including statutory moral rights to determine true authorship, now in the hands of one body, the Dali Foundation.

Pollock

The Pollock-Krasner Foundation is (at the time of writing) in dispute with Professor Ellen G. Landau, a Jackson Pollock expert based at Case Western University, who authenticated thirty-two works discovered in 2002, including twenty-two small drip paintings on board.[1] Landau's opinion that the works are Pollock originals is supported by strong circumstantial evidence: they were discovered by Alex Matter, the son of Pollock's friend the photographer and designer Herbert Matter (1907–84) and the painter Mercedes Matter, who had labelled them as Pollock experiments executed in the 1940s, and had placed them in storage. Landau's credentials as a Pollock expert are also strong: she had been a member of the Pollock-Krasner Foundation's authentication board until it was wound up in 1995.

The dispute arose after the Foundation had sent six transparencies of the Matter finds to a professor of physics at the University of Oregon, Richard Taylor, who is a painter, an art theorist, and – significantly – a pioneer in a new authentication technique know as 'fractal analysis' (images are magnified, and repeated patterns identified). Taylor compared his findings in relation to the newly discovered works with previous works (that had been accepted by the Foundation as authentic Pollocks), which he had also subjected to fractal analysis. He found 'significant differences'. Taylor's full report is with the Foundation, and it has triggered the co-authors of Pollock's *catalogue raisonné* publicly to doubt the authenticity of the new finds.

In February 2006, the Foundation published a brief statement setting out its position regarding the disputed works, which is reproduced here in full:

> The Pollock-Krasner Foundation has reviewed the findings of Professor Richard Taylor of the Department of Physics at the University of Oregon concerning his testing of a group of newly discovered paintings attributed to the American Abstract Expressionist artist Jackson Pollock (1912–1956). The study was conducted as part of the Foundation's ongoing investigation into the authorship of these works. Taylor's findings are reported today in a news article in the scientific journal *Nature* (vol. 439: 648, 9 Feb 2006).

Taylor, a leading authority and pioneer in the field of fractal analysis, has studied the work of Jackson Pollock since the mid-1990s and has compiled a database of scientific information about Pollock's work. Taylor states:

> Over the course of our research, my group has developed a computer pattern analysis technique – Dimensional Interplay Analysis – that detects artists' characteristic patterns in their paintings. All of Jackson Pollock's poured paintings analyzed by my research group are composed of a highly specific and identifiable form of fractal patterning. When paintings attributed to Pollock are analyzed, the computer looks for the specific fractal signature that we have found in Pollock's poured paintings.

Taylor's initial discovery of Pollock's fractal patterns first appeared in *Nature* (vol. 399: 422, June 1999). Taylor continues:

> Our analysis has revealed significant differences between the patterns of the six paintings submitted by the Pollock-Krasner Foundation and our database of the fractal nature of Pollock's paintings that we have analyzed. These differences indicate that Pollock's specific fractal signature has not been found in the submitted paintings. The analysis has also revealed that the patterns vary between the paintings, indicating that they may have been painted by different hands.

The investigation by the Pollock-Krasner Foundation is under the direction of the art historian Dr Francis V. O'Connor, co-editor of the Jackson Pollock *catalogue raisonné*, the definitive five-volume inventory of Pollock's work. O'Connor, who has studied Pollock's work for more than forty years, states:

> The sophistication of Professor Taylor's methodology is admirable; he is capable of both distinguishing between and comparing the fractal patterns of Pollock's body English or signature, and the fractal patterns of poured fluid. His method goes beyond just recognizing the latter patterns as fractal patterns in Pollock (poured paint is poured paint). He also recognizes patterns unique to Pollock. Integrating fractal traces of Pollock's physiology into the process of pouring is the basis for the validity of his testing.
>
> Professor Taylor's fractal test results reinforce my own skepticism and reservations concerning the paintings in question. The historical documentation to date provides no conclusive proof that the new works can be attributed to Pollock. Further, a careful stylistic inspection of Pollock's poured works from the period in which the paintings are supposed to have been painted – roughly 1943 to 1950 – reveals no relation to Pollock's known stylistic development.

As part of its investigation, the Foundation has assembled a team of experts to review the paintings in question and has requested supporting materials to document the works from the group claiming the Pollock attribution. Information requested includes:

- a complete set of pre-conservation photographs
- a list of the experts commissioned to analyze the works
- the results of provenance, scientific and forensic analysis
- any new information that would provide credible supporting evidence for the authenticity of the works.

Charles C. Bergman, Chairman of the Board and CEO of the Pollock-Krasner Foundation, states:

> The results of Professor Taylor's analysis provide a valuable contribution to our investigation. The Pollock-Krasner Foundation will review the results of any additional materials or research once it is made available. The Foundation is withholding any final opinions as to the attribution of the newly discovered paintings until further research is completed and a consensus of scholars who have had hands-on experience with Pollock's work supports a final decision. The assertion that the newly discovered paintings are by Jackson Pollock was made in 2005 by the owner of the paintings, Alex Matter; art dealer Mark Borghi of Mark Borghi Fine Arts, Inc., New York; and art historian Ellen Landau.
>
> The Pollock-Krasner Foundation is heir to the legacy of the artists Jackson Pollock and Lee Krasner. It is therefore deeply concerned about the integrity of its founding artists' reputation and works. The Pollock-Krasner Foundation's mission is to aid, internationally, those individuals who have worked as artists over a significant period of time. The Foundation's dual criteria for grants are recognizable artistic merit and financial need, whether professional or personal.

Whether this authentication dispute will develop into litigation is unclear. As explained earlier, US legislation dealing with attribution of authorship is significantly different to such legislation in the UK, European Union (EU) and elsewhere in the world. In the USA, an artist's statutory right to claim or deny authorship of work exists only until death. In this case, therefore, it seems that the Pollock-Krasner Foundation would not have the statutory moral rights to determine true authorship that they would enjoy in the EU and elsewhere.

Warhol

The Andy Warhol Art Authentication Board has provoked great media interest through its 'denied authentication' of yet another collector's professed

Warhol picture, one of a limited edition of *Self-Portrait* silk-screens made in 1964–65. The collector was Joe Simon, a London-based film producer. He bought the silk-screen as an investment in 1988 within a year of Warhol's death, paying £120,000. The picture's provenance appeared to have been well established. Warhol had made an acetate of a photographic self-portrait, which he gave to a friend, Richard Ekstract, to make the silk-screens as decorations for a party celebrating the premiere of Warhol's first underground video. Ekstract sent the acetate to a printer. After the party, Warhol gave the pictures to Ekstract in gratitude for his having facilitated both the video production and the party. Ekstract gave some of the limited edition to partygoers. The Andy Warhol Foundation, established by Warhol through his will, authenticated Simon's picture, as did Fred Hughes, who is the sole executor of Warhol's will, and his former business manager. Simon proposed to sell his picture for around £1.4 million, and a potential buyer submitted it to the Andy Warhol Art Authentication Board, Inc. for authentication.

The Andy Warhol Art Authentication Board, Inc. is a limited liability company registered in New York State. Its website is minimal, merely saying 'a procedure has been established for the authentication of works of art purportedly by Andy Warhol', that it 'does not offer any appraisal services', gives Claudia Defendi as the contact name, and a Manhattan address and landline. Its website is accessed via The Andy Warhol Foundation For Visual Arts, Inc: www.warholfoundation.org/authen.htm.

The Foundation is a separate limited liability company also registered in New York State, and its website offers the link directly to the Board – without further explanation of their legal or business relationship. The Foundation, not the Board, was established through Warhol's will and was therefore the legal body specifically entrusted and empowered by him to safeguard and promote his artistic legacy, and has commissioned and already published three volumes of Warhol's *Catalogue Raisonné* (paintings and sculpture from 1961 to 1969), with two more volumes in train. Given these uniquely authoritative publications by the Foundation, and its direct personal links with Warhol up to his death, it is difficult to fathom why it does not itself authenticate authorship of 'works purportedly by Andy Warhol'. Applicants to the Board say that it does not certify or discuss why it denies authentication (to around one in six submissions). It is widely believed that the Board's essential criterion for authenticating a work is whether it is satisfied that there is good evidence of Warhol's having supervised and overseen its creation. Given the common knowledge and ample documentary evidence of Warhol's unique and deliberately perverse ways of working, especially during The Factory years, it might have again been expected that the Foundation was the best body to understand such ways of working, to interpret and decide all authentication issues.

Art historian and friend of Warhol, John Richardson, owns works given to him directly by Warhol, but has said that even he would not 'dare submit

these things to the Board for fear of being told they're not by Andy', and questions whether it is possible to authenticate Warhol's output: 'He used to do these silk-screens, and assistants would come in at night and run off a few copies for themselves. But did they make them any less authentic than the ones they ran off for Andy during the day?'. For many years Warhol engaged teams of assistants to execute his ideas. Paul Morrissey, Warhol's former manager of The Factory, maintains: 'There's no such thing as an authentic Warhol'. Ronnie Cutrone, a Warhol assistant: 'Actually, Andy rarely got involved. He had an ability to let go and say, "You do it". It was easy to rip off his paintings and sign them'. Sam Green, who curated some Warhol shows: 'I would do his signature. Andy only cared about authorship when it came to selling.'

Warhol actively encouraged such challenges to hitherto traditional approaches to authorship: 'Why don't you ask my assistant Gerard Malanga some questions? He did a lot of my paintings'. And *à propos* his *Flower* paintings:

> I decided I won't sign the fake ones that're turning up all over Europe – the ones that people told us they bought from Gerard. Maybe I should do new ones and make good on the fakes in Europe. I don't know. I'll see.

On the back of some of the fakes made of his print portfolios (*Marilyn Monroe* 1967 and *Flowers* 1970) Warhol endorsed: 'This is not by me. Andy Warhol.'

As Warhol's works continue to circulate throughout the secondary global art market, vast sums of money have been and continue to be invested in their purchase and sale, and the achievement of huge profits (or losses) will largely depend on buyers' (and/or their agents') satisfaction as to authenticity. The Board appears already to have established itself with art market professionals as the preferred authentication authority, not the Foundation or other Warhol experts.

The Board requires all applicants submitting works for authentication to sign an undertaking not to challenge the Board's decision in court. The validity of this purported waiver of legal rights has yet to be legally challenged. The strongest legal contestant should be the Foundation, since it should own Warhol's statutory moral rights to claim or to prevent false attribution of his authorship. As explained earlier, under international intellectual property laws, these rights should last for the same length as copyright (in Warhol's case probably for decades to come), but under US law such rights apply only in respect of works in the artist's ownership at death (and which were presumably inherited from Warhol by the Foundation). In the case of works not owned by Warhol at his death (i.e. the vast majority, now circulating in the global secondary art market) these rights will have expired at Warhol's death. This effectively produces a *Catch-22* situation: only works inherited from Warhol by the Foundation – and not works that were sold or given away by

him – can be the subject of legal challenge, but only by the Foundation; and since the Foundation appears to be acquiescing in (if not tacitly supporting) the authentication decisions of the separate authentication Board, collectors of works during Warhol's lifetime appear to have no legal remedy under current US law.

Envoi: back to the future

As stated at the outset, lineage is at the heart of the matter. Living artists could greatly help themselves, their heirs and successors of their artistic estate – as well as assisting future art academics and market professionals – by adopting good professional business practices of the Renaissance period, namely by documenting their works from initial ideas, through execution to first studio sale or transfer; and for art market traders always to do likewise: to ensure the accumulation and perpetuation of sound provenance of true original authorship and true legal ownership.

Note by the editors

1 The dispute of the paintings attributed to Jackson Pollock by Alex Matter is ongoing. Harvard University Art Museums released a document at the end of December 2006 'Technical Analysis of Three Paintings Attributed to Jackson Pollock' (which is available at www.artmuseums.harvard.edu under 'Research'). 'The Harvard University Art Museums have conducted an independent, pro-bono analysis of three of a group of thirty-two recently discovered works thought to be by Jackson Pollock (1912–1956)' as 'part of a broader ongoing investigation into the materials and techniques used by twentieth century artists and fits with the Art Museums' mission of object-based teaching and critical inquiry'. The three works were analysed using a variety of techniques to determine the age and composition of their materials, with the following conclusions: 'Some pigments raised questions about the proposed date of creation of the three works the research team analyzed (1946–49)'; and 'Some media raised similar questions'. A series of related responses, essentially press releases from late January 2007, are collected at www.pollockexhibits.com, which also promote the Pollock Matters exhibition (September 2007):

> The Museum of Fine Arts, Boston (MFA) is conducting scientific research on four paintings attributed to Jackson Pollock by Alex Matter, the son of photographer Herbert Matter, for the exhibition Pollock Matters at the McMullen Museum of Art at Boston College.
>
> (MFA)

> Scientific analysis can attempt to eliminate a work of art as genuine, but it can't determine if it is indeed the work of any given artist. That has been, and remains, the job of the scholar. A number of leading Pollock scholars have examined the paintings discovered by Alex Matter, through a range of methods from technical analysis to connoisseurship. Many attribute them to Jackson Pollock and nothing in the Harvard report effectively challenges that.
>
> (Alex Matter via Zucker Public Relations)

If someone other than Pollock did do these paintings, he or she had an amazing knowledge of Pollock's working methods. This includes knowing exactly how Pollock made corrections as he went along (information not publicly available until the MoMA conservators report published in 1999).

(Ellen Landau: response to the Harvard report)

9 Celebrating the artist's resale right

Joanna Cave

Introduction

On 14 February 2006 the Artist's Resale Regulations were implemented in the UK. Sharing a date with the feast of St Valentine served as a reminder that, just as the path of true love is said not to run smoothly, the progress of this legislation has been fraught with tension, debate and strong feelings, producing a result that was the cause of celebration for some and commiseration for others.

This chapter puts the case for celebration. The Artist's Resale Right entitles artists (and their beneficiaries) whose work is protected by copyright to a percentage share of the sale price every time their art work is resold by or to a gallery, dealer or auction house.

An artist's entitlement to benefit from the right is subject to a number of conditions, but in simple terms this law has the potential to generate additional income for creators of art. Most readers will appreciate how valuable this could be for artists, the majority of whom struggle to generate sales and obtain commissions. But the resale right does more than just reward artists financially: by creating an ongoing link with the original artist, this new legislation also serves to remind art market professionals, buyers and sellers, who created the art in the first place. Artists have welcomed the royalties they are now receiving and will hopefully be encouraged by the prospect of obtaining greater recognition in a fiercely competitive field where many try but few succeed to make a living and establish a reputation from their art.

This chapter will consider in detail how the legislation benefits artists by exploring the origins of the law; considering the intentions and provisions of the European Directive; examining how the Directive has been interpreted by the UK government and transposed into domestic legislation; considering the impact it has had to date; analysing how the law is working in practice (including explaining the role of the collecting society) and contemplating future developments.

How intellectual property rights benefit artists

It is generally acknowledged that creativity, in all its forms, improves our lives individually, enriches our society as a whole and benefits the economy. Visual art now spans a huge range of activity, from painting to photography to installation and an increasing number of visual creators have developed new working practices across these disciplines. From the high-profile Young British Artists movement of the 1990s, the phenomenally successful launch of Tate Modern in 2000 and the impact of major collectors such as Charles Saatchi, it would seem that art has achieved a new popularity. This trend has been reflected economically. The British art market has grown by a staggering 600 per cent since 2002 and is estimated to be worth £4.2 billion.

The impact on the individual artist is more complex. There are some examples of stellar success, both in terms of profile and wealth – consider for example Tracey Emin, David Hockney, and David Bailey. However, many artists find it hard to survive in an increasingly changing and highly competitive environment. Almost 50 per cent of all artists and visual creators fail to earn a living from their art,[1] a percentage that rises significantly among certain groups, such as painters and sculptors. Those practitioners who depend upon commissioned work, such as illustrators, have experienced a slump in demand in recent years. Photographers face new threats to their professional practice through the power of global image suppliers such as Getty and Corbis. In recent years, the Arts Council of England has responded to this trend by focusing on assisting individuals, in a marked shift away from awarding grant funding to arts institutions, in order 'to stimulate the economy for artists.'[2]

Against this background, the intellectual property rights to which creators are legally entitled such as the Artist's Resale Right have never had such an important part to play in the life of an artist.

Origins of the Artist's Resale Right

In fact, the romantic associations of the Artist's Resale Right existed prior to the chosen date for implementation in the UK. Following the death of the great French painter Jean-François Millet, which apparently left his family destitute, a Millet painting achieved an auction sale price of FF1 million, having previously sold in his lifetime for FF1,200.

Apparently, this sorry tale prompted the French government to create new legislation in recognition of the fact that art work does not achieve its full value until late in an artist's career or, as in Millet's case, after his death. The *droit de suite* was introduced in France in 1920 in an attempt to redress this inequity by providing an entitlement in law for artists to share in the ongoing sales of their works and also to allow them to make appropriate provision for their families.

A less benevolent account of the origins of the resale right is made by some commentators, who claim that the legislation arose out of the collapse of the

French Salon and with it state sponsorship of the visual arts. This dramatic change left artists in France subject to the vagaries of the free market for the first time, meaning only those who were able to sell their work would be likely to earn a living. The Artist's Resale Right reinforces the significance of commercial success by rewarding only those artists whose works are traded on the open market. Seen in this light, the French initiative can be regarded as an early example of the trend towards reduction in the levels of state regulation in favour of regulation by market forces.

Over time, other countries also adopted resale right legislation with Italy implementing in 1941, Germany in 1965 and Spain in 1977 as well as a number of countries outside Europe. By the late 1990s, eleven of the then fifteen members of the European Union had some form of Artist's Resale Right in their domestic law (although some did not enforce it).

The European Directive

The Artist's Resale Right has been implemented in the UK as a consequence of European Directive 2001/84/EC. It is important to appreciate the key aims of the European legislation in order to understand the rationale behind the UK law which followed.

The Artist's Resale Right Directive formed part of the European Commission's ongoing harmonization programme which aims to regularise certain laws across all Member States with the objective of creating a consistent approach throughout the European Union. Within the category of the intellectual property (to which the resale right belongs) there have been nine such harmonization initiatives to date.

It is worth noting that the European Commission considered two approaches to achieving harmonization. The first was to define common legislation to which all Member States would be required to conform. This would entail Member States adjusting their existing laws to match the requirements of a Directive or, for those Member States with no pre-existing law, introducing the right in line with the Directive. The alternative was to abolish the legislation altogether. When consulted about the two options, the majority of Member States expressed a preference to retain the right.

The harmonization process commenced in 1995 and aimed to create parity and eliminate inconsistencies between Member States. However, harmonization initiatives rarely achieve this completely and the Artist's Resale Right proved to be no exception. Following the process of Member State consultation, the resultant Directive contains a number of mandatory provisions, in addition to a number of options (also known as derogations). These derogations permit Member States a degree of flexibility in domestic implementation and although the harmonization is still incomplete, with some Member States yet to determine how they will implement the new Directive, already there is some variation in provisions. While the European Commission does not consider that harmonization will be adversely affected as a consequence,

the inevitable outcome of this arrangement is that some artists will benefit more than others, depending on which options Member States choose to adopt, or not.

The Artist's Resale Right appears as Article 14 of the international treaty on copyright, the Berne Convention for the Protection of Literary and Artistic Works 1886, but it is optional rather than mandatory for signatories. Although a number of Berne signatories outside the EU do have the resale right ranging from Brazil to Morocco and the Russian Federation, countries with significant art markets such as the USA (with the notable exception of the state of California) and Switzerland currently do not.

At the time of harmonization in 2001, Austria, Ireland, the Netherlands and the UK were the only Member States with no pre-existing Artist's Resale Right. The ten new Member States which were later admitted to the European Union on 1 May 2004 are also required to adopt the Artist's Resale Right in line with the requirements of the Directive (as are any countries which join in the future).

The modernization of the resale right

In common with other harmonizations initiatives, one of the main justifications for the Artist's Resale Right Directive is elimination of unfair competition within the EU and removal of barriers to free movement of goods. But in harmonizing the right, the European Commission also took the opportunity to bring the legislation up to date. This modernization of the *droit de suite*, which is reflected is several areas of the text, is of particular importance in understanding how the resale right will benefit artists.

Levelling the playing field

The Directive clearly states that one of its aims is to 'redress the balance between the economic situation of authors of graphic and plastic art and that of other creators who benefit from successive exploitations of their works.'[3]

The ability of writers, composers and other creators to earn royalties from sales of their works is well established. Most visual artists however attempt to establish a reputation and earn a living by exhibiting and selling original works of art (and/or securing commissions to produce new work). Such works of art are by their very nature usually unique creations. In this sense, the practice of artists differs from the activities of other creators, such as writers of fiction and composers of music, whose original creations must be mass produced in the form of books and CDs in order to create success.

However, the need to earn an income and obtain recognition is common to all creators, yet whereas writers and composers are entitled to a share in the ongoing value of their creativity because they earn a royalty on every sale, visual artists in the UK had no such opportunity prior to the resale

right. The specific wording in the Directive signals that the Commission recognized this disparity and saw the resale right as a way of rectifying it.

The fact that artists are entitled to a resale royalty irrespective of whether the work in question increases or decreases in value has prompted comment. While it might seem more logical to pay an artist a royalty only if the sale of the work generates a profit, it is easy to see that this could be open to abuse. The Commission was keen to avoid this. The other part of the explanation for this rule lies in the Commission's desire to create equivalence for artists with other creators: a writer of a novel continues to earn a royalty on each sale of the book, even if such sales decline.

Eliminating discrimination

The Directive recognizes that differences between national provisions 'lead to unequal treatment of artists depending on where their work is sold',[4] and makes it clear that the right is to be provided to third country nationals on a reciprocal basis.

Prior to harmonization, those artists who were nationals of countries such as France and Germany were entitled to resale royalties, whereas British artists were not. The Directive specifically sites relevant case law in this regard,[5] and indicates that it is the intention of the legislation to prohibit discriminatory treatment of artists on grounds of nationality. When considered in the wider context of the reality that is the European Union, which entitles its residents to equal treatment in many areas of life, it was impossible to justify some European artists benefiting from the resale right while others did not.

The Directive requires all Member States to recognize the entitlement of any artists who are nationals of the European Economic Area (which covers the European Union plus Liechtenstein, Iceland and Norway) to benefit from the resale right on a reciprocal basis. This means that artists in other Member States will be entitled to receive royalties when qualifying works are resold in the UK and likewise for British artists in respect of foreign resales. The benefit to artists of this provision is clear: artists receive royalties when their work is sold not only in their country of origin but also from any sales which occur in other qualifying countries. This is especially pertinent, given the international nature of the art market.

Encouraging new artists

One of the most interesting features of the Directive is its declared intention to ensure that the Artist's Resale Right is specifically designed to 'promote the interests of new artists.'[6] Notwithstanding that fact that the Directive follows the traditions of copyright law by applying throughout an artist's lifetime followed by a fixed term following death (which is usually seventy years), this wording represents a significant shift in emphasis from the French

legislation of 1920, which aimed to provide artists with a means of supporting their families.

The intention of the Directive to encourage 'new' artists – which might be better interpreted as including artists on low incomes – is reflected in several provisions. One is in relation to the royalty rates. Unusually, these are dictated by the legislation. The rates are calculated as a percentage of the sale price on a sliding scale, starting at 4 per cent for the lowest value works and decreasing to 0.25 per cent for the more valuable items. Therefore artists whose works achieve lower prices will nonetheless achieve proportionately greater royalties. Furthermore, the lowest royalty rate of 0.25 per cent is capped at a maximum payment of €12,500 which applies to resales of €2 million and above. This means that more valuable works (such as those by well-established and deceased artists) will generate a smaller proportionate royalty.

Article 3 of the Directive provides that only those art works that achieve a certain value when resold will attract the royalty. The highest the threshold can be is €3000 but Member States were offered the option to introduce a lower threshold. This has been one of the most controversial aspects of the legislation. The lower the threshold, the more artists will benefit, particularly those artists whose works command lower prices. It is these artists whom the Directive seeks to encourage because they are likely to be at the start of their careers and/or on low incomes.

It is also one of the areas where harmonization has failed to be achieved, with Member States announcing a wide range of thresholds as they each transpose the Directive into their domestic arrangements.

The UK Regulations

Once the Directive was adopted, the UK government was required to implement new domestic legislation to incorporate at least the mandatory provisions of the European Directive. This process, which also involved consideration of the optional provisions, resulted in Statutory Instrument no. 346, known as the UK Resale Right Regulations 2006.

Prior to harmonization, representatives of the British art trade lobbied strongly against the resale right on the grounds that it would damage the market for contemporary art by driving sales from the UK to non-resale right countries. Although this campaign ultimately failed to prevent the creation of the Directive, the art trade lobby achieved a number of significant concessions which have limited the scope of the legislation

Once the Directive was adopted and it became apparent that the introduction of the resale right in the UK was inevitable, the UK government used the period leading up to the implementation deadline to consult all stakeholders about certain aspects of the legislation, including the options available to Member States.

The Culture, Media and Sport Committee[7] and the Greater London Authority[8] each conducted official inquiries into the issue. In May 2005, the

Patent Office[9] at the Department of Trade and Industry (the government department responsible for implementation of the Directive) concluded a public consultation exercise,[10] which resulted in some 140 submissions. This was followed by a partial regulatory impact assessment, the results of which were published in October 2005.[11]

Having sympathized with the art trade lobby against the Directive, the UK government remained committed to ensuring that the new law did not impact unnecessarily adversely on the British art market. However, there was also a growing interest in ensuring that the legislation genuinely benefited artists. Since the existence of the Directive meant that implementation of the Artist's Resale Right in the UK was by now inevitable, it is likely that this new attitude reflected a degree of pragmatism on the part of the legislators. However, there is no doubt that as more evidence emerged as to the potential impact of implementing certain of the options available, a commitment grew to crafting a law which delivered genuine benefits to artists, with a particular focus on encouraging new artists and those on low incomes.

Inevitably, this attempt to achieve some balance between opposing interests created some tension between representatives of artists who wanted to ensure the law delivered genuine benefits, especially to those most in need, while art market professionals were keen to minimize the impact of the new law on their business and were particularly concerned that clients and customers were not discouraged from buying and selling in the UK in favour of non-resale right countries. The ensuing debate, which was occasionally quite fierce, was widely reported in the media. Against this background, the resultant legislation, while imperfect and in places unclear, reflects a fair and sensible outcome overall.

Following harmonization in 2001, Member States were given until 1 January 2006 to transpose the Directive into domestic legislation. Several Member States missed the deadline for implementation and at the time of writing, some have still failed to implement including France and Spain. Those which already had a resale right have continued to operate it on pre-harmonization terms. Of the other Member States for whom the legislation was entirely brand new at the point of harmonization, the UK implemented first some six weeks past the deadline, followed by the Netherlands in April 2006 and Austria in May 2006. Ireland has partially implemented the legislation following a successful compensation claim for failure to implement on time,[12] which was made by one of its leading artists, Robert Ballagh. The significant provisions of the UK Regulations are surveyed below.

Works of art which are covered

The Directive defines works of art to which the right relates as 'original works of graphic & plastic art',[13] and includes a non-exhaustive list of examples including 'copies which have been made in limited numbers',[14] which means that resales of editions of works such as prints, bronzes and photographs will

attract the royalty (although the 'limited numbers' of these is not defined). The definition has been transposed without amendment in the UK Regulations.[15] However, this wording differs somewhat from the definition of original work of art in UK copyright law.[16] Significantly, works of artistic craftsmanship are not mentioned as a category qualifying for resale royalties, although items such as 'a tapestry, a ceramic, an item of glassware',[17] which might otherwise be regarded as examples of such works, are included. This means that two slightly different definitions of an original art work now exist within the UK, leaving open the possibility of disputes as to whether or not certain works such as pieces of furniture should attract a royalty. In practice, few disputes have arisen to date.

However, this lack of clarity plus the fact that the definition in the Regulations is somewhat narrow when considered in the context of contemporary art practice, have the potential to disenfranchise creators of certain art works such as artists working in installation, film and performance.

Persons entitled to receive royalties

The resale right follows the principles of copyright which means that the artist is entitled to receive royalties during his or her lifetime. After death, the artist's beneficiaries will benefit for a period of seventy years.

The UK government successfully negotiated a transition period for those Member States introducing the resale right for the first time allowing the legislation to be implemented in two phases. The effect of this derogation is that only living artists benefit from resales in the UK now,[18] whereas beneficiaries of deceased artists will have to wait until 2010. The Directive offers the possibility of extending this period to 2012 if a case can be successfully made for needing more time to adjust.

Given the fact that this provision was a direct result of lobbying from the UK, the adoption of this derogation is perhaps not surprising. Members of the art trade consider it to be one of the most important decisions made in their favour, since the most valuable part of the art market is typically in works by deceased artists and withholding the right from beneficiaries will therefore save art market professionals and/or their customers some money in royalty payments, at least for a limited period.

There is no other satisfactory explanation for the move which reflects something of a prejudice against the right of creators to bequeath his or her rights to their heirs and beneficiaries for a fixed term following death, as per copyright. This was fuelled to some extent by the erroneous claim that in France and Germany resale royalties benefit only a handful of famous artists' estates rather than living artists. This is not correct: during 2004, approximately 2,000 artists in France[19] and 800 artists in Germany[20] received resale royalties; included in both cases were numerous small payments to living artists. Of course, some artists' estates are wealthy (although there are no known examples of resale royalties accounting for such wealth), but

these account for only a very small number. In reality, many artists' bene-ficiaries inherit a responsibility and an overhead as opposed to a cash cow when rights are bequeathed and any royalties generated (which are usually very modest) provide essential income to help cover the costs of storing, maintaining and insuring works and providing access to scholars and loans to museums.

Therefore, this decision to withhold the right from beneficiaries until 2010 or 2012 is regrettable. What is more, when the Regulations were debated in the House of Lords in January 2006, the government announced its intention to appeal to the European Commission for this derogation to be made per-manent.[21] Since the Directive makes it clear that 'those entitled under the author must be able to benefit fully from the resale right after his death at least following the expiry of the transitional period',[22] it is hard to envisage how this might be achieved.

If and when beneficiaries become entitled, it is worth noting that the UK has chosen to limit beneficiaries to natural persons, save for registered char-ities.[23] The inclusion of registered charities is not an option provided in the Directive but the government was persuaded to provide it in recognition of the practice of some artists to bequeath some or all of their intellectual property rights to charities. It is likely that a variety of good causes, including public museums, will benefit from this provision.

The Regulations make no mention of employment status potentially dis-qualifying artists from benefiting from the resale right. However, the draft Guidance for Business[24] (originally published by the Patent Office,[25] but no longer in circulation at the time of writing) states that 'art works made in the course of employment are not owned initially by the creator but rather by the employer, and would therefore not be eligible for resale right.' Since the resale right is inalienable and cannot be assigned or waived,[26] it is not envisaged that an employer of an artist will be able to exercise his or her employee's resale right (as the employer can in respect of copyright): in this case, entitlement will simply cease to exist. It is not clear why the government chose to side-step this issue by making comment on it while declining to include it in the Regulations; perhaps it was felt that this would go further than is permitted by the Directive, which makes no mention of employment status. Clearly, any artists making work in the course of their employment will be disadvantaged by this provision.

Significance of nationality

Artists must be of a qualifying nationality in order to benefit from the right in the UK and reciprocal treatment by other Member States. A qualifying national is defined as natural person who is 'a national of an EEA state',[27] or 'a national of a country listed in Schedule 2'.[28] This schedule lists all those countries around the world which operate the resale right and whose nation-als are therefore entitled to reciprocal treatment under the Berne Convention.

The nationality of the artist plays an essential part in determining his or her entitlement to receive a royalty.

The Directive provided the option for Member States to extend the benefit to artists who are also habitual residents in qualifying Member States but this provision has not been adopted in the UK. This decision fails to recognize the transient nature of the art world whereby artists will typically gravitate towards centres of creative excellence and artistic activity and thus become habitual residents of other countries during one or more periods of their lifetime, lending an international character to most artistic communities. Doubtless there will be artists who may have been habitually resident in the UK for many years who fail to qualify for resale royalties when their work resells in this country.

Assignment and/or waiver of the right

The Directive provides that the resale right is inalienable and incapable of waiver. This is a mandatory provision of the Directive, made in recognition of the fact that without it, artists would be pressurized to give up their right. This provision shares some characteristics with the treatment of continental moral rights and perhaps reflects the fact that the resale right has its roots within the civil law tradition (as opposed to the common law system of the UK).

The UK Regulations reinforce this quite strongly by making it clear that 'any charge on a resale right is void',[29] 'a waiver of a resale right shall have no effect',[30] and 'an agreement to share or repay resale royalties shall be void'.[31] This protects artists against deductions being made from the royalty by another person, such as a dealer, again reinforcing the aim of maximizing benefits to artist. The other consequence of this provision is that artists have no choice but to accept their right and any royalties resulting from it, though of course they are free to do whatever they wish with any monies received.

Royalty rates

In recognition of the fact that prior to harmonization many Member States provided a higher royalty rate which was not capped for their artists and with the express aim of delivering proportionately greater benefits to artists whose works sell for the lowest prices, the Directive provides an option to increase the royalty rate that applies to the lowest price band from 4 per cent to 5 per cent. However, this option has not been taken up in the UK, which will mean artists whose works are resold in the UK receive a lower royalty payment than those whose works are sold in countries operating the 5 per cent rate.

The rates are cumulative, which means that when calculating the royalty due, the rate which applies to each price band on the scale must be taken into account in the event that the value of the work straddles more than one price band.

Qualifying threshold

The government has chosen to set a qualifying threshold of €1000 (approximately £680) in the UK.[32] Given the UK's historic hostility towards the Directive, the decision to implement a threshold which is lower than the maximum available raised some eyebrows. However, the government was clearly keen to see the legislation benefit many more rather than fewer artists: 'setting this threshold at €1,000 will greatly increase the number of UK artists who will receive royalty payment.'[33]

There is no doubt that had the UK opted for the highest possible threshold of €3000, the receipt of royalties would have been limited to a relatively small and elite group within the artistic community. A higher threshold would have failed to benefit the majority of artists whose works sell for less than this sum, as well as disenfranchising certain groups of visual creators such as photographers, print makers and crafts makers whose work rarely commands such prices as high as those for fine art, even at the height of their careers. The Culture, Media and Sport Committee agreed that the right 'should not benefit solely the richest artists',[34] and recommended a threshold of €1000. Artists whose works sell for the qualifying lowest sum (when converted, this is approximately £680) receive a royalty of approximately £27. The maximum an artist can earn is capped at €12,000, which is approximately £8,500.

Although it is clear that a threshold of €1000 will result in more payments to more artists, the royalty rates are so modest as to render the impact of a lower threshold on the art trade immaterial.

There was wide support among the artists' lobby for a lower threshold of €1000. However, the art trade opposed it on the grounds that the costs of administering small royalty sums would be disproportionately high, which in turn would diminish the benefit to the artist.

There are two main costs to consider in relation to the resale right. One is the cost incurred by art market professionals, who will need to undertake a certain amount of administration to determine their liability and pay the royalties due. The second area where costs will be incurred is in association with collecting and distributing the royalties to artists such as would normally be incurred by a collecting society. In the end, the government was not convinced that there was sufficient evidence to support the claims that any of these costs involved would increase significantly by introducing a lower threshold.

In its forthcoming review of the legislation, the government will be keen to ascertain whether or not the decision to set a threshold at the rate of €1000 has made any difference to artists. To date, 60 per cent of the artists who have received resale royalties from DACS have qualified for a royalty payment only because the threshold is €1000. This is an example of how the law is succeeding in one of its main aims: to encourage those artists who are at the start of their career or who are on low incomes. Clearly, these artists are most likely to be those whose works sell at the less expensive end of the market.

There are a range of thresholds in operation throughout the European

Union: at the time of writing, the threshold in Germany is €400; in Sweden it is €200 and in France is still €15 (although this may change when France finally harmonizes). Other countries for whom the right is new, such as the Netherlands and Austria, have implemented the maximum threshold of €3000.

The cap

One the most striking features of the Directive is the cap on the maximum royalty an artist may earn from each resale, which is set at €12,500.[35] As a mandatory provision, this has been transposed in the UK Regulations.[36] Such a measure is unprecedented in intellectual property legislation and will have the effect of creating a diminishing benefit to artists as the rate depreciates over time.

The impact of this measure will be most keenly felt for those artists whose works sell at the high end of the market (though this is relatively few). Artists in those Member States which currently operate the resale right without such limitations will potentially lose out. For example, prior to harmonization an art work selling in Germany (where the royalty rate is currently uncapped at 5 per cent) for €2 million would generate a royalty for the artist of €100,000, significantly higher than the capped payment of €12,500 to which he or she is entitled under the new Directive.

Liability to pay resale royalties

The Directive proposes the seller of the art work as the person who is liable for paying royalties but there are options available for Member States to vary this provision. The UK has made the seller and art market professional jointly and severally liable for royalty payments.[37]

This was a sensible decision, since enforcement of the right against individuals, such as private collectors, whose identities are often a closely guarded secret, would have been extremely difficult for artists. The art market professional sharing liability with the seller means that artists may collect their royalty from either party. In practice, the payment is claimed from art market professionals, who are free to pass the cost on to their customers. Furthermore, this arrangement does not necessarily require the art market professional to disclose the identity of their clients to artists and/or collecting societies, which has come as a source of relief to the art trade.

Right to information

The Directive provides the artist (or his/her beneficiary) up to three years to obtain 'any information that may be necessary to secure payment of royalties.'[38] Art market professionals are obliged to provide this information, irrespective of whether the cost of paying the royalty is passed on to sellers and/or buyers.

Regulation 15 transposes this provision and adds: 'the person to whom the request is made shall do everything within his power to supply the information requested within 90 days of the receipt of the request.'[39] The Regulations also set out some examples of the information which may be requested, such as 'the name and address of any person who is liable' for paying the royalty,[40] which includes the seller. This requirement threatens confidentiality but provided sufficient information is supplied to facilitate calculation of the royalty (such as title of the work sold, name of the artist and the price achieved) the declaration of such sensitive information is unlikely to be necessary.

In practice, this period may be capable of extension to six years in the UK under the statute of limitations. The Regulations are silent on what happens if the period expires before a claim is made but it is possible that entitlement to a royalty will fall if no request for information is made within the stated time period.

One of the major hurdles to exercising the right is the onus placed on the artist to claim his or her royalty. Art market professionals are under no obligation to inform artists of their entitlement until an information request is made of them. In order to claim a royalty, an artist (or his or her beneficiary) will need to become aware that a resale has taken place and request the information necessary to calculate his or her entitlement within three years of the sale taking place. Major auction houses advertise their activities and publish sales records; in theory, close monitoring of these would enable artists to become aware if their work is resold. However, galleries and independent dealers operate very differently and are not in the habit of revealing sale prices. It will present a significant challenge to artists to successfully make a royalty claim in such circumstances (another good reason which supports the decision not to limit liability for payment to the seller only). Foreign sales in qualifying territories will be harder still for individuals to monitor. It is likely that these factors informed the government's decision to implement compulsory collective management (see below, 'The role of the collecting society').

The 'bought as stock' exception

The UK has adopted the option permitting Member States to exclude art works which are bought as stock by art galleries and resold for less than €10,000 within three years of purchase.[41] This rather complex provision, which has become known as the 'bought as stock' exception, recognizes the practice of galleries which purchase works directly from artists as stock, to resell at a later date.

This provision is a rare example of one which found support from both DACS and the art trade. It was felt that dealers should not be dissuaded from this practice since it serves the interests of artists for their work to be purchased in this way particularly early on in their career.

The role of the collecting society

The Directive provides the option for Member States to implement a scheme of compulsory collective management meaning only collecting societies are able to collect and distribute resale royalties to entitled artists.

The UK government has taken up this option,[42] which means that the law in the UK obliges artists to receive their resale royalties via a collecting society. While this has the effect of depriving artists of the opportunity to collect their own royalties directly, the government took this decision for several reasons:

- It would be hard, if not impossible for artists to individually monitor all sales of their works that take place, not just in London but throughout the UK.
- It would also be very difficult for artists to collect their own royalties, especially when these are generated overseas.
- Experience of rights management in other fields tells us that resale royalties are administered most efficiently if they can be collectively managed. Although the system of rights management in the UK is dominated by voluntary licensing, some compulsory arrangements do exist in relation to certain rights that are difficult (and expensive) to manage individually.
- Collective management is convenient for art market professionals who would otherwise be required to respond to numerous royalty claims from lots of individual artists which would be disruptive and time consuming.

Collecting societies operate in all other creative sectors: music, film and literature as well as the visual arts. These organizations are typically not-for-profit membership bodies which must be set up according to specific rules and are required to operate to certain standards in order to safeguard the interests of their constituent. This is especially important when management of rights by a collecting society is compulsory, as it is for the resale right.

The Regulations define a collecting society as 'a society or other organization which has as its main object or one of its main objects, the administration of rights on behalf of more than one artist.'[43] Only a collecting society may deduct a fee for managing the right from the royalties collected. Collecting societies manage the royalties in all those Member States currently operating the right.

Competing collecting societies

A curious feature of the UK Regulations is the provision that allows more than one collecting society to be involved in the management of the resale right. In the UK, the Design and Artists Copyright Society has been established since 1984 as a collecting society for artists and their beneficiaries,[44] it has been managing the rights of artists in the UK since the law was imple-

mented. Two new societies have formed since the Artist's Resale Right came into force on 14 February 2006 with the objective of also managing resale royalties for artists: Artists' Rights Administration Ltd and Artists' Collecting Society (ACS).

It has been suggested that the provision within the UK Regulations for competing collecting societies creates desirable competition which should promote efficiency and offer artists a choice of service provider. In reality, there is very little scope for competition between collecting societies in respect of the resale right. The royalty rates are dictated by law, meaning artists cannot be offered a higher rate by one society over another. Likewise, the circumstances in which a royalty can be collected are strictly defined and provide no opportunity for enhancement in favour of the artist.

However, because the collecting society is free to determine the charges for collecting and paying artists' royalties, it is feasible that societies could compete on the charges made to artists. But the problem with this theory is that it fails to take account of the fact that collecting societies typically operate as not for profit organizations and therefore only make sufficient charges to cover the expenses associated with collecting and paying the royalties. Therefore, it is unlikely that much variation in charges can be achieved between societies all incurring similar overheads in order to collect the same royalties.

Unfortunately, the existence of more than one collecting society managing the resale right has created additional administration for dealers and auction houses. Far from having a choice of societies, art market professionals are obliged to respond to information requests from as many societies as make them. No doubt this has increased the burden of administration which may in turn have a negative impact on the associated costs incurred by art market professionals complying with the law.

It is not normal practice for more than one collecting society to compete to manage the same rights. It is only when the right is managed collectively on behalf of the entire constituency of artists by one organization that genuine efficiencies of scale can be achieved, which ultimately benefits the artist and is much more convenient for the art trade. The UK is the only country in the world where more than one collecting society manages the resale right.

Artists who do not belong to a collecting society

In the UK, artists do not need to become a member of a collecting society to receive their royalties. However, in light of the fact that more than one society operates in the UK, the following guidance has been offered by the Patent Office in respect of those artists who fail to join any society:[45]

> Any number of collecting societies may set up to collect resale right provided they have mandates from those they represent but only those societies which manage copyright in general on behalf of artists could be deemed to be mandated and entitled to collect on behalf of non-

mandating artists. Currently DACS is the only organization we are aware of which meets this criteria. DACS may therefore collect on behalf of all artists who have not mandated another collecting society.

Clarification of this point is necessary in light of the fact that artists have no choice but to receive their royalties through a collecting society under the UK system of compulsory collective management. In the case of more than one society operating, at least one must be identified as willing and able to collect royalties on behalf of artists who do not belong to any society. Currently, DACS is the only organization entitled to provide this service to non-members.

Choosing a collecting society

Although artists do not need to join a collecting society to benefit from the resale right, it will be easier for a collecting society to pay those artists whose contact information and bank details are known to it. If faced with a choice between organizations, the artist may wish to consider the following questions.

How quickly will royalties be paid?

The Regulations are silent on the speed at which the collecting society must pay the artist any royalties collected, although the existence of the ninety day period allowed to art market professionals to make a response to information requests will have some bearing on this. It is clearly in the interest of the artist to receive their money as soon as possible. DACS pays resale royalties to artists on a monthly basis and guarantees that all artists registered with DACS receive their royalties within thirty days of DACS collecting the money.

What will the collecting society charge?

Collecting societies are permitted to deduct a percentage of the royalty to cover their administration costs. It is in the interest of the artist to be aware of the rate at which the charges are made. DACS charges artists 15 per cent on royalties arising on UK sales and makes no charge on royalties arising from foreign sales (on the basis that a local agent is likely to have made a charge prior to remitting the payment to the UK).

What kind of organization is it?

How a society operates may also be an important consideration for an artist: collecting societies should operate fairly and transparently. They are often governed by their creator members in order to ensure the interests of the constituency are protected. This is true of DACS which operates a Members' Charter setting outs its service standards and obligations towards the artists

it represents. The activities of collecting societies are not yet formally regulated in the UK (although this is currently under review). Companies House, the Office of Fair Trading and the Copyright Tribunal all play a role in ensuring that collecting societies demonstrate accountability and follow good practice.

How effective is the society at monitoring qualifying sales and collecting royalties?

This will depend to a large extent on the experience and expertise of the society and the resources they have available to do the work involved in collecting royalties and paying artists. Clearly, a large part of the art market is based in London but it is just as important that royalties are collected wherever they are generated in the UK. DACS is in contact with over 5,000 art market professionals throughout the UK who are required to respond to information requests which are issued on a quarterly basis throughout the year.

How will royalties be collected from overseas?

It is essential that the collecting society is able to demonstrate its ability to monitor sales overseas effectively and to collect any royalties due to British artists, since this task will be virtually impossible for artists to undertake individually. For example, DACS has agreements with partner organizations operating in twenty-seven other countries in order to ensure resale royalties arising from qualifying sales of work by UK artists taking place abroad are collected and paid.

Circumstances in which the resale right will *not* apply

The factors that govern when the resale right will apply are naturally counterbalanced by circumstances in which the resale right will not apply. The following transactions are exempt:

- Sales which take place between private individuals.
- First sales of works (including those by art market professionals).
- Sales which meet the 'bought as stock' exception.
- Sales of art works to public museums transacted by persons acting in their private capacity.

Furthermore, there is no entitlement to a royalty for creators of the following:

- Works that fail to achieve the qualifying threshold of €1000 when resold.
- Works that do not meet the definition of original art work as contained within the Regulations.

- Works which are out of copyright at the date the law is in force.
- Works which are authored by deceased artists (until 2010 at the earliest).
- Works authored by American, Swiss or other non-qualifying nationals.

Other issues which may present practical challenges are:

- Sensitive nature of the information the art trade is required to supply may conflict with their obligations under data protection legislation.
- Jurisdiction, on which the Regulations are silent.
- Absence of guidance of what happens to those royalties for artists who cannot be located.
- Calculation of the threshold and price bands based on rates set in Euros could result in inconsistencies and disputes when these are converted into sterling.

Some or all of these issues may well result in legal proceedings; in the UK remedies to breaches of the law will be limited to the civil courts.

Impact of the legislation

At the time of writing, the Artist's Resale Right has been in operation for just over twelve months in the UK. That there has been an impact on the art market is undeniable. Art market professionals have been required to make adjustments to their business practices, which has obliged some to become more transparent about their dealings (a development that has been welcomed by some commentators). Collectors of art works are finding themselves paying slightly more, as it would seem that the general preference is to pass the cost of paying the royalties on to buyers of art works.

To the extent that the UK Regulations are unclear in parts, there have been some operational challenges. As predicted, the most taxing of these has been the complete absence of guidance on jurisdiction which has unduly complicated the task of assessing whether or not the right applies to certain international transactions. Given the international nature of the art market, it is most unhelpful that the legislation makes no comment about jurisdiction and it may be that this will need to be revisited in order to provide some certainty. The definition of copies made in limited editions has proved inadequate which resulted in early confusion in respect of certain categories of prints. And as mentioned above, the unsatisfactory non-exhaustive list of art works to which the right applies has occasionally led to some difficulties.

However, the principal concern of art market professionals – that the resale right will drive sales of art works to other markets such as Geneva and New York – does not appear to be materializing. There are no signs yet that the additional expense of paying the royalties is acting as a deterrent to buyers, or indeed sellers. In fact, some auction houses have reported that their

customers have reacted positively to the idea that the artist now receives a small share of the sale price.[46] Since the implementation of the legislation in the UK, the art market has continued to prosper with record prices being achieved for works by contemporary artists. This is most welcome news, since a buoyant art market serves the interests of all parties.

At the time of writing, DACS has collected £2.3 million in resale royalties for artists (there is no information available about the amounts collected by the other two societies).

Royalties have been paid to artists living not only in London but also in every county in the UK. Painters and sculptors have received payments and so have illustrators, potters, printmakers, photographers, jewellers, furniture makers and silversmiths. The youngest artist to receive a royalty is 25, while the oldest is 102. Royalties have reached artists newly emerged from art school, a retired coalminer and even a future king of England. What has been common to all payments, whether large or small, is how delighted the recipient has been.

The ability of artists to receive their royalties is largely dependent on two factors: the willingness of art market professionals to comply with the law and effectiveness of the societies collecting and paying the royalties. To date, compliance levels among art market professionals have been very good and meant that artists were able to start receiving their royalty payments at the earliest possible date following implementation.

Conclusion

The rights of artists can make the difference between their ability to survive and to thrive. An enlightened society that values creativity and wishes to encourage its expression should respect the rights of the creator, just as we would recognize the entitlement of any dedicated professional to be appropriately rewarded for their work. The income that artists are now receiving from the Artist's Resale Right, though modest, is valued and helps stimulate fresh creativity. Of equal importance (and more so, to some) is the potential offered for increasing recognition and generating respect.

The Artist's Resale Right also creates equality by affording UK artists the same economic opportunities as their equivalents on the continent and placing visual artists on a level playing field with songwriters and authors, who have for a long time received royalties from sales of their work, a reality which has not harmed their respective music and publishing industries. The focus in both the Directive and the UK Regulations on benefiting those artists on low incomes has been justified by the payments successfully made to such individuals and is to be applauded.

As for the impact on art market professionals, there is no doubt that the resale right has resulted in a new overhead which needs to be absorbed by the art market but the impact of this has been carefully controlled within the framework of the legislation so as not to cause material damage. Although it

is early days, all signs so far suggest no ill effects from the new law as the UK art market continues to go from strength to strength which is welcome news for everyone.

As an instrument of law, the Artist's Resale Right Regulations are far from perfect. From an artist's perspective, the fixed royalty rates and the cap on the maximum royalty payment are unique and will always conspire to produce modest payments which means artists will not benefit from the same earning opportunities that exist within other creative industries, such as music and publishing. Denying beneficiaries of artists has no justification, other than saving art market professionals and their customers some money and delaying the inevitable.

However, these provisions have been balanced to some degree. One of the most important decisions the British government made when contemplating their options for how the new law should work was to ensure that artists whose work sells for lower values, also benefit. Over 60 per cent of the artists receiving royalties in the first twelve months were able to do so only because the qualifying threshold was set at one thousand Euros, roughly £680. The resale right therefore benefits not only those artists who have achieved success but also those who aspire to it.

The ability of artists to receive their royalty payments has been greatly assisted by the decision to ensure art market professionals share liability for payment with sellers. Enforcing a system of compulsory collective management denies artists the opportunity to collect their own royalties but does without doubt offer the best solution to the challenging task of collecting royalties wherever they arise in the UK and throughout the world. However, the possible advantages of such a system and the benefits it could offer art market professionals have been diminished by the existence of several societies.

Looking forward, the UK government has announced its intention to conduct a study on the effect of the legislation in 2007–08 and work has commenced to prepare for this. The European Commission is committed to reviewing the harmonization initiative in 2009. Hopefully, these two reviews will create opportunities for all stakeholders to provide feedback of their experience of the new law and to influence the need to clarify those parts which are currently obscure and/or lacking.

At the time of writing, there is a sense that artists, the copyright community and the art trade are starting to come to terms with the fact that the Artist's Resale Right has become a reality in the UK. A distinctly civil law initiative in many ways, which sits rather oddly within the common law landscape of the UK, this new legislation has attempted to strike a balance between those who pay the royalty and those who receive it. It has resulted in a piece of legislation that is arguably one of the most significant developments for creators of artistic works in modern copyright history. While the legislation is idiosyncratic in parts and is yet to be loved by some art market professionals, it is a success insofar as it genuinely benefits

artists. The royalties that artists receive from the resale right may be modest but they can help many artists buy time. Now that's worth celebrating.

Notes

1 The Artists Information Company.
2 Ambitions for the Arts 2003–06: www.artscouncil.org.uk.
3 Recital (3).
4 Recital (14).
5 Judgment of 20 October 1993 in Joined Cases C-92/92 and C-326/92 Phil Collins.
6 Recital (22).
7 *The Market for Art*, Sixth Report of Session 2005–06 Culture, Media and Sport Committee.
8 *Going, Going, Gone: the impact of droit de suite on London's art market.* London Assembly: Economic Development Culture Sport and Tourism Committee (January 2006).
9 The Patent Office has since been renamed the UK Intellectual Property Office.
10 www.patent.gov.uk/about/consultations/resalerights/full_droitdesuite.pdf.
11 K. Graddy and S. Szymanski (2005) *Scoping Study: Artist's Resale Right.* London: Intellectual Property Institute.
12 www.mhc.ie/news-+-events/news/128/.
13 Article 2 (1).
14 Article 2 (2).
15 Regulation 4.
16 Section 4, Copyright Designs and Patents Act 1988.
17 Regulation 4 (1).
18 Regulation 17.
19 ADAGP, Paris.
20 VG Bildkunst, Bonn.
21 Lord Sainsbury of Turville, Column 1144 Artist's Resale Regulations 24 January 2006, Hansard.
22 Recital (27).
23 Regulation 9.
24 www.patent.gov.uk/about/consultations/responses/resale/guide.htm.
25 See note 9
26 Regulations 7 (1) & 8 (1).
27 Regulation 10 (3) (a).
28 Regulation 10 (3) (b).
29 Regulation 7 (2).
30 Regulation 8 (1).
31 Regulation 8 (2).
32 Regulation 12.
33 Lord Sainsbury of Turville, Column 1144 Artist's Resale Regulations 24 January 2006, Hansard.
34 *The Market for Art*, Sixth Report of Session 2004–05.
35 Article 4 (1).
36 Regulation 12 (4) (b).
37 Regulation 13.
38 Article 9.
39 Regulation 15 (4).
40 Regulation 15 (3) (b).
41 Regulation 12 (4).

42 Regulation 14.
43 Regulation 14 (5) (a).
44 www.dacs.org.uk/arr.
45 See note 9.
46 S. Reyburn (2006) 'A resale rights carry-on', *Antiques Trade Gazette* (11 March).

10 Ethics and the art market

David Bellingham

At this moment, America's highest economic need is higher ethical standards
– standards enforced by strict laws and upheld by responsible business leaders.

George W. Bush in a corporate responsibility speech (9 July 2002)

Introduction

The source of this hypercritical moralizing political statement may surprise,
and consequently amuse, some readers. In hindsight, however, it can be
deconstructed as a paradoxical yet prophetic statement. Its ethical and legal
implications have apparently penetrated art markets as widely and as deeply
as the multinational corporations which were its main target. In the new
millennium, the media headlines art crimes and scandals as often as the ethical
transgressions of big business. Indeed, ethical issues are currently at the fore-
front of all aspects of global contemporary culture, including sport as well as
the arts. 'Ethical issues tend to come to the fore at moments of crises . . . when
the body politic exudes more heat than light.'[1] Arguably, the recent expansion
of ethical awareness is related to the far too rapid and consequently over-
heated process of globalization from the 1990s to the present day. Businesses
in particular, including the art business, are faced with increasingly byzantine
moral dilemmas because their transactions are made within a highly complex
cross-cultural marketplace. The plurality of contemporary art markets means
that dealers and collectors are often unexpectedly confronted with differing
ethical systems which affect both micro and macro aspects of trading, from
everyday etiquette to the wording of contracts and the brokering of deals. To
be perceived by both domestic and foreign art market players as acting in an
ethical manner appropriate to local cultures is likely to lead to a reputation
for good practice and consequent long-term business advantages: no edition
of *The Art Newspaper* is without a story of unethical art market practice.
Likewise, art dealers need to be aware of and respect the cultural differences
in local artistic practice: economic globalization does not give the art market
the right to homogenize the production of artists.[2]

If the Friedmanite business ethic is applied to the art market, dealers and

auction houses need only to comply with the law.[3] However, a basic under-standing of the major ethical issues affecting the art market not only creates an instinctive perception of relevant laws, but also facilitates the invaluable mental process of informed decision making.[4] An ethically informed action is rarely a transgression of the law, since every legal system is underpinned by ethical debate. Not every unethical action, however, is an illegal one. Museums and art dealer associations have created codes of ethics, but these tend to be aspirational, and are only occasionally affirmed by the law. The semantics of the term *code of ethics* are highly informative when decon-structed alongside the similar terms *code of conduct* and *code of practice*. Players in the art market have adopted *codes of ethics* as opposed to *codes of conduct* or *codes of practice*.[5] Violations of *codes of conduct* can lead to warnings and dismissal from a professional body. Violations of *codes of practice* can lead to legal action. *Codes of ethics* are lightest in this hierarchy of codes, being mainly aspirational and using light coercion to encourage members:

> Most professions have developed codes of ethics. Some have argued that such codes are just veiled attempts to generate a positive public image for a profession. Others claim that such codes merely establish a moral minimum and are incomplete.[6]

Arguably therefore, the code of ethics of an art dealer or museum is more concerned with the creation of a politically correct public image than with religious adherence to a set of stone-inscribed commandments.[7]

According to Julian Radcliffe, chairman of the *Art Loss Register*, 'The art trade is the least transparent and least regulated commercial activity in the world.'[8] As one of the world's last unregulated markets, art business continues to remain relatively untouched by the creation of purpose-built 'strict laws' recommended by the president. 'Higher ethical standards' have, however, become an increasingly important element in the branding and rebranding of auction houses and art dealers. The main ethical philosophies employed (consciously or unconsciously) by the art market are Pragmatism, Relativism and Utilitarianism.[9] Ethical issues affecting the art market cover a very broad range, but tend to fall under the following main headings: provenance; intel-lectual property rights; fakes and forgeries; deaccessioning; monopolization; conservation and restoration; and unethically sourced materials.

Provenance

The ethics of provenance in the art market falls into two main areas: archae-ology and war-looted art. In the light of recent archaeological and looted art scandals, antiquities dealers in particular are now beginning to project their new ethical image by stressing apparently strict provenance policies in highly visible statements in their stalls at major art fairs.[10] In the case of the major

international auction houses, to be seen to be acting in an ethical manner has led to some highly publicized, and sometimes drastic, actions. Since the 1990s, media exposure of unethical art dealing has had a detrimental effect on implicated art businesses. After the disclosure in 1997 of Sotheby's involvement in unethical or illegal exporting of Italian heritage art objects, Christie's London antiquities department outsold Sotheby's for the first time in forty-three years.[11] Consequently, Sotheby's closed its London antiquities department, and currently continues to miss out on a fast-growing market.[12]

Christie's and Bonhams, who continue to duopolize the London antiquities market, have themselves not escaped media attention over their ethical positions in regard to selling ancient objects. In 2005, Christie's planned to sell the famous 'Achaemenid Relief', a masterpiece of ancient classical Persian sculpture dating from the fifth century BC. It was removed from Iran in 1931, one year after local national legislation banning the export of antiquities. Moreover, it had been excavated in Persepolis, now a World Heritage Site protected by UNESCO. Christie's experts gave the sculpture an estimate of £200,000– 300,000, but were forced to withdraw it from the sale when the Iranian government threatened High Court action.

More recently, and far more controversially, in October 2006, Bonhams organized a private exhibition of the notorious *Sevso Treasure* in their Bond Street showrooms.[13] The treasure consists of fourteen late antique Roman silver banquet utensils. The unwillingness of the present owner, Lord Northampton, to display 'the world's most magnificent collection of late Roman silver' is itself arguably unethical for the following compelling reason: such uniquely important historical pieces are objects of global heritage value and therefore should be available for public consumption.[14] Their importance is also reflected in the £40 million which Lord Northampton is believed to have paid for them in the early 1980s.[15] Monetary value rarely fails to coincide with academic value and endorsement by the public sector. Similar antique silver treasures are highly prized exhibits in major museums.[16] The payment of £40 million dramatically exceeds the current British auction record for an antiquity, the *Jenkins Venus*, sold in 2002 by Christie's London for £7,926,650.[17] Furthermore, Northampton was encouraged by Peter Wilson, chairman of Sotheby's until his death in 1984, to purchase the silver as a financial investment. However, sale of the *Sevso Treasure* at Sotheby's Zurich in 1990 was blocked by a New York Supreme Court injunction. The treasure was on a pre-sale global publicity tour, and while in New York the Lebanese government claimed that the treasure had been illegally excavated and smuggled out of their country. The case was further complicated by Croatia (at the time part of Yugoslavia) and Hungary adding their own patrimonial claims to the treasure. In 1993, the infamous seven-week trial by jury concluded in favour of Lord Northampton's ownership. The *legal* owner is accordingly now heavily burdened by the *ethical* implications of unsubstantiated provenance, and therefore lack of *valid title* to the treasure. Furthermore, the high-security Bonhams exhibition of 2006 appeared to be a

cynical attempt to test the current temperature of academic and journalistic opinion. Since then, Tim Loughton, MP, has instigated an Early Day Motion which calls for 'an expert and independent evaluation of all the evidence relating to the Sevso Treasure'.[18]

The ethical problems raised by the *Sevso Treasure* are manifold. First, to the archaeologist, objects of potentially high value to our understanding of the past have been excavated without any record of their provenance; it even remains uncertain which part of the far-flung Roman Empire they are from.[19] Second, the fourteen pieces are now believed to be only a part of the total hoard, which means that the treasure not only lacks secure provenance, but also is incomplete.[20] This breaking up of collections of both art and archaeological objects is considered highly unethical in both the private and public sectors, because in terms of cultural information, the whole is considered greater than the sum of its parts. Third, although the *Sevso Treasure* should be on public display, no museum's ethical code would feel comfortable with its acquisition. The International Council of Museums (ICOM) states: 'Museums should avoid displaying or otherwise using material of questionable origin or lacking provenance. They should be aware that such displays or usage can be seen to condone and contribute to the illicit trade in cultural property.'[21] Fourth, the sale of the treasure for an apparently exorbitant sum, and subsequent high-profile media exposure, encourages further illegal and unethical archaeological excavations across the world. Finally, there are issues of patrimony: these objects belong in the first instance to the country in which they were discovered; they are an integral part of its history and heritage.[22]

The case of the *Sevso Treasure* begs a question concerning other archaeological objects on the market: is it ethical to sell *any* ancient objects of unknown or dubious provenance, including those of low monetary value? Every antiquities auction catalogue contains ethically unsound provenance statements such as: 'ex Swiss private collection'; 'Given to the current owner as a birthday present, 18 years ago in London'; 'Acquired from the London Art Market'; 'The property of a private collector, acquired about 8 years ago in London. It had previously been in a collection in America'.[23] The objects thus described have all been removed from their contexts, without any record of their original archaeological provenance. They are also all heritage objects, now protected by the laws of their countries of origin. The vendor can also be compromised by the fact that they may well have acquired such objects in a *bona fide* manner, at a time prior to current high-profile provenance issues.

Although various nations had previously created laws to protect their own cultural heritage from leaving the country, the problem of protecting national heritage at an international level was not addressed until 1970.[24] In that year UNESCO formed a policy aimed not only at curtailing the unethical export of heritage objects from their country of origin, but also at discouraging art-buying nations from importing such objects without due diligence as to their provenance.[25] Although the agreement was to be welcomed by those interested in ethical dealing, there remain various unresolved ethical

problems. Many nations were reluctant to sign up: predictably those with more heritage to lose and/or less spending power on the art market were early signatories; while some of those major economies with established art collecting and/or dealing histories have only recently signed, with the significant exception of the USA, which signed their acceptance at the relatively early date of 1983, in the second year of Ronald Reagan's presidency.[26] The USA, however, refused to implement Article 6(b) of the convention, which demands export controls for individual states.[27]

The 1970 UNESCO Convention has had a growing impact on the art market. In 1984 a *Code of Practice for the Control of International Trading in Works of Art* was agreed by some of the most important UK organizations. These included the auction house duopoly of Christie's and Sotheby's, as well as leading dealers' associations such as the Antiquities Dealers Association, the British Antique Dealers' Association and the Fine Art Trade Guild.[28] However, the efficacy of the codes in discouraging illicit trade in art has been questioned many times.[29] Although the codes request 'due diligence' in establishing the provenance of art objects, this tends to be disregarded, particularly in relation to objects of lesser monetary value.[30]

Perhaps the most ethically problematic feature of the 1970 UNESCO agreement was that the new guidelines were not retroactive: objects removed from their countries of origin or imported into another country prior to 1970 were deemed to be unaffected by the regulations. In the field of ethics, this is an example of historical relativism: the further back in time an object has been removed from its original context, the more complex are the historical problems surrounding it. Thus the Parthenon ('Elgin') Marbles were removed to England from Greece after it had been under Turkish rule for over 300 years. Since their removal, the political context has changed, with Greece having regained its independence. By adopting this relativist standpoint and making 1970 the *terminus post quem*, UNESCO has avoided the unravelling of such complex issues of national heritage and ownership. However, the Parthenon Marbles issue also highlights the ethical weakness of relativism. Most would agree that the original removal of the marbles from the Athenian Acropolis was ethically wrong on a number of counts: the sculptures and architectural elements were integral parts of the Parthenon, Erectheum and Temple of Athene Nike; the permit for their removal was issued by an occupying nation.[31] However, that ethical situation was relative to a political situation now some 200 years distant from us today. To the proponent of relativism, we are not morally responsible for such historically distant events, and to attempt to unravel them would lead to impractical situations. If the argument for the return of unethically removed cultural objects to their original contexts were applied to every object, not only would private collections be reduced, but so would the world's most important public museums.

The same relativist ethical argument was (implicitly) applied by Christie's when it agreed to sell the *Jenkins Venus* for the current British auction record price for an antiquity of £7,926,650 (including premium).[32] The ancient

Greco-Roman marble nude had been at the Yorkshire stately home of Newby Hall for some 250 years. It had been acquired in Rome by the dealer Thomas Jenkins and sold to the collector Thomas Weddell while on his Grand Tour in 1765. Therefore it was considered by the art market to have sound provenance, as though the statue had been made in England. However, some absolute ethical questions remain: where was it excavated, and does not its country of origin have a greater right to its title? If it was exported with the agreement of its country of origin, where is the paperwork?[33] Does the fact that the ancient statue was itself probably a Roman copy of a Greek original confound any issues of heritage and title? It was sold to Sheikh Saud-al-Thani and is now in Qatar. The final ethical irony of the Jenkins Venus is that the Sheikh was later arrested for the misuse of public funds to acquire art.[34] In the mean time, the vendor, Richard Compton of Newby Hall, has had a polyurethane replica made using state-of-the-art laser technology; this in turn was copied in 2006 in Carrara marble by Italian sculptors and now replaces the original statue in its niche in Newby Hall's sculpture gallery![35]

The for-profit art market bears the brunt of ethical critiques of provenance. However, similar issues also apply to the public sector. The bronze head, known until our more recent politically correct times as the *Chatsworth Apollo*, was acquired by the British Museum in 1958.[36] It was purchased by the Chatsworth family from an art dealer in Cyprus in 1838. At the time of its excavation it was part of a complete bronze nude of the god Apollo. The head was reportedly detached from the body when the figure was pulled along the ground with ropes. The body was probably sold as scrap metal. If the figure had been properly excavated it would be one of only a handful of free-standing life-size or heroic bronze statues surviving from the Classical period of Greek art. Because the figure was removed from Cyprus prior to the 1970 UNESCO agreement, it is virtually impossible for Cyprus to lodge a claim for its return. Unfortunately, this encouragement by major private and public collectors of unethical and illegal excavations continues today and often leads to similar irreversible damage and/or to the application of unethical restoration techniques to art objects.

In recent years, the *ethics* of exporting heritage objects has become increasingly an international *legal* issue. The *cause célèbre* is the case of the Euphronios Krater, a sixth century BC red-figure Athenian terracotta bowl for the mixing of wine with water, signed by the painter Euphronios. The krater was purchased in 1972 by the Metropolitan Museum of Art, New York, for $1 million. In 2006, the museum agreed to return it, together with five other illegally excavated antiquities, to the Italian state. The Metropolitan surrendered to the threat of international legal action by Italy. However, a former curator of the Getty Museum, Los Angeles, is currently on trial in Rome, similarly accused of the purchase of knowingly stolen objects from Italy. At last the 1970 agreement, based on ethical principles, is being strengthened by a number of highly publicized legal cases, albeit only for objects of high monetary value.[37]

The irony of the *historical relativism* standpoint within the world of art and archaeology is that it forms the backbone policy of the international museum. Paradoxically these same museums now employ codes of ethics which denounce the acquisition of objects of unethical provenance in order to protect their own heritage as well as that of other nations.[38] Museums also regularly denounce the art market for encouraging the private acquisition of cultural objects, while holding similar objects in their own storerooms because of rules forbidding deaccessioning. Both private and public sectors act unethically when they fail to display important works for public consumption. Their response to this criticism is that such objects are accessible to the *bona fide* student. Although this is a practical standpoint – it would be impossible to display every surviving cultural object – it fails under *Utilitarianism*.

The pursuit of art which has been looted during times of war and political conflict has only relatively recently become a legal as well as an ethical issue.[39] The ethical issues involved in the reclamation of war-looted art are similar to those of plundered heritage. However, the situation differs because cases of war-looted art tend to be from more recent history. Since the mid-1990s, the main area of debate at the high end of the art market has involved art looted by the Nazis both within Germany itself as well as the occupied territories from the 1930s up until the end of the Second World War. The acquisition of art by conquest has been an essential feature of military imperialism since the ancient Roman armies began to display looted Greek art in their triumphal processions from the third century BC onwards. The display of art objects as war booty, particularly antique statues and Old Master paintings, has continued to be a powerful visual sign of the defeat of a foreign culture by an emerging Empire in more recent times. Napoleon, in imitation of the ancient Roman emperors, between 1796 and 1814 looted the most important Italian antiquities and Old Masters, and made them the centrepiece of his own triumphal return to Paris.[40] Adolf Hitler deliberately targeted a broader chronological range of important art objects during the Nazi expansion into France and Italy: modern masters were sought out alongside ancient Classical and Hellenistic sculptures. In the case of both Napoleon and Hitler, works looted from major public collections were returned after their respective defeats. However, thousands of art objects from the private collections of those ideologically opposed by the Nazi regime, in particular Jews, were never returned to their owners because of their extermination or flight from the Nazi territories. Since the early 1990s research into Nazi-looted art has become a lucrative profession for art detectives. An increasing number of art objects in both private and public collections, whose provenance history becomes blank or dubious during the rise to power of the Nazis, have been traced back to mainly Jewish owners.[41] The works were acquired by force in an indisputably unethical manner, and a number of famous legal cases have established that the heirs of the original owners hold title to them. What is a very interesting development on an ethical level, however, is that claims of the objects proven to be Nazi-looted art are now generally settled out-of-court by

the current owners and rightful heirs. If the heirs are happy that the current owner acquired the work in a *bona fide* and therefore ethically innocent manner, a percentage of the sale price is awarded to that owner. Although the owner may have no legal title to the art, the case is settled in an ethically correct manner, although this is partly because of the financial risks involved in suing the current owner.[42] Sadly, the problem of looted art is not confined to history, as witnessed in the recent wars in Afghanistan and Iraq.[43]

Intellectual property rights

The above ethical arguments involving the rightful title (ownership) of art are related to another controversial area, that of intellectual property rights. Anglo-American copyright law has an economic basis: 'to ensure continuing profit to the originator or creator of a copyrighted work'.[44] Historically, however, this has been applied to written texts as opposed to the visual arts. Copyright has been felt to be less relevant to fine artists, where original works by painters from Picasso to Hirst have fetched high prices in the primary market. The ethical argument for not awarding such artists copyright is, of course, that, unlike books, photographs, engravings or lithographs, their art objects are physically unique, and that once sold, they become the property of the buyer. There is, however, an alternative ethical argument gaining increasing legal authority within the European Union: that of the artist's resale right (*droit de suite*). The argument states that fine artists, like their literary equivalents, should retain intellectual property rights to their creations, and therefore profit from sales of their work in the secondary or tertiary markets. A further ethical argument which relates to fine artists in particular, is that they are often under economic pressure to sell their works for relatively small amounts early on in their careers, and that they therefore have an ethical right to share in the profits made by dealers in the event of their works growing in demand. The UK is one of the more recent acceptors of this ethical argument, which has now received legal status. A proportion (currently around 3–4 per cent) of every resale is awarded to the artist.[45] This sounds very fair, but is actually an example of an ethical standpoint lacking on both pragmatic and utilitarian levels: 'the rich get richer'. In practice, the law favours only a few famous artists. It is also perceived as unethical that the resale right has not been applied by major art dealing nations such as the USA and Switzerland.

Fakes and forgeries

There are other aspects of copyright related to the art world, including the ethics of the copying of art by the artists themselves. The practice of making copies of original art objects runs throughout the entire history of art. The Western tradition places far greater value on the original work as can be seen in the relative prices for originals and replicas: copies of Old Master paintings typically sell for between 1 and 5 per cent of the price of an original.

Therefore it is obviously in the economic interest of dealers and auction house experts to attribute works as closely to the circle of the original master as possible, a practice which is not always academically objective. Copies of art objects have often been produced for perfectly ethical reasons, never pretending to actually be the original work. Problems tend to arise in later periods when it becomes more difficult to ascertain whether a work is the original or a copy. It is obviously unethical to appraise a work as an original if there are any doubts regarding its authorship. However, this is often purely a matter of the subjective opinion of leading connoisseurs and is therefore sometimes open to abuse. If a work is created and sold openly as a copy, it is regarded as a 'fake'; however, when a work is deliberately in the style of another artist and pretends to be an original by that artist, it becomes an unethical 'forgery':

> At one pole lies the faithful 'replica', at the other lies the errant forgery. Within this typology the 'imitation' of 'masters' is a creative tradition amounting to the construction of forms analogous to those of the 'original'; indeed such acts reinforce the very prestige of the 'original'.[46]

Within the postmodernist traditions of contemporary art, copying as a deliberate, often ironic, allusion to another visual icon has become an important feature of creative expression. Thus, for the 1999 Venice Biennale, the Chinese artist Cai Guo-qiang produced *Rent Collection Yard*. This openly recreated a number of iconic sculptures originally produced during the Cultural Revolution. The act was regarded as slavish plagiarism by the Sichuan Academy, which had created the originals, and Cai Guo-qiang was threatened with legal action.[47] In the same year, a similar transgression of copyright was perceived in *Hymn* (1999) by Damien Hirst. This sculpture replicated in a colossal bronze a male anatomical toy. Hirst was sued for copyright by the toy firm Humbrol, eventually making an 'ethical' out-of-court donation to a charity in recompense.[48] Art law experts see this as an unsolvable dilemma: 'An unbridgeable antimony between art and the law, which will be the subject of continuous debate.'[49]

The status of fakes and forgeries within the art market became a major topic of debate in 1999 when forged paintings by the Hungarian aristocrat Elmyr de Hory were exhibited in the Terrain Gallery, San Francisco.[50] This was of ethical rather than legal interest because de Hory's infamous forgeries were now selling on the open 'legitimate' market for over $20,000. Elmyr de Hory had earlier been exposed as a fake painter in 1967, after having sold many paintings purporting to be by classic modern artists such as Matisse and Modigliani to both private and public collectors. His claim to be the most famous of the twentieth century art fakers was strengthened in 1975 when he featured in the Orson Welles film *F for Fake*.[51] In 1976 he committed suicide in Ibiza to avoid extradition to be tried in France. The high publicity surrounding his death further increased art market interest; in 1977 the English

antique dealer John Pyle purchased a number of the paintings and because of their subsequent high monetary value, contemporary artists are now making forgeries of his fakes!

Deaccessioning

The practice of deaccessioning museum objects for sale on the art market is regular in most states of the USA. A current example involves the sale by auction of twenty-two Dutch, Flemish and British Old Master Paintings belonging to the Getty Museum in Los Angeles.[52] The ethical arguments for deaccessioning the paintings are: first, that they were early acquisitions by Getty, 'done more with an eye for furnishing a room than strengthening a picture gallery'; second, that they had never been on public display; and third, that the money generated by selling the paintings will be used to buy 'finer' works for the gallery. The deconstruction of these arguments reveals an essential feature of the ethical self-justification of the art market; works not considered of sufficient aesthetic quality or art historical importance to merit public display may be bought and sold without the ethical constraints which apply to more significant art objects. This argument is based on subjective appraisals of art, and ignores the ethical 'archaeological' argument: that every artefact, be it of high or popular culture, is of value to our understanding of past and present societies. For this reason, deaccessioning of objects is strongly discouraged under the ethical codes of museums in the UK.[53]

Some of the most difficult ethical problems in the art world are those where two differing ethical standpoints conflict with one another – the dilemma. The classical Socratic position regarding the moral dilemma is that truth is absolute, and that if a person acts according to what is right, they can never do wrong. The problem with this argument is that the Truth was deemed to be the preserve of a philosophical oligarchy. It cannot operate within any egalitarian socio-political system because there would be too many conflicting definitions of absolute Truth: no wonder democracy was despised by the Academy.

The ethical standpoint of museums in Britain has recently led to a highly publicized example of an ethical dilemma relating to public/private as well as art/society oppositions within the art world: the deaccessioning and sale of an English urban landscape painting, *A River Bank* (1947) by L.S. Lowry (1887–1976). The painting was purchased in 1951 by Bury Town Council for the relatively modest sum of £175. It was sold at Christie's, London, Modern British Art sale on 17 November 2006. The estimate was £500,000–800,000: it sold to a private UK telephone bidder for £1.25 million (£1,408,000 with premium), the second highest price paid for a Lowry at auction.[54] The ethical problem is that the painting was the property of the democratically elected Bury Town Council. It had been on public display in the Bury Art Gallery and Museum, to be enjoyed by the people of Bury, who owned it. Some political commentators argued that a plebiscite should have been held to

decide on the fate of the painting.[55] The leader of the town council, Wayne Campbell, had argued for its sale because the council had developed an annual budget deficit of £10 million. The council held the national government responsible for their financial deficit, thus hoping to wash their hands of the ethical dilemma. Campbell argued that the alternative to selling the painting would be redundancies and closure of valued services: 'People come before a picture and that can only be right'. He countered the more emotive ethical criticism of 'selling the family silver' with an equally emotional ethical argument of his own, namely that vulnerable children were being put at risk because of the cuts in social services.[56] This was a rare example of the public being caught up in an ethical debate: 'is a work of art worth more than public services?' A local newspaper even ran a public opinion poll on whether the painting should be sold: 41 per cent answered 'Yes', while a clear majority (59 per cent) answered 'No'.[57] Museum associations argued that Bury Art Gallery and Museum had signed up to certain ethical protocols when they registered with the Museum, Libraries and Archives Council (MLA): deaccessioning an object contravened those protocols.[58] MLA protocols are based on the International Council of Museums (ICOM) code of ethics which states:

> The removal of an object or specimen from a museum collection must only be undertaken with a full understanding of the significance of the item, its character (renewable or non-renewable), legal standing, and *any loss of public trust that might result from such an action* [my italics].[59]

The MLA chief executive, Chris Batt, argued that Bury Art Gallery's status as a registered museum was jeopardized by its sale of the painting, and threatened that future funding opportunities would be lost.[60] Somewhat paradoxically, The Art Fund (former National Art Collections Fund) presumably did not consider the painting important enough to save for the public sector. However, their director, David Barrie, proceeded to criticize the sale as 'a deplorably short term and irresponsible approach, and Bury's cultural heritage is the poorer for it.' The ethical position of the Art Fund might be called into question by this statement. Their refusal to act in this case was, however, ethically defensible from a utilitarian standpoint. Had they matched the hammer price of £1.25 million in order to save the painting for Bury Art Gallery, a precedent would have been created and Bury Town Council's action would be imitated by many other town councils, in the belief that they would also be bailed out by the Art Fund. The utilitarian consequence would be that many more public museum objects could be lost to the private sector.

Simon Jenkins of the *Guardian*, however, adopted a more politically liberal argument and laid a greater proportion of the ethical blame on the national government, as well as the MLA: 'The Museums Association is not protecting galleries whose relationship with their council has collapsed under *government force majeure*. It should encourage sale and exchange by drawing up

protocols by which such sales can be monitored.'[61] Jenkins also employed a utilitarian provincial – capital oppositional argument: 'London's institutions [museums], in flagrant defiance of the museum's code [of ethics], treat their collections as private not national property . . . buried unseen in the vaults of the Metropolis.'[62]

Monopolization

The structures of the art market have recently undergone several cataclysmic changes, some of which are having profound consequences on traditional art dealing. Since the mid-1990s the major auction houses have metamorphosed into art dealers: they offer private treaty sales, commission new art works, and offer investment advice. According to Christie's chief executive, Edward Dolman, one of the most significant changes to the business was that: 'Over the last 20 years we have moved away from being just auctioneers.'[63] In 1996, Sotheby's New York agreed a merger with the contemporary art gallery, André Emmerich: the auction house assumed all expenses, in return for access to both stock and studios.[64] In 2006 Sotheby's exhibited twenty-seven monumental modern and contemporary sculptures in the grounds of Chatsworth House, Derbyshire.[65] There was no traditional concluding auction: the works were sold by private treaty to established collectors; the artists were directly involved in the sales contracts and were able to veto buyers whom they considered inappropriate; and several new sculptural editions, including originals by Hirst, Gormley and Chihuly, were commissioned specifically for the sale.

To art dealers, such transgressions by the major auction houses into their own territory have been interpreted as highly unethical attempts by multinational corporations to monopolize the art market at the expense of the small commercial gallery. Their ethical argument against monopolization is based on the utilitarian principle, namely that, in the words of the founder of modern Utilitarianism, Jeremy Bentham: 'Ethics at large may be defined, the art of directing men's actions to the production of the greatest possible quantity of happiness, on the part of those whose interest is in view.'[66] Within socio-economic philosophy, this utilitarian principle reached its ultimate form in the Utopian writings of Karl Marx.

The business world has created its own ethical principles in order to defend capitalism against Marxist and Socialist utopianism. Pragmatism, pioneered during the late nineteenth and early twentieth centuries by philosophers such as William James and Charles Pierce, argues that our ethical decisions should be based on the practical consequences of an action.[67] Art dealers have responded to the monopolizing strategies of auction houses by creating their own corporate events in the form of international art fairs. To the pragmatist, the consequences of business competition can lead to an increase in consumer participation in the market: this is certainly the case with the Art Fair, with their visitor numbers increasing dramatically since the mid-1990s.

Friedmanism would argue from a variation of Utilitarianism that it is ethically correct for a business to maximize profits for its financial stakeholders, so long as remaining within the law: the government makes the law, and receives taxes from capitalism to distribute to the broader stakeholders of the community. Friedman's monetarist philosophy is the strongest argument for those who believe in the free market. To the Friedmanite, the Sotheby's Chatsworth Sculpture sale was not illegal, and the company was acting in an ethically defensible manner by seeking to maximize profits for its shareholders by broadening its sales strategy. At the same time, the Sotheby's exhibition was open to the public visitor to Chatsworth House at no extra cost, and therefore bringing fine examples of modern and contemporary sculpture to a large number of extra-metropolitan viewers, an additional utilitarian ethical argument. Therefore, the independent dealers have their art fairs and the auction houses have expanded into dealer territories: to the pragmatist and utilitarian both sides are happy with the expanded market. Or are they? There is a final twist. In June 2006, Sotheby's purchased Noortman Master Paintings. The Old Master gallery, based in Maastricht, is continuing to exhibit in 2007 at The European Fine Art Fair (TEFAF).[68] Effectively, the auction house will now have a major stand at the world's most important traditional art fair. Christie's has responded by successfully demanding that it should also be allowed a stand in the 2007 fair. Neither auction house will be allowed to employ their brand name, and exhibits will be for private treaty sale not auction. As one commentator has stated about the ethical lack of transparency in this quite ridiculous situation: 'Art fairs are supposedly the trade's answer to auctions, a way of creating a glamorous event to attract buyers, so the presence of an auction house in a fair . . . was seen as a Trojan horse.'[69]

Conservation and restoration

The main ethical aim of the conservator and restorer of art and archaeological objects in public museums is to preserve the heritage aspects of the object by ensuring minimal intrusion into its physical state, as well as the reversibility of any alterations to its fabric.[70] In the art market, the ethics of conservation and restoration are further complicated by the pressure on dealers to maximize their profits by presenting the work in as attractive a condition as possible. It is well known that dealers prefer to buy unrestored works so that they can add monetary value during their own particular restoration process: hence the surprising number of unrestored paintings exhibited at auction house previews. By the same token, an art object in an irreversibly poor state of preservation will be valued at only a small percentage of the value of a well-preserved work. Therefore, whereas in the museum environment conservation takes precedence over restoration, in the context of the art market restoration tends to have primacy over conservation. Because restoration changes the aesthetic features of an art object, as well intruding

into its physical state, ethical discussions often lead to fierce disagreements.[71] The ethical decision a dealer or collector has to make is one of balancing the aesthetic appearance of the art object with the conservation of its physical state. Insensitive over-restoration in an attempt to reproduce the work's pristine appearance will very often mean that conservation factors have been minimized. In the short term this might not appear to matter, but unethical destructive conservation methods could lead to deterioration of the object in the long term, and therefore a reduction in its monetary investment value. Even the pragmatist would therefore probably argue for the primacy of correct conservation over incorrect restoration techniques.

Unethically sourced materials

Over recent years, the ecological drive towards using sustainable and ethically sourced materials throughout all human activities has begun to affect the art world. Ivory is now seen as a highly unethical material for artists to employ because it requires the unethical slaughter of the elephant, walrus and whale.[72] Most nations have imposed a legal ban on the import and export of recently sourced ivory, following the Convention on the International Trade in Endangered Species of Wild Fauna and Flora (CITES) in 1975.[73] This may seem an absolute ethical standpoint, but our museums are filled with ivory art objects carved from antiquity to the early decades of the twentieth century produced when the killing of such animals was considered a divine gift to human beings. In spite of the laws, new ivory is still in demand by artists and craftsmen intending to fake ancient ivories. It is virtually impossible to ascertain its date, making forgeries difficult to identify, as well as encouraging continued wilful killing of the source animals.

An apparently less emotive material, because no animal deaths are incurred in its extraction, is the diamond. However, the ethical aspects involving diamond mining are not dissimilar to provenance issues discussed above. A majority of the world's diamonds are sourced in countries in which military conflict leads to the exploitation of the stones for the purpose of smuggling and arms-dealing.[74] Most recently, Sierra Leone has been a major victim of the trade in conflict diamonds.[75] Only in the early years of this millennium has the situation been addressed by the Kimberley Process.[76] This document seeks to create an ethical code of practice for the global diamond industry, in order that provenance is thoroughly checked before dealers and consumers purchase the finished jewellery item.

Perhaps the most bizarre current ethical debate within the art market concerns the sourcing of artistic materials and the making of art objects using 'wet-lab' processes.[77] These involve ethically controversial genetic modification and interference with DNA structures. Players in the art market can only wonder what new ethical time-bombs and monsters the future has in store for them.

Concluding remark on the artist, aesthetics and ethics

It is perhaps fitting to conclude with a brief discussion of the role of the artist and religion within these complex ethical webs. Chris Ofili provides an example of how moral dilemmas affect practising artists. In 1999, Ofili's painting of *The Holy Virgin Mary* was displayed in the Brooklyn Museum of Art's exhibition *Sensation: Young British Artists from the Saatchi Collection*. The exhibition had already caused a degree of public moral indignation when shown at the Royal Academy in London. This went one step further in New York when the mayor Rudolf Giuliani referred to Ofili's image as 'sick stuff'. The painting included elephant dung and pornographic photography as part of his interpretation of the Christian icon as a black woman. Giuliani failed in his subsequent attempt to withdraw city funding of the museum. Hillary Clinton agreed with Giuliani that the exhibition was 'objectionable' but criticized his threat as 'a very wrong response'.[78] Ofili himself was profoundly upset by the negative reception of his work.[79] He himself is a practising Roman Catholic and argued from a *utilitarian* standpoint against censorship of art:

> The Church is not made up of one person but a whole congregation, and they should be able to interact with art without being told what to think. . . . This is all about control. . . . We've seen it before in history. Sadly, I thought we'd moved on.[80]

Ofili became involved in a different type of ethical dilemma when in 2006 Tate Modern was accused by the Charity Commission of breaking the law by buying art produced by serving trustees.[81] The work in question was another Christian subject by Ofili: a composite group of images entitled *The Upper Room* (1998–2002). It was purchased by the gallery for £600,000 (plus VAT) while Ofili was serving as a trustee. The Charity Commission was eventually satisfied that the acquisition was in the interests of the gallery because some 250,000 members of the public viewed it between 2005 and 2006. Once again, the *utilitarian* argument prevailed, this time over the law itself, with the public interest being considered more important than strict adherence to the law.

To conclude, it is perhaps ironic that, in an increasingly secular world devoid of authoritative ethical codes, religion has once again become a subject of art and ethical controversy, as it was in the Renaissance.[82] Internationally famous living artists such as Damien Hirst, Anselm Kiefer and Chris Ofili have all recently produced images drawn from biblical sources, as if attempting to refill the contemporary moral vacuum. A spokesperson for the Charity Commission, reflecting on the Tate/Ofili affair stated that a conflict of interest is 'a fact of life, and not necessarily a problem as long as it is properly managed'.[83] In the absence of a universally accepted secular or religious code of ethics players in the

art market may do worse than to take heed of this *pragmatic* statement.

Glossary of terms from the International Council of Museums (2006)

Appraisal The authentication and valuation of an object or specimen. In certain countries the term is used for an independent assessment of a proposed gift for tax benefit purposes.

Code of ethics A body of ethical guidelines drawn up and agreed by a professional association in order to agree and maintain a certain level of moral standards in their behaviour and dealings both within and outside of their association.

Conflict of interest The existence of a personal or private interest that gives rise to a clash of principle in a work situation, thus restricting, or having the appearance of restricting, the objectivity of decision making.

Cultural heritage Any thing or concept considered of aesthetic, historical, scientific or spiritual significance.

Dealing Buying and selling items for personal or institutional gain.

Due diligence The requirement that every endeavour is made to establish the facts of a case before deciding a course of action, particularly in identifying the source and history of an item offered for acquisition or use before acquiring it.

Legal title Legal right to ownership of property in the country concerned. In certain countries this may be a conferred right and insufficient to meet the requirements of a due diligence search.

Museum A museum is a non-profit-making permanent institution in the service of society and of its development, open to the public, which acquires, conserves, researches, communicates and exhibits, for purposes of study, education and enjoyment, the tangible and intangible evidence of people and their environment.

Non-profit organization A legally established body – corporate or unincorporated – whose income (including any surplus or profit) is used solely for the benefit of that body and its operations. The term 'not-for-profit' has the same meaning.

Provenance The full history and ownership of an item from its discovery or creation to the present day, through which authenticity is determined.

Valid title Indisputable right to ownership of property, supported by full provenance of the item since discovery or production.

Notes

1 Hennessy (1989) 12.
2 For a discussion of artists, the art market and globalization see Morgan (2006).
3 The application of the pragmatist theories of the economist Milton Friedman (1912–2006) which predicate that it is ethically correct for a business to maximize

profits for its financial stakeholders, so long as it remains within the law. See Friedman (1970).

4 For discussions on applying ethics in the international business and arts environment, see Edson (1997), Kline (2005) and King and Levin (2006).

5 See for example the Fine Art Trade Guild Code of Ethics: www.fineart.co.uk/Codeofethics.asp

6 Langford (2000: 209).

7 For discussions of the problems involved in defining and implementing ethical codes, see Merryman (1998) and O'Keefe (1998).

8 Mueller (2006).

9 Pragmatism looks at the practical consequences of an action as opposed to the morality of the action itself and its more immediate effects. Relativism forgoes universal and absolute ethical standards and views situations solely within their own specific individual, cultural and/or historical context. Utilitarianism addresses the morality of actions, which are assessed in terms of which produces the greatest benefit for the greatest number of people.

10 The European Fine Art Fair (TEFAF) 2006 had several examples of such ethical high visibility in the form of ethical provenance guarantee labels; however, these were absent at the 2007 fair!

11 Watson (1997).

12 The antiquities market has grown from an annual turnover of US$18,620,436 in 1995 to US$70,800,000 in 2004. Even the third auctioneer, Bonhams, has had an annual turnover of £1 million (approx. US$2 million) since 2000.

13 Bonhams (2006): see especially pp. 119–20 for a legal viewpoint sympathetic to Lord Northampton.

14 Renfrew (2007). Ironically, the treasure was offered for sale to the Getty Museum in 1984. The museum declined when it realized that the Lebanese export licences had been forged.

15 Ruiz (2007): 'The Marquess of Northampton later sued his former London legal advisors, Allen & Overy, for damages in relation to advice given during the purchase of the silver. The claim was settled by payment of an undisclosed sum believed to be around £25m'.

16 For example, the *Mildenhall Treasure* in the British Museum and the *Boscoreale Treasure* in the Louvre and the Metropolitan Museum of Art.

17 The sale at Sotheby's New York (June 2007) of a bronze figure of *Artemis and the Stag* (circa first century BC to first century AD) sold for $28.6 million, making it the most expensive sculpture ever sold at auction. The buyer was Giuseppe Eskenazi, bidding on behalf of a private collector. The consignor was the Albright-Knox Art Gallery in Buffalo, New York.

18 Renfrew (2007).

19 Dr Mihaly Nagy, a curator at the National Museum in Budapest, believes that the treasure is from Hungary because the word 'Pelso' is inscribed on one of the plates: 'Pelso' is the ancient Roman name for modern Lake Balaton in Hungary.

20 Ruiz (2007): ' "187 silvergilt spoons, 37 silvergilt drinking cups, and 5 silver bowls" were available for sale along with the 14 known pieces of Sevso silver in the 1980s'.

21 ICOM (2006: 8, section 4.5).

22 Renfrew (2007).

23 Bonhams, New Bond Street Antiquities Sale (20 October 2005): Lots 127, 128, 140 and 209.

24 During the nineteenth century national legislation on the movement of cultural property was passed by the following countries: Greece (1834), Italy (1872) and France (1887).

25 O'Keefe (2000).

26 A selection of UNESCO agreement signatories and dates: India (1977), Italy

(1978), Greece and Turkey (1981), United States of America (1983), UK (2002) and Switzerland (2003).

27 O'Keefe (2000: 106–13).

28 O'Keefe (2000: 123).

29 Brodie et al. (2000: 38).

30 The upper estimates of the lots cited in note 20 range from £4,000 to £25,000.

31 The status of the permit as a Turkish legal document has been doubted.

32 Christie's *Important European Furniture, Sculpture, Tapestries and Carpets*, Thursday 13 June 2002, LOT 112.

33 Bennett (2005). Jenkins in fact employed a number of falsehoods in his paperwork in order to obtain the export licence from the Roman authorities, including false valuations and condition reports, and the outright lie that it was being sold to the King of England! See, for example, Johann Winckelmann's letter of 19 June 1765 in J. Winckelmann (1956) (W. Rehm, ed.) *Brief*. Berlin: de Gruyter.

34 Baring (2005).

35 For an account of Weddell and the Newby Hall sculpture gallery see Leeds Museums and Galleries (2005: 73–91).

36 Mattusch (1988: 154–57).

37 Slayman (1998).

38 ICOM (2006: 8, section 4.5).

39 Soltes (2006).

40 Haskell and Penny (1981: 108–16).

41 For a recent example of Nazi-looted art (Cranach's *Cupid Complaining to Venus* in the National Gallery, London) see Beckford (2007); for academic research into relevant documentary records see the National Archive website: www.archives.gov/publications/prologue/2002/summer/nazi-looted-art-1.html

42 See, for example, Sotheby's *Impressionist and Modern Art* Evening Sale, London (19 June 2006): Lot 35.

43 For a discussion of art looted or destroyed during the most recent Iraqi war, see Shahout (2006).

44 Thomas (1968: 27).

45 See Lydiate (2005a, 2005b). For a report on the UK collection of the levy, see Capon (2007). Currently France levies the charge for sales of over €3,000 while the UK minimum is €1,000. The UK levy applies only to living artists, and France is considering changing the *droit de suite* from seventy years after the artist's death to living artists only.

46 McClean and Schubert (2002: 27). See also Benjamin (1968) for his classic discussion of the status of original art.

47 'Cultural Revolution, Chapter 2; Expatriate Artist Updates Maoist icon and Angers Old Guard', *New York Times* (17 August 2000).

48 'Hirst pays up for *Hymn* that wasn't his', *Guardian* (19 May 2000).

49 McClean and Schubert (2002: 37). For an excellent discussion of the problems of art and copyright see the whole of McClean's introductory chapter.

50 Hamlin (1999).

51 Other more recent forgers of classic modern artists include Englishmen David Stein (Picasso and Chagall) and John Myatt (Braque, Giacometti, and Matisse). For discussions of art fakes and forgeries, see Jones (1990) and Radnoti (1999).

52 Scott Schaefer, curator at the Getty Museum, quoted in *The Art Newspaper* (14 December 2006); the paintings were sold at Sotheby's New York (25/26 January 2007).

53 ICOM (2006: 4–5, sections 2.12–2.17).

54 The record for a Lowry painting is £1,926,500 (with premium) for *Going to the Match*, bought by the Professional Footballers' Association in 1999.

55 For example: Simon Jenkins, *Guardian* (27 October 2006).

56 www.bbc.co.uk/manchester (25 October 2006).
57 The Bolton News.
58 www.mla.gov.uk (25 September 2006).
59 ICOM (2006: 4–5, section 2.13).
60 www.24hourmuseum.org.uk (20 November 2006).
61 *Guardian* (27 October 2006).
62 For a discussion of the ethical rights of museums to title, see Freudenheim (2006).
63 Adam (2003).
64 Bevan (1996): the merger failed and was eventually abandoned; but it set a precedent for more successful mergers and opened up the contemporary market for auction houses.
65 *Beyond Limits: Sotheby's at Chatsworth: A Private Sale Offering* Catalogue (2006).
66 Bentham (1789: ch. 17, section 2: cccviii).
67 Malachowski (2004); Shock (2006).
68 Even before Robert Noortman's death in January 2007 the situation was complex as Noortman was a co-founder of TEFAF.
69 Adam (2006).
70 Child (1993, 1997); Munoz-Vinas (2005).
71 For a discussion of the ethical issues surrounding the controversial restoration of Michelangelo's *Pietà*, see Janowski (2006).
72 Horowitz (1991).
73 www.ukcites.gov.uk/intro/default.htm; for a discussion of the application of CITES, see Stiles (2004).
74 For a general discussion of conflict diamonds, see Bourne (2001).
75 Pham (2006).
76 www.kimberleyprocess.com.
77 See Levy (2006).
78 Barstow and Herszenhorn (1999).
79 Kimmelman (1999).
80 Vogel (1999).
81 Higgins (2006).
82 Examples include: the modest overpainting of the *ignudi* in Michelangelo's *Last Judgement* in the Sistine Chapel, Rome, and the uproar caused by the display of Caravaggio's *Madonna of the Pilgrims* in the church of Sant'Agostino, Rome, with its prostitute model for the Virgin Mary and dirty-footed worshippers.
83 Higgins (2006).

References

Adam, G. (2003) 'Interview with Edward Dolman', *The Art Newspaper* 132 (January).
Adam, G. (2006) 'Dealers angry as Christie's follows Sotheby's to Maastricht', *The Art Newspaper* 174 (November).
Baning, L. (2005) *Daily Telegraph* (30 April).
Barstow, D. and Herszenhorn, M. (1999) 'Museum Chairman Broached Removal of Virgin Painting', *New York Times* (28 September).
Beckford, M. (2007) 'A wartime Cupid that still has the power to sting', *Daily Telegraph* (29 March): 3.
Benjamin, W. (1968) 'The work of art in the age of mechanical reproduction', in H. Arendt (1992) *Illuminations*. London: Fontana.
Bennett, W. (2005) 'The art of replacing £8m goddess', *Daily Telegraph* (22 March).
Bentham, J. (1789) *An Introduction to the Principles of Morals and Legislation*. London: T. Payne & Son.

Bevan, R. (1996) 'Emmerich/Sotheby's: the way ahead?', *The Art Newspaper* 61 (July).

Bonhams (2006) *The Sevso Treasure: a private exhibition* (October). London: Bonhams.

Bourne, M. (2001) *Conflict Diamonds: roles, responsibilities and responses*. Bradford: Department of Peace Studies, University of Bradford.

Brodie, N., Doole, J. & Watson, P. (2000) *Stealing History: the illicit trade in cultural material*. Cambridge: McDonald Institute for Archaeological Research.

Capon, A. (2007) 'Droit de suite nets £1m in its first year', *Antiques Trade Gazette* (6 January).

Child, R.E. (1993) 'Conservation ethics', in D. Fleming (ed.) *Social History in Museums: a handbook for professionals*. London: HMSO.

Child, R.E. (1997) 'Ethics in museum conservation', in G. Edson (ed.) *Museum Ethics*. London: Routledge.

Edson, G. (ed.) (1997) *Museum Ethics*. London: Routledge.

Freudenheim, T. (2006) 'Museum collecting, clear title and the ethics of power', in E.A. King and G. Levin (eds) *Ethics and the Visual Arts*. New York: Allworth: 49–63.

Friedman, M. (1970) 'The social responsibility of business is to increase its profits', *New York Times Magazine* (13 September).

Hamlin, J. (1999) 'Master (con) artist: painting forger Elmyr de Hory's copies are like the real thing', *San Francisco Chronicle* (29 July).

Haskell, F. and Penny, N. (1981) *Taste and the Antique*. New Haven, CT: Yale University Press.

Hennessy, P. (1989) 'The ethic of the profession' (FDA GCHQ Lecture, 31 May 1989). Unpublished: available in the National Archives, Kew.

Higgins, C. (2006) 'How the Tate broke the law in buying a £600,000 Ofili work', *Guardian* (19 July).

Horowitz, J. (1991) *The Ivory Trade*. Boston, MA: Northeastern University Press.

International Council of Museums (ICOM) (2006) *Code of Ethics for Museums*. Paris: ICOM.

Janowski, J. (2006) 'The moral case for restoring artworks', in E.A. King and G. Levin (eds) *Ethics and the Visual Arts*. New York: Allworth: 143–54.

Jones, M. (ed.) (1990) *Fake? The Art of Deception*. Berkeley, CA: University of California Press and British Museum.

Kimmelman, M. (1999) 'A Madonna's many meanings in the art world', *New York Times* (2 October).

King, E.A. and Levin, G. (eds) (2006) *Ethics and the Visual Arts*. New York: Allworth.

Kline, J.M. (2005) *Ethics for International Business: decision making in a global political economy*. London: Routledge.

Langford, D. (ed.) (2000) *Internet Ethics*. London: Macmillan.

Leeds Museums and Galleries (2005) *Drawing from the Past: William Weddell and the transformation of Newby Hall*. Leeds: Leeds Museums and Galleries.

Levy, E.K. (2006) 'Art enters the biotechnology debate: questions of ethics', in E.A. King and G. Levin (eds) *Ethics and the Visual Arts*. New York: Allworth: 199–216.

Lydiate, H. (2005a) 'Droit de suite', *Art Monthly* 284 (March).

Lydiate, H. (2005b) 'Artist's resale right', *Art Monthly* 290 (October).

McClean, D. and Schubert, K. (eds) (2002) *Dear Images*. London: Ridinghouse/ICA.

Malachowski, A. (ed.) (2004) *Pragmatism*. London: Sage.

Mattusch, C.C. (1988) *Greek Bronze Statuary*. Ithaca, NY: Cornell University Press.

Merryman, J.H. (1998) 'Cultural property ethics', *International Journal of Cultural Property* 7(1): 21–31.

Morgan, R.C. (2006) 'Unraveling the ethics in cultural globalization', in E.A. King and G. Levin (eds) *Ethics and the Visual Arts*. New York: Allworth: 235–42.

Mueller, T. (2006) 'To sketch a thief', *New York Times Magazine* (17 December).

Munoz-Vinas, S. (2005) *Contemporary Theory of Conservation*. Oxford: Butterworth-Heinemann.

O'Keefe, P. (1998) 'Codes of ethics: form and function in cultural heritage management', *International Journal of Cultural Property* 7(1): 32–51.

O'Keefe, P. (2000) *Commentary on the UNESCO 1970 Convention on Illicit Traffic*. Leicester: Institute of Art and Law.

Pham, J.-P. (2006) *The Sierra Leonean Tragedy: history and global dimensions*. New York: Nova Science.

Radnoti, S. (1999) *The Fake: forgery and its place in art*. Oxford: Rowman & Littlefield.

Renfrew, C. (2007) 'Time for the Sevso evidence to be made public', *The Art Newspaper* 178 (March).

Ruiz, C. (2007) 'The silver missing from the Sevso hoard?', *The Art Newspaper* 178 (March).

Shahout, N. (2006) 'The preservation of Iraqi modern heritage in the aftermath of the U.S. invasion of 2003', in E.A. King and G. Levin (eds) *Ethics and the Visual Arts*. New York: Allworth: 105–20.

Shock, J.R. (2006) *A Companion to Pragmatism*. Malden, MA: Blackwell.

Slayman, A. (1998) 'Recent cases of repatriation of Antiquities to Italy from the United States', *International Journal of Cultural Property* 7(2): 456–63.

Soltes, O.Z. (2006) 'Politics, ethics and memory: Nazi art plunder and Holocaust art restitution', in E.A. King and G. Levin (eds) *Ethics and the Visual Arts*. New York: Allworth: 65–87.

Sotheby's (2006) *Beyond Limits: Sotheby's at Chatsworth: a private sale offering*. Catalogue. London: Sotheby's.

Stiles, D. (2004) 'The ivory trade and elephant conservation', *Environmental Conservation* 31: 309–21.

Stuart Mill, J. (1861) *Utilitarianism*. London.

Thomas, D. (1968) *Copyright and the Creative Artist*. London: Institute of Economic Affairs.

Vogel, C. (1999) 'Holding fast to his inspirations; an artist tries to keep his cool in the face of angry criticism', *New York Times* (28 September).

Watson, P. (1997) *Sotheby's: the inside story*. London: Bloomsbury.

11 Art and crime

Clarissa McNair and Charles Hill

This chapter has two related sections on art and crime: Clarissa McNair's 'The art of crime' and Charles Hill's 'Art crime: the high profile, but low down, and barbaric kind'.

THE ART OF CRIME

Clarissa McNair

Perhaps the most romantic art theft was perpetrated by Adam Worth, an infamous criminal of the Victorian era and the model for Arthur Conan Doyle's brilliant and villainous Professor Moriarty. Worth stole Gainsborough's portrait of the Duchess of Devonshire and kept it hidden, sometimes sleeping with it, for twenty years (Macintyre 1997). Worth returned the painting to William Pinkerton, the American detective who had become a trusted friend, after elaborate arrangements had been concluded, in 1901. But almost all other art crimes are more prosaic.

The English language has more than a hundred words to connote deception: fraud, forgery, fake, counterfeit, copy, illusion, sham. The verbs are endless: to deceive, swindle, fool, ensnare, to dazzle, to trick, to beguile. Documents can be forged, a provenance can be doctored, paintings can be faked, antiquities can be looted, works of art can be stolen, and designs can be copied.

Copies and counterfeits

As a private investigator working in the world of intellectual property, my general assignment is to find the fakes, make evidential purchases by painstakingly gaining the trust of the counterfeiters, and to notify law enforcement. My sketches of the factories and warehouses with entrances, exits, elevators and stairways are used by the Organized Crime Intelligence Division (OCID) of the New York Police Department and the Joint Terrorist Task Force. Searches and seizures follow, the goods are taken, vehicles and property impounded and 'perps' are put in cuffs. Often, to our chagrin, there is so

much cash available that bail is made before the product (i.e., luxury goods or works of art) can be counted and tagged.

The operations often involve months of planning, teamwork, undercover work with aliases and phones and addresses that do not exist, confidential informants we call 'cheese eaters', scam calls, tails, stakeouts, nocturnal garbage grabs and midnight dumpster diving.

Usually the clients for these cases are the designers of jewellery, watches, handbags, sunglasses or sportswear. But counterfeiting extends far beyond fashion brands. Fake pharmaceuticals can kill and equal the danger of installing counterfeit parts in an automobile or an airplane. Counterfeit baby formula has been distributed in Africa.

Counterfeits vary: there are passable knock-offs; others are very poor in quality. Workmanship can 'appear' excellent, hiding the inherent inferior quality. Sometimes a team of experts working for the designer will spend days looking for the tell-tale difference in the real thing sold for thousands of dollars and a cheaper version peddled on the street. It might be a grommet that is one millimetre larger than it is on an original or eighteen stitches to the inch instead of twenty. Moreover, counterfeits can be over-runs from a factory with a contract to make the real thing; this is selling 'out the back door'. In May 2004, a judge in the Federal District Court in Miami ruled in favour of furniture designer Nancy Corzine against the showroom which sold her furniture and counterfeits of her furniture. It took nine years and many thousands of dollars in legal fees, but the designer won the case.

Kevin F. Dougherty, president of Counter-Tech Investigations in New York, says that people perceive counterfeiting as a victimless crime: 'But it isn't. It's comparable to the identity theft an individual suffers when his wallet is stolen. When a product or a design is counterfeited and sold, our client's good name is stolen and misused.'

One case involved me wearing a 'wire' – actually two in case one failed – and posing as an owner of jewellery stores in Houston and Dallas. I armed myself with a new name, fake business cards, a fake business history, a 'col-league' in the diamond district who would vouch for me and a southern accent. Two Armenians gave me a crash course in points and carats and coached me on how to negotiate prices – how to pretend that I had years of experience in the diamond trade.

A certain diamond dealer on 47th Street in New York was copying a very famous designer's jewellery. Hired by the designer, my assignment was to get an admission and the name of the designer on tape. Locked in a small room within a locked room within a locked room with video surveillance, I 'bought' over $30,000 worth of stones on the table before me and ordered the designs. In less than two hours all that I needed had been recorded. I concluded the transaction, remembering *not* to shake hands with the Hasidic Jew and was escorted out of one room after another with the doors again locking behind me. The designer was now prepared for court.

The entertainment industry, not just in Los Angeles but in Bollywood, too, is fighting in the arena of digital piracy. DVDs appear in China before the movie opens in US theatres. No musician gets royalties from a CD that is sold for a few cents on another continent before it is released in his or her home country. Publishing, too, is affected by the flouting of intellectual property laws. Harry Potter's latest adventure is out and for sale on the streets of Shanghai before the midnight book party in London.

Scores of new laws have been enacted since the mid-1990s and there are organizations in the USA, Europe and Asia founded to fight counterfeiting. But the free movement of goods – as within the European Union – is a boon for illicit operators. Travel between countries is more open than ever, with the majority of shipments arriving uninspected.

The internet has introduced a borderless trade zone. In September 1995, eBay began operations with its trademark claim, 'The World's Online Marketplace'. Although eBay does not claim responsibility for the authenticity of what is offered for sale, the firm does act to enforce copyright infringement when informed.

It is claimed that counterfeiting is a market worth more than $500 billion or 7 per cent of world trade (Phillips 2005). Counterfeiting is enormously lucrative. No taxes are paid. It is a river of cash flowing into the coffers of gangs as diverse as the Mafia, Asian tongs and fundamentalist Islamic groups. Federal law enforcement officials say counterfeiting funds terrorism and that there are links to those responsible for the 1993 World Trade Center bombing.

If the photocopy machine revolutionized espionage then the personal computer has forever changed the world of counterfeit goods. In particular, the internet has given the nether economy a marketplace in the ether.

Fakes, forgeries and frauds

Fraud in the art world is rife. However, an auction house, unlike a street vendor or a website, stands behind the products that change ownership under its banner. There is responsibility for authenticity whether it is a painting, a tapestry or a silver chalice. The provenance, the seals, the hallmark, the signature can all be examined and verified. There are experts at Sotheby's and Christie's, but still fakes appear.

Celebrity memorabilia, by its very nature, has a provenance that links the object to the glamour or fame of its previous owner. Of course, this provenance could be deceptive. A Rolex can be examined and proved to be counterfeit; a real Rolex with its serial number can be traced to the purchaser and the purchase date, but does not provide proof of who actually wore it. A famous murder case in Canada in 1996, involving financier Albert Walker, began with the Rolex found on the corpse's wrist.

Andrew Sulner, a forensic document examiner in New York and former state prosecutor, says, 'If ever there was an industry where the cautionary

phrase "caveat emptor" applied, this is it.' The expert on forgeries displayed baseballs autographed by sports great Mickey Mantle and then put the forgeries, indiscernible to the untrained eye, beside them.

Maps and documents can be examined, with the type of ink and paper or parchment easily determined. Handwriting and signatures can be confirmed. Carbon dating can ascertain age, ultra-violet fluorescent light can find repairs to a canvas. Polarized light microscopy analyses pigment and a conventional X-ray can detect an earlier work under the present one. None of this can prove that a painting was actually painted by a specific artist but the examinations can pinpoint a time when the materials were available and thus rule out when it could not have been painted.

According to Thomas Hoving (1996), former director of the Metropolitan Museum of Art, about 40 per cent of the 50,000 works of art he examined during his sixteen years at the Metropolitan were not what they were represented to be.

In May 2000, Paul Gauguin's *Vase de fleurs* was offered for auction at Sotheby's – and at Christie's. Federal agents in New York discovered that Sotheby's had the real one; Christie's had the fake. Elly Sakhai, owner of Exclusive Art in Manhattan, pleaded guilty to fraud charges. He had purchased genuine works of artists, such as Gauguin, but lesser known works and had them copied by forgers who worked from the originals. Many of the forgeries were sold to private collectors in Japan and Taiwan, but he kept the originals. When Sakhai decided to sell the original Gauguin, he had no idea that his forgery would be offered for auction at the same time.

Looting and smuggling

Authentic works of art can also be stolen ones. Marion True, former curator of antiquities at the J. Paul Getty Museum, is on trial in Italy charged with conspiring with antiquities dealer, Robert Hecht, to export illegally excavated treasures. The case against True hinges upon thirty-five objects that are from looted archaeological sites. They were acquired between 1986 and the late 1990s and are valued at millions of dollars. True's lawyers have admitted to their dubious provenance, but claim that True did not know that they had been looted.

According to Malcolm Bell, professor of art history at the University of Virginia: 'For the last decade, however, the Getty has prohibited the purchase or acceptance as a gift of any work whose existence is not documented before 1995.' He continues:

> other museums, including the Metropolitan Museum of Art, the Museum of Fine Arts in Boston and several major university collections (Princeton and Harvard among them) instead follow the policy adopted by the Association of Art Museum Directors, which allows the purchase of undocumented antiquities if the museum believes acquisition is justified.

The problem here is that objects newly on the market with no known history are almost certain to have been recently pillaged. If dealers revealed the origins of such works they could not possibly be sold.

(*New York Times*, 28 November 2005)

Various institutions have been linked to the looting, but the Getty Museum is by far the most financially impressive. Established in 1976, upon the death of the oil tycoon, the J. Paul Getty Trust has an endowment of $5 billion and, with an additional $4 billion in assets, the Getty is the third largest foundation in the USA.

The case against True is a strong signal by Italy that the country is ready to fight to protect its cultural heritage. Greece has taken action to recover several works. Other countries may follow suit. Peru, for instance, is threatening legal action against Yale University.

During negotiations with Italy over objects in the Metropolitan's collection, many proposals have been put forward, one of which might become a template for other US institutions. Italy would reclaim ownership of certain treasures with questionable provenances in exchange for allowing long-term loans, which Italy has never allowed before. This would be a face-saving gesture for US art museums, and would benefit both sides.

Philippe de Montebello, director of the Metropolitan, met for three hours on 20 February 2006, with representatives of the Italian Cultural Ministry in Rome. They reached an agreement for the museum to return twenty objects in its collection and, in exchange, the Met will receive long-term loans of objects of 'equivalent importance and beauty'. This meeting finalizes details of the return of the famous Euphronios krater. The vase has been one of the museum's most important antiquities for thirty years. Montebello will also be returning a set of Hellenistic silver which archaeologists say was looted from Morgantina, a site in Sicily.

'People think there is an illicit market and a legitimate market,' said Ricardo J. Elia, associate professor of archaeology at Boston University. 'In fact, it is all the same' (*New York Times*, 23 February 2004). By way of illustration, the intricate path of a four-foot high stele, unearthed in Akhmim in Egypt at a government archaeological site, is described: the stele passed through the global market in the late 1990s and five years later appears in the foyer of a Fifth Avenue apartment. The link to the West was an Englishman named Jonathan Tokeley-Parry. The handsome Cambridge graduate was a restorer of antiquities who originally went to Egypt to advise a Danish dealer. In Cairo, at the Old Windsor Hotel, he met Ali Farag and the two became accomplices in a highly successful smuggling operation. Using his skills, Tokeley-Parry disguised artefacts as tacky tourist souvenirs and talked his way through customs. Tokeley-Parry says that in six years, by the summer of 1994, his partnership with Farag had an impressive record: more than sixty trips between Egypt and England and more than 2,000 objects smuggled out without incident (*New York Times*, 23 February 2004). The story, which

begins in a field in Egypt, proceeds to the never-never land of the free port in Zurich and on to Geneva, London and New York, and ends in a Cairo courtroom, is mesmerizing.

Laws concerning patrimony

The disparate laws of nations complicate regulating what is bought and sold and how works can travel. In Egypt, under a law passed in 1983, all discovered artefacts belong to the state and are prohibited from export. But smugglers in the 1990s openly bought objects found by farmers in their fields and looters called in tips about new finds. None of this would have gone on without bribery and the complicity of government officials.

In Italy, a law passed in 1939 to protect cultural heritage seems to encourage subterfuge and foul play. If an antiquity is found by a landowner, he or she is required to alert the authorities. The authorities can then seize not only what was just discovered, but also the ground where it was discovered. Then the land can be excavated. All of this can happen, legally, without any compensation to the owner. Many say that this law encourages the quiet removal of objects from farmland and their secret sale to a dealer. Before 1939, information about the origins of an object was obtainable because the owner did not fear prosecution. Now it is nearly impossible to get that information.

UK policy is quite different on what is deemed Treasure Trove. In practice, on discovering an antiquity, if one reports it to the Crown then one is free to sell it. The UK also has less restrictive practices of allowing works to leave the country.

Illegal art trafficking is often spoken of in the same breath as drug smuggling and arms dealing. Indeed, Robert K. Wittman, a special agent and senior FBI investigator in Philadelphia, said: 'Cultural property crime is the fourth-largest economic crime worldwide, following drugs, money laundering and illicit arms' (*New York Times*, 30 March 2005). Elizabeth Olson has described the FBI's recently formed Art Crime Team, of which Wittman is a member (see *New York Times*, 30 March 2005). The antiquities market has always been notoriously corrupt and, in the past, once an antiquity reached a dealer in Geneva or London there was a tacit policy of 'don't ask, don't tell.' Perhaps the trial in Italy will signal an end to the acceptance of this ethical ambiguity.

Malcolm Bell ends his editorial in the *New York Times* by saying:

> If there is one major lesson to be learned from Mr. Ferri's (the Italian prosecutor) investigations, it is that collectors and museums, in America and around the world, must take into account not just the aesthetic value of the objects they acquire but also the ethical and legal consequences of their acquisition policies.
>
> (*New York Times*, 28 November 2005)

The spoils of war

More widespread than the looting of archaeological treasures is the looting during war, revolution and social upheaval. From Cambodia to Yugoslavia to contemporary Iraq, the story is much the same. Nazi plundering of art works during the Second World War is now well documented. But many Cubans in Miami feel that they have suffered distress by leaving their property and possessions behind when Fidel Castro came to power.

The family of Pepe Fanjul, a sugar tycoon who lives in Florida, fled Havana in 1959. He has been pursuing a family painting by Joaquín Sorolla y Bastida. Castro claimed one of the Fanjul mansions for his government and renamed it – with all furnishings, sculpture and paintings intact – the National Museum of Decorative Arts. Fanjul's brother, Alfy, said:

> So long as the collection remained in the Museum of Decorative Arts, we were willing to wait out the end of the regime. After the fall of the Soviet Union, we became concerned that the collection might be removed from Cuba and sold off for hard currency by the Cuban government.
>
> (*New York Times*, 21 November 2004)

In 1993, the Fanjuls registered several Sorolla works with the Art Loss Register (which has the world's largest private database of stolen and lost art works with 145,000 items listed). Many paintings by Sorolla are still in Cuba but when one surfaced in the London office of Sotheby's in 1998, it spurred Fanjul to take action. The Fanjuls remain convinced that at least one of their Sorollas has been sold through Sotheby's and that one or more are or have been in Spain and Italy. They are pursuing this through the US State Department, which says that the agency is 'committed to aggressively pursuing cases involving foreign nationals trafficking in confiscated property.' Sotheby's has pledged to cooperate fully with the State Department. The Fanjul family is seeking to cite 'trading with the enemy' sanctions against Sotheby's, accusing the auction house of knowing the whereabouts of the Sorolla painting (*Miami Herald*, 16 December 2004). Pepe Fanjul was quoted in the *New York Times* (21 November 2004):

> I think that the Cuban government or whoever fronts for Castro and his henchmen are using this Sorolla to test the market. I'm not fighting this because it's the most valuable Sorolla we have. It's about property rights and my family's heritage.

Victims of Nazi era plundering (1933–45) have even stronger feelings about property rights and family heritage. In *The Lost Museum*, Hector Feliciano (1995) tells the story of several European families and of what happened to their art collections. He describes:

The schemes, ploys, and tricks the Nazis devised to dispossess them. When the Nazis arrived in Paris, works by Van Eyck, Vermeer, Rembrandt, Velazquez, Goya, Degas, Monet, Cezanne, Van Gogh, Picasso, Matisse and Braque were swiftly taken off the walls, rolled up and crated by their distraught owners, and ferreted away in temporary safety, only to be discovered – rather sooner than later – by the Nazis, or by an intricate network of collaborators, moving companies, neighbors, and house servants who informed them. When the sought-after paintings were found, they were quickly sent to the Jeu de Paume (a museum used as a warehouse during the war), to be catalogued, photographed, and shipped by train to Germany.

Paris was the world's centre for art in the 1940s. It had galleries, museums, auction houses and private collections unrivalled anywhere else. The Rothschild collection alone was said to contain masterpieces of every period: antiques, silver, rugs, tapestries, and thousands of rare books. It follows then that, as Feliciano (1995) writes, 'France became the most looted country in Western Europe. One third of all the art in private hands had been pillaged by the Nazis. Many of the tens of thousands of works stolen then are missing to this day.' France was a treasure trove; The Netherlands and Belgium also suffered but not to the same extent.

It is no surprise to note that the Nazis' precision meant that their records have been the most helpful in locating these works of art. Every movement of every painting was noted in files. The looting was actually inventoried.

Hitler, a frustrated artist, had begun amassing his own art collection in the 1920s. In 1939, he appointed the director of the Dresden Museum, Hans Posse, to oversee the acquisition of works for the Linz Musueum. Linz, in Austria, where Hitler had spent happy days as a youth, was to be a showplace for Nazism, along with Berlin, Munich and Nuremberg. The museum was to be housed in mammoth buildings which would contain every European master of sculpture and painting. That is to say, every European artist recognized by the Nazis. Hitler was a great admirer of Rembrandt but it troubled him that the Dutch painter often chose subjects in the Jewish ghetto of Amsterdam.

Posse's budget was DM10 million (today's equivalent is $85 million). Often it was unnecessary to actually buy anything for Posse could choose whatever he wanted from the art that was pouring in from the confiscated collections of Jews and other 'undesirable persons' in Eastern Europe. In June 1940, Posse wrote his first annual report to the Führer and in it, he says that he had acquired 465 paintings in one year alone. Once asked to authenticate the provenance of a Vermeer, it was surprising to me to discover that the painting had actually been purchased in the name of Hitler; supposedly it had hung in his dining room throughout the war.

Hermann Goering, head of the Luftwaffe and an enthusiastic art collector, was said to have profited most from the looting of Paris. He controlled the

Einsatzstab Reichsleiter Rosenberg (ERR), which was responsible for most of the art confiscated in France. Stories have been told of Goering walking through freight cars loaded with paintings and pointing to this one and that one to be shipped back to Germany for his own hoard.

The final ERR report was written in July 1944 in Berlin. Between April 1941 and July 1944, twenty-nine major shipments of art works arrived in Germany from Paris. The first shipment had a Luftwaffe escort courtesy of Goering. There were a total of 120 railway cars packed with 4,170 crates of art. This represented 21,000 objects from 203 collections; there were 10,000 engravings, drawings and paintings.

According to Feliciano (1995), the German confiscation meant that the art market in Paris was inundated with stolen art put up for sale. The complex circuit of the confiscated art evolved through several phases, driven by the new German clients, the confiscations, and the peculiarities of the Nazi taste. Feliciano claims that 'in twelve years – not the thousand that the Führer had predicted – as many works of art were displaced, transported and stolen as during the entire Thirty Years War or all the Napoleonic Wars.'

In June 2004, the US Supreme Court ruled that victims of Nazi era plundering could sue in US courts to reclaim confiscated art. This provided the first opportunity for survivors and heirs to take legal action to recover art and other cultural property that their families had lost to the Nazis. Art museums have had to address the Supreme Court ruling by re-examining the provenance of suspect works. As an example of museum restitution, in 2004, the Utah Museum of Fine Arts returned François Boucher's *Les Amoureux Jeunes* to the heirs of the prominent French art dealer Andrew Jean Seligman. A researcher writing on the art collection amassed by Goering discovered that in 1940 Seligman had had the Boucher confiscated. Case after case has followed.

In February 2006, following an eight-year campaign, the Dutch government announced it would return two hundred Old Master paintings to the heir of Jacques Goudstikker, a Jewish art dealer and collector who fled Amsterdam in May 1940, just ahead of the advancing German troops. The paintings had been hanging in seventeen Dutch museums since the 1950s, making it one of the largest restitutions of art seized by the Nazis.

Efforts continue to reunite Nazi-looted art with their rightful owners or heirs. The Commission for Art Recovery of the World Jewish Congress is one of several organizations engaged in this activity.

ART CRIME: THE HIGH PROFILE, BUT LOW DOWN, AND BARBARIC KIND

Charles Hill

Unlike the use of thinking or considered dishonesty in art crime through deception, fraud, deceit, fakes and forgeries, including contrived provenance

and dodgy attributions, art theft has artless spectaculars. They are often robberies of priceless works from museums. As examples, take two, one from either side of the millennium divide. The Isabella Stewart Gardner Museum robbery of March 1990 and the Munch Museum robbery of August 2004 have been covered extensively in the press. What can be written and what can be done about either? At the time of writing this chapter (January 2007) the works of art stolen from the Gardner Museum have not been recovered, but those stolen from the Munch Museum were, in August 2006.

The Isabella Stewart Gardner Museum robbery

The Gardner Museum was a very unusual art robbery in the USA. It appeared to have been patterned on the art crimes of Dublin's Martin Cahill in the 1980s. Cahill was a notorious Irish gangster who styled himself 'The General' and was murdered in 1994, ostensibly by the IRA. In 1986, he had stolen a Vermeer and other important works from Russborough House in County Wicklow, now a part of the National Gallery of Ireland.

What was interesting about the Gardner robbery, when two men posing as Boston Police Officers tricked their way into the Museum, is that it was on St Patrick's Day night, 17–18 March 1990. Also, one of the robbers used the word 'mate' to a guard they tied up. That is a word used by Irish people, Brits, Australians, New Zealanders and a few others. It could be a clue. In style, you could consider the robbery as a gesture theft.

The way to look at such a crime is to ask the question why? If a mad art lover existed, one who would pay for such a crime, surely the great Titian, *The Rape of Europa*, would have been stolen, along with the Gardner's Vermeer and Rembrandt seascape that *were* stolen. Probably size and portability were factors, but an insight into the thieves' thinking is to capture the flag mentality. They also stole the finial to one of Napoleon's Imperial Guard regimental banners, and a Chinese beaker from antiquity. No doubt someone thought it would look good as an ornament on top of his TV set along with a Kissmee Quick Hat from his last vacation at the Orlando Disney World.

Over the intervening years, word, much of it exaggeration, has surfaced about what happened to the Gardner's pictures. Other than *Boston Herald* reporter Tom Mashberg's midnight ride to a warehouse in Boston, and convicted informant William Youngworth's persistent bullroar, indications have been that the pictures headed abroad. Discount Japan; Italy and Ireland seem the favourites. The FBI have followed thousands of leads and put in some big time air miles, but have studiously avoided an obvious conclusion. The Irish mob in Boston stole the paintings. My own view is that the pictures went to Ireland.

The main thing to do in an art crime investigation is to follow your experience and instincts, tempering them both with some rational judgements to prevent yourself being submerged in irrational and time-wasting idiocy. You'll only have your reputation at stake because the money to pursue any

investigation will have long gone by the time you recover what you are looking for. A reasonable reward might then get you out of debt.

Law enforcement officers want to catch the art crooks. They are less interested in recovering stolen property. The arrest and successful prosecution of a thief generally counts for more in police statistics than the recovery of the piece the thief stole. In the Gardner saga, the Boston office of the FBI may well have been reluctant to pursue the main brain behind the robbery because he was for many years one of the Bureau's Top Echelon informants who enabled them to eviscerate the New England Mafia. However, when the bodies in subsequent years of the people he had killed while under FBI protection, were counted up, nineteen was too many. If you look at the FBI's website, you'll see the man in the Top Ten, with no mention of the Gardner Museum robbery. That's on another FBI site, unlinked, with no hard evidence to link them.

The fact that he was Boston Irish, with strong connections in the West of Ireland, is significant. Even the gang he used to commit the robbery at the Gardner Museum had links to Ireland, although their particular gang leader was later shot dead by his wife, and she subsequently died of a drug overdose. These are all pieces of a jigsaw puzzle.

In my own investigation, which has simply meant asking people if they had heard anything, a criminal informant told me that a Vermeer was on offer in the West of Ireland, specifically in Tarbert, County Kerry, showing a man playing a piano. That's an inaccurate description, but accurate enough. The Gardner Vermeer depicts the image of a seventeenth century man with his back to the viewer listening to a young girl playing something like a harpsichord. The people who stole the Gardner Vermeer, and the people who hold it now, are not aesthetes, nor are their intermediaries likely to be knowledgeable.

About five years ago, I went to see another man, a gangster called Martin Foley in Dublin. He is one of the last of Martin 'The General' Cahill's gang from the 1980s and 1990s. We talked about art thefts in Ireland. I asked him about the Gardner Museum pictures and if they were in Ireland. He said that he knew all about that, but 'they'd kill me if I got involved.' Who are they? Obviously, they are harder men than he is.

In 2005, a notorious Traveller (indigenous gypsies who are Irish, Scots, English and Welsh, but not Romany) in the British Isles told me that some Travellers he knew in the West of Ireland had the Gardner pictures under their control and were holding them for 'others'. He said that an American doctor had been with them, but when he wanted money in exchange for the paintings, they kept the pictures and sent him away. The Boston Irish criminal who probably organized the Gardner heist has a prescription medication heart condition. My assumption is that the doctor who the Travellers sent away didn't keep his degrees and diplomas on the wall. Avoid him if you find him; ring in for the reward. He's a killer, not a healer.

If you're interested in the man, watch Jack Nicholson's portrayal of him in *The Departed*, Martin Scorsese's 2007 Oscar-winning film. And, like Jack

Nicholson himself, he's still alive. The DVD of *The Departed* comes in a boxed set with one disk showing extra material: in the section *Stranger than Fiction*, Scorsese and others discuss Whitey Bulger's criminal career as it relates to Jack Nicholson's portrayal. It is worth watching.

And so it goes on. There are limits to what you can find out without endangering your life or making a complete fool of yourself. A former police colleague of mine had an informant in Brighton, on the south coast of England, who had heard about the Gardner Museum pictures being held in Ireland and developed a curious plan to get Senator Ted Kennedy and the Cardinal Archbishop of Boston involved in their recovery. More recently, a well-known Manhattan journalist (the figure upon whom the character Peter Fallow in Tom Wolfe's *Bonfire of the Vanities* is based) spent a fortune on Irish food and drink pursuing the story of the Gardner saga, and looking for the pictures in the Athlone area.

My view is that you have to be persistent, downright dogged in your approach, cultivate informants and bide your time. Someone, someday, will recover the Gardner paintings, but it won't be until the people who have them are prepared to relinquish them. They have a mantra about not wanting to go to Guantanamo Bay. Even though the FBI says that only the paintings' recovery is an issue now because a statute of limitations for arrest for their theft has long past, the perception of the people who hold the paintings is different. Frankly, these people are too violent to push, and too dangerous to pander to.

Another saga – the armed robbery of two Munch paintings in August 2004

Another question to ask is why anyone would steal specifically artist's copies of masterpieces he had painted. Perhaps they thought they were the originals, perhaps they thought it was so easy, why not do it for the anti-establishment laugh, or perhaps they did it to serve as a distraction from another crime, or as some *macho* stunt, or all of the above. Understanding the thieves' motivation is the place to start looking for the pictures.

There are four painted versions of *The Scream* by Edvard Munch. The original is in the National Gallery in Oslo; another version is owned by the sons of the late Norwegian shipping magnate Fred Olsen; and two versions are in the Munch Museum. Also, there are endless numbers of woodcuts, reproductions, cartoons, not forgetting plastic dolls, key ring fobs and the like.

In 1994, the original was stolen from the National Gallery in Oslo and recovered several months later in a police undercover operation. For details of that, read Edward Dolnick's *The Rescue Artist* (2005) or *Stealing the Scream* (2007), but skip the human interest aspects and background chapters. The 2004 armed robbery of Munch's *Scream* from the Munch Museum was different, and in August 2006 it was recovered, badly damaged.

In 2004, a group of dangerous muppets waving a gun around pulled a version of *The Scream* and another of Munch's *Madonna* from the Munch Museum's walls and made off in an Audi that was fairly quickly found. Later, a disastrous police surveillance operation missed the pictures as they were moved from one location to another. Two of those three thieves were later arrested, and one purportedly died of a drug overdose. A man subsequently arrested for handling the two pictures was let off after he claimed that fear and coercion forced him to act as he did. He has returned to his normal life driving a car painted as a Batmobile.

Why did they commit the robbery? The two arrested haven't said much, and their reason is fear. Someone was behind the robbery, and those thieves are still terrified of him. Working on the assumption that the robbery was a distraction crime, the next question to ask is from what? Why would anyone steal two versions of paintings when the originals were elsewhere? Arrogant ignorance, bullying venality and insouciant ease are the most likely explanations. But that doesn't fully explain motivation. The Munch Museum robbery was in August 2004. In April 2004, an armed robbery took place in Stavanger in western Norway. A police officer was shot dead. The robbers were all dressed up in SWAT Squad gear. The Norwegian police were onto that major crime with a vengeance. The way to dissipate the heat was for the robbers to start another fire. That did not work.

Most of the armed robbers in Stavanger have gone on trial, admitted robbery but each one has denied murdering the police officer, and cannot remember who did. The interesting thing about them is that they are Albanians from Kosovo.

Read Moises Naim's *Illicit: how smugglers, traffickers and copycats are hijacking the global economy* (2005) for the general background to Kosovar Albanian crime in Stavanger, and Oslo for that matter, and Gothenburg and Stockholm, too. Groups of outlaws are the downside of the global economy and international social development. They congregate in their own chosen areas. Curiously, the Kosovars in Scandinavia follow the same pattern as the Serbs did there in the 1980s and early 1990s.

For art crime investigation of the high-profile heist kind, apply imagination to your thinking and then direct it to direct action, without getting shot and killed along the way. Follow your experience and instincts, tempering both with rational calculation, and ask the right people for help.

In the case of the Munch Museum paintings, an armed robber from the Stavanger raid named David Toska decided to help police recover the pictures after he was convicted. His lawyers told the police where to find them, and they did. If there is a deal, and Norwegian police are very shy about explaining what it is, it would seem to be conjugal rights for Toska with his girlfriend while he is inside, and a million chocolate M&Ms offered by the candy company as a publicity stunt reward. Apparently, Toska is an armed robber, possibly a cop killer, and a chocoholic. Trophy art theft is a combination of stupidity, tragedy and bathos.

The police tend to be preoccupied with catching crooks, not with recovering stolen art. That's true in almost all art crime cases. The police fail to see art crime as an Achilles heel for a crook who commits other crimes as well. That's down to a lack of imagination.

In Norway, Kosovar Albanians appear to have been behind the armed robberies that have taken place throughout Scandinavia since the mid-1990s. Curiously, they picked up where their enemies, the Serbs, left off before the start of the Yugoslavian civil war. They also deal in drugs, prostitution, stolen cars and various types of fraud. For sheer, crass barbarism, the armed robbery at the Munch Museum in 2004 pointed indirectly to them. The problem with catching only the thieves is that they will take their punishment in a Norwegian prison, come out and restart their lives where they left off. Only time and integration into Norwegian and other Scandinavian societies will temper their excesses.

The recovery of the two paintings has been a qualified success story. They are back at the Munch Museum, but damaged. Of the two, *The Scream* is the worst damaged. There is no happy ending. Trophy art robbery is a low class mugs' game, and it will be with us for a long time.

References

References to newspapers like the *New York Times* and the *Miami Herald* are cited in the text.

Dolnick, E. (2005) *The Rescue Artist: a true story of art, thieves, and the hunt for a missing masterpiece*. New York: HarperCollins.

Dolnick, E. (2007) *Stealing the Scream: the hunt for a missing masterpiece*. Cambridge: Icon.

Feliciano, H. (1995) *The Lost Museum: the Nazi conspiracy to steal the world's greatest works of art*. New York: Basic Books.

Hoving, T. (1996) *False Impressions: the hunt for big-time art fakes*. New York: Simon & Schuster.

Macintyre, B. (1997) *The Napoleon of Crime: the life and times of Adam Worth, master thief*. New York: Farrar, Straus & Giroux.

Naim, M. (2005) *Illicit: how smugglers, traffickers and copycats are hijacking the global economy*. New York: Doubleday.

Phillips, T. (2005) *Knockoff: the deadly trade in counterfeit goods*. Philadelphia, PA: Kogan Page.

Part IV
Voices from the field

12 Voices from the field

Rory Blain, Robin Duthy, Philip Hoffman, Alexander Hope, Peter Osborne, Tim Schofield, Colin Sheaf, Simon Staples, and Pierre Valentin

Introduction

Given the significance of social networks and relationships in the art world, interviews are important. Sotheby's Institute of Art views access to 'insiders' as an advantage of the MA in Art Business programme; however, these sessions are conducted *in camera*. Thus an alternative was sought. In 2006 interviews were conducted by Iain Robertson with a range of art business specialists for Xalt.tv, a subscription service, which offers webTV interviews on issues of relevance for the global wealth management industry. Art as part of one's portfolio – including the aesthetic and financial rewards of owning art and minimizing risk to capital – is a core theme of the interviews (see www.xalt.tv/art), which have been edited by Derrick Chong, to offer insights from industry experts. All the interviewees are based in London.

According to cultural economist Bruno Frey (2000), interviews should complement econometric analysis. This recognizes that the auction prices, the data used by economists, represent only a partial picture of art market activity and excludes all primary market sales. The pioneering work of Raymonde Moulin in the 1960s on the French art market and the research of Olav Velthuis (2005) on the contemporary art market in New York and Amsterdam are based on interview data. Likewise, *Collecting Contemporary* by Adam Lindemann (2006), which includes analysis of his own collecting decisions, is based on discussions with dealers, consultants, collectors, and curators.

To aid contextualization, reference is made to the *ADAA's Collector's Guide to Working with Art Dealers* (ADAA 2000) by the Art Dealers Association of America (www.artdealers.org), which is a text read by the MA in Art Business candidates. ADAA seeks to promote the highest standards of connoisseurship, scholarship, and ethical practice since it was founded in 1962. The 150 ADAA member galleries (e.g., Didier Aaron, Acquavella, Cheim & Read, Ronald Feldman, Marian Goodman, Luhring Augustine, PaceWilderstein, Andrea Rosen, Sonnabend, Sperone Westwater, Donald Young, and David Zwirner) cover every major collecting field.

Interviewees

Rory Blain: *Head of Sales, Haunch of Venison*

Haunch of Venison (www.haunchofvenison.com) was established by Harry Blain and Graham Southern in 2002, to specialize in American and British art from 1960 to the present. Galerie Judin in Zurich became part of Haunch of Venison in 2005. Gallery artists include Dan Flavin, Richard Long, Simon Patterson, Robert Ryman, Keith Tyson, Bill Viola, and Wim Wenders. Haunch of Venison attends international art fairs such as The Armory Show and the Frieze Art Fair. In early 2007 – after the interview was conducted – Christie's purchased Haunch of Venison.

Robin Duthy: *Founder, Art Market Research*

Art Market Research (www.artmarketresearch.com) was established in 1985 and produces 500 indexes accepted by leading art and financial institutions (such as Christie's, Sotheby's, the UK Inland Revenue, and the US Federal Reserve Bank) as measures of price movements in the art and related markets worldwide. AMR indexes are published in major financial press publications such as the *Financial Times*, the *Wall Street Journal, Business Week, Handelsblatt*, and the *Art Newspaper*.

Philip Hoffman: *Chief Executive, The Fine Art Fund*

The Fine Art Fund (www.thefineartfund.com) is the most successful managed fund; it offers fine art as an alternative asset class for investors. In 2003 Dewey Ballantine LLP, an international law firm, advised UK-based fund manager Fine Art Management Services Ltd on the formation of its special asset class fund, The Fine Art Fund, which sought to raise $350 million to invest in museum quality art. TFAF invests in modern and contemporary art as well as works of art by Old Masters and the Impressionists. TFAF is structured as a ten-year limited liability company. Prior to founding TFAF, Hoffman, a qualified accountant, spent over a decade working for Christie's, which he joined from KPMG.

Lord Alexander Hope: *International Business Director and Specialist in Old Master Pictures and Drawings, Christie's*

The auction house was established in 1766 by James Christie (www.christies.com). In 1999 Christie's was purchased by François Pinault and taken into private ownership. With fourteen salesrooms, including London, New York, Los Angeles, Paris, Geneva, Milan, Amsterdam, Tel Aviv, Dubai, and Hong Kong, Christie's generated global sales of $4.67 billion in 2006. Prior to joining Christie's in 1997, Hope was a merchant banker.

Peter Osborne: *Founder Partner, Osborne Samuel LLP*

Osborne Samuel (www.osbornesamuel.com) was formed in 2004 as a partnership between Peter Osborne's Berkeley Square Gallery and Scolar Fine Art/Gordon Samuel. The partnership has a strong emphasis in modern and contemporary sculpture, in particular the works of Henry Moore and Lynn Chadwick. Modern British art sits alongside a substantial inventory of twentieth century works on paper (by the likes of Picasso and Miro). Indian art is also a specialty and has led to a relationship with Saffronart, an online auctioneer of modern and contemporary Indian paintings (e.g., M.F. Husain, Krishen Khana, Ram Kumar, J. Swaminathan, and F.N. Souza). Osborne is on the executive committee of the Society of London Art Dealers (www.slad.org.uk), a leading UK trade association.

Tim Schofield: *Head of Motoring, Bonhams*

Bonhams (www.bonhams.com) has unrivalled experience in the sale of collectible motor cars, motorcycles, cycles, and aircraft with offices in London, Paris, and San Francisco. The heritage of Bonhams motoring department can trace its roots back to Brooks, the specialist collectors' motoring auctioneer founded by Robert Brooks and James Knight in 1989.

Colin Sheaf: *Head of Asian Art, Chairman of Bonhams Asia, and Deputy Chairman, Bonhams*

Bonhams (www.bonhams.com) is the third largest art auction house in the world; the present company was formed by the merger, in 2001, between Bonhams & Brooks and Phillips Son and Neale UK, which has been supplemented by acquiring Butterfields in the USA and Goodmans in Australia. A Hong Kong auction business opened in 2007. Sheaf is an expert in Ming and Qing porcelain, jade, and Chinese export ware.

Simon Staples: *Sales Director, Berry, Bros. & Rudd*

Berrys (www.bbr.com) is Britain's oldest wine and spirit merchant, having traded at the same London shop since 1698.

Pierre Valentin: *Solicitor and Head of Art and Cultural Assets Group, Withers LLP*

Withers (www.withersworldwide.com) is an international law firm with offices in London, New York, Geneva, and Milan. Valentin's specialist team offers a one-stop-shop for art market professionals and collectors on all legal issues arising from collecting and transacting in art. Clients include Hauser & Wirth Gallery, the Italian Ministry of Culture, the estate of Matisse in New York,

the Art Loss Register, and the Film Council. Before joining Withers, Valentin was legal counsel at Sotheby's.

Editors' note

In a limited number of cases, the editors have used square brackets to offer a supplemental note to an interviewee's comments.

Things to consider in buying art

ADAA: Authenticity ('no one wants to buy a fake'), *quality* ('it is always advisable to buy the best one can afford'), *rarity* ('rarity tends to enhance value'), *condition* ('a reputable dealer will inform a prospective purchaser of any significant repairs and defects'), *provenance and exhibition history* ('a good provenance can help establish authenticity, art-historical importance and title'), and *value* ('taste and market conditions change and values change accordingly') are the key things to consider when weighing a potential purchase (ADAA 2000: 4–5).

Valentin (on Due Diligence): Check what you are buying. This is due diligence, which is about minimizing risk. Two issues are identified: authenticity and provenance. Authenticity is not a legal issue. Rather it is a scholarly issue to identify the artist and the condition of the work (e.g., restorations), which also means rooting out forgeries, mistaken attributions, and reproductions. However, how a work of art is described by the seller or the agent can become a legal issue. If you bought a painting described as a Rubens and it transpires that it is not by Rubens, what are your legal remedies? Provenance is about tracking the ownership of the work. This may require consulting exhibition records and academic publications to verify ownership, or assess the risks that ownership might be disputed (e.g., looted art and family disputes). Moreover, as part of due diligence, it is customary to check a database of stolen art. The Art Loss Register is not a complete record of stolen art, but verifying that the art you are looking to buy is not recorded on that database helps to mitigate risk. The vendor may also be asked to provide evidence of previous sales. There may be no such documentary evidence or the seller may not be willing to disclose it. It is a matter of judgement whether the lack of documentation, or the seller's refusal to produce it, points to a potential ownership issue. This can be mitigated by appropriate contractual warranties. Another area to watch out for is illegal export. Illegally exported works of art are increasingly difficult to sell. Furthermore, knowledge that the art was illegally exported at the time of purchase may trigger the commission by the buyer of a criminal offence.

Hoffman (on TFAF's Process of Due Diligence): A strong internal regulation process is critical for investor confidence. The due diligence process is very important. TFAF makes investments using a 20-point process (e.g., how does the proposed price for the work compare with similar works, provenance,

condition of the work, market conditions for buying, etc.). Everything needs to be documented. Lord Gowrie, former chairman of Sotheby's Europe, is chairman of the fund board. There are five art buyers (Johnny van Haeften and Charles Beddington, both Old Masters; James Roundell, Impressionists and Modern; Ivor Braka, Modern and Contemporary 1960–85; and Thomas Dane, Contemporary 1985–2005). The decisions of the art buyers are aided by art advisors (Ugo Pierucci, Old Masters; Ian Dunlop, Impressionists and Modern; and Roger Bevan, Modern and Contemporary), who are able to factor in forthcoming exhibitions. The art buyers, art advisors, fund board, and fund managers are involved in different stages of the purchase approval process. Most investment purchases we make are private transactions, occasionally opportunistically (such as distress sale), to minimize transaction costs; occasionally, we buy at auction.

Hope (on Provenance): People in the art market take provenance very seriously. At Christie's we employ staff to research provenance for any work that is being consigned for auction. This includes checking the consigned object against known databases of looted art such as maintained by the Art Loss Register.

Blain (on Due Diligence): Risk is inherent in any investment, but ultimately that risk can be reduced or managed by taking good advice and, like any investor, doing your homework in the area you are looking at. If I were an investor stepping into this world for the first time I would expect to take as wide a view of information as possible from dealers and auction houses. I always and utterly advise passion when collecting. The advice I have for those who come to me is to buy the best that you can within your budget.

Sheaf (on Authenticity): It has always been a problem in the art market to be absolutely certain of the authenticity of an object. Most people would take a fairly pragmatic view that, whereas one can have a very firm opinion of authenticity, it will never be an objective certainty unless unimpeachable documentation exists. However, science is increasingly on our side to help us substantiate subjective opinions.

Hope (on Attribution): Old Master attribution is a key issue when an artist does not sign a work or paints in different styles. There can also be complications between a work fully attributed to an artist and a work attributed to the studio of the artist: the difference in market value can be colossal. Moreover, expert opinions on attributions do change. [For example, the Rembrandt Research Project was established in 1968 to adjudicate on the authorship of the Dutch master.] It is not so much a case of going to a dealer or auction house. The crucial thing is to be aware of the complications: those you can learn from dealers, auctioneers, or museum curators. Some basic knowledge is important for prospective collectors; more importantly, do not be afraid to ask questions. It is such a vast field so no one knows everything and to admit that you do not know something is important. Some people try to bluff it, but it is a bad idea. Ask questions: the dealers and auctioneers will be there to help. Do not try to assemble a collection all at once, pick carefully each

individual piece and do not try to be too clever. Some people try to make an overly academic argument for something they do not like and the truth is if they want to sell it again there is no guarantee that anyone else will like it either.

Sheaf (on Taste): In the past Tang horses have been more expensive than fifteenth century porcelain; in the past, pairs of Chinese export models of dogs and large animals made for the Western market in the eighteenth century have been more expensive than classical pieces of Chinese porcelain and classical jades made for the domestic market. Taste has completely changed over the last twenty years. We have seen the re-emergence first among the offshore Chinese (i.e., Singapore and Hong Kong) of old classical connoisseur collector taste and now, for the first time in 100 years, we are seeing it re-emerge on the mainland of China.

Staples (on Wine and Pleasure): Wine gives so much pleasure; great wine and great food at the end of the working day. Wine is meant to be enjoyed. All wine knowledge in the world can be distilled into one simple question: is it good to drink? At more than £100 a bottle, the issue is less about taste and more about kudos. Wine critic Robert Parker's 100-point scoring system has contributed to this, particularly in the USA, where wines which score above 90 points have shown the greatest appreciation in value.

Schofield (on Motors and Pleasure): There is a real 'fun factor' in collecting and enjoying classic motors, which may be the most pleasurable of alternative investment classes. Runs and races (on public roads and private circuits) can broaden friendships. There are lots of events globally.

Sectors of the market

The art market is best understood on a sectoral basis. Segmenting is by key periods, schools, and movements. Key segments are Old Masters, Impressionism and Post-Impressionism, Modern, and Contemporary. Non-Western segments include Indian and Chinese art. Both fine wine and collectible motor cars have established markets of collectors and appear as specialist categories at auction.

Hope (on Old Masters): You read a lot that this is a dying market. This is absolutely not the case; it is remarkable how many great works appear every year. Old Master drawings represent an undervalued area. For example the painting–drawing price differential is wider for Old Masters than Impressionists.

Osborne (on Modern British Art): Ben Nicholson without question; Patrick Heron increasingly so; Graham Sutherland because of the growing European market. Really good oil canvases by John Piper are getting high prices, likewise Ivor Hitchins. Stanley Spencer has become a big six-figure artist at auction, though he sells only to a British and Canadian buyer base. L.S. Lowry, of course, even though many said Lowry would die out; rather, he has gone from strength to strength. Henry Moore now sells for $5–6 million

for a big one that would have been $2–3 million ten years ago. Lynn Chadwick has had very consistent growth, likewise Barbara Hepworth. Demand from outside Britain is good news because when the market base is narrow it is difficult to hold with conviction. With sales in the USA, Europe (like France), and the Far East it is much easier to have confidence and justify price appreciation.

Osborne (on Contemporary Art): A lot of contemporary art is ephemeral by definition. So how do you preserve the intrinsic value of something that may corrode, collapse, fade, or disappear. I think that there will be issues of what to do with some of the art of the YBAs in ten years: fading colours, machines that do not work, and leaking formaldehyde, for example.

Blain (on Photography): If you are looking for one of the exciting things in contemporary art, it's photography. For many years, it has struggled to gain recognition relative to painting and sculpture. As a new medium, photography raised questions regarding value. What is the value of a photograph versus an oil on canvas created by the hand of the artist. This discussion will continue, I am sure well beyond the next two decades. But the discussion has been around for long enough for photography to be accepted as a fine art medium. The prices achieved by the top artists [such as Thomas Ruff, Thomas Struth, Cindy Sherman, Nan Goldin, and Jeff Wall] speak for themselves. We can see that the art world has accepted that.

Osborne (on Photography): Photography has seen spectacular growth over the last ten years. Huge, huge prices are being paid for things that are editions (i.e., essentially reproductions and in some cases unlimited reproductions). From an investment point of view, some contemporary photography worries me.

Sheaf (on Chinese Art): As the economy in China has expanded, works of art are going back there through international auction houses. This is purely down to China's economic strength. Chinese art breaks down into three distinct areas: (1) art made for the domestic market which is often very high quality; (2) Chinese art which is archaeological in inspiration and has been dug up such as Tang horses and bronzes from as early as 2000 BC; and (3) Chinese arts and crafts made for the export market. These three markets are very different and only one of them – category one, art made for Chinese domestic taste – is very strong at the moment. The market for Export art (category three) was rampaging a few years ago: then the American dollar slumped. Export art market is traditionally popular in the USA, but American dealers do not want to buy expensive stock when the US dollar has made such objects more difficult to sell. Category two, archaeological art, has been unpredictable and principally driven by the retail trade for many years, but for completely different reasons due to the nature of collecting in the West versus collecting in China. Chinese buyers are interested in category one, artefacts made for the domestic market but never intended to be buried; that is to say, made for secular and religious purposes. That is why we are looking at a market which is driven by Chinese collectors and that has

evolved to focus on the finest Imperial jades and porcelains, historical paint-
ings, and calligraphy; above all, objects made by top craftsmen for an elite
market in China.

Osborne (on Indian Art): The Indian market is a very good example of an
emerging market that has established itself very quickly on the world stage. It
has happened for the following reasons: as Indians, who are proud of their
national heritage, are getting richer they want to buy art of their country. A
great many Indians are ex-pats making up the wealth economies in London,
New York, and Paris, for example, and it is a perfect opportunity to spend
money on artists from their country. This collecting started about ten years
ago and has really taken hold. I am also interested in selling to non-Indians
and bringing it back to the mainstream because I believe that if Indian art is
to be a serious prospect in ten years' time it has to be as much collected by
Americans, the French, and British as it is Indians who have to live in
those countries. This will be a challenge, I mean convincing non-Indians
to buy it. Institutions are also a challenge. Bit by bit interest grows. The Tate
has started to show an interest in Indian art and they have made space for
F.N. Souza. Indian donors to elite art museums will also start to influence
directors and acquisitions committees. It is not a bit cynical to say that every
major art museum in the USA with a world-beating collection of Artist X can
be traced back to elite patrons who were keen on Artist X through donations
of works or cash for acquisitions. Saffronart is a good example. It was estab-
lished in 2000 to sell Indian art to ex-pats in the USA and then Europe.
However, the client base is growing in India as Saffronart expands from its
origins as an auction house conducting high-profile auctions several times
per year. Saffronart is working with artists by visiting studios and advising
artists about exhibiting at particular commercial galleries as part of building
a market. They are good friends and we have done projects and hopefully will
continue to do so: they speak my language, they are interested in nurturing
and building artists, publishing books on artists, supporting activities outside
of India, and working closely with commercial galleries in India.

Staples (on Wine): Wine is a minefield. Berrys' is best at French Bordeaux
[The main districts of Bordeaux are Médoc (the most important), Pomerol,
Saint-Émilion, Graves, and Sauternes. The 1855 Official Classification of
Bordeaux, as part of the Exposition Universelle in Paris, established five
divisions or growths, known as the *grands crus classés*, from premier down
to cinquième, of the top red wine-producing châteaux of Bordeaux. White
wines of Sauternes were divided into two subcategories. There has been only
one official change: Mouton-Rothschild was promoted to premier grand cru
classé in 1973.] The first growth châteaux – Lafite-Rothschild, Mouton-
Rothschild, Margaux, Haut-Brion, and Latour – remain the benchmark of
excellence. Great wines in limited supply include Pétrus (£3,000 per case
which quickly rises to £10,000) and Le Pin (approximately 500 cases per
annum at about £10,000). Some 'pretenders', which attract high prices and
are highly sought by collectors, have emerged: Italian 'super Tuscans',
Californian 'cult wines', and 'branded' Australians. [Super Tuscans emerged

in the late 1980s outside the official premium Italian wine designations, DOGC and DOC, as Bordeaux varieties were used. Most are still sold as *vino de tavola* or table wine, though Sassicaia – a proprietary name for a Cabernet Sauvignon/Cabernet Franc blend – has its own DOC status, Bolgheri Sassicaia. 'Cult wines' is an American term used to describe largely Cabernet Sauvignon wines produced in small quantities by California's Napa Valley wineries such as Araujo, Colgin-Schrader, Frog's Leap, Grace Family, Harlan Estate, and Screaming Eagle. Australians emphasize the producer (as the brand) rather than the source of the grapes, with notable successes like Penfolds Grange Hermitage and Penfolds Bin 707 Cabernet Sauvignon.]

Schofield (on Motors): There is much knowledge in the public domain for classic motors. An opportunity to purchase a highly competitive and eligible entry (race ready condition) to the great variety of historic sportscar events around the globe – such as Le Mans Classique, Goodwood Revival, and Monaco Historique Grand Prix – are key drivers of consumer demand and market popularity. As such, a well-document provenance (including events and repairs) enhances value. In the UK, a main financial advantage is that classic motors do not incur capital gains tax and those that were built before 1973 do not incur road tax. Insurance also tends to be generally cheaper as the insurer assumes the owner is devoted to the car and will not take risks.

Art as investment

ADAA (on Value):

> Particularly when prices are rising, the idea of 'art as investment' gains credibility. However, collections assembled with the hope of financial profit alone often prove to be poor investments. Collectors should be wary of apparent bargains and promises of future gain. Art chosen solely on the basis of price will yield a mediocre collection that does not necessarily hold its value on resale, especially during economic downturns. It is collections formed with passion and intelligence that stand the test of time, both aesthetically and monetarily.
>
> (ADAA 2000: 5)

Sheaf (on Investing and Taste): If we are talking about pure asset management investment, treating art explicitly as a financial asset (which history does not encourage one to do over the long term) I would no more buy art because I like it than I would buy gold shares because my favourite colour is yellow, or buy sugar futures because I like boiled sweets. If I am to invest in art, I should be looking at the economic and social variables which underpin and move the market. I should look at the way other people are currently collecting, and have collected in the past, to identify those sectors which have stood the test of time as 'blue chips' of the art market. I should also look at the economic strengths and weaknesses of any country from which the art comes that I am

considering as a financial investment, and I should take a view of the actual and potential economic development of that country. Maybe it is very nice to buy works of art for investment because you like them as well. But, in the last resort, you are then back to the problem that you are backing your own taste. This means that you are not looking at the rest of the market and at those active buyers and irrational variables that are actually going to move the market.

Hope (on Ongoing Maintenance Costs): The largest ongoing cost is insurance and you can spend as much as you want, but it depends on where the work is being kept. People often think of Old Masters paintings as being very fragile, but they are very durable and have been around for 400–500 years and have stood the test of time. In a normal house there is no need for any special atmospheric conditions: what paintings do not like are excessive swings in temperature and for paintings on wooden panels humidity can be a problem, but in most climates there is not a great deal to be done (other than not to drop them or put them over radiators and fires).

Blain (on Aesthetic Yield): If you are going to invest in art or have it as part of a portfolio, as a fiscal plan, like any investment it can go down as well as up. However, art has many other things going for it: not many people who buy stocks or shares will sit there and admire them, gain enjoyment from them, and have a value beyond their simple monetary value. Art is a very different kettle of fish in that respect.

Sheaf (on Market Timing): To invest in art requires two very important considerations that have nothing to do with the works of art themselves. One is to do with timing: when you buy and sell. The second, which is far more important to my mind, is to look at the context of the economy into which you are buying. Anyone can go and invest in anything they like, but it is far more intelligent to look at the socio-economic background. If you had invested in Chinese works of art in 1910, you would have been wiped out in the short and middle term because the context was a declining empire; if you had invested in the 1940s it would not have been very good either. Now we are looking at a country emerging from the shadows of massive political repression, economic hardship, and social dislocation and turning into a country in which many individuals are making vast amounts of money in all sorts of enterprises. This provides a safer basis for investing in the culture again, with the proviso that only certain sectors are traditionally popular in China. There are many sectors of Chinese art that have never been collected in China or by Chinese people. In my opinion, grave goods will never become popular subjects since the Chinese are not by tradition grave robbers. It is unlikely that Chinese unlike Western buyers will ever look at Tang horses or bronzes as items they want to dress a drawing room with, whereas an Imperial jade vase or piece of porcelain are items the Chinese have enjoyed for half a millennium and will continue to do so in the future.

Blain (on Contemporary Art and Holding Period): There is a wider audience of buyers and appreciators of art. That there are more people looking to buy

means that there is a bigger base and this will have an upward effect on prices, which can shorten the holding period. Some collectors will look to realize capital gains from work in order to raise money to buy new pieces, so there are valid reasons for doing it. The honest answer is yes, the way the market has developed has seen holding times reduce.

Hope (on Old Masters and Holding Period): In the field of Old Masters, paintings are held for a longer period of time so that there is less short-term speculation. The holding period tends to be a generation, but there are exceptions. I think the majority are your fairly traditional collector category, but there are investors as well, and there are some speculators, so there is not just the *obvious* Old Masters buyer.

Sheaf (on Contemporary Chinese Art and Dealers): The Chinese are a very conservative nation. They always look back to earlier styles of painting and it is a complete novelty that in the past few decades they have begun painting in a Western medium and following Western techniques of proportion and indeed subjects. As for the market for contemporary art in China, it is different to what we are used to. It is an exciting place to be, but not one I would recommend for alternative investments simply because you do not have any perspective on it, you do not have the background to make informed judgements. It is very difficult to work out who the winners will be in twenty years as the market for particular artists will often be driven by individual dealers who do a splendid job in presenting an artist and helping his career growth and developing a band of collectors for him. If that dealer drops out for any reason or changes to other artists, markets can change very quickly in the contemporary art market.

Duthy (on Art Market Indexes): Art remains a complex market, and it is clearly a jungle for the unwary, but investors can begin to move into this market with confidence as more research tools and indexes are developed. Indexes exist for equities and real estate, so why not one for art? Each art work is unique, so it is challenging to create art indexes. Art Market Research is based on taking art sales data, starting in 1975, from public auctions around the world (though there is no reliable method to collect data from emerging markets like India, Russia, and China). Though auction house data are only a partial picture, there is no reliable and transparent method to collect data from the sales of dealers or private treaty sales of auctioneers. The methodology is based on the centre 80 per cent – that is eliminating the top and bottom ten per cent, respectively – of auction prices for individual artists collected on an annual basis since 1975. The late Sir Roy Allan of the London School of Economics validated the methodology. The data set has 1000 separate artist indexes and 300 sectors are represented. We believe that Art Market Research is superior to the work of Mei Moses, which is based on repeat-sales at auction where a chief weakness is a bias to successful resales at auction (i.e., unsuccessful lots – that is bought-in second offerings – are ignored). Art Market Research helps by offering objective data, which enhance the efficiency of the art market. This leads to greater trust. The

AMR Collection Manager is a bespoke service whereby an index can be assigned to individual objects.

Osborne (on Art Market Indexes): There is no such thing as an art index which tells the truth. Some of them tell some of the truth some of the time such as when they examine the progress of an artist at auction, but they do not really look at the quality of the picture that sold for a million as opposed to the picture that sold for a hundred thousand. Artprice has always pretended to be the biggest and the best. I always tell people to look at Artprice and Artnet: at least it gives you a picture of things sold at auction. But above all go and speak to the people who represent the artist.

Hoffman (on TFAF): Given the phenomenal interest in art as an asset class, TFAF was established in 2004 as an investment vehicle for art (including oil on canvas paintings, works on paper, and sculpture) from the thirteenth century to the present. Whereas private collectors will have an aesthetic perspective in mind, TFAF is an investment vehicle [i.e., the aesthetic yield is zero]. TFAF is structured just like a private equity fund. [A private equity fund is a limited partnership with a holding period, of say five to seven years. Two categories benefit from private equity funds: those who provide the capital that allows the acquisition of (limited partners); those who manage the fund (general partners).] Objectives in assessing a work's potential include growth of 40 per cent in one year or tripling of value in three years. Works are bought in the range $300,000 to $5 million, with an average of $600,000 per work. The minimum investment is $250,000 and investors are committed for at least three years. Such a timeframe reduces the liquidity problem. Costs are kept to a minimum by mostly buying and selling privately, so cutting out the transaction costs associated with auctions. The fund is able to move opportunistically, for example, by buying from distressed sellers. Co-investment is another method: it allows a group of investors to buy a specific work or works with a short holding period (mostly one to two years) in mind. Most of the works in TFAF are stored in Geneva or out on loan to art museum exhibitions. Fund members can pay a rental charge of 1.25 per cent of the work's insured value in order to display a work at home. It is recommended that a diversified portfolio has 5 per cent invested in art (as the majority of art sectors have a low correlation to stocks and bonds). For a $1 million investment in art, I would recommend $500,000 in an art fund, $300,000 in a co-investment, and $200,000 devoted to a private (home) collection.

Staples (on Wine): Wine is classified by UK Inland Revenue as a 'wasting asset' so it does not incur capital gains tax. There are three points in time to buy wine. First, *en primeur* (or wine futures) is the process of buying wine in the summer after the harvest but not actually receiving it for another eighteen months, when it is bottled and released onto the market. Second, when the wine is physically available, which is usually two to three years after the vintage. Third, ten years before the wine is ready to drink. One investment strategy is to buy five cases *en primeur*: drink two and sell three. Berrys' is often a willing buyer. The opening *en primeur* price is almost always considerably cheaper

than the future price for the wine on the open market; *en primeur* can also be the only way to secure wines that are available in very limited quantities. In building a cellar, red Bordeaux remains key: in the main, buy the greatest wines from the greatest vintages. Sauternes is the last one to invest in. Buying *en primeur* requires storing wine in a bonded warehouse: the advantage is that the purchase is ex-VAT (17.5 per cent) and ex-Duty (UK Duty is £1.29 per 75cl bottle for still wine); the disadvantage is that the owner is not able to take physical possession as part of an in-house cellar. [Berrys' offers 'ten tips for investing in fine wine': deal only with established and reputable merchants, but shop around for advice and prices; buy your wines 'in bond' so that Duty and VAT are not payable up front. This will maximize your investment; buy unmixed sealed cases, in original wood if possible, as these will be worth the most; expect to invest over a five year period, but be ready to sell if advised; buy as close to the opening price as possible; buy parcels of five cases or more whenever possible; invest at least £5,000 if you are looking for serious returns; do not blindly buy just the big names – they may have less profit potential; listen to your wine merchant; make sure you know the provenance and storage history of any wine you buy as this will seriously affect the market price; and take out insurance so that your wine is fully covered at market price rather than the price you paid for it.]

Roles of the dealer and relationships with auction houses

ADAA (on What Dealers Do): Education, publications, curatorial, appraisals, and sales and resales are listed as the range of services.

> Buying a work of art from an ADAA dealer is often the beginning of a long-term relationship. Art dealers not only help collectors buy, but can also help clients sell works when the time comes to upgrade or change the direction of a collection. It is always worth consulting the dealer who originally sold a work before reoffering it, since dealers frequently keep track of requests for specific works on behalf of clients. Dealers appreciate clients who turn to them when reselling, and are more likely to offer these collectors important works in the future.
>
> (ADAA 2000: 6)

> It is important to recognize that prices achieved at auction do not necessarily reflect the fair-market value of the works in question. One can easily overpay at auction, and when selling at auction, one may well net less than by selling through a dealer.
>
> (ADAA 2000: 9)

> A dealer will be able to begin marketing a work from the time it is received, unlike auction houses which must sometimes wait six months for a suitable sale date. Sellers have more control over the final price and conditions of sale when working with a dealer than is possible at auction,

in part because there is far less time pressure. This lack of pressure allows for a measured and effective interchange between the dealer, the seller and potential buyers. Dealers protect sellers with confidentiality and comparative privacy, avoiding the negative effects of exposure through auction catalogues. The information that a particular lot has failed to sell at auction is as widely disseminated as the catalogue itself. With a dealer, a seller can always adjust the price if the market changes or has initially been misread.

(ADAA 2000: 7)

Dealers also tend to attract more museum clients than auction houses, since the short lead time makes it difficult for museums to bid at auction. Knowledgeable sellers of museum quality works therefore often prefer to rely on dealers.

(ADAA 2000: 9)

Blain (on Representing Artists): The role of dealers as an interface in the marketplace tends to be necessary in the primary art market. Dealers represent living artists who are producing works; we help in exhibiting artists and disseminating their work to wider audiences. At the same time, dealers are essential for private collectors and museum curators: we offer professional assistance to buyers to help them develop their collections. It is important to remember that as a dealer our number one concern is to look after our artists. It is not just about selling their work. If that were the case, it would be a great deal easier. It is about placing works on the right platform for a particular artist so it reaches the right audience. Whether that is a private or public collection, a number of considerations are taken into account.

Osborne (on Quality Assurance): In my job as a dealer, I always stand by everything I sell. I am on the executive committee of the Society of London Art Dealers, which has a code of conduct. I strongly recommend every collector should always ensure that they get the right information from the gallery they buy from in terms of authentication and certification guarantees, it is what he says it is, in this exhibition catalogue, reference book, or *catalogue raisonné*. All of this information should be made available. If any gallery owner does not or cannot provide this sort of information, as a buyer I would hesitate long and hard before buying.

Blain (on Auctioneers): As a dealer I am aware of competitors including leading auction houses. Public auctions lend transparency to the art market so that prices are easier to understand and access. In the long run, auction houses are good for business.

Osborne (on Auctioneers): It is increasingly difficult because the auction houses are doubling and redoubling their efforts to get our clients into the sales rooms. All the auction houses have increased their private treaty sales. All the auction houses are targeting our clients. So what is a fair price? It used to be that the auction price was your yardstick. This is no longer the

case. It is up to us, the dealers, to provide the right sort of information to our clients and to tell them what we think is a fair price and to tell them where we think the market is going for the artist they are interested in collecting – almost in spite of what they have seen in an auction room. You need to be able to justify your actions as a dealer and have confidence in the art works and prices you are charging.

Concluding remarks

The aesthetic and financial rewards of collecting fine art, which is about minimizing the risk to capital, dominate the issues raised by the interviewees. The aesthetic yield, associated with connoisseurship and private collecting, features: a good collection is greater than the sum of its parts; do not attempt to assemble a collection all at once; take time, ask questions of dealers and auctioneers; and learn about artists. This is all about educating one's eye. 'Art as investment' thinking chips away the aesthetic yield.

'Doing one's homework' has an added significance if a financial return is the motivation for buying art. This is certainly the case with art funds serving as an alternative asset vehicle for sophisticated high net worth individuals. Given the low level of regulation in the art market, due diligence is important to ensure a higher level of confidence in art transactions: the object is what the vendor says it is; and the seller is in a legal position to sell the work. There is a need to understand the market. Certainly, more information has been made available to collectors: the Art Loss Register is a key source for due diligence; and published price data based on auction results are useful and provide awareness of how the market has moved. Timing remains important: when to buy and when to sell; how to identify the turning points in an art market sector or for an individual artist.

The rise of contemporary art and the emergence of art and collectors from China and India reflect current taste patterns and market conditions. First, particular attention has been devoted to contemporary art. As contemporary art is a reflection of our society it can be hugely rewarding and fascinating to collect. The popularity of contemporary art is buoyed by the role of celebrity and an accompanying social scene. One consequence has been shorter holding periods. For example, in many cases less than a decade separated primary market sales and high-profile auction sales. Some have questioned whether long-term value is secured with such rapid price appreciation. Second, 'Chindia' has gained much media attention in the financial press so it is not surprising that artists and buyers from China and India have started to take root in the art market. A key objective of dealers is to grow the buyer base beyond one grounded in the nationality of the artists being collected. More and diverse collectors, for a sector and individual artists, enhance overall buyer confidence.

The role of the dealer as a key intermediary, fostering relationships with artists and collectors (who are buyers and sellers), is a core ADAA theme. In

the primary market, the role of the dealer in artist representation remains crucial. However, dealers may be feeling greater pressure from auction houses in the secondary market. Relations between dealers and auctioneers reflect traditional channel issues of cooperation and competition. The traditional benefit of the auctioneer – offering price transparency to the art market – is under threat according to dealers, who view private treaty sales by auction houses as counter to price transparency. Christie's purchase of the Haunch of Venison is one manifestation of the dynamism of the marketplace.

References

Art Dealers Association of America (ADAA) (2000) *ADAA Collectors' Guide to Working with Dealers*. New York: ADAA.

Frey, B. (2000) *Arts and Economics: analysis and cultural policy*. Berlin: Springer.

Lindemann, A. (2006) *Collecting Contemporary*. Cologne: Taschen.

Moulin, R. (1987) [1967] *The French Art Market: a sociological view*. Arthur Goldhammer, trans. London: Rutgers University Press.

Velthuis, O. (2005) *Talking Prices: symbolic meanings of prices on the market for contemporary art*. Princeton, NJ: Princeton University Press.

Index